REMEMBERING THE PRESENT

Remembering

Johannes Fabian

the Present

PAINTING AND
POPULAR HISTORY
IN ZAIRE

University of California Press
Berkeley Los Angeles London

The publisher gratefully acknowledges the contribution provided by the Art Book Endowment of the Associates of the University of California Press, which is supported by a major gift from the Ahmanson Foundation. Publication was also made possible in part by a grant from the Netherlands Organization for Scientific Research (NWO).

University of California Press
Berkeley and Los Angeles, California

University of California Press, Ltd.
London, England

Library of Congress Cataloging-in-Publication
Data

Fabian, Johannes.
 Remembering the present : painting and
popular history in Zaire / Johannes Fabian.
 p. cm.
 Includes bibliographical references and
 index.
 ISBN 0-520-20375-5 (alk. paper). —
ISBN 0-520-20376-3 (pbk. : alk. paper)
 1. Tshibumba Kanda Matulu—Themes,
 motives. 2. Zaire in art—Exhibitions. 3.
 Tshibumba Kanda Matulu—Criticism and
 interpretations. I. Title.
ND1099.C63T7534 1996
759.96751—dc20 96-13328
 CIP

Printed in the United States of America

9 8 7 6 5 4 3 2 1

The paper used in this publication meets the
minimum requirements of American National
Standard for Information Sciences—
Permanence of Paper for Printed Library
Materials, ANSI Z39.48-1984.

CONTENTS

PREFACE AND
ACKNOWLEDGMENTS

Part I of this book exhibits the work of Tshi-
bumba Kanda Matulu, a painter from Shaba, a
region in southeastern Zaire dominated by the
mining industry during colonial and postcolo-
nial times. He painted these pictures as part of a
project to present the history of Zaire. They are
accompanied by the artist's narrative, translated
from a local variety of Swahili, as well as excerpts
from my conversations with him and historical
notes.

Tshibumba Kanda Matulu was about twenty-
seven years old in 1973–74, when I first got to
know him as one of the many genre painters
who plied their trade in the towns of Shaba —
men of the people who sold their pictures to the
people. A sample of his work had been acquired
to add to a growing body of ethnographic docu-
mentation on the social significance of popular
painting. It was in the course of a routine inter-
view about his life and his conceptions of artistic
work that Tshibumba conceived or made known
his project of painting the entire history of his
country. In later conversations he talked about
feeling confined by the generic canon of
subjects that had emerged in Shaba and defined
the local market. He thought of himself as a
historian and an educator of his people. But he
knew that his local customers would never offer
him the opportunity to make the comprehensive
statement he wanted to make. For his voice to be
heard, in images and words, Tshibumba needed
the sponsorship of someone like this expatriate

anthropologist who, he suspected, might take an interest in his story.

During the seventies, thousands of genre paintings were sold in the towns of Shaba. With very few exceptions, the buyers were members of the African working class or emerging petite bourgeoisie. They would acquire one or two paintings but seldom more, selecting genres they fancied. Tshibumba's History of Zaire, a series of one hundred paintings, would never have had a chance to be sold on the market, whether to local users or to occasional expatriate collectors. While we worked on the project, from 1973 to 1974, and in subsequent years, Tshibumba found among my expatriate colleagues a few buyers for several shorter versions of this initial series. As far as I know, these buyers had previously been only incidental collectors of genre paintings.

Economic constraints were only part of what prevented an easy, natural transition from genre painting to a painted history of Zaire. A further impediment was the use to which paintings were put by local customers and occasional collectors. Genre paintings were made and acquired to be displayed in a living room or small commercial establishment. Tshibumba's series never had such a prospect; a hundred paintings will not fit into such a space. Although this plan remained implicit at the time, the pictorial elements of Tshibumba's account were destined from the beginning for exhibition in the medium to which he wanted to contribute as a historiographer: the book. The idea that the entire series might one day be exhibited in a museum never crossed our minds when we were engaged in the project. Now — after a delay of twenty years, dictated by personal as well as professional circumstances — as this book completes the initial project, it confounds accepted distinctions between an exhibition of art and one of ethnographic objects. It is, moreover, impossible to apply a more fundamental (and culturally deep-seated) separation

of images from words to Tshibumba's History without destroying its integrity. Anthropology may in the course of its history have established habits of representation according to which natives are seen rather than heard. These habits have come under heavy theoretical attack, and there is no lack of arguments in that debate. What we need more of are practical refutations such as this book offers.

Tshibumba often framed his images by painting a black border on the canvas. Similarly, as the ethnographer who recorded Tshibumba's narrative and our subsequent conversations, I have framed the texts to be exhibited here: I have selected passages for translation from a transcript that amounted to several hundred pages; numbered each painting according to its place in the sequence; and formulated concise titles (adopting the painter's own designations whenever they were available), as well as the headings that mark the major divisions, or "chapters," of the painter's narrative. Most of the paintings bear inscriptions of varying length on the painted surface, usually at the base of the image, as captions or comments on what is depicted. These inscriptions are in French (with two exceptions, in Lingala), and I have supplied translations immediately following the painting number and title.

Each painting (except those in the last section, on the future) is introduced by portions of Tshibumba's narrative, which appear in sans serif type below the painting itself. They are followed by excerpts from our conversations about the picture, with the speakers marked *T* for Tshibumba and *F* for Fabian. I have added explanatory notes, which are set in small type at the end of the painting's text, whenever necessary. Everything that appears in both the narratives and the conversations was recorded in Swahili, but I must emphasize that not everything that was recorded is displayed. In addition to selecting the texts, I have translated and edited them. In the narrative passages, traces of conversation —

brief interjections, repetitions, hesitations, and much of the redundancy that characterizes oral performance — have been silently omitted. Only larger gaps are marked by ellipsis points. Excerpts from our conversations are similarly treated, and these required even more editing — most often in the form of omissions but with occasional additions, usually to paraphrase or explain terms that would be difficult to understand without extensive notes. The translation of a text that is the transcript of an oral performance can never be more than a script for another performance, one that recreates the artist's telling of a story and his ways of explaining and reflecting on his work. Many of our exchanges were dialogues. Dialogues are events whose meaning is never adequately represented by literal reductions to writing. Those who wish to take Tshibumba — and the translator — "at his word" will have to consult the Swahili transcripts that I hope to make available eventually. A few Swahili excerpts, as well as numerous more literal translations, appear in the second part of this study.

The biographical and reflective exchanges offered here as the Prelude to Tshibumba's History of Zaire give the reader an idea of the difference between exhibiting textual material and presenting protocols of verbal exchanges. These texts were recorded before Tshibumba began to tell the story of Zaire, and their translation tries to preserve the flavor of the original just short of the point at which faithfulness to the Swahili utterances would result in a caricature of the event that produced them.

What Tshibumba shows and tells is impressive; it is often amusing, shocking, incredible, and plainly erroneous. Above all, his History is not just a story but an argument and a plea. While every picture, every narrated episode, every comment can stand on its own — after all, paintings and text fragments are objects not consumed by any single interpretation — none can be under-

stood fully, let alone judged fairly, outside its cultural and political context. This truism applies to all interpretation of cultural products, but here it is a major challenge, given Tshibumba's profoundly dialectical approach to historical truth. He "thinks" his paintings (that is his own term) by setting up contradictions. He plays with incongruities, practices irony, and revels in allusion. In short, he uses all the tricks he shares with the singers, actors, and storytellers of his country, who, in a long history of colonial and postcolonial repression, had to learn to speak the truth in ways that assured the speaker's survival.

Although I have decided — with the qualifications noted — to let this History first speak for itself, I realize that the viewer and reader who is not an expert in the history of Zaire (and I myself can claim only a modest expertise) will require some help to understand just how much this account challenges established historiography. Tshibumba's inventive genius and the originality of his perspective, as well as the restrictions imposed on him by his limited formal education and access to sources, can at least be divined from the notes that accompany pictures and texts.

For a while I toyed with the idea of providing a sort of naked confrontation between his account and official ones by including a "correct" chronology culled from published sources. But even apart from philosophical questions about the objectivity of selection in chronologies, this would have been a doubtful exercise. Dates, once established, need little interpretation, but events always require it: places, protagonists, and the sequence and significance of actions are never givens; they need to be worked out. As an interpreter of the history of his country, Tshibumba competes with journalistic reporting and academic historiography, and his voice should not be silenced by dismissing him as unprofessional. This is why I decided to let the sequence of paintings and narrative episodes determine

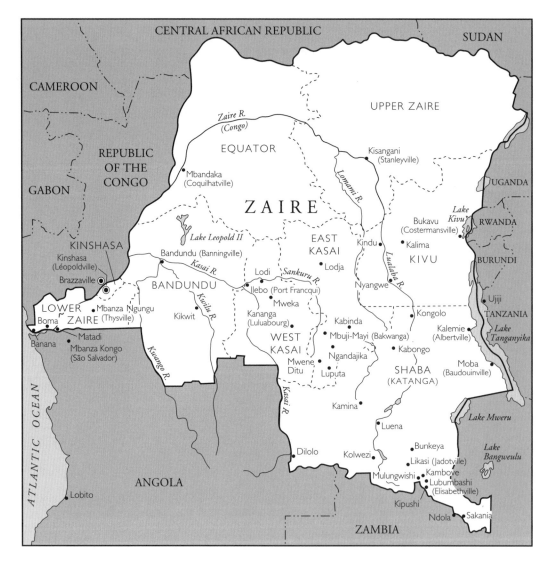

Zaire. The broken lines within the country indicate regional boundaries. Former (colonial) place names are given in parentheses.

that of the notes on chronology, biography, and geography.

Contradictions that arise between Tshibumba's account and written histories thus become visible. The notes should help to highlight the nature and importance of these contradictions but are not intended to resolve them. Nor are they the place to submit Tshibumba's vision of the history of his country to detailed scrutiny and critique in the light of academic scholarship. For an example of such work see Vellut 1992, a painstaking fifty-page commentary on one painting by Tshibumba, written by the author of a comprehensive guide to sources for the history of Zaire (1974). Few of Tshibumba's statements that count as errors by the standards of African historiography are simple mistakes (which he would be the first to correct). Most of his departures from fact — especially from such seemingly simple facts as dates — are fictions with a message. They are intended to "make us think" (the phrase that Shaba genre painters, Tshibumba among them, used when asked to describe the purpose and effect of painting). It is hard to imagine that anyone could view these paintings and read the texts and not be made to think.

Many dates given in the notes are a matter of debate, especially for series of events. It is often impossible to extract dates from a single publication, since some may be wrong in the source from which they are quoted. In compiling chronological annotations, I therefore made a point of citing a fairly representative sample of references — works by scholars and journalists and recollections written by participants in the events — without entering academic debates. Often these notes will reveal discrepancies between Tshibumba's narrative and established historiography, perhaps confirming hunches an interested nonexpert reader might have. Some of the more conspicuous disagreements are indicative of the nature and scope of the challenge that this History of Zaire presents for the scholarly commentator and analyst. Several of

the sources cited in the notes are writings by Zairian historians (Lohaka, M'Bokolo, Ngandu, Tshimanga), who in part share Tshibumba's experiences and perspective. They report oral traditions and offer interpretations that may constitute a link between Western historiography and Tshibumba's vernacular history. Zairian historians with academic training have also compiled extensive chronologies (Tshimanga n.d. [1976]; and especially Mandjumba 1989). All translations from published sources are my own.

There is one problem that all historians of Zaire face. The names of localities, geographic features, and institutions have changed in the course of history (and may change again as of this writing). Tshibumba himself takes a "presentist" approach on the whole (though not consistently): he employs names that were current when he spoke. I have respected this practice in my translations and in references to the texts. The map includes many former names, in parentheses, along with the present ones, to help orient the reader.

One issue may be too urgent to be left for the interpretive part of this work. Some of the paintings and inscriptions might give the impression that Tshibumba glorified the Mobutu regime. That impression is completely dispelled if one listens carefully to the narrative and comments and, indeed, considers the pictorial series as a whole. Gestures of submission, rehearsed in colonial times, are found in all expressions of Zairian popular culture. Local audiences are not fooled by them — nor, I suspect, are the authorities.

Part II follows the exhibit of Tshibumba's work with ethnographic essays, beginning with a history of this History of Zaire and ending not with an all-embracing conclusion but with an open-ended confrontation. The approach taken and the main issues to be addressed are outlined in the brief Introduction. Following Part II is an Appendix listing technical information on Tshibumba's paintings that make up the series, as

well as a few others. The References at the end of the volume cover both parts of this study.

To acknowledge debts to Tshibumba Kanda Matulu by expressing the usual gratitude to him as my "informant" would be inappropriate. The briefest glance at our relationship, as evidenced in the texts presented here, shows that we were engaged in a common task. To the extent possible under the economic and political circumstances, we owed each other. It is thus all the more saddening that Tshibumba could not take part in the completion of our project. After my departure from Zaire in 1974, we stayed in touch through letters, and he sent me a few more paintings through a colleague in early 1976. Not much later, Tshibumba disappeared from Lubumbashi and was presumed killed during the 1978 invasion of Shaba. But then a French version of his historical narrative, dated "Lubumbashi, September 1, 1980" was recently made available to me by B. Jewsiewicki, and Vincke 1992 cites a letter from Tshibumba and reproduces several pictures, all dated 1981. Vincke notes that after 1982, his attempts to find Tshibumba were futile (as were mine during two visits to Shaba in 1986 and 1987). A rumor that is currently being pursued is that Tshibumba left Shaba for the Kasai, the native region of his parents, perhaps for political reasons. Such a move would make much sense today, since Kasaians are once again persecuted and massacred in Shaba, but that was not the situation in the early eighties. Personally, I think it is very unlikely that all our attempts to find him should have failed and that Tshibumba would not have tried to get in touch with us, or that his growing international fame should have escaped the attention of everyone in his undoubtedly wide network of relatives and friends. One way or another, he is gone.

My stay in Shaba between 1972 and 1974 was initially funded by the United States National Endowment for the Humanities (for research on language and labor among Swahili-speaking workers). These ethnographic inquiries soon extended to expressions of popular culture. The recordings of Tshibumba's narrative and our conversations were made as contributions to a project on colonial and postcolonial art in Shaba undertaken by Ilona Szombati. During that phase (1973–74), my stay in Zaire was supported by a grant to the National University of Zaire from the Rockefeller Foundation.

Library research for this book was conducted at the Herskovits Library, Northwestern University. I would like to express my thanks for the help I had there, especially from Mette Shayne, who shares my interest in Zaire. Gratitude is also due to the Institute for Advanced Study and Research in the African Humanities, Northwestern University. My work was supported by a grant from that institution, supplemented by funds from the Faculty of Political and Social-Cultural Sciences at the University of Amsterdam.

A brief stay at the Getty Center for the History of Art and the Humanities, Santa Monica, allowed me to check references, especially to genre theory in art history. Versions of the essays in Part II were presented as lectures at various universities and academic conferences, most recently as a seminar course at the New School of Social Research, New York. I thank all those who invited me to speak about Tshibumba's History for the opportunity to put my interpretations up for discussion. Finally, I am grateful to the Netherlands Organization for Scientific Research (NWO) for subsidizing the production cost of this volume.

I have had editors in the past who just did their job. Stanley Holwitz, who was the first to express interest in this project; Monica McCormick, who saw the contract and manuscript through the review process; and Rose Vekony and Nola Burger, who worked on the text and the design, respectively, made me feel special. I thank them for their enthusiasm, which, if not by me, is

richly deserved by Tshibumba and the genius of the people he represented.

These acknowledgments would not be complete without an appreciation of the kindness and generosity my friend and former colleague at the University of Lubumbashi, Bogumil Jewsiewicki, has demonstrated through the years by sharing his insights and findings. By now many have written about Tshibumba, but no one has done more than he to establish the artist's justly merited fame.

Amsterdam/Xanten, June 1994

PART I

The History of Zaire
as Painted and Told by
Tshibumba Kanda Matulu

PRELUDE

Tshibumba on Tshibumba

The texts that make up the Prelude, unlike the ones that accompany the paintings, are attempts at literal translation. Repetition, monosyllabic interjection, repair, and other elements of live conversation are preserved in this version, and only a few brief passages are omitted (marked by three dots). Just as shapes and shades are worked out in a painting, sometimes with much brush-work, sometimes by merely a few strokes, so are ideas developed in oral communication, which is characterized by both redundancy and ellipsis — too much and too little for the reader who was not present in the flow of speech and cannot benefit from clues that get filtered out when speech is transposed into writing. Thus I occasionally needed to fill the gaps, and I have marked these additions by square brackets. Sometimes short passages are incomprehensible because of poor recording, overlapping speech, or background noise. These places are indicated by a question mark with three dots to either side. Trailing speech and incomplete words or phrases are marked by three dots.

ON HIS ORIGINS AND HIS WORK

December 12, 1973, sometime in the afternoon. Tshibumba, the painter, had come to our house in Lubumbashi with a companion carrying a few pictures that were for sale. Where did he come

from? What were his thoughts about his work? He had no objection to my recording the conversation we were about to have. The beginning was difficult. "Don't worry about the recorder," I said,

F: Just talk to me.

T: Good.

F: Yes.

T: And how, for example? Sorry.

F: Um, about the beginning.

T: The beginning of my work.

F: That's it. So, to start with your beginning: What year were you born?

T: In 1947.

F: 1947?

T: Yes.

F: Here in Lubumbashi?

T: In Lubumbashi.

F: And your name is Tshibum . . .

T: Tshibumba Kanda Matulu.

F: Kanda Matulu.

T: Yes.

F: So, you were born here in Lubumbashi?

T: Lubumbashi.

F: In a township, or in the workers' camp of the Gécamines mining company?

T: No, in Kenia township.

F: Kenia township.

T: In a small place that had been there for a long time, called *nyashi* [straw-covered huts].

F: And your parents were immigrants. Where did they come from?

T: My parents are people from East Kasai.

F: From East Kasai.

T: Yes.

F: So they were immigrants to this region?

T: They came here for work.

F: To do their work.

T: Father worked at Amato Frères.

F: . . . ? . . . At the firm of Amato Frères?

T: Amato Frères. Before that, he had worked for the KDL railway company, the one that used to be called BCK.

F: Uh-huh.

T: After the accident he had near Kalule North station — the time when a train with English soldiers went down a ravine — he quit and left his work.

F: I see — Kalule North, Kalule North, that's where the bridge is?

T: Yes, the place where the bridge is.

F: So he fell . . .

T: He went down with that train.

F: Your own father?

T: My father, mm-hmm.

F: . . . ? . . .

T: Together with a whole group of soldiers, the railway cars — everything went down there.

F: Mm-hmm.

T: And he came out of it alive.

F: Did you go to school?

T: [After elementary school] I got to do two years of trade school, that's all.

F: Mm-hmm, and then you quit.

T: Then I quit. After I quit I began to try a little painting at home. And that's what I kept doing until 1961, when I went to Kambove [another mining town in Shaba].

F: Mm-hmm.

T: I went there to do occasional work as a day laborer for the Cofoka. . . ? . . . , as the Cofoza [construction] company used to be called then.

F: Mm-hmm.

T: Then I left there and went to Likasi. From Likasi I moved along with my father, and on June 23, 1969, we went to Luena [a coal-mining town].

F: To work?

T: To do the work of painting.

F: Painting, in that place?

T: Well, that is what I started with, but now it's finished.

F: Mm-hmm.

T: Anyhow, I worked for a while, then we went to Kamina. The date on which we left was September 17, 1969.

F: Mm-hmm.

T: We arrived in Kamina and I worked there for quite a while, about three years, I believe. Then I left again and came here [to Lubumbashi]. After that I left and went up to Kalemie [in northern Shaba].

F: I see.

T: From Kalemie I went to Kindu.

F: Kindu.

T: I left Kindu and got to Bukavu. After that I came back to this place. Here I was just by myself, so I left again and went all over the country, to Luluabourg, to the former Port Francqui, now called Ilebo.

F: Ilebo.

T: Yes, and then I came back. I got to Likasi but then hit the road again, and now I live in Kipushi.

F: Mm-hmm.

T: So that I can easily get to Likasi.

F: I see . . . Do you have a home in Kipushi?

T: In Kipushi I have my home.

F: Are you renting?

T: Yes, I'm renting.

F: I see.

T: Yes.

F: And do you live with your father?

T: No, right now I'm on my own, together with . . . ? . . . my wife.

F: I see.

T: Father stays in Likasi. He owns a piece of land there.

F: All right then, so you first took up the work of painting here in Lubumbashi, or was it in Likasi?

T: No, it was in Likasi that I started, in my father's house.

F: I see.

T: Mm-hmm, and I might add that I was seventeen when I started there.

F: Do you know some other painters who come from Likasi?

T: From Likasi? I know some.

F: And who work here?

T: They work here.

F: What are their names?

T: Oh, wait, what was it again? Nkulu.

F: Nkulu wa Nkulu.

T: Nkulu wa Nkulu, yes; and the other, what was his name?

[His otherwise silent companion answers]: Kapenda.

F: Kapenda.

T: Ah, yes, Kapenda . . .

F: . . . So, what was the year when you started painting?

T: Let's see, I began to paint steadily in 1969.

F: I see.

T: Yes.

F: From 1969 on.

T: Actually, I started in 1966, but I was only learning then.

F: Mm-hmm. And where did you learn?

T: I began learning all by myself, by trying it out.

F: Trying it out?

T: Yes.

F: Without taking lessons?

T: Right, without going to school or learning from . . . anyone else.

F: Did you use other painters as models?

T: No, I had my own model, in my head. I worked alone.

F: I see.

T: Yes.

F: So, since 1969 you have been doing only this sort of work?

T: Just this work, all the time, up to this day.

F: Mm-hmm.

T: Yes, every day, I work every single day.

F: How many pictures do you do each day?

T: Per day?

F: Or per week.

T: [Well, it depends.] Landscapes are not my strength, right?

F: Mm-hmm.

T: I am good, for instance, at the kinds of pictures you have in the house, the historical ones.

F: Mm-hmm.

T: I'm strong in history. Of the flogging there [points to "Colonie Belge," Painting 34] I can do three a day. Pictures of Lumumba I can do two a day, if I work hard.

F: Mm-hmm.

T: Because you must seek to work with care on detail.

F: But landscapes?

T: Landscapes, I could do five or six.

F: Mm-hmm.

T: Sometimes ten, if I get up well and work hard.

F: Mm-hmm.

T: Yes.

F: Mm-hmm. And then you go around selling them?

T: Selling? Sometimes I do it myself, sometimes I have young people working for me.

F: Everywhere?

T: There are some places I go alone.

Here the recording was interrupted by other visitors. When we returned to it, we needed to find the thread again.

F: . . . I forgot, what was the last point we made?

T: The last point — let me think. You asked: Do you work alone, or do you do some other work on the side?

F: Ah, all right, that's it.

T: I'd say that I do my work all by myself.

F: Alone.

T: I do no other work.

F: No other work. But you have some other people to help you with your work?

T: Just this young man here, he helps a little. We started with him . . . I think it has been a week now.

F: One week?

T: Yes.

F: And how does he help you?

T: He helps me with cutting the lumber.

F: Mm-hmm.

T: And with nailing the canvas . . . nailing it onto the stretcher.

F: Mm-hmm.

T: After that, I paint. He puts on the latex ground, I make a sketch, and then I begin to paint.

F: Mm-hmm.

T: Yes.

F: Mm-hmm. And to sell, you walk around every day and have to get here to the center of town?

T: To sell — there are troubles with the authorities, with the papers. Because we don't have a legal permit yet. So we go and sell in the middle of town, but on the sly.

F: Do you need an identity card?

T: No, an artist's card.

F: You must have it with you?

T: You must have it with you, all the artists must have one, and he [pointing to his companion, who we learn a year later is the painter Kabuika] does not have one either. For this year we haven't got one. Because you have to renew it each year.

F: Where are they issued?

T: At the Department of Cultural Affairs.

F: Cultural Affairs?

T: That's right.

F: And are they issued to every person who comes and says, "I am an artist"?

T: No, they issue them only when you bring money.

F: How much?

T: Two, three, five Zaire, I don't know. [One Zaire was worth two U.S. dollars at the time. A worker's monthly wage was Z15–30.]

F: Five Zaire?

T: I don't know exactly the current rate.

F: Well, well.

T: Yes.

F: So the police may stop you occasionally?

T: In the center of town?

F: Yes.

T: In the center of town it is forbidden to sell unless you have a permit like those issued at the Department of Finance [i.e., business licenses]. Each year you have to buy a new card.

F: Mm-hmm.

T: Yes.

F: So, there are many of you?

T: Doing what?

F: Artists.

T: There are lots of artists. They are artists, but it's like manual work.

F: Mm-hmm.

T: Yes.

F: Now, how does the work of an artist differ from other kinds of work?

T: How does the work of an artist differ from other kinds of work? There are many kinds of work. You mean compared to working for a company, say?

F: Mm-hmm.

T: Ah, it's different from that kind of work because we work and when our work is finished it is bought. That's how we like it, and that is how it differs. You make your own money, whenever you feel like it. It depends on your own strength. If you don't have the strength — ah!

F: And that's all there is to it?

T: Yes, I believe so. But you were asking how it differs from ordinary work. Yes, it is different in many ways. The difference lies in how you make money. Everyone works for money.

F: Mm-hmm.

T: So it's different, but in others respects it isn't. It's the same because work is work.

F: Let's take the work of a carpenter, or . . . Is it like the work of a carpenter?

T: No, the artist's work is a matter of a person's intelligence. It is like a gift from God himself.

F: Mm-hmm.

T: If you like, you can become an artist. The work is not different; all work is one. But when we work, we die for our work. Just think of all the time it took me to get used to this work.

F: This sort of work — how do you see it? Were there many artists in the old times, as there are now?

T: No, in the old days there were very few. And when we started it went like this: You would see someone working as an artist, and you would be intrigued and ask him how he did it. But nowadays, we are very many. Even small children . . . ? . . . do it.

F: Mm-hmm.

T: Yes.

F: When looking at a picture, as we're doing now —

T: Yes.

F: — can I recognize that this painting is yours, and that one somebody else's? Is the work of every artist distinctive?

T: It is.

F: What is it?

T: What reveals an artist? It's the style, quite simply. The style — each person has his style.

F: The style?

T: Yes, the style. That is to say, the manner in which a person works is his own. When you see the way I draw, you know that this painting was done by a certain person. Whenever someone draws, you can tell that the drawing was done by a certain person; that's how it is.

F: So let's take that picture there . . . How will I see that it is your style?

T: My style?

F: Mm-hmm.

T: Someone, a fellow artist, who is used to my work — for instance, this Nkulu — he'll see it. He will recognize my way of mixing colors, the way I draw, and he will know who did this painting.

I then tried to press Tshibumba to tell me exactly what it was that made a style, or his style. After some back-and-forth that produced answers similar to the one he had just given, I tried another approach:

F: All right, so you have your style; do you need to change it sometimes?

T: I can change it.

F: You can?

T: It's like with songs.

F: Mm-hmm.

T: You know how it is with musicians. When one of them sings, when it's recorded, you know, you recognize that this is by a certain artist. Then you may read the record cover and you'll say, It's this artist. And so, from just one drawing, you will be able to tell who did it.

F: Mm-hmm.

T: That's how it is with us artists.

F: Mm-hmm.

T: Sorry, I should say painters. Because we all are artists.

F: Now, how do you see development among the artists here?

T: Among the Zairian artists?

F: Mm-hmm.

T: Yes, I see that it will go well, except that the state neglects us. Our state really neglects us. That's what I think, but the prospects are very good.

F: You get no support, or do you?

T: They don't help us; they are just after us all the time.

F: I see. Do you have an association of artists, a group?

T: There is no association. There is no association.

F: Why is that?

T: It's because there's no mutual understanding among us, as I told you before.

F: But what is the reason? . . .

T: It's that we do not communicate; we don't even agree that we should set up an association.

F: So there is no mutual understanding?

T: There is some, to the extent that you can go to a fellow artist and talk with him.

F: Yes.

T: But then you go home.

F: Fine, but . . .

T: But there is no agreement on rules.

F: Mm-hmm.

T: To say, Look, this is the work we do; let's work together in one house, which could then become a gallery, and that is how we'll make progress and become big—this sort of thing does not exist.

F: And why is that?

T: I think it's greed for money. I don't know. Say we were to put our money together; there would always be one who has the power, and he would take it all.

F: So you don't know a single group of artists here in Lubumbashi that works by pooling their income?

T: What? In Shaba? No. I never saw artists in this region who were organized as a group.

F: No?

T: Not in Kipushi or Kamina, no. I once tried it with someone in Kamina.

F: Mm-hmm.

T: But God refused; the person died.

F: He died?

T: Yes. It was Nyembo Albert.

F: Mm-hmm.

T: That was his Christian name then.

F: Nyembo?

T: Nyembo Albert, that used to be his Christian name, but he died. He did work like the paintings you have here on the wall [most of them by well-known "academic" painters of the colonial school of Elisabethville and a few others painting in similar styles].

We went on to talk about those painters. With the exception of Mwenze, Tshibumba knew none of them personally. The rest of this session was spent discussing the paintings that Tshibumba had brought along. A few days later (on December 16, 1973), we met again and picked up where we had left off. Most of the paintings turned out to be about historical events, especially the life of Lumumba. Could you do more of those, I asked (and this may have been the moment our project was born; in any case it was the moment I realized that Tshibumba had ambitions beyond painting the few historical subjects that had become an accepted genre).

T: I'll come with a lot.

F: Pictures showing Lumumba's history?

T: History and nothing but history.

F: But, as you said, you are a historian.

T: Fine.

F: And an artist.

T: I am an artist, yes. I am a historian.

F: Now, the artists, are they all historians?

T: Not really, and I am not saying this to show off.

F: I see.

T: It's just that I have been around a lot. And I found myself in this work, realizing that I alone do history. There are some among the other artists who have come close to what I'm doing.

F: Mm-hmm.

T: I know this because they come to ask for a sketch. They say, Help us with this sketch. Then I say, No, this comes out of my head. I myself work it out.

F: Mm-hmm.

T: Yes.

Then we went back to the paintings. Eventually, I showed him a picture by another genre painter, Ilunga. "What do you think of this picture?" I asked.

T: To be honest, I too started like that. I started like that . . . at the very beginning.

F: Mm-hmm.

T: But then I got used to painting, and I made progress based on my intelligence.

F: Mm-hmm.

T: So, to continue, this is a person who is still at the beginning.

F: Because he is not yet advanced in the way he paints?

T: He doesn't know much yet; he just started.

F: I see.

T: Yes. If I were given that picture, I could improve it in light of my thoughts and bring it back to you.

F: Mm-hmm.

T: Yes, in light of my thoughts I could improve it nicely and bring it back.

F: Mm-hmm.

T: Yes.

F: But how do you think he must progress? . . . What must he do? How?

T: To make progress?

F: Mm-hmm.

T: He must stay close to other artists, to our elders such as Pilipili, or Kalumba Gabriel, to cite another name from the old days.

F: Mm-hmm.

T: Because he is still at the beginning.

F: Mm-hmm.

T: Yes.

F: And you did it by yourself?

T: That's true. I did it all by myself, as I explained to you.

F: Mm-hmm.

T: It was truly in my own intelligence alone. I began slowly, and that's what he is doing. By painting a picture and drawing a line, it will first come out like a sketch, no?

F: Mm-hmm.

T: Fine. So one day he will discover the trick of leaving out this outline [Ilunga outlines his figures] so as to improve the painting. This will become a habit, and that's when he will make progress.

F: Ah, so you see it in this outlining—that's where it appears?

T: It makes the painting just like a sketch, let's say.

F: Just a sketch. So he hasn't got the knack for painting?

T: No, he hasn't.

F: But what about the colors?

T: The colors, you say? Yes, he mixes them, but [with a chuckle] he is just learning. But we don't reject this, because among artists, in art, there is no critique.

F: There is no critique in art?

T: In art, you don't criticize your fellow artist.

F: It's not allowed?

T: No. Just look: the ideas he realizes, they are good. But the people who look at it may have criticisms, yes, or those who are knowledge-able—a professor like you, [or] someone who trained at an academy.

F: Mm-hmm.

T: . . . But we—there are some I meet whose work I consider good.

F: Mm-hmm . . . But within the group of artists you cannot criticize?

T: No, I cannot criticize a thing made by a[nother] person, because it's thought that is at work, and he struggles for progress in this thought. What I can do is help him with this thought, if it is there.

F: So it's like this: All of you, each artist just works by himself?

T: We artists work by ourselves, through our thoughts.

F: I see.

T: What counts is that I come up with a good result.

F: So you cannot improve another person?

T: Ah, no, I can improve someone else.

F: You can?

T: I said I can improve someone else.

F: But without criticizing?

T: That's it, no critique. He can be counseled if you have advice.

F: Mm-hmm . . .

T: You can offer advice, saying, Do it this way, do it that way. That is how he will know. That's how it will go with the young man who happens to be with us [his companion]. If he is a person of intelligence.

F: Mm-hmm.

T: Because we spend much time together, someday he may know how to paint.

F: Mm-hmm.

T: Or take this other young man who was with me in Kamina. Mbuyi, I believe it was.

F: Mm-hmm.

T: Yes, Mbuyi. It was his father who brought him to my house. He took out a little money which he gave me, and he said, "Teach my child this work." So he stayed on with me, although I wasn't doing much myself at the time.

F: Mm-hmm.

T: So I taught him, and he stayed for six months. I saw that he was still a child, fourteen years old, I believe.

F: Mm-hmm.

T: Then he quit. "I'm leaving," he said, and he went to Kinshasa. There in Kinshasa he enrolled in the Academy of Fine Arts, and he's making progress in his understanding. For all I know, he may now have surpassed me by far . . .

F: Mm-hmm.

T: Yes, that's how it is. We always help each other.

F: Mm-hmm.

ON BEING A HISTORIAN WHO PAINTS

Throughout the year that followed our first encounter, I stayed in touch with Tshibumba. A few paintings were acquired, but he had now found other customers, mainly among expatriate academics teaching at the university. In the autumn of 1974 a project emerged out of our conversations, one that would allow Tshibumba to demonstrate what he had termed his strength in history. His dream had been to paint the entire history of his country, and I encouraged him to do this. My stay in Zaire was nearing its end, so it was under considerable time pressure that Tshibumba set to work. Eventually, he presented his series in four recorded sessions. The first three unfolded in a similar fashion. Tshibumba would select about thirty paintings from among those he had brought with him or that had been acquired previously. They would be laid out on the floor of our living room, and Tshibumba would first give a narrative in sequence as we walked alongside the pictures. Then we would sit down to talk about each of the pictures in some detail. Here, by way of introduction to the texts, is the dialogue that preceded the first portion of the narrative, recorded on October 6, 1974.

F: We can begin with the story, or maybe let's start with a little conversation about how you got the idea to produce this history; how you first thought of it. This idea to do a series, right? A sequence like the one you've done now.

T: Yes.

F: Was this a thought you've had since long ago?

T: I have had the idea since long ago.

F: I see.

T: But I did not have anyone come to me and ask me to work, the way you have asked me to now.

F: I see.

T: Yes. When you asked me, I got the strength to tell myself: I should work [to show] how things used to be. It is the story of the whole country. Every country has its story.

F: Its story.

T: Yes.

F: I see. So — but you needed to teach yourself, didn't you? You needed to teach yourself the story of the country. Like long ago, in the time of the ancestors, they had their stories, hmm? And each ancestor would tell his story to his successor.

T: To his successor, yes.

F: . . . ? . . .

T: He who had a successor would impart to him his story.

F: Right.

T: Take us — we had our father. He explained what happened to him. For instance: "That was the year I had an accident."

F: Mm-hmm.

T: It had stayed in his head. So we would sit by the fire in the evening with our parents [and he would say], "You see, in the old days, this is how this country used to be." And then we entered school, and school also taught us how it used to be: how we had lived, in the beginning, with the Arabs, and how they had treated us. And some told lies and others spoke the truth.

F: Mm-hmm.

T: Then I followed the books, and some spoke the truth and so we followed that story.

F: Mm-hmm.

T: We grew up that way, and then we saw these things with our own eyes and knew that they were true. We began to work with them and we made progress.

F: So — how shall I say — the way you see the story now, it differs from the way [things] used to be seen long ago, or does it not?

T: That's right. Formerly we followed what was said among the elders.

F: Mm-hmm.

T: Among the ancestors.

F: And today?

T: Whereas today we work it out in our own minds, how things happened.

F: I see.

T: Yes.

F: How things happened?

T: How things happened.

F: Now, did you start reading books?

T: I began to read books. Like, by chance I asked a school supervisor in Kamina.

F: A school supervisor?

T: A Methodist, yes; Kasongo wa Mukalay.

F: Mm-hmm.

T: He gave me an entire book that contained nothing but a history of the Congo. But I forgot who published it. I read that book in . . .

F: *Histoire du Congo?*[1]

T: *Histoire du Congo.*

F: Who wrote it? The name of . . .

T: No, I don't know the author, the one who did it, . . . the writer.

F: Was it an old book?

T: No, it was recent.

F: Recent?

T: Yes, of the whole history of the Congo, how it happened and how [the country became] Zaire, such things.

F: I see.

T: Yes.

F: Did it have illustrations, or not?

T: It had illustrations.

F: Many illustrations?

T: Many illustrations of all the big people, some of whom have disappeared and others who are still alive.

F: So now, when you begin to paint the way you do —

T: Ah.

F: — do you have an image?

1. Most likely this is the actual title of the book, possibly Cornevin 1963 or Deward 1962.

T: When I paint now, I have an image only in my head.

F: Mm-hmm.

T: I don't copy [people] from some photograph. I do this with my mind. I see what a person was like [and] I try.

F: Mm-hmm.

T: I know there are mistakes in every drawing. You cannot draw a person exactly the way he was. Even if you have a photograph, you'll do it differently each time.

F: Now, we have the historians. They write the history of the Congo, that is to say, of Zaire as a whole, or of one area, such as Bunkeya.

T: Yes.

F: Or the Bakongo region.

T: Mm-hmm.

F: All right, they write. Now, it is true that they give themselves a name. They themselves call each other:

T: We are . . .

F: . . . historians.

T: Historians, yes.

F: Historians, hmm? Now, take yourself. How do you differ from them? You write, but that's writing with painting, isn't it?

T: That is correct. It's true, I admit that those historians do [good] work.

F: Mm-hmm.

T: But you know well that among them there are [those who make] historical mistakes.

F: Really?

T: Oh yes, among them there are those who make errors because they, too, were informed by others.

F: Mm-hmm.

T: And some things they have not seen with their eyes.

F: So that's a fault, but the way you see it, you don't suffer from such a fault?

T: I also work.

F: Ah.

T: And now and then I will make a small mistake in [my work].

F: Mm-hmm.

T: We could quarrel among ourselves. He studied; I had no education.

F: Uh-huh.

T: Yes.

F: But otherwise — let's say your work differs from the work of [professional] historians. But you yourself, are you a historian?

T: Me?

F: Yes.

T: A historian? That is to say, the work is not different because a historian is someone who does history.

F: Ah.

T: He calls himself a historian.

F: Ah.

T: All right, the way I am now, I would want to tell them: No, I am a painter. [But] let us say I want to play music.

F: Mm-hmm.

T: Then I will be a musician. They will call me a musician.

F: Mm-hmm.

T: Given what I am doing now, I also am a historian.

F: Mm-hmm.

T: Yes.

F: But you add something, something that makes you different from [other] painters. In other words, you add, you enlarge.

T: I enlarge because I work through painting.

F: Ah.

T: I tell things through painting. That is to say, through painting I show how events happened, right? I don't write but I bring ideas, I show how a certain event happened. In a way, I am producing a monument.

F: Mm-hmm.

T: Yes.

F: You produce a monument.

T: Yes.

F: Some of the paintings we see here and want to talk about — did people buy them now and then? You said . . .

T: I think there are some they have bought now and then.

F: Mm-hmm.

T: Yes. But others they haven't. Especially many of those I [just] brought people have not bought yet.

F: Not yet.

T: No. Because that was an idea that came up in our conversations [when we talked about] whether I could produce [this series]. And I got the idea to work out everything that was in my mind.

F: Fine.

T: Pardon me, but there is still what you said about me being like the historians.

F: Mm-hmm.

T: Right?

F: Mm-hmm.

T: Yes, that's true, I am a kind of historian, because not long ago I created a picture of the Martyrs of the Union Minière.

F: Did you?

T: Yes. I brought it here.

F: Mm-hmm.

T: Fine . . .

F: . . . We have it.

T: Yes. A few days later a newspaper came out where they talked about this affair, [but] I had already talked about it. They showed that this event had really happened.

F: Mm-hmm.

T: That means that I am a historian.

F: Mm-hmm. This was in *Taifa*, no? *Taifa* or *Mwanga* [two newspapers sold in Lubumbashi].

T: No. No, this was in *Taifa*.

F: *Taifa?*

T: No, *Mwanga. Mwanga.*

F: *Mwanga.*

T: *Mwanga*, but that makes no difference.

F: Mm-hmm.

T: It was finished . . . ? . . .

F: [This was] about the strike.

T: The strike of those workers.

F: Of the mining company.

T: Yes. That means I was ahead of them in my work and they published [theirs] later. Now, the knowledge with which I worked and the one with which they worked was the same.

F: Mm-hmm.

T: That means we all are historians.

F: That is true.

T: They are writers, I am a painter.

F: Mm-hmm.

T: But we are the same; we join [forces].

F: Mm-hmm.

T: Because a man cannot have a complete life without a woman, only if he is with a woman.

F: Mm-hmm.

T: It's like a marriage.

F: Mm-hmm.

T: He is going to write, whereas I may have an image, or a picture that shows this event.

F: Mm-hmm.

T: That's the significance of what I produce: It is to help one another so that we learn the history of our country correctly.

F: Mm-hmm. Um, if you are ready, we can begin with . . .

T: . . . with the story.

F: With the story . . .

T: All right, since I am ready:

To begin the recording of the narrative I prompted Tshibumba with the customary opening-formula for storytelling:

F: The story is this.

T: This is the story [he laughs].

Landscape

Ancestral Couple

Traditional Chief

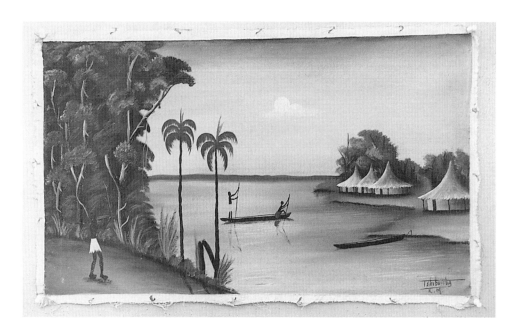

The black man has existed since Adam and Eve. Without following the precepts of any religion, be it Catholic, Protestant, or Kimbanguist—this is how our Zaire existed since the days of old. And there were our ancestors, as you see them in the painting. Our ancestors knew how to dress. They had raffia clothes, as you see here in the painting. They knew how to work. Those people there by the water are working to catch fish, and in Katanga they began to make copper ingots in those times. They produced copper ingots, made copper wire, and went to sell it. They knew how to eat, to dine. They had manioc and they cooked *bukari*. This was our food. They knew how to build. As you see there, they built houses. When they built they used leaves on top and on the ground. Or they would take boughs, join them well, put on clay, and there you have it: they slept in there. And to lead them-selves, they knew how to govern themselves. In other words, they had government. For example, King Banza Kongo. They had a complete government. Yes, people like Ngongo Lutete, all of them were governments. Only they had not joined forces to create unity. They set up a federation. Our ancestors knew how to dress, they knew how to converse, they knew how to have children, they knew how to govern themselves. In the third painting you see a whole village and its people, perhaps a hundred of them. There was also a chief. But I show him as I have thought him up, and I don't give him a name, because our "recourse to authenticity" is really a "blind return" to the past. The thing is, we don't know our ancestors anymore; we have lost that knowledge.

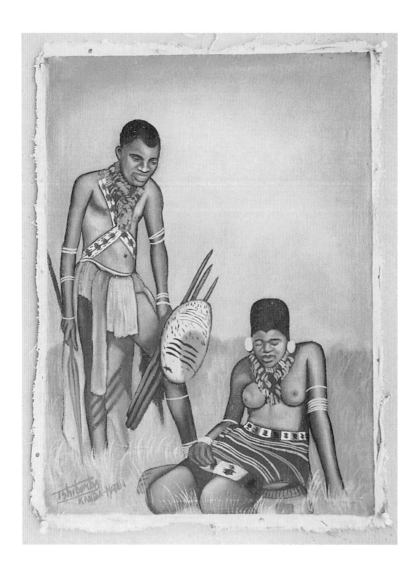

F: I'm a little surprised, because earlier you said that landscape painting is a recent thing. But now I see that in your thoughts it's like something of the past.

T: In my thoughts, a landscape painting is something of the past; in fact it is the very first thing. As regards painting — of course we know that the Europeans brought painting. So in the end, I'm following an idea of the whites' when I paint. But when we paint, we depict matters that concern us and that we have seen. The landscape is the first thing in a history of Zaire.

. . .

T: They came to colonize us, and then all the notions we had were lost. Nowadays we dress the way the Europeans do. But this painting shows how we dressed in the beginning, how we talked to each other, and how we, too, had feelings. At home we would speak with our wives. We were human beings.

. . .

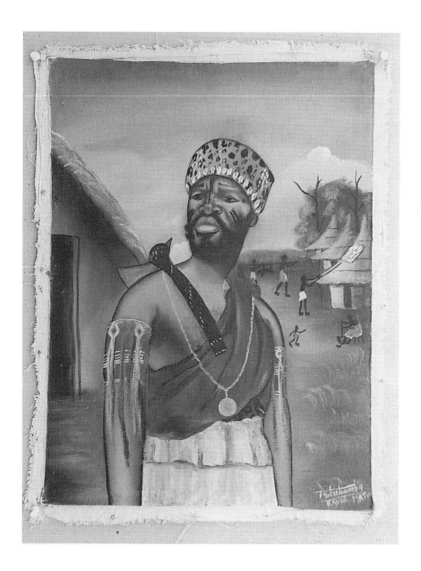

T: And from the beginning we governed ourselves; we had our own thoughts. That's how it was.

F: What I see here, is this a village? There are people coming back from the hunt with an antelope.

T: Yes, and there's a man spreading manioc on a roof. It will be pounded, as you can see his wife pounding there below, and there is also a child.

The little child is playing. The wife is preparing the evening or midday meal. It is the same dish that we eat today, *bukari*. This is how it was in the village. And there was a chief who had his chiefly attire.

The Three Magi

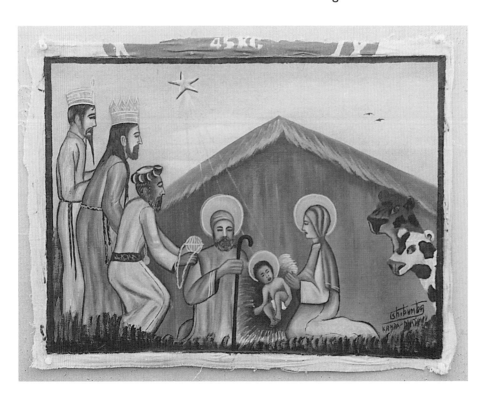

et's go back to the story, the sacred scriptures, the story of God. It says there were three people, the three wise men. They went to adore Jesus. Among them, in their midst, was a black man, someone from Africa. That means that the black man, too, had his origin in the days of old. The sacred scriptures also teach us that there was a father who had two children. Of those two children, there was one who had sinned. Some say this is where the black man came from—that is, from the child who had sinned. So, their father used to drink a lot. One day, after drinking a lot of beer, the father went to sleep in the house, naked, without any clothes on. Now there was this one child of his who came and opened the door. He looked at his father. "Oh," he said, "father is naked." He ran outside to call his brother. He called his brother

and came back with him. He said, "Come and see." His brother came and opened the door. He looked; his father was naked. He said, "I don't understand; why does he act this way?" This child ran away quickly and brought some clothes to cover his father. He did it without looking at him. He walked backward when he went to cover his father. And his father woke up. This is how the sacred scriptures report it. His father woke up; he was no longer drunk, but although he was still dizzy, he saw that this child of his had solved the problem of how to cover him without looking. And he summoned the other child of his, the firstborn, and explained to him: "You—I don't think I can deny that you are my child. No, you are going to remain my child. But from this day on, all the children you will beget are going to be black. Furthermore, not one of them will be intelligent. They will be children without value. And they will always be poor, to the day they die."

T: This is how the sacred scriptures put it. But the way I myself see it — as I told you, I am a writer — in my view, it's a lie. Why is it a lie? Because I think that in the time of the Lord Jesus, before that story of the three wise men, the black man was already there. Ah, I think they were Balthasar and Melchior, and another one. I guess I forgot his name. So the black man was already there. . . . But he was lost long, long ago. I took those three wise men as my point of departure because one of the three was a black man. He did not return. They killed him and he perished. To this day he cannot come back. I believe this is the story of the black man right there; it was lost.

President Mobutu said on October 10, 1973, at the United Nations — may I quote? — "Recourse to authenticity is not a narrow nationalism, a blind return to the past." All right, that is how he spoke. On reflection — the way I see it — this is true. Because — it's the story of the black man himself that I'm explaining to you, right?

. . .

We go [back] — it is a blind return to the past. The thing is, we don't know the ancestors anymore; we have lost that knowledge.

Diogo Cão and the King of Kongo

Diego Cao and the King of the Congo. "Yes, this is the river Nzadi (Zaire)," Banza said. A few days later was the meeting of Stanley with Diego's group, which was composed of Dhanis, Bodson, and the others.

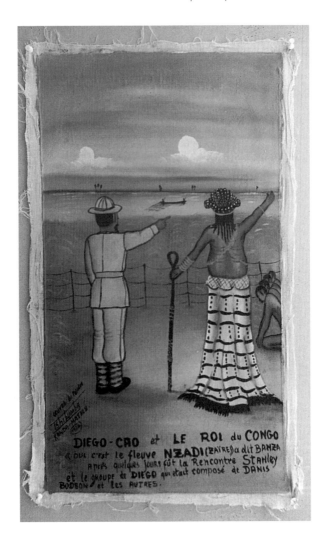

DIEGO-CAO et LE ROI du CONGO
« Oui c'est le fleuve NZADI (ZAÏRE) a dit BANZA
Après quelques jours fût la Rencontre Stanley
et le groupe de DIEGO qui était composé de DANIS
BODSON et les AUTRES.

Now I am getting to the time when the story of the Congo begins. But I believe it was "Zaire" in those times. Yes, our Zaire existed and it had kingdoms. . . . Among them, I know the kingdom of the Kongo, for instance, and the Tetela kingdom, the kingdom of the Kete, that of the Luba, and many other kingdoms. . . . On the river Zaire—it used to be "Nzadi"; that was its name, "Nzadi"— there was a chief; his name was Banza Kongo. He is the one you see there in the painting. One day he received the Portuguese explorer Diego Cao and his party of fellow explorers, and the black people with whom they had set off from Angola. Banza Kongo informed them of the name of the river, it

was "Nzadi." Diego Cao himself called it "Zaire." They did not understand each other, and when Banza Kongo said, "It is Nzadi," they said, "Yes, it is Zaire." Diego Cao pronounced it "Zaire." He wrote in his book, "I discovered the river Zaire." Then Banza Kongo told them about the Arabs and about those other chiefs who liked to sell their brothers. He took his time about it and began to explain to them how the Arabs behaved in the interior of the Congo. They made their brothers suffer, killing people in the villages and selling others. And among the people there who helped them were our brothers. Then Diego Cao went back home and so did his party. He had found that there was a Zairian civilization. That is to say, the Zairian civilization began to exist with Banza Kongo. And he was astonished; he was amazed. Not much later, Diego Cao returned and his party penetrated the interior of Zaire. Eventually, Diego Cao went back to Portugal. Now, in the party that was with him there was a certain Dhanis—he is one I know of—and others, and they got into the interior of the Congo. "Let us discover the whole country now," they said, "so we will know what it's like."

Painting 5 The Portuguese navigator Diogo Cão (exact dates unknown) first arrived at the mouth of the Congo River in 1482, but only during his second voyage, in 1485, did he actually meet Africans in a place called Mpinda, on the left bank in what is now Angola. He learned that Mbanza Kongo (later called São Salvador, when it became the capital of the Kongo kingdom in the sixteenth century) was the name of the residence of an important ruler, whom he would meet on his third trip, in 1487. The ruler, Nzinga Kuwu (d. 1506), was either the fifth or the eighth successor of the kingdom's founder, Nimi a Lukeni, a smith who had led a party of adventurers to this area from the Mayombe region on the northern side of the river. In 1487 Nzinga Kuwu, Tshibumba's Banza Kongo, sent an embassy to Portugal. It returned in 1491, together with numerous missionaries, soldiers, craftsmen, and presents for the king. On May 3, 1491, Nzinga Kuwu was baptized João, sharing this name with the king of Portugal (Cornevin 1989, 43–49).

Francis E. J. M. Dhanis (1862–1909) was a member of the last expedition of King Leopold's International African Association, prior to the establishment of the Congo Free State. The expedition arrived in Bagamoyo, on the east coast of Africa, in December 1884 but never left for the interior because the boundaries of the Congo state had been fixed by then (Cornevin 1989, 142). Dhanis was back in Belgium in 1885 but once again in Africa, as the secretary and traveling companion of Camille Coquilhat, in 1886. Until 1889, he was involved in the occupation and pacification of the Bangala region. Later he was to lead the "exploration" of the Kwango area and the southern Sudan. In 1892 Dhanis commanded the troops that defeated Ngongo Lutete (see Painting 11), and in 1893 he was involved in the confrontation in which Munie Muhara was killed during the anti-Arab campaign (see Paintings 12–13) (Cornevin 1989, 190–91, 195, 209, 213, 217; Institut royal colonial belge 1948, 311–26).

Omer P. G. J. Bodson (1856–1891) first came to the Congo in 1887. After a leave in 1890, he was back as a member of the expedition of Captain W. Stairs, which set off from the east coast of Africa and reached Katanga. There Bodson died on December 19, 1891, fatally wounded by a bullet he received during a confrontation with Msiri (see Painting 17) and his troops (Institut royal colonial belge 1948, 129–32).

Livingstone in Katanga

Already in the sixteenth century Livingstone had met a caravan that came from Katanga village.

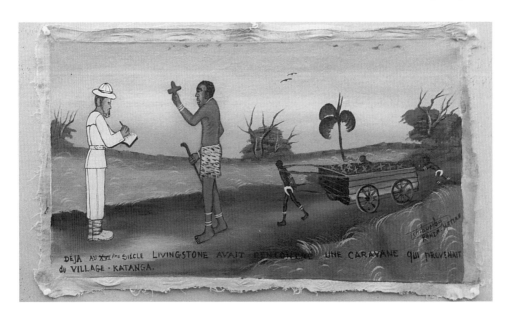

DÉJA AU XVI^{me} SIÈCLE LIVINGSTONE AVAIT RENCONTRÉ UNE CARAVANE QUI PROVENAIT du VILLAGE·KATANGA.

In the region of Katanga, Livingstone got to meet people from Katanga village. They had come with a shipment of copper ingots from Katanga and were going to sell it in faraway places. And he was amazed to see for the first time human beings different from himself, with a color other than his. But after all, he was there to do research, and so he saw the copper ingots and the copper wire and other things on the cart they were pushing. He thought, Where are they going to sell that copper? He asked them, but they simply had no language in which to communicate. They belonged to different peoples; each spoke the language of his home country, and so they failed to understand each other. Someone showed Livingstone the copper and pronounced the name of Chief Katanga. And Livingstone wrote it down in his book. And Livingstone continued his travels; on his way he passed Lake Mweru and came to Nguba, where he met black people who were producing salt. Then he

arrived in Mulungwishi, and that is where he went on to teach the Protestant religion. Finally he got tired and rested.

T: Livingstone had met a caravan that came from the village of Chief Katanga.

F: I see, and they could not communicate in a common language.

T: Right.

F: So the leader of the caravan just holds up a copper ingot . . . and Livingstone wrote down . . .

T: . . . the name I gave you: Katanga. . . . So Livingstone said: Oh, those people come from a place called Katanga. And that is what he wrote down in his book. . . . In those days our copper was being sold in East Africa, even in West Africa; it got to faraway places. Only we didn't have sense enough to make something of it. We just mined and smelted the copper, and that was it.

Stanley's Arrival

"Our ancestors were not thought to be human beings, or even beings at all . . . but rather a mass of muscle that would be asked to perform mechanical efforts such as one expects of a horse, a buffalo, a donkey, or an ox" (Mobutu). Stanley, the first explorer to arrive in the Congo (region of Katanga).

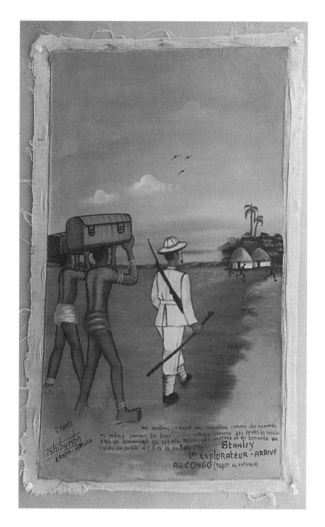

And at that time another explorer, by the name of Stanley, managed to leave Belgium and arrive in Angola. From there he went on to Zaire and Katanga. Whenever he came to a village and saw people, they all fled into the bush. There was nothing he could do. He got tired and went back to Belgium. . . . Stanley was Portuguese. . . . Because his father and mother had died and he had no one to take care of him, he left home at a very early age and traveled all over the place, for instance, as a sailor on ships, but the other sailors chased him away. Then he had the good fortune to get to

Belgium, where they put him into an orphanage. There he grew up to become an intelligent person. One day he met with King Leopold II. He told Stanley, "If you have the strength, go to Africa. You should discover that place where we've heard people live. When they first named those people it was said that they had tails. Were they like monkeys? We don't know what kind of people they are. We see, or rather we hear, that this is what they are like. So, you go and see whether they have a language, go and look." So Stanley left Belgium, and after a long trip he came to Angola. In Angola he met people and together with them he entered Zaire. So he traveled, but whenever he came to a village where he encountered people, those people ran away as soon as they saw him, they all ran away. Every time they took off for the bush. Stanley got tired of this. After all, he had come from far away. But he simply never got to ask them: Where am I, what kind of place is this?

F: Now, Stanley was wearing a hat, a pith helmet.

T: Yes, a hat. And he carried a rifle. . . . And he had cut himself a walking stick from the bush, to beat down the undergrowth before him, or to indicate the road they were to take.

F: And who are those people, his servants?

T: Yes, his servants. And they are carrying things on their heads. Those are Stanley's belongings — his change of clothes, his soap, and a lot of other things that were carried for his travels.

F: And were did his servants come from?

T: From Angola.

Stanley Reports to Leopold II

In Belgium, at the residence of Leopold II, Stanley makes his reports on the situation in central Africa.

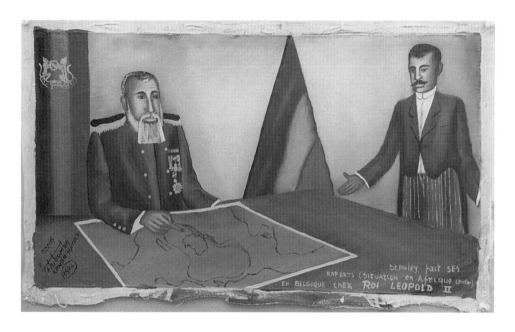

Stanley went back to make his reports to Leopold II. And he told him, "I went where you sent me. I got there and it is true, I managed to meet with other people. So they exist. I took them along and we traveled together into the interior of Africa. I met those people who live there, but I only saw them from far away and I don't know whether they are people or animals. They all ran away into the bush. There was nothing I could do about it, so I came back. I returned here to tell you about it." Then Leopold told him, "Yes, as you said, there is a person who already spent some time there. He went earlier. The name we heard was something like 'Livingstone.' He is an Englishman. . . . We must try, go and look for the place where you can find him. He is going to inform you thoroughly, and you will get to know this village." That is why Stanley set out to look for Livingstone. So he went and looked for him all over the place, until he found him in Mulungwishi.

F: There is Leopold II, with his beard.

T: Ah, he had quite a beard. White, because he was an old man. We have a suspicion — I say, a suspicion — that Leopold II never died. He abandoned his throne in Belgium; he just left it. I think he came to live here. He was Monseigneur de Hemptinne.

F: Really?

T: That is what one suspects. . . .

F: Do other people think this?

T: Many do. Many, many. We were talking about it just yesterday. . . . How could a king simply abandon his office and die in a riding accident, falling from a horse? No way. And if you really look at how it was in the Congo, sovereign power

was not in the hands of the Belgians; it was held by the Catholic religion. . . .

F: So, how did people look at de Hemptinne, what kind of person was he?

T: He was Leopold II. They looked alike in face and body.

F: But what about his spirit? Was de Hemptinne a good person or a bad person?

T: Oh well, there you ask a question . . . Many say he was a bad person.

F: What evidence do they give?

T: The evidence is what happened, with his knowledge, to the people of the mining company in Lubumbashi, all those many people who died.

Painting 8 In a history of the colonial army I found reproduced a painting by James Thiriar that, without serving as a model for this painting, depicts the event in a similar way: Leopold II, standing before a monumental map of Africa, receives Stanley in his palace in Brussels. The caption dates this event to 1878 (Janssens 1979, 24).

Stanley Meets Livingstone

The meeting between Stanley and Livingstone at Mulungwishi (Katanga region), followed by Livingstone's death.

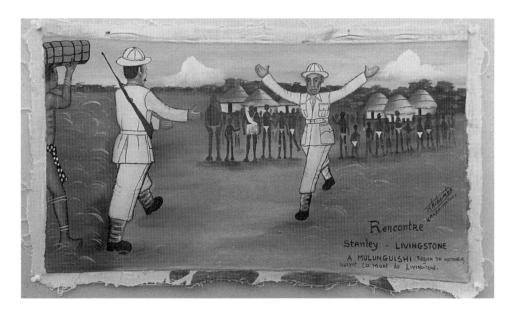

It was at Mulungwishi that Stanley found Livingstone. He had lived there for who knows how long, together with people from Zaire, the same that were said to have run away from Stanley. They got along fine. When he had arrived there he found they were producing salt and copper ingots, and they talked. He began to teach them about religion; he taught the religion that was the first to come into Zaire, that of the Protestants. And he continued to teach them for a long time. It took Stanley only a short while to get to this village. There he found many people, a chief, and to his surprise, Livingstone as well. They greeted each other and were full of joy. Stanley stayed a while in this village, then he told Livingstone, "I must be on my way. I shall continue my mission." Livingstone accepted this and said, "Fine, but I'll stay here, because I am sick." So he stayed behind; Stanley left.

F: I notice that Stanley and Livingstone are dressed alike.

T: Exactly. They are wearing their work clothes. They were like those of the military. In fact, they were members of the military.

F: Even Livingstone?

T: All of them; they were hired . . . as explorers to get to know the Africans, and they were paid for that.

· · ·

T: Livingstone was the one who brought the Protestant religion. . . . But I am asking myself: In what language did he begin to teach them? Was it Swahili? Or which language? . . . He was a stranger.

Paintings 9–10 The Scottish missionary David Livingstone (1813–1873) had passed through a part of what is modern Katanga when he traveled in the region of Dilolo and crossed the upper Kasai River (in February 1854; Cornevin 1989, 114). On an expedition begun in 1866, he reached the Lualaba (i.e., the upper Congo) at Nyangwe on March 29, 1871. The meeting with the British journalist Henry Morton Stanley, born John Rowlands (1840–1904), took place in Ujiji, on the eastern shore of Lake Tanganyika, on October 28, 1871. (Mulungwishi, site of the encounter in Tshibumba's narrative, is a village between Lubumbashi and Likasi and was the residence of the founder of the Methodist mission in Shaba, the American John M. Springer.) The most famous picture of the Stanley-Livingstone encounter appeared in the August 10, 1872, *Illustrated London News* (reproduced in Cornevin 1989, 120).

On November 20, 1871, both men traveled, at the request of the Royal Geographical Society, to the northern end of the lake, then continued to Unyanyembe toward the east, where Stanley left Livingstone on March 14, 1872. Livingstone died in the village of Tshitambo, on the southern shore of Lake Bangweulu. He was found dead by his attendants on May 1 or 4, 1873. His faithful servant brought his body and his notes and instruments to the east coast (Institut royal colonial belge 1948, 607–11; on Stanley see 864–92).

Livingstone's Death

Livingstone's death. And he was buried in Africa by the Africans.

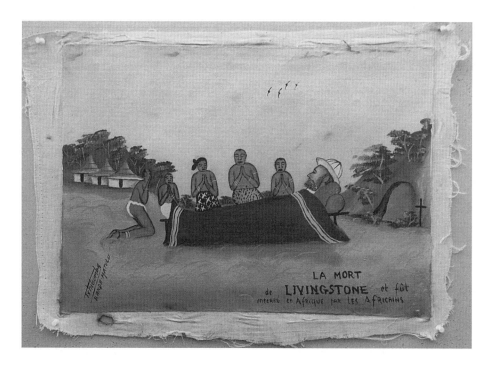

A fter Stanley had left, Livingstone continued to be ill and died. Livingstone died in the arms of black people, those he had begun to teach. They buried him. Following the custom of our ancestors, they dug a hole among the rocks. They took him there, put him inside, and covered the hole. So Livingstone was dead. . . . It was at the time when Livingstone died, I think, that Stanley went on and covered a great distance until he got to the area of Stanleyville, which long ago used to be Kisangani. He found this name, Kisangani. He traveled a lot, and when he got there he explored the region. Then he returned and made his report to Leopold II: "I come from Zaire, where I have completed all my tasks. I know everything that is happening there."

F: I see a cross here.

T: The cross is next to the burial chamber where they will put him. . . . It is carved into the rock.

F: Do people still know the place?

T: No, the body was taken out and carried away. They went off with it to Europe. . . . This was so long ago that people have lost the memory of the place. That is to say, the village was abandoned long ago. Only bush remains.

Chief Ngongo Lutete

Ngongo Lutete, man-eater, and the Arab trader.

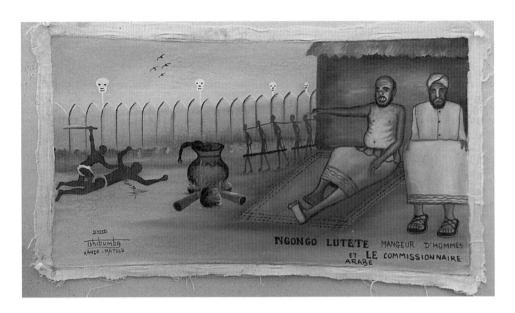

At that time, in the interior of Zaire, the people of Ngongo Lutete were sowing death. Ngongo Lutete sustained himself by killing people. He had them cut up and put into a cooking pot; then he ate their flesh. Others were tied up and sold as slaves to Arab traders. He delivered those people to them and they tied them up, took them away, and brought them to Zanzibar. And they sold them to the whites. And the whites went off with them and sold them as slaves. In Europe and America. So there are now black Americans, Negroes. They are the people who came from our country and were sold at that time. I think this happened four hundred years ago.

T: The person there on the left is one of Ngongo Lutete's people. You can see how he is busy killing a person. And he's already butchered another one, cutting off an arm and the head to be put into that pot. . . . A fire is burning, and there's water in the pot. They're going to add tomatoes, and they will eat very well indeed.

F: [*embarrassed laughter*]

T: But this sort of thing is being done right here and now.

F: What?

T: During the events that took place between 1960 and 1965, people ate each other. Right here in Lubumbashi.

F: In Lubumbashi?

T: Yes, and in northern Katanga . . .

. . .

T: The people over there are slaves who are tied up. They've come to be presented to the Arab trader so that he may take them away and bring them to Zanzibar. He has already paid for them . . .

F: I see that Ngongo Lutete is bald.

T: That's because he was a very old man. . . .

F: Also, I notice . . .

T: . . . his teeth. They are pointed; they were filed that way. Because you can see this in our country.

F: I've seen it . . .

T: It used to be — what shall we call it? — a mark of beauty, Zairian beauty, culture . . .

. . .

F: And then I notice his — what do you call them?

T: His long fingernails. . . . That shows that he was fierce, very fierce indeed. . . . He was a terrifying person. He would sit outside in his compound and give orders: Go, kill that one. I want to eat today, I like his meat. Kill that one, I want to eat meat today.

Paintings 11–13 Ngongo Lutete (ca. 1856–1893), or Ngongo Leteta (apparently the preferred spelling now), was born Mwanza Kasongo. A Tetela by birth, he first served the Tetela chief Pena Mwimba and later the Songye chief Kilembwe; he was eventually proclaimed Songye war chief. He then joined forces with Tipo Tip and embarked on a career as a slave trader. (The richest source on Tipo Tip is his autobiography; see Bontinck 1974.) In about 1884, still under the aegis of Tipo Tip, Ngongo Lutete set out to conquer much of the right bank of the Lomami River and later a considerable part of the Kasai region on its left bank. The Songye chiefs Lumpungu and Panya Mutombo are said to have been his vassals.

Hoping to free himself from his Swahili overlords he sought an arrangement with the whites in 1890, but Dhanis mistook his initiative for an attack and attempted to subdue him. Finally, on September 13, 1892, he surrendered to Dhanis and the Congo Free State. What had begun as a defensive action by Ngongo Lutete against his former Swahili lords turned into the famous anti-Arab campaign (concluded in 1894). Exactly one year after his submission, Ngongo Lutete was accused of high treason and tried by a military court. He was executed on September 15, 1893, at about the age of thirty-seven. (See Hinde 1897 and Lohaka-Omana 1974.)

Arab Defeat

The end of the Arabs.

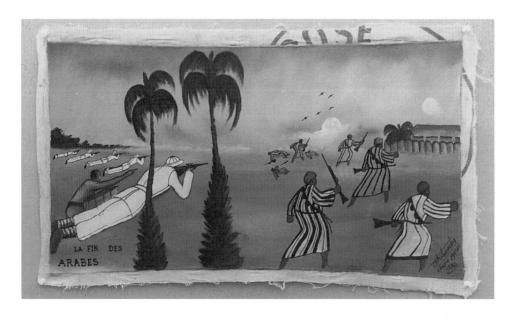

Not long after that, Stanley joined forces with Dhanis and his group. They then confronted the Arabs and eventually discovered the residence of Ngongo Lutete. They had a fierce fight; they killed many Arabs and chased them away forever. The Arabs were chased away and fled.

T: The house there with the skulls on stakes, that is Ngongo Lutete's. So the Arabs were attacked, beaten; some were killed, others fled. And that was it. There was nothing at all that could be done about it.

F: What is this dress they are wearing?

T: They wear Arab clothes . . .

F: And those people on the left?

T: Those are Stanley, Dhanis, and their people; the explorers now united their forces.

F: Ah, the explorers?

T: Yes, they are shooting. And this black man there is saying,"Look, this one's trying to run away; kill him." So they would shoot and kill everyone.

F: Where was Ngongo Lutete's home?

T: Ngongo Lutete lived in the Maniema region.

The Execution of the Arab Leaders

*The arabisé leaders are killed. Rumaliza—
Tipo Tip —Mwinimutara.*

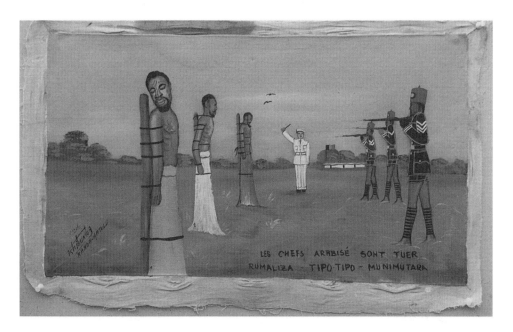

They captured the most important Arab leaders and killed them. Among them, I believe, they caught Rumaliza, Tipo Tip, and Mwinimutara. Then they killed them, and that was that.

F: Who was Mwinimutara?

T: He and the others were called *arabisés.* They were the leaders engaged in the slave trade. Actually, they were Zairians, Congolese, but they were "Arabized." In this picture, the first one is Rumaliza, the second Tipo Tip, and the third Mwinimutara . . .

. . .

F: So Tipo Tip is being executed; do you know his story?

T: No. I used to know all the stories, but I lost that knowledge as I grew up. Still, if I did some serious research I could get to know all of that. . . .

. . .

T: Actually, at first we were pleased, because the three of them had been killing our people. Let's say, we were pleased when the whites first conceived the plan to get rid of them; that was a good thing. Once they had disposed of those evil rulers they took over, and at first they were good. But then they set about establishing their government, and they in turn killed our people.

Painting 14 [see color plate]

The Poisoned Banza Kongo

King Banza Congo dead, poisoned. "Africa is the continent that suffered the greatest humiliation in history. . . . The black has no escape from the raids, for he simply loses his rights, his homeland, and his freedom" (Mobutu).

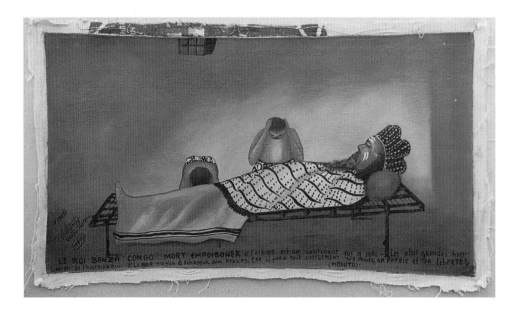

After they had killed the Arabs—take Banza Kongo. He liked everyone, white or black. He liked the whites; he liked the black man. Above all, he was a person who liked being the chief, and he made much progress. There was civilization among the black people of Kongo. Banza Kongo was friends with Leopold II. Leopold II thought up this idea: "Because this man received my associates and lived with them, I am now going to remove the name 'Zaire.' I am going to take"—this was his idea and his plan; we don't know what kind of politics he had in mind—"I am going to take this name away, and I shall call it 'Congo'—that will replace 'Zaire'; 'Zaire' as the name of the river will have to go." And he did in fact take Banza Kongo's name and give it to the country of the Congo. He called it "Congo," and the name "Zaire" died at that time. When the name "Zaire" had disappeared, the whites told Banza Kongo: "We want to organize a feast during which you will be installed as ruler of the entire country of the Congo." Truly, he was pleased to accept, and there was joy, great and sincere. And then, in the midst of this joy, they gave Banza Kongo some poison. They poisoned him and he died. With the death of Banza Kongo, I believe, the people lost all their possessions and all their knowledge. . . . That was the time when the black man lost everything, and from then on he lived in slavery. Then they took a white person, a Portuguese, who replaced Banza Kongo. Once they had replaced Banza Kongo there was no way out; we lived in slavery. Our sovereignty died right there.

F: So in this picture Banza Kongo is dead, he's lying on his deathbed.

T: On his deathbed. And he's wearing this attire. They've covered his legs with a blanket, and his head rests on a pillow.

F: And they put *pemba* [white clay] on his face.

T: They put *pemba* on his face because, everywhere in our country, when a chief dies, his body must be prepared. Immediately after his death they say, "People, don't cry, just be silent" even to his own wife or whomever. And then they prepare him in a special small house, put white clay on his face and on his head a feather headdress, the sign of his chiefship, which he received when he was installed. We call it *lusara wa nduba*.

F: Is it made of bird feathers?

T: Yes. Those are the feathers of a certain bird . . . that are reserved for the chief. Let's say it is symbolic. And only after they have finished all the preparations, then the people begin to mourn the dead chief. . . .

. . .

F: And who are those two? Are they mourners?

T: Yes . . . I would say they are his wife and a relative who are mourning.

Painting 14 The inscription quotes Mobutu's speech before the United Nations (Mobutu 1975, 2:363, 364).

Painting 15

Chief Katanga and Chief Msiri

Grand Chief Katanga takes his leave of Msiri, the criminal. N.B.: Msiri is the great-grandfather of Godefroid Munongo, former minister of the interior of ex-Katanga.

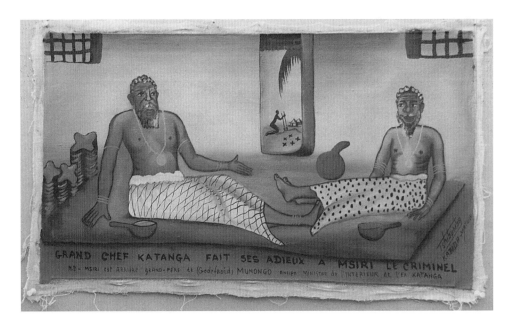

When sovereignty was lost, Stanley returned to Europe and informed Leopold: "In the Congo nothing is in our way anymore, except one ruler. His name is Katanga. Chiefs Msiri, Pande, Kashipo, and Nkwande are also left, but they are under the leadership of Katanga." Actually, when Stanley left Africa, Chief Katanga was already ill. Because he and Msiri were friends—Msiri was a close friend—Katanga called him to his house. He made him sit down and told him this: "Msiri, you are my friend. Among my offspring I have only one small child, a boy. He has not grown up yet. If I try to appoint someone from my village to be the chief I will lose everything. Therefore, seeing as you are my friend, take this country of mine. Take my possessions, my wives, my goats, everything, and also my wealth. Guard it. When this child has grown up, give him back all that belongs to him."

F: Chiefs Msiri and Katanga are sitting inside a house, right?

T: Yes, inside. Outside there's a man; he is busy casting copper ingots. He works a bellows, and the heat makes the copper flow. Then they make these copper crosses. . . . They would store them and then get them to faraway places to be sold. . . . On the ground, that's a drinking gourd. That thing there used to be our cup, like the glass you offer me. . . . There's beer in the big gourd there. But we also had earthen pots that kept our drinking water cool . . .

. . .

F: The chiefs are wearing something like wrap-around skirts . . .

T: Yes, this symbolizes their position as chiefs; that's how it was way back in the times of the ancestors. They were made of raffia . . .

F: And on their arms they have copper bracelets, and they're also wearing chief's medals . . .

. . .

T: Chief Katanga had been making copper objects since the days of old. And that's where the whites got the idea . . . of making these things.

Paintings 15–18 Chief Msiri, or Mushidi, born Ngelengwa (?–1891), was well received by Chief Katanga when he arrived in his country. According to Msiri's eldest son and eventual successor, Mukanda Bantu, he was given one of Katanga's daughters as a wife, as well as copper ingots and a piece of land on which to settle (Verbeken 1956, 48–49; see also Munongo n.d.). Msiri was present at the scene of Katanga's death shortly after the event and was accused of having killed the chief in order to take his place. M'Bokolo notes that the accusations gave Msiri the opportunity to take over: "One after the other, he had his accusers decapitated, among them the son of Katanga" (1976, 41).

On Msiri's opposition to raising the flag see Delvaux 1950, quoting excerpts from the diary of Captain Stairs. To this day, several versions need to be considered in reconstructing what happened on December 20, 1891. According to A. Verbeken, Msiri's refusal led to an altercation between Bodson and Msiri. Msiri pulled his saber; Bodson interpreted this as an attack, drew a handgun, and shot Msiri in the chest, killing him. Then Masuka, one of Msiri's sons, shot Bodson (who did not die immediately) and was in turn killed by members of Bodson's escort. Captain Stairs then ordered Msiri beheaded and his head displayed on a stake (1956, 241–42, 232). Verbeken also cites a member of the Stairs expedition, Dr. Moloney, who stated that Msiri's headless body was "transported" away so that his sons would not be able to bury him secretly and then declare that the king was still alive (234). Tshibumba's version, however, is supported by the relevant entry in Tshimanga's chronology: "1891 (December 20): Lieutenant Bodson is killed by Chief Msiri" ([1976], 186).

Msiri Kills Katanga's Son

The son of Chief Katanga executed by Msiri, his father's friend.

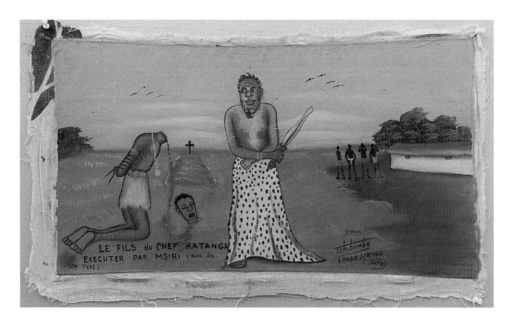

LE FILS du CHEF KATANGA
EXECUTER PAR MSIRI l'AMI de
SON PERE ?

Then Katanga died, while Msiri stayed alive and took over the office of chief and everything. Having been left with the office of chief and everything, he looked about; he saw the village and found the office of chief to be sweet. He said, "What am I going to do? I will, before everybody's eyes, grab the child they left in my care and kill him." It's true, he took him and went with him to this open space alongside the village. That was where the burial ground with the grave of this child's father was, and the grave still wasn't overgrown, which would have meant that it had been there for some time. Msiri took the child and beheaded him. After he had killed the child, he remained chief of the people of Katanga as well as of Bunkeya.

T: It was by Chief Katanga's grave. Msiri went there and killed the child by cutting off his head.

F: What's this knife? I never saw one like it.

T: It is a machete, the kind we use back home. I think it's called *mwela* in Tshiluba. In Swahili we call it *mpanga*. . . . It's a double-edged knife.

F: And who are the people in the background?

T: Those are people from the village; they came to watch. Msiri did not do it in secret. He just grabbed the child. And you can see one of them commenting: "Well, well, he is killing him." And this other one says: "Is that any way for a human being to act?" And another one just says: "Ah, ah, ah." All of them are truly terrified . . .

F: And this long house here, what is it?

T: It's the chief's own house. It used to be the house of Chief Katanga. But now, having done the killing, Msiri took everything.

Msiri Kills Bodson

Bodson was killed by Msiri.

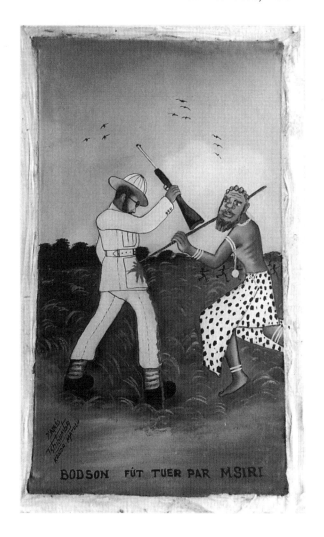

BODSON FÛT TUER PAR MSIRI

One day Bodson and his group began to descend on Katanga. They had reports about Chief Katanga from the place where Stanley had gone. When they arrived it turned out Katanga was already dead. So now they met Msiri. They explained to Msiri, "We have come here to Bunkeya and we want to raise our flag, that of the Belgians." All of them were Portuguese, but they were paid by the Belgians, by the king of the Belgians. They worked for the ruler of Belgium. So they said, "We want to raise our flag here in Bunkeya." Msiri said,

"Raising a flag here in my country is not acceptable." He didn't even know what "flag" meant, but he refused anyway. "This piece of cloth," he said, "must not be put up inside my country." Then Bodson, being a headstrong person, said, "I am going to raise it nevertheless." He took the flag and began to raise it. Msiri came out with a lance, a spear. He struck Bodson and killed him. When members of Bodson's group saw this, they brought out a gun and fired at Msiri, whereupon he died.

F: There is Bodson with his glasses.

T: Yes indeed, he just died.

F: Did you see a picture of this, or what?

T: No, I worked it out in my head. . . . Everything I'm bringing to you was worked out while painting. I take a while to think, then I make a sketch, and there it is. In this particular painting, however, I tried to reproduce a pose from a book on the history of Rwanda. In one place in that book you see two chiefs who are killing each other.

F: We have the book here.

T: Right, that's where I got it from, but only Msiri's pose.

F: *Histoire du Ruanda*, by Abbé Alexis Kagame . . . And the people there in the background, are they running away?

T: The people saw how Msiri killed Bodson. "So the chief exploded," they said. "He killed the white man; what are we going to do now?" And then they saw other whites who began to fire their guns. So the people fled and the village died.

Painting 18

Msiri Is Beheaded

Msiri had his head cut off
(which then went to places unknown).

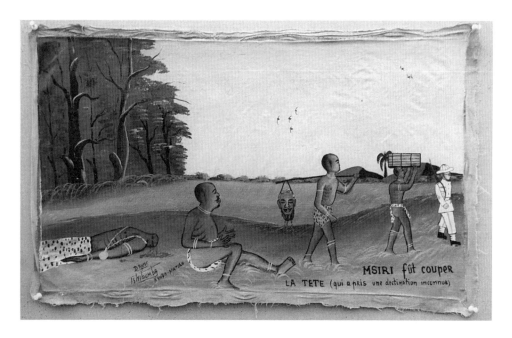

MSIRI fût couper
LA TETE (qui a pris une destination inconnue)

After Msiri had died, they took his body and cut off the head, which they kept apart. Then they took the head and carried it off. And those who were carrying it encountered black people who were setting out with those Portuguese explorers. The way they carried this head was to put it on a pole and walk with it. And they traveled very far indeed with this head. Eventually, the one who first carried the head would say: "I am tired." "What do you mean, you're tired?" the others would say, "let's go on." "No, I am very tired and someone should relieve me." I believe what happened is this: No sooner had the one carrying the pole spoken than he dropped dead right there. Then a second person carried the pole. He died. I think that wherever this head went, the person who carried it died. The person who carried the head died. I am telling you this because it's a story we were first told by our forefathers, we had already found it. In all truth, we don't know where this head went. Is it in Europe, in some museum or in the house of Leopold II, or with whom? To this day, we don't know . . . At any rate, I think that was the moment when the sovereignty of the black people was definitely lost. No one was left; they had eliminated all the rulers.

F: Now to the story of Msiri's head. That is really something.

T: Yes, and his body is lying there, as you see, with all the chiefly regalia . . .

F: And this one man, the one sitting in the center — is he tired?

T: The one who's sitting there is tired. . . . You see how I painted him with his arms like this [*makes the gesture*]? . . . It's as if he's rigid, like a person who is about to die . . .

F: So that's a gesture of death?

T: Right, he is about to fall flat on the ground and die. And those others just continue with the head. . . . But no one knows where that head is going, except that white man. . . .

F: Who is the white man?

T: Just one of the explorers. There were many of them . . .

Painting 19

The Beginning of Belgian Colonization

Beginning of the Belgian colony. "Under the pretext of having come to Africa to civilize us, the first whites, 'pioneers of that civilization,' were to empty each of our countries of its fundamental substance" (Mobutu).

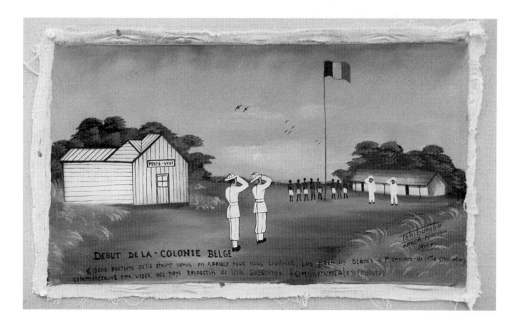

They managed to raise the flag. They managed to raise the first Belgian flag. That is what it says in the painting: "Beginning of the Belgian Colony." What the beginning of the Belgian Colony was like is summed up by our head of state. I quote: "Under the pretext of having come to Africa to civilize us, the first whites, 'pioneers of that civilization,' were to empty each of our countries of its fundamental substance." This is true; when they first arrived we thought they had come to take over from those rulers who had caused our brothers to perish. Then we realized: Now we shall be lost forever.

F: What is this house on the left?

T: That was a kind of office, the district office at Vivi, which is still a town now, near Boma.

Paintings 19–20 Tshibumba had both paintings before him when he made his comments. The inscription quotes from Mobutu's address to the United Nations (Mobutu 1975, 2:363). Partly as a result of international pressure and partly for financial reasons, Leopold II had to divest himself of the Congo, a private possession that was recognized as an independent state during the Berlin Conference of 1884–1885. Independence was proclaimed at the post of Banana, near the mouth of the Congo River, on July 19, 1885. The Congo became a Belgian colony in 1908. For a recent appraisal of Leopoldian colonialism and its aftermath, see Stengers 1989.

The Congo Free State

July 1885. L'Etat Indépendant du Congo.

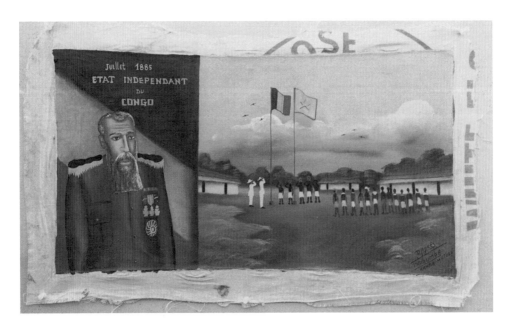

At first Leopold II had the idea of giving us independence. But that independence was not real. This was around 1885. Although two days ago—now, in 1974—I heard Radio Kinshasa say on the news that the independence of Zaire, that is, of the Congo, was signed by Leopold II in 1884 at Vivi. They even found a woman who was there at the time and had her present when they raised the flag to mark what they called the independence of 1884–85. But according to the history I learned, it was 1885 . . . But to get on with the history, it was in July 1885 that he signed independence. It's true, he signed independence, but the people were slaves under the whites. When the whites first arrived, there were only very few of them, and yet they imposed their rule.

T: The two paintings don't refer to different events. It's just that one of them depicts Leopold, who signed the act of independence. What happened is that they hired soldiers and policemen and called the people together. There were many of them, and they built a town nearby. Then they raised the flag . . .

F: We see two flags.

T: Yes, the two flags show that the Congo was an independent state but under Belgian domination. That's the Belgian flag there.

The Hanging of Chief Lumpungu

Grand Chief Lumpungu hanged at Kabinda.

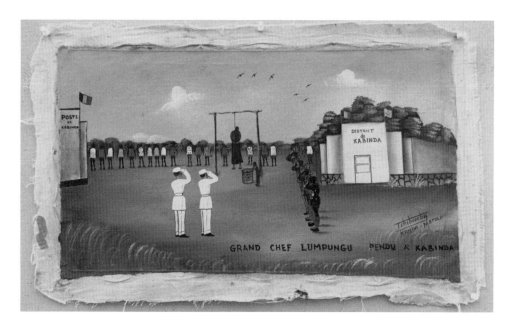

GRAND CHEF LUMPUNGU PENDU A KABINDA

So they set up their government. The years went by, the years went by. At Kabinda, there was a chief by the name of Lumpungu. Lumpungu was a chief, and a headstrong one at that. As the whites were looking for ways to eliminate Zairian civilization, they now schemed to get Lumpungu. It was said that a young woman, married to a white man and a native of Shaba—now Shaba, Katanga in those days—had traveled to Kabinda, together with her child. That child was a mulatto, right? Because she had it by a white man. She arrived and entered Kabinda. Lumpungu—at least that is what they said later in the court findings—had her apprehended, killed her, and ate her. So they carried out investigations, as usual in colonial times, and found that it was Lumpungu who had killed and eaten that young woman. They locked him up . . . , tried him in a

court of law, and came up with a verdict: Lumpungu is sentenced to die. It's true; they called together the people from the town, people from all over the Kasai, all over the Congo who happened to live in Kabinda. They took Lumpungu and hanged him. But I forgot the day of the month, even the year.

F: I see that you inscribed the building "District of Kabinda." Is that because you yourself are from Kabinda?

T: No, Kabinda . . .

F: . . . Or was it your father?

T: My father was Kabinda, he still went to school there. So my home district is Kabinda. . . . I am Luba, right?

F: That's right, Luba.

T: From the Kasai.

F: So they hanged Lumpungu. And there we have the hangman pulling . . .

T: He pulls the barrel away, then the rope tightens around the neck and the person dies.

F: And what about the people looking on?

T: At that time the people had already begun to dress well — shorts, shirts, and all that. Except at first they did not wear shoes.

Painting 21 Standard sources do not mention this episode. In a recent article J.-L. Vellut notes that it was not Lumpungu but his successor Yakaumbu who was hanged for having made a young woman disappear (a controversial affair at the time; see Vellut 1992, 208). Vellut also cites a study by C. Young which reports that at about the time of independence, the "Basongye Unity Movement" had invoked the memory of former chiefs, among them "Chief Lumpungu II, hanged by the administration for alleged barbarian practices" (209). Young took his information from an interview with a Songye political leader (Young 1965, 251). Neither Young nor Vellut gives the date of the hanging.

Lions from Europe

The Simba-Bulaya, Lions from Europe.

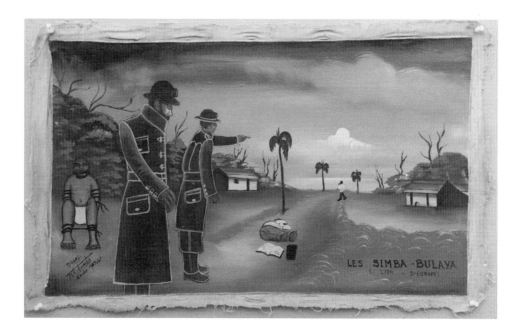

So they hanged Lumpungu, and we admitted the fact that Lumpungu had destroyed a human being. But at that time, the very same time that Lumpungu committed this crime, the whites themselves were busy colonizing us; they took people too, and many more than he did. They also began to take people, they who had hanged Lumpungu because he had had this person apprehended. For instance, take the Mutumbula—we call them Mutumbula. They were the Simba Bulaya, *Lions d'Europe* in French. This is how it worked: If you, a black person, left your property at night because you wanted to go to the toilet, you might meet two or three of them. Among them were our brothers whom they had hired; black people were in it, they began to work for the whites. One white man would be in command, and once he got there they grabbed that person. They took his clothes, his papers, all he had on him, and left them right there. Then they carried him away and killed him, just as Lumpungu had done. And there was never a black man who would have asked a white man about that, even to this day there's not. That's why I thought I wanted to show this story here. Even right now they may be waiting for this black person, and when he gets close they grab him, and what they do to him is take his clothes and tie him up with a rope. Then they carry him away to this place we do not know. Those people—this is not just a tale, nor something you gossip about—that's how they are, to this very day. We don't know whether they ate them, or how they disposed of them.

T: You've heard stories about this, right?

F: Yes, yes.

T: You really heard about it, right? They were the Batumbula. We call them Batumbula, "butchers."

F: Batumbula.

T: Yes, they'd wear long black coats and miners' hats with lamps, and then, at night . . . My own father, for instance, once got caught up in this. At that time he was working for the firm of Amato Frères. One night he'd left for work, and when he was halfway there, he ran into them. Now this person who works for the whites is a black man, and so are you. If you just say a word in Swahili, right away they are going to grab you. But if you are fierce and put up resistance, God will help you get away. . . . Father passed them and when he was ahead of them he started running, and so he got to the place where he worked. He then told his white supervisors about it. They said — the white man himself said — "Don't you know that this is a place where there are many Lions from Europe?" They knew that there really were Lions from Europe on the street. They were living persons who went about grabbing black people.

. . .

T: Once again, I speak from personal experience. This is not a lie; what I am telling you really happened to my own mother in the railway workers' settlement in Likasi. She had been to a wake at an aunt's place. Then she left with me. I was a tiny toddler then, and she carried me on her belly. She just told me this story the other day, and we could go to Likasi, where she would tell it to you. So we left and went outside. My mother put me down so I could relieve myself. That was when the Batumbula came.

F: Who? Black people?

T: Those Batumbula . . . So they arrived and came upon Mother. They were carrying a flashlight, which they pointed at her. They looked her up and down. They talked in Swahili to each other: "Shouldn't we let her go? She's with a child. We'll let her go." But that child was me.

F: Really?

T: Yes, they left and went away. We were lucky, and Mother went home.

Painting 23

The Arrival of the Railroad at Sakania

The railroad was laid down in Sakania in 1905.

Now we come to the time—it was in 1905, yes, 1905—when the whites brought in the railway. For the first time, they brought it here into Zaire. And this railway was not the KDL, the Katanga-Dilolo-Lobito line, as we call it now, it was the CFK. That was for *Chemin de Fer du Katanga,* Katanga Railways. It did not start from here, from the Congo; it came from South Africa. They made the connection and then it continued even farther, so that by today one branch reaches Ilebo and another, Dilolo. So it came to Sakania in 1905. The date when it arrived in Lubumbashi I've forgotten, I am afraid, but I have those dates, I wrote them down on a piece of paper.

F: Where did you get the model for this locomotive?

T: Going back to 1905, you mean? I used to see it. Not in 1905, of course, because I was born in 1947. But I saw it in the KDL railway company yard, long ago, in 1955 or 1954, it was still there. And we used to call it Kamalamba.

F: What does that mean?

T: Oh well, it was just a name they gave it; I think the old people may know the meaning. At any rate, they began to use that little Kamalamba to transport people. The cars were just made of wood. People would be told to get in, and they'd be carried to their destinations. And there you see the man with a flag. He was watching the crossing, because there were no stations then. The station was where you got off at a crossing.

They would let you off there, and your friends and relatives would come to greet and receive you. That was the first railroad that came from South Africa and linked up with Shaba.

F: And what are those poles?

T: Those are telephone poles; they always used to follow the railroad. It used to be you had to crank the phone, crank it, crank it: Hello? — no response. Crank again and again: Hello? Today it's no longer like that; the phone is modernized.

Paintings 23–24 The Comité Spécial du Katanga, often qualified as "a state within a state," was chartered on June 19, 1900; the Union Minière du Haut Katanga on October 28, 1906; and the Compagnie du Chemin de Fer du Bas-Congo Katanga (BCK) on November 5, 1906. The standard works on these topics are Fetter 1976, on the history of Elisabethville; Katzenellenbogen 1973, on the history of railways in Katanga; and Perrings 1979, on the history of mine labor in this region. Two glossy, richly illustrated memorial publications (Union Minière du Haut Katanga 1956 and Elisabethville 1961) were widely circulated during Tshibumba's youth, but there is no evidence that they were available to him.

The Founding of the Mining Company

In 1906, the Union Minière du Haut Katanga was created.

EN 1906 UMHK fut CRééé

Now we really get into the time when the colony was established. In 1906, they created the mining company and began construction. I think you see how they began building the smokestack. They got as far as they wanted, and then the smokestack was finished.

F: This shows the construction of the Union Minière factory.

T: Yes, and the same place will come back again when I show the fighting that went on in the war of 1960–1963, during the secession of Katanga.

F: I see that the slag heap is still low.

T: That's to show that the operation was at its beginning, and there was as yet little slag. It was my idea to draw it that way in order to show that this was the beginning. The red and yellow flag is the flag of the mining company, up to this day . . . Because the mining company used to be a state within a state, a government within a government. It was established in 1906 and began to build its installations.

F: First the smokestack?

T: Yes, the smokestack.

F: People must have been amazed in those days.

T: That's true, they were really amazed when they saw what was being built. Also, it was the people who did the construction work. Black people did the work; the whites had the knowledge and gave the orders.

Simon Kimbangu in Court

"Simon" Kimbangu. The date of his birth is set around 1881 . . . Neither a prophet, nor a politician, nor even an impostor. On October 3, 1921, at Thysville, judged and condemned. (After the play by Elebe Lisembe.)

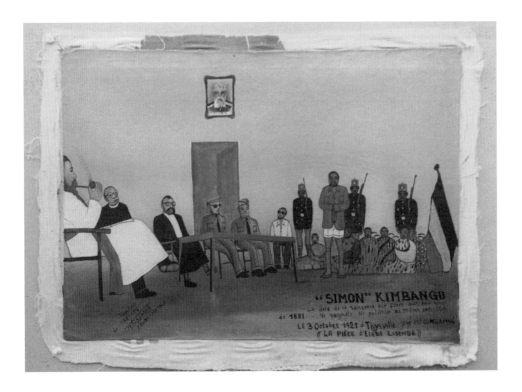

As I've told you, this was the time when they colonized us. But then they got other ideas. Indeed, at that time, around 1921, there was a man, his name was Simon Kimbangu. This Simon Kimbangu, he was not a politician, he was not a prophet or an impostor. He was a person to whom God had given enough reason to help and support himself. As to the drawing I've made here, I do this in order to help. I don't do politics, I am not a politician. Rather, I am a historian, and what I can do here is follow history. What I mean by "helping" is this: God gave Kimbangu whatever knowledge he had. A sick person would come to him and Kimbangu would pray to God, and the person would be healed. Kimbangu would go to a village and meet a person who had broken a limb and help him up. The whites saw that this man's knowledge was great and that this could not go on. So they were planning to get rid of him.

F: The model for this picture you took from *Mwana Shaba*, the mining company's newspaper.

T: Yes, from *Mwana Shaba*, no. 24; it was a photo of a play by Elebe Lisembe, a student. He deserves credit for this idea, and I imagine he was congratulated by the newspaper in the presence of his teachers. Now, as for his play, as

you can see, I — or rather, Elebe Lisembe had it performed by black people. But when I painted it I put in whites . . . and I added the flag and the portrait of Leopold II.

F: And that person there?

T: That was a missionary. It is said that Monseigneur de Hemptinne was present at the trial. He is smoking his pipe; you see the smoke rising. He was thinking, "How dare he found a religion. Am I not the one who brings the religion of the white man? We cannot have a black man preaching religion . . ."

F: So, that was the trial of Simon Kimbangu. Do you want to add anything?

T: No, there is nothing to add. They locked him up and killed him. Well, actually, it was said that he died in prison. Perhaps his fate would have been different had he gone free.

Paintings 25–26 Simon Kimbangu (September 24, 1889–October 12, 1951) was tried by a military court in the presence of a missionary observer. He received the death penalty on October 10, 1921, which, a few weeks later, was commuted to a sentence of life imprisonment. In December 1921 Kimbangu was brought to Elisabethville, where he died a prisoner thirty years later. The literature on Kimbangu is large and still growing. The three most comprehensive studies (Andersson 1958; Martin 1975; and Ustorf 1975, containing a detailed chronology of events in the life of the prophet) were written from a missiological perspective. For the later development of the Kimbanguist church, see Asch 1983. The only hint I could find as to the identity of John Panda is in the most famous early account of "the passion of Simon Kimbangu" (Chomé 1959, 42–43), which tells that a Belgian newspaper linked a certain John, relative of a certain Paul Panda Farnana, to an early organized network of Africans in Belgium. As to the involvement of Monseigneur de Hemptinne, Martin notes that the provincial governor and the warden of Elisabethville prison recommended in 1935 that Kimbangu be released for good behavior, but this met with opposition from the authorities in the lower Congo and from "the archbishop" (1975, 63).

The photograph that served as the model for Painting 25 was published in the Gécamines company paper *Mwana Shaba*, no. 217, September 15, 1973, and is, except for the modifications mentioned by Tshibumba, a rather faithful copy. During our conversation recorded on October 6, 1974, Tshibumba read to me a large part of the accompanying article (in French) that reports on the play written by Elebe Lisembe (*Simon Kimbangu, the Black Messiah*). It was performed by the theater group of the National University at Lubumbashi in the Cinquantenaire (the building depicted in Painting 56) at the close of the 1972–73 academic year, on July 14, 1973.

Painting 26 [see color plate]

Simon Kimbangu and John Panda in Prison

Kimbangu and John Panda. Soon after that Kimbangu is transferred to the famous central prison at Elisabethville, which had the honor of housing many Africans who held advanced ideas. There were many Africans who tried to create politico-religious movements; even these men are forgotten. After thirty years, Kimbangu met his end.

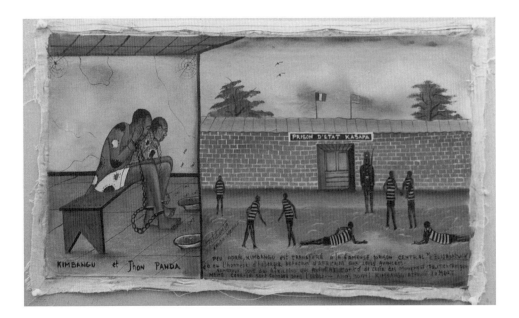

Now there's a second picture that goes with telling the history of Simon Kimbangu. In both of them I followed his tribulations. And John Panda is also there.

т: This side shows Kimbangu in prison, in chains, where he met John Panda. Now take John Panda. He was a man from Kinshasa and he had to die, too. He wanted to know, Why do we live in slavery? We should have equal rights. In other words, he was troubled by our being dominated and came to the conclusion that we were slaves simply because the whites had forced themselves on us. The whites did not like John Panda's ideas, so he was locked up. We don't know when he died . . .

ғ: And then there's the other side of the picture.

т: That is to show that Kimbangu was not alone in this jail. Many were there in those days. Many of them were highly intelligent people who had begun to think about the situation and what to do about it. . . . And in prison they were surprised to meet others like themselves. They greeted each other and exchanged news. They formed a group. But then it would happen that one morning one of them would not show up. Where was he? They didn't know where he went. And so all of them would eventually disappear.

Painting 27 [see color plate]

The Monument to Leopold II

Léopoldville was incorporated as a city on June 21, 1941.

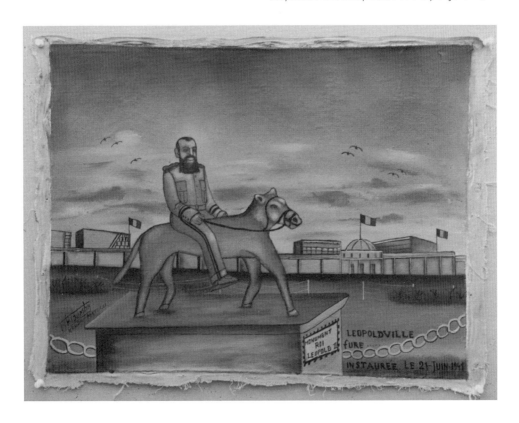

What happened was that we now had nothing left. I think it was on June 21, 1941, that Kinshasa was recognized as a town and they erected the monument to Leopold II. The whites did that, and they did away with everything we had created, our works—how shall I say, well, just our works, such as statues and all that—everything was thrown out or carried away. We were told, "These objects you use are magic charms. Don't believe in them; they are useless. We are going to erect our monuments, and that is something good. And things like statues of Mary, all that is very good." So then we saw the monument of Leopold II, which was put up in Kinshasa at the time when he died in Brussels, while he was horse-jumping. A horse rolled over with him—this happened near a pond—and he died. The whites said they were going to put up his monument because he was the king of the Congo. On the other hand, Banza Kongo's memory was completely lost; there was no monument, no nothing.

F: Did Leopold have a nickname, like King Baudouin, for instance, who was called *bwana kitoko*, "the well-dressed gentleman"?

T: No, Leopold was just Leopold. His name was Leopold II. But to this day there is the suspicion that he was also Monseigneur de Hemptinne, Jean-Félix de Hemptinne . . .

F: Let's look at this monument in the picture. It shows Leopold riding a horse.

T: It was in Kinshasa, in front of the Palais de la Nation, which used to be the governor's palace in the old days. . . . What happened is they erected this monument when Kinshasa was built and incorporated as a town, as was Lubumbashi in 1944 and Likasi, the third largest town of the Congo, in 1944 . . .

F: Why did you paint the sky behind the monument gray?

T: Gray? Frankly, that's a good observation.

F: Had you run out of blue paint?

T: No, I had the paint.

F: So?

T: I did it differently in order to indicate the time of day — it was in the afternoon or evening — and to bring out the monument better. It should be yellow, because it was made of brass.

Painting 27 Leopold II (1835–1909) has been the subject of many biographies and critical studies (for a fairly recent one that tries to balance his virtues and vices, see Emerson 1979, with a select, but still extensive, bibliography). Leopold II died of an embolism in his bed on December 17, 1909, and was given a state funeral two days later (Emerson 1979, 277–78). A photograph of an equestrian monument for Leopold II is reproduced in Institut royal colonial belge 1948, frontispiece. The monument was still standing in 1961; see the photo in Tan Siew Soo 1989, preceding p. 37.

Painting 28 [see color plate]

Victims of the Miners' Strike

The martyrs of the Union Minière du Haut Katanga. At the stadium formerly called "Albert I," now "Mobutu." Kenia township, Lubumbashi.

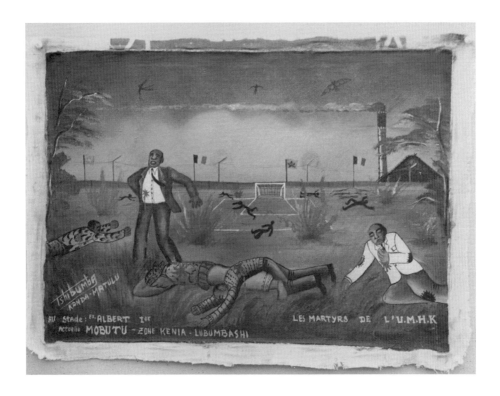

Now, the mining company had been operating ever since 1906, as I said in that other painting. It employed workers, and the workers were black people as well as whites. They killed workers of Gécamines in Lubumbashi on December 9, 1941, because they had gone on strike. They went on strike because they wanted a raise. The money involved was fifty cents. They kept asking for a raise. The workers got a hearing from the compound manager, they had talks with him. This compound manager was a Mr. Temperville, or something like that. That's how I pronounce it. Then the strikers were summoned to the stadium of the mining company (because after the talks with the compound manager, they had gone home to their houses in the compound). So, they were summoned to the soccer field on December 9, 1941, to appear before Governor Maron. "Come," they were told, "Governor Maron is calling." The people remained firm and refused to go back to work. And Mr. Maron found that the people refused to work. "No," they said, "we won't work unless we are given a raise." Now, there was one man, his name was Mpoyi. This Mpoyi stood up on behalf of all the people; he was their representative. He spoke: "The workers are striking because they want the company to come up with a raise." Mr. Maron pulled a gun and shot Mr. Mpoyi. Mpoyi died right there. It was Governor Maron who gave

59 *Colonial Times*

the soldiers of the Force Publique, the colonial army, permission to kill the people who were in the stadium. And they killed all of them, you understand? They just massacred them. There had been an understanding between the bosses of the mining company and the religious leaders, you understand? The go-ahead for all this was given by Monseigneur de Hemptinne, Jean de Hemptinne. He was informed of this matter. He had participated in the meetings where they decided to kill those people. And they killed them on December 9, 1941.

F: Now to "The Martyrs of the UMHK." Here again, the sky is sort of greenish.

T: That's true. The color of the sky is to show that it is dark. You see that the floodlights are on. That's what those yellow lines radiating from the lamps are supposed to show. I think it happened at night, and I wanted to show that it was dark. I use black down here at the lower edge, and again up there. That means that it is night . . .

F: And what are those things in the middle of the picture?

T: Those are explosives they put there, dynamite. And the soldiers of the colonial army were on the other side. They began to fire and killed many, many people.

F: And this one here, on the right?

T: That one was hit by a bullet and fell on the ground. And there's a woman who fell down; there were many who died with their whole families. . . . Rumor has it they called the people together announcing that a movie was to be shown . . .

F: What is the meaning of the birds in the sky?

T: It is evening, there are bats . . . and there's a bird with a long tail that comes out at night, but I don't know its name . . .

F: And then there is the flag of the state.

T: That is how it used to be whenever they held ceremonies. There would be both flags, the Belgian flag and that of the Congo Free State. And there's the smokestack of the mining company in Lubumbashi.

F: I notice that the workers are well dressed.

T: Oh, by that time they were dressing well, with shoes and everything. But among the people who had asked for higher pay, some were poor. They walked around in torn clothes. So they said: "We should get a raise so that we have enough to dress and to eat."

Painting 28 This event constitutes a major chapter in oral and written popular historiography (see Fabian 1990a, 109, 154). The most recent scholarly account of the events of December 1941 may be found in Higginson 1989, 185–96. Incidentally, Higginson notes that, according to an eyewitness, "The massacre of the African strikers did not occur on the night of 9 December but shortly after 12:00 noon. The mining company simply waited until nightfall to remove the dead and the dying with dump trucks" (193–94).

The Colonial Army Victorious

Victory of the Force Publique over the Italians, who had tried to invade the Belgian Congo. Under orders from the colonial authorities, the soldier Kamakanda killed hundreds of Italian soldiers. Then he himself was killed by the colonial authorities.

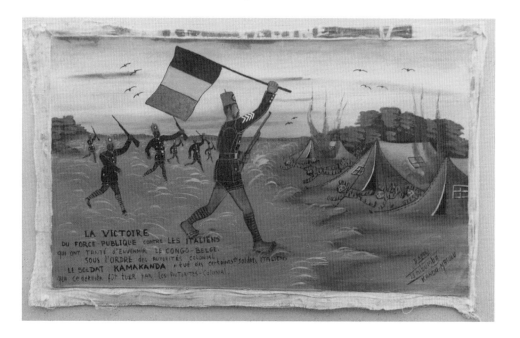

So the Belgians were holding the Congo hostage. The time came when the Portuguese had this desire: Let's get into the Congo and be its rulers. Who else? The Germans yearned to invade the Congo, and so did the Italians. So they came to make trouble at the borders of the Congo. When trouble broke out, the Belgians sent their soldiers of the Force Publique, the colonial army. Their order was: "Engage those people in battle; they must by no means be allowed to try to invade the country." The truth is, the one who took command of the Congolese troops and gave them orders was Kamakanda. He gave orders, and they fought a fierce battle, I think. After fighting for a while the white officers stopped the fighting: "Stop the war

now," it was said, "let's eat." That's how it is with the whites. When they are at war with each other, they may stop the fighting and tell their soldiers to eat and have a rest, and then they say: "Let's start fighting again." In Africa we don't fight each other that way. When we say war, it's war. There is no eating, no talk about dying of hunger. You are going to die by the gun. So they told Kamakanda to stop the war because the whites wanted to eat. "After that," they said, "we will fight again." All right, but when it was time to eat, Kamakanda took his gun and his soldiers and attacked the whites on the enemy side. He and his men killed all the whites,

the Italians, and that was the end of the Congolese border war. When the war was over, Kamakanda returned as a victor to the Congo. The whites congratulated him at first. Then they came to his home where he was staying to take him away. They said: "Because you fought so hard and lost a lot of blood and sweat we will care for you, you understand?" He needed medical treatment. They were going to give him medicine so he could rest. They gave Kamakanda an injection and Kamakanda died. They just killed him with an injection.

F: So now we come to the attack on the Italians . . .

T: Notice that at the time, our soldiers walked barefoot. They wore gaiters, but that was it.

F: What tribe did Kamakanda belong to?

T: I don't know, he was a Congolese.

F: Where did you get the story of Kamakanda from?

T: I got it from the old people; they know it very well. He died, but so did many others. But the way I see it, were I to do paintings of all of them, it would be difficult to sell them.

F: [aside] No, I'd like to have all the stories.

Painting 29 On the so-called Abyssinian campaign (1941), see Janssens's history of the Force Publique (1979, 211–16). He celebrates the heroic exploits of the Belgian colonial army a year after the defeat of Belgium, in 1940, but neither here nor in other standard sources could I find a trace of the Kamakanda story.

Painting 30

The Tetela Revolt

The Batetela revolt. "When your brothers rose up they would tell you: 'Go, kill the savages who are rebelling'" (Mobutu) [quoted in Lingala].

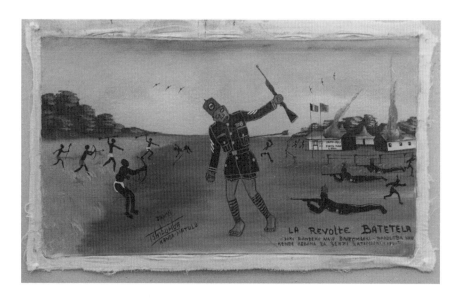

After Kamakanda's death, this is what happened. Among the soldiers who had fought that war, many were Tetela. At that time the Tetela tended to join the Force Publique to become soldiers. Now, the way the soldiers saw it, what happened to Kamakanda was bad. They considered it bad and they exploded and staged a mutiny, the Tetela mutiny. They revolted and fought other soldiers who took the side of the whites, as well as the whites themselves. They fought ferociously and killed each other. That was the Tetela mutiny. It was about the conditions in which the soldiers lived. In the army they did not treat them like human beings. Let's just say they regarded them as animals.

F: I see that there are soldiers on one side and warriors on the other.

T: Yes, but the warriors are also soldiers, it's just that they took off their uniforms. They did this to show which side they were on. On the side of the soldiers, there were the ones who were responsible for all the suffering and for the death of Kamakanda. Those who took the other side had come to realize that being in the army was useless. So they exploded. And the ones who were in the uprising fought with arrows and spears, whereas the loyal troops had guns. And the rebels set fire to the houses in the military camp. This was in Lodja, because the Tetela are the people of Lodja.

Painting 30 According to standard sources, the so-called Tetela revolt was a series of mutinies in the Force Publique that broke out in 1895 in and around Luluabourg. In these uprisings, "Tetela," especially the former elite troops of Ngongo Lutete, played a prominent role. The revolt went on for more than twelve years, until May 12, 1908, when the last groups surrendered (Janssens 1979, 117–18). Although Janssens views it as a revolt inside the Force Publique, it is obvious that it was a popular movement of resistance. Turner shows that armed uprisings among the Tetela continued after 1908; "the *Shimba* rising of 1931 was the last event of its kind" (1973, 208). Luluabourg would again be the center of a military mutiny and widespread popular uprisings in 1944.

Prince Charles Visits the Congo

Prince Charles visits the Belgian Congo in 1947. "All the children born in 1947 should have one eye ripped out" (Prince Charles).

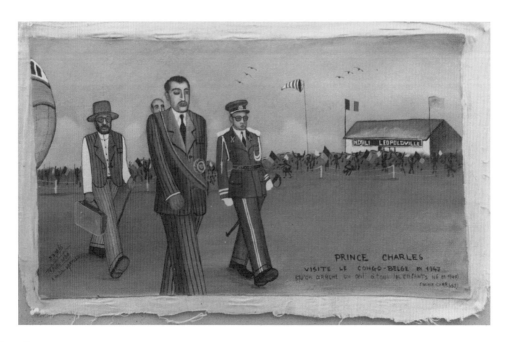

Not long after that there was the royal tour. By now the Belgians had settled in Zaire, the Belgian Congo, as it was then called. Not long after that came the tour Prince Charles made of the Congo. That was in 1947. Before that there had been the tour made by Prince Leopold, the future king. Leopold became the ruler after Albert died, and he had traveled here in 1925. In 1928 King Albert and Queen Elisabeth traveled in the Congo. In 1947 Leopold, or rather Charles, the prince regent, traveled in the Congo. When he arrived, the prince regent made a speech. I should first say that he had a deformity in one of his eyes. He had only one eye. So he said, "To mark my trip to the Congo, the order should be given that every child born in 1947"—I myself belong to this group— "should be picked up and should have one eye removed. Every child born in 1947." And he said, "Now that I am here, this is how I am going to

sleep. I order that every black man have the hair on his head cut off." (You understand? They should cut their hair—not everyone, though; only those they could find with a lot of hair.) "The hair will be used to stuff the mattress on which I am going to sleep." But what happened was that the Belgian parliament refused to go along with this. It stated: "That is impossible. You are the king, and you are the ruler. But it cannot be allowed for someone like you to take a human being, and a child at that, and have his eye removed." Prince Charles, incidentally, had meant all the boys, not the girls; they would not have to have an eye removed. "This deformity you have," the parliament said, "it was you who got it. And we cannot go after those children who were born, sent by God, without a fault. They should remain whole and healthy." Prince Charles went back to Belgium.

F: So this shows Prince Charles and his party arriving at Ndjili airport in Kinshasa.

T: Yes, Ndjili, in Léopoldville. At that time the airport had only one building, with a thatched roof.

F: And this sack you painted up there?

T: That's what they have at airports, to indicate the direction of the wind . . .

F: So Prince Charles arrived with a guard; and who are the others?

T: Those are government ministers, a delegation.

F: And the people seem to be cheering.

T: Yes, they are cheering his arrival. If you look carefully, you see some of them beating drums to show their joy. But at the same time, they are talking among themselves: "Listen to the news, what was said about your children, those who were born in 1947, having their eyes cut out." And they were saddened.

Paintings 31–35 Two Belgian kings visited the Congo as crown princes, Albert and Leopold III. King Baudouin made several visits to the Congo, the most spectacular one in 1955. On the political context of these visits and on the royal message of January 13, 1958, see Young 1965, 48–50. Pétillon made a famous speech in 1955 (published in English translation, 1955; see also his recollections, 1967, 1985).

Painting 32

King Baudouin Visits the Congo

His Majesty King Baudouin I visits the Belgian Congo in 1955.

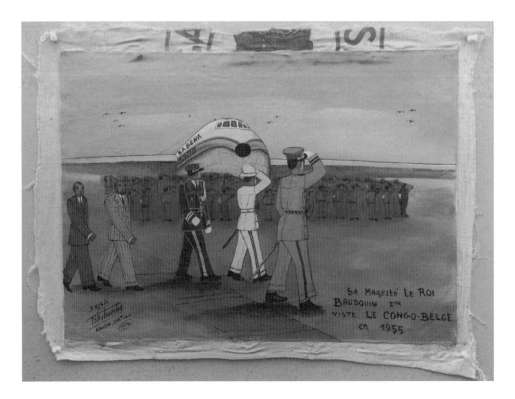

Then in 1955 King Baudouin, His Majesty King Baudouin, came to the Congo. When the king of the Belgians arrived I was an eyewitness. It was in 1955, I was a first-grader in elementary school; that was when he came to visit Shaba, at Jadotville. That is what Likasi used to be called at that time. And they put a flag in my hand and I kept cheering him. I saw him coming in a black car, and when he arrived he got out in front of the church. They greeted him, and then he went to the center of the township. All right. When King Baudouin arrived he was accompanied by Pétillon, who was the governor general.

F: Baudouin arrives at the airport. And who is this?

T: That's Pétillon and a bodyguard.

F: And the two whites behind them?

T: Some big shots, like governors. And there, under the airplane, soldiers are lined up to greet him. The king salutes them. That dark strip they are walking over is concrete . . . and in the background there is a cloudy sky, full of birds.

King Baudouin Giving a Speech

"Eat, drink, and dance together with the blacks of the Congo" (Baudouin). To hinder independence.

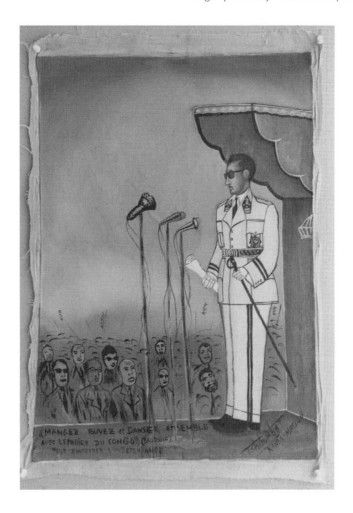

King Baudouin was shown around by Pétillon and he was well received. Also, he had ideas that were good. He made a speech in which he told the whites: "My brothers, enough years have gone by. Time has come for the people of the Congo to have their sovereignty returned to them, the sovereignty that was taken away by our ancestor, Leopold II. Because that time has come now, the only thing I can do is give them their independence. You have been expecting this. . . . Therefore, listen to me: you should eat together with those people, in the hotels, each from his own plate or from one plate; you should drink together with them. Take your wife and let her dance with them. This does not mean that they should sleep together, just dance together. . . . Then they will see that everything is all right and that there is nothing wrong between you and them." But the Belgians said: "No way. We cannot eat together with a black person, drink or dance together with him. We categorically refuse. Do you really mean it?" they said. And he said: "I do."

Painting 34 [see color plate]

Colonie Belge: Under Belgian Rule

The Belgian Colony, 1885–1959

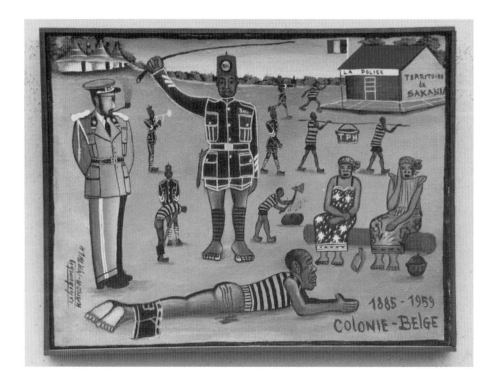

The colonial period was a time of servitude. They put people in prison and beat them with canes. Yes, they were flogging people in prison. It wasn't the way it used to be in the village when you had transgressed and they would grab you and beat you. In prison, the flogging was like paying a fine when you had done something bad. The flogging took place during roll call. It could happen that you were in the lineup and did not quite understand what the supervisors said. Then they would beat you with a cane.

F: We've talked a lot about this painting, but let me ask you this: Why did you decide to write "District of Kambove" on the building?

T: It was not a matter of selecting the district of Kambove. There are many of these paintings, and it just so happened that this was the one I sold to you. Others have Kakanda, Sakania, Lodja, Matadi—I could do all the districts or towns of Zaire, because there were prisons in all those places.

F: So we see the building of the district commissioner here. And over there, is that a village?

T: No, that's not a village, it's the police barracks. It is close to their place of work. Every policeman had his job. One would wake up all the prisoners in the morning. . . . Another one is pursuing a prisoner who is trying to run away from

the flogging and the prison. "Get him," the policeman shouts, "he is taking to the bush!" Another policeman is making a prisoner undress to make sure he's ready when the roll call comes and he will get his flogging.

F: And those there, what are they carrying?

T: They're carrying shit.

F: Shit?

T: Yes, because when the people are in prison the doors are locked and they relieve themselves in a vat. Then in the morning, some of them are picked to carry the stuff and throw it out.

F: And what is TPM?

T: It stands for *Travaux publics ya mécanisation*, Public Works and Motor Pool.

F: And those two women?

T: Those two are wives of prisoners. They are there because they brought food. "Let's bring them a bowl of food and a bottle of water in the morning," they had said, and then they found one of the husbands being beaten. You see here his wife as she puts her hand to her cheek, in a gesture of distress. And the other one is sad, too. We don't know which of the prisoners is her husband.

F: Well, well. And now to this white man.

T: Smoking his pipe. And then you see the policeman with his badge number. Because when the Belgians ruled, every policeman had his badge number. If he caused you trouble on the road or asked you for money, you would just take down his badge number and go away to report him to his superior. . . . He would be called in and be made to face the charges.

F: Really?

T: Yes.

Painting 34 At the time, we were looking at a version of *Colonie Belge* inscribed "District of Kambove"; however, the version in my collection, reproduced here, is inscribed "District of Sakania." This substitution also shows how Tshibumba's paintings looked before they were taken off the stretcher.

Pétillon Giving a Speech

*Mr. Pétillon at the residence of the lord mayor
of the town of Jadotville in 1957.*

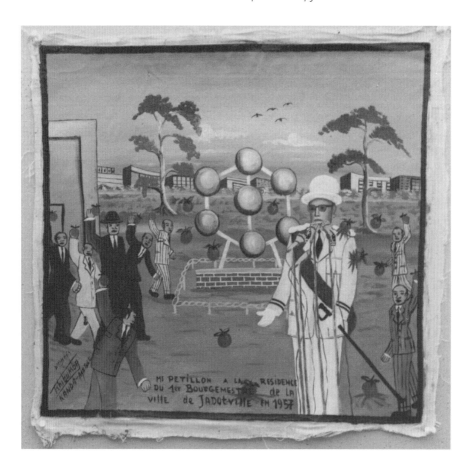

Then in 1957 came Mr. Pétillon. He traveled all over the Congo, as the country was called then. So he got to Likasi. He was at the lord mayor's residence in Jadotville, which was the name of Likasi at the time. He called together the whites, and many came. He explained to them: "Brothers, I am just an emissary, sent to settle the matter that King Baudouin left unfinished. What do you say? What have you agreed on?" They picked up tomatoes, threw them at him, and chased him away, saying, "You can inform him that we reject what he said."

F: Who was Pétillon?

T: He was governor general, something like head of state, and he lived in Kinshasa. This scene was at the residence of the lord mayor of Jadotville.

F: I see a kind of monument there.

T: Those balls? It's still there. If you travel to Likasi and get into the mayor's — sorry, the subregional commissioner's — residence, you'll find it.

F: What is it? What is its meaning?

T: No idea; it's something the Belgians left behind. I don't know what it means . . .

F: Then I see that the whites have come out.

T: They are throwing tomatoes; one of them has burst on Pétillon's shoulder, and another on his arm. They categorically reject what he has been telling them.

F: What did he say?

T: He said: "Baudouin has sent me to take care of the matter he left unfinished at the time when he visited. He wants you to eat and drink with the blacks. Actually, we should give them independence. I take it you reject this." "If that's how it is to be," someone said, "then get lost with this independence and all that. We don't like it." So then they pelted him with tomatoes.

. . .

F: So how do you see this now? Do you think that what was said then was in fact meant to prevent independence, since that's what you wrote on the other painting: "to hinder independence"?

T: Of course. Had they acted as the king asked them to, had things been then as they are now, we would not have imagined what independence was like . . . we'd all have been content if independence had never come. But now it has come, and you ask me how I see it now. Well, what counts now is money. If I look at the situation in different countries, they have, in a word, hit bottom. Like in Africa, there is a lack of money everywhere, even in Europe or Asia. If you have money, you can love any color and your love will be returned.

Lumumba, Director of a Brewery

Lumumba, director of the brewery of Stanleyville.

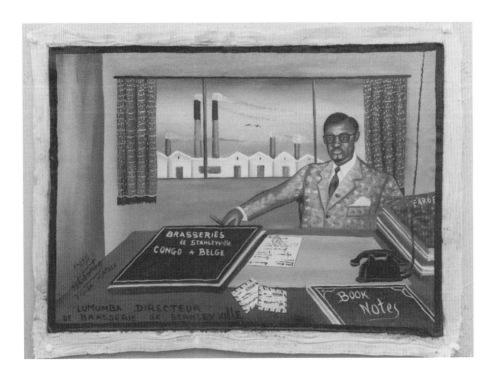

When this affair was going on, during the time of servitude under the Belgians, there was a black man who already at that time had attained a position of importance, that is to say, a certain rank in an organization. He had a position, the directorship of the brewery at Kisangani. Right now it is Kisangani; earlier it used to be Stanleyville. He was Lumumba. In carrying out his duties, Lumumba showed great intelligence. Nobody understood how he did it.

T: In those days we were slaves. Even in the army, I don't think anybody reached a rank higher than sergeant. We were sergeants, corporals, and that was it. That is how it used to be. In those days a person may have been competent enough to be a general or occupy some other position of importance, but there was simply no way. It was this sort of injustice that made the Tetela rise up and stage their revolt. And it was also at issue in the death of Kamakanda.

F: But Lumumba is well installed.

T: He sits in his office, with his arm resting on the chair, and he's talking with a smile, I show him in a smiling pose. . . . There is a letter he wrote and signed and is going to send somewhere. There is the book of the brewery . . . there are files, a telephone, a notebook, and two envelopes. Through the curtained window you look out on the brewery plant.

Painting 36 Hundreds of articles and books have been written about Patrice Lumumba (among them Kanza 1972, with a photograph on the cover that may have been the model for Painting 67). A critical reexamination of that literature, augmented by oral testimony from persons who were close to Lumumba or had a part in the events of his career, was recently published by Willame (1990). He implies that knowledge like Tshibumba's remains to be tapped—Africans "have other histories to tell" (17)—and he reproduces one of the many versions of the painter's African Calvary (Painting 67) on the cover. The book is an important source for linking Tshibumba's pictures and narrative to printed history. The following summary of Lumumba's biography is based on Willame. (See also Turner 1993b for a review of Willame and of two other recent studies, Brassine and Kestergat 1991 and Manya K'Omalowete 1985.)

1925–1943: Lumumba was born Elias Okit'Asombo, the son of François Tolenga, a Catholic, monogamous farmer belonging to the Tetela ethnic group, in the Katako-Kombe territory of the Sankuru district. His father wanted him to become a catechist, then one of the few avenues of social advancement, but as soon as Lumumba was literate he rebelled and joined the Methodist mission nearby, from which, after four years, he was expelled for lack of religious fervor. He then went to the Catholic institute of Tshumbe-Sainte-Marie and was expelled after one year; he enrolled in a Methodist school of nursing and was again expelled. After that he returned to the village, did odd jobs, and read everything he could get from the mission library of Wembo-Nyama. Eventually, he left for town and changed his name to Lumumba, a patronym from his maternal lineage (Willame 1990, 22–25).

1943–1956: After working for four months in Kalima (in the Maniema region) for the Symétain mining company, he moved on to Stanleyville in July 1944. There he worked full-time as a postal clerk and took evening courses with the Marist Brothers. Impressed by his qualities, his employers transferred him to a better position at the agricultural center in Yangambi. In 1947 he was accepted at the postal academy in Léopoldville, where he passed his examination with 94.4 percent and became *commis 3e classe* (a rank also occupied by whites who made twice his salary). Back in Kisangani, now in the postal administration, he lectured and published articles, especially in *La voix du Congolais*. He married a woman from his village but had two other wives, one Luba and the other Kongo, both educated. In 1952 he met and befriended the French sociologist Pierre Clément. With Clément's guidance, he filled a major gap in his education under the Belgian regime: the study of politics (26–28). Although proud and independent, during this period Lumumba was, according to Willame, a typical *évolué* who had internalized much of the ideology of the *oeuvre civilisatrice*. In 1953 he applied for the status of *immatriculé*, assimilated native. He failed the examination, apparently because the examiner found his readings disquieting and because Lumumba could not calculate exactly his family budget. With support from enlightened European friends he obtained that status in 1954.

That same year he met the Belgian Liberal minister Auguste Buisseret, who was traveling in the Congo. They got along well, and Lumumba joined a liberal circle in Stanleyville and founded the Amicale Libérale, a political party in the making. Twice Buisseret arranged lengthy meetings between Lumumba and King Baudouin, who was then traveling in the Congo. The spokesman for numerous organizations of *évolués*, Lumumba nonetheless faced opposition within those groups, both because of his own ambitions and his promotion of Buisseret's cause, the creation of secular schools to end the missionary monopoly on education. Although he eventually had to step down as president of the Association des Evoluées de Stanleyville, he was part of a study group brought to Belgium in 1956. On his return on July 6, 1956, he was arrested upon leaving the plane and accused of having embezzled 126,000 francs from the postal administration. He pleaded guilty and was sentenced to two years in prison, later reduced to eighteen months. Willame points out that taking from the whites was generally considered legitimate, and collections among his friends helped to repay the sum in a few months. His "crime" made Lumumba popular in *évolué* circles beyond Stanleyville. In prison he wrote a book calling for the full emancipation and integration of Congolese *évolués*, a document that was eclipsed by the manifesto of Joseph Kasavubu's Alliance des Bakongo (known as Abako), which appeared in August 1956 and demanded immediate independence within a federal structure (26–37).

1957–1958: Lumumba, who got out of prison in June, had lost his position in the postal administration and moved to Léopoldville. There he became *directeur commercial* (actually fronting for the European sales manager) in the Brasserie de Léopoldville et du Bas-Congo. The brewery's sales had suffered from rumors that its beer, Polar, caused impotency, and Lumumba was to repair its image with the help of his contacts and free beer. At that time he also took leading positions in liberal and ethnic organizations and entered the scene dominated by the Abako and by Catholic social-democrat–inspired movements. Joseph Ileo and Joseph Ngalula were setting up the Mouvement National Congolais (MNC) to counteract Abako ethnic nationalism. Lumumba joined that party (together with socialist union leaders Adoula and Nguvulu). After about a year he assumed the leadership of this group, greatly helped by his mobility and contacts. In August 1958 he took a leave from his job at the brewery to go to the Brussels World's Fair, where he widened his contacts among socialists and liberals. Back from Brussels, he formally set up the MNC as "his" movement. Recognition came when, together with Ngalula and Gaston Diomi (an Abako dissident), he was invited to participate in the Panafrican Conference in Accra (37–41).

Lumumba Meets Kwame Nkrumah

*Lumumba and Kwame-Nkrumah in 1957
at the Panafrican Conference in Ghana.*

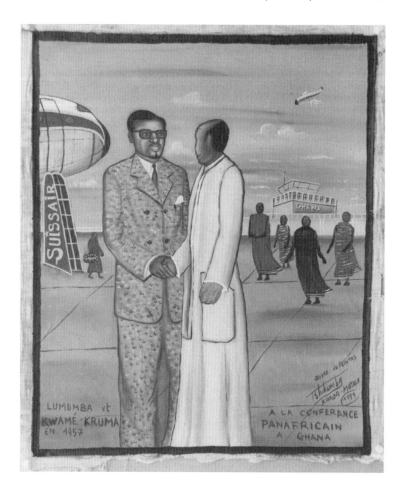

Lumumba divided his activities between politics and his work. In 1957 there was a conference they organized in Africa, in Ghana. This was the Panafrican Conference. . . . We were still living under slavery then, and Lumumba was the only one among the black people intelligent enough to find a way of getting to this conference to participate in the meetings. Lumumba got there, and he was welcomed at the conference.

T: As I show you there in the painting, Kwame Nkrumah greets Lumumba as he leaves the plane. Then there are people who happened to be at the airfield to greet arriving guests. It's the wind that lifts their clothes. All right. Then there is another airplane approaching, carrying dignitaries who are going to participate in the conference. As far as the Congo was concerned, we saw only one black man who really wanted to participate in the conference; he was the first one.

· · ·

F: So where is this airport, in Ghana?

T: It's in Ghana, but because I don't know the national flag of Ghana I couldn't put it there. I would have drawn it had I known what it was. . . . So Lumumba was greeted by Kwame Nkrumah, who was then president; later he died in Guinea. And there is another guest coming off the plane. "Ghana" is written on his bag.

• • •

F: So they took Swissair?

T: Yes, that's what enabled him to make the trip. Had Lumumba taken Sabena, the Belgian line, they could have discovered why he was traveling.

Painting 37 The Panafrican Conference was held in Accra, December 8–12, 1958. Lumumba, president of the newly founded MNC, was not the only Congolese participant. Also present were Ngalula, editor-in-chief of *Présence congolaise*, and Diomi, the Abako mayor of Ngiri-Ngiri township in Léopoldville (Geerts 1970, 46–47). Afterward, all three reported on their experiences at a popular meeting in Léopoldville-Kalamu on December 28, 1958. Enthusiasm among the seven thousand participants for Lumumba's call for independence was the prelude to the events of January 4, 1959 (Geerts 1970, 46–47).

Painting 38

Kasavubu Is Elected Mayor

*In 1958 Kasavubu becomes the mayor
of Kintambo township.*

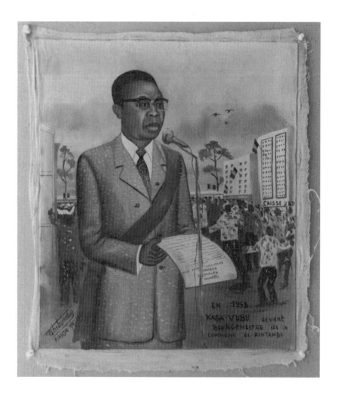

Then, also in the Congo, there was another black man who, in 1958 already, was appointed mayor. That was Kasavubu. I was around at the time, and I saw that he was a black man. I saw the same thing happen in Likasi. There Mutonkole Noël was also the mayor at that time. This was explained to us, and we all were amazed to hear that a black person was occupying a position of importance.

T: Here Kasavubu appears as mayor. It was in 1958, wasn't it? . . . He holds a piece of paper inscribed, *Mesdames, mesdemoiselles, messieurs* . . . That is how you addressed people in those days . . .

F: Is that his speech on that piece of paper?

T: It's the speech he was about to make. You see the people dancing, they could not believe it. There was great joy, and the Belgian flag is flying on the buildings there. That one is the savings bank, and there are birds in the sky . . .

F: I see that he's wearing the Belgian colors on his lapel.

T: Yes, he was wearing a jacket. He wore the colors because he was mayor during Belgian times. So he took a pin representing the Belgian flag and put it on.

Painting 38 Municipal elections were held in Léopoldville in December 1957. At his inauguration as mayor of Dendale township on April 20, 1958, Kasavubu demanded general elections, causing a sensation. A few days later he was given an official warning and reprimand by the governor of the province of Léopoldville (Cornevin 1989, 361–62).

Painting 39 [see color plate]

Kasavubu and Lumumba Meet at the Brussels World's Fair

At the exposition in Belgium in 1958, the first encounter between Lumumba and Kasavubu.

ecause of his position, Kasavubu was allowed to travel to Brussels, to Belgium. He went and there was an exposition. To represent an exposition, I put paintings up there in my picture. But that doesn't mean it was like that at that exposition. What was it an exposition of? I simply don't know. In order to show that it was an exposition, as they said, I placed those paintings up there. On those paintings I wrote "Picasso," "van Gogh," and "Tshibumba Kanda Matulu," all that. Anyhow, a lot of people were there, among them Kasavubu. Kasavubu said to himself: I am going to walk around in there. Then he and another black man saw each other; the other one was Lumumba. And Kasavubu was startled to see for the first time a fellow black there. Kasavubu said, whispering to himself: What do you know? Then to Lumumba, "Say, what's new?" Lumumba said, "I also came to look at the exposition; what's happening?" Because Lumumba was a person of great intelligence who had traveled

to attend conferences, he explained to Kasavubu what his traveling was about. Kasavubu said, "Is that so?" Lumumba said, "Yes indeed, I went to the Panafrican Conference and participated in it. They welcomed me, and I was shocked by the state of slavery in which we find ourselves up to this day." Kasavubu said, "Really? What was it you were looking for?" That was when they conceived the idea of independence.

F: So now Kasavubu meets Lumumba.

T: Yes, it was at an exposition. But, as I told you, I don't know what the exposition was about. Was it books? Or paintings? Now, since I am an artist it did not take me long to decide that it was paintings. So I put in paintings with the names of Picasso, van Gogh, and my own name. . . . There were many people; you see a European lady and gentlemen. And there are Lumumba and Kasavubu, two Congolese, looking at pictures. I painted one of them in the pose of looking at a painting while the other one is approaching. How come, he says, there is a black person here? And then they got to know each other.

Painting 39 According to Cornevin, this is what happened at the fair: The pavilion of the Catholic Mission became a sort of center where many *évolués* and their Belgian sympathizers met and began to discuss the formation of a national Congolese party of Christian orientation. Government circles encouraged this project in the hope that such a party would be a largely rural counterweight to the predominance of the Abako in the capital. Already Lumumba seems to have been recognized as a likely opponent to Kasavubu, leader of the Abako (Cornevin 1989, 362).

Lumumba Leading the Léopoldville Uprising

The speech of January 4, 1959.
The martyrs of independence.

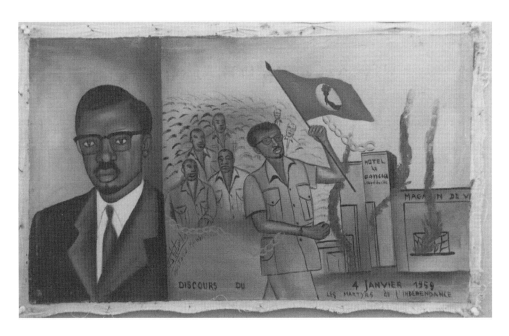

With their idea of independence they returned to the Congo. When they arrived, the discussion among the whites was already under way: The black people have seen the light, we must come to an understanding with them about this matter. Kasavubu went to work on it, and so did Lumumba. . . . On January 4, he gave his speech in Kinshasa. When the people heard what he was talking about they were troubled, and they didn't really understand it. . . . After the speech, the people exploded and killed each other in Kinshasa. . . . That was on the 4th of January, 1959, at Léopoldville.

T: There are two versions of this painting. When I painted the one we are looking at, I put in our present flag so that I would be able to sell it. . . . The other one was properly situated in history, with the flag of the period. Anyway, Lumumba picked up the flag and the people are behind him. That was in 1959, and as a result of this demonstration houses were looted and things were thrown outside, destroyed, taken away. People made off with clothes, appliances, radios, and many other things . . .

F: But this is really two paintings. One shows the uprising of January 4, the other a portrait of Lumumba.

T: The idea behind that is to show that this event started with Lumumba's speech. . . . It was because of what he had said that the people exploded.

F: So the portrait on the left shows him giving his speech?

T: Yes.

F: It looks to me as if you painted this very quickly.

T: No, but it may look that way because I made it some time ago, before I met you. . . . That's the way it is with art, it comes in many kinds. I could also do it in different colors.

Painting 40　An event that occurred on June 16, 1957, can be seen as a prelude to the unrest in 1958–1959. After a soccer match between a Belgian and a Congolese team, the crowd became upset over faulty decisions made by the referee. Some European cars were stoned, numerous people were wounded, and the eighteen thousand Europeans living in Léopoldville were stunned (Cornevin 1989, 361).

In his speech to the rally at Kalamu (see note to Painting 37) Lumumba had asked for unconditional independence. That speech, published in the Léopoldville paper *Présence congolaise* on January 3, 1959, may have been Lumumba's most important contribution to the events of January 4 (Van Lierde 1963, 13–21). The following summary of what occurred that day is based on the most detailed day-to-day account of the events around independence, Vanderstraeten 1985, 20–28.

The Abako had announced a meeting to be held on Sunday, January 4, at the YMCA, which was located between the Kalamu and Dendale townships. Having been denied a permit, the organizers wanted to call off the rally at the last minute. By then, however, masses of people had started to arrive, and around noon the police were informed. Inside the YMCA building a journalist, J. Mobutu, was lunching with his photographer. The president of the MNC, Lumumba, was selling party membership cards. Kasavubu lived around the corner and eventually came to address the crowd. No one could hear him because there were no microphones or speakers. Kasavubu declared the meeting closed and left. The crowd took to the streets and began to insult and stone Europeans. A small police contingent arrived around 2:30 P.M. and tried to disperse the people. When the commanding officer was manhandled, one of his men fired a shot; that was the turning point. The word went out: they are killing blacks.

The crowd milled around for three more hours, until twenty thousand spectators poured out of the nearby Baudouin I Stadium, where a big match had just ended. Many joined the rioters in looting white businesses; there were also attacks on white women. As the crowd moved toward the center of town, buildings were set on fire. Around 8:45 P.M. the civil authorities gave orders to shoot. When this failed to stop the crowd they appealed to the Force Publique. Police measures were taken to protect the European city; no one knows exactly what happened among the 350,000 inhabitants of the African city. By 4:35 A.M. the troops were fully deployed. The rioters dispersed into the six central African townships. They continued plundering and raping until the Force Publique proceeded to a "systematic cleanup" of the communities closest to the European city. Meanwhile, Belgian forces had been called in, arriving on Monday night at Ndjili airport from their base in Kamina. The cleanup was concluded on Wednesday, with an official count of 49 Congolese dead and 101 Congolese wounded; 15 Europeans wounded. Unofficial estimates indicated between 100 and 300 dead.

Troops Intervene in Léopoldville

*January 4, 1959, in Léopoldville and the
intervention of the UN (Ghana).*

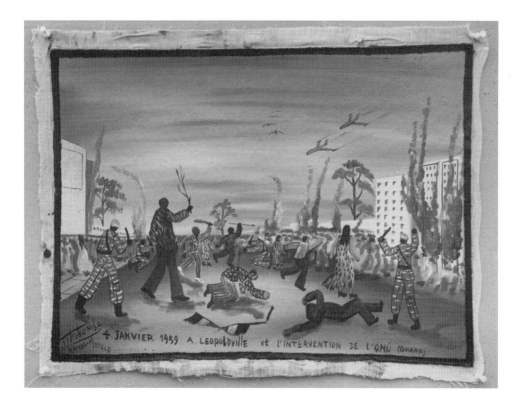

So the fighting began and people slaughtered each other. For the army, the ones who fought in this war of January 4 were Belgian mercenaries and soldiers of the Force Publique. I am sorry, but on my picture I wrote that it was an intervention of the United Nations. That was an error; they came later.

T: The Belgian paratroopers and the colonial army prevented the fighting from getting totally out of control.

F: I see whites.

T: There are whites in the midst of it, a white woman and a white man, and someone with a spear, out to kill. This white man is dying and so is that black man; there was mutual slaughter.

F: And this tall guy?

T: That's a tall black guy. He has grabbed a stick and is hurrying to join the killing and fighting. And those planes are war planes. I heard that

they were all over Kinshasa in those days. They were jet fighters of the colonial army, stationed at Kinshasa. But they were manned by Belgian paratroopers, not by colonial soldiers.

F: The flag has been torn to pieces.

T: They tore up the Belgian flag and threw it away. The turmoil was unbelievable.

Painting 41 Tshibumba recognizes a chronological error in that this painting and the following one have United Nations troops arriving in 1959. The first calls for involving the United Nations came from the Abako and others in April 1960. The idea was to internationalize the command of the Force Publique (that is, to take it away from the Belgians). The appeal itself came in July 1960, days after the declaration of independence, when the Force Publique staged a mutiny. On July 19, there were 3,300 United Nations troops in the Congo, flown in by the United States Air Force and commanded by the Swedish general Von Horn (see Willame 1990, 127–29, 143, 310–38).

Colonel Kokolo Is Killed

*On January 4, 1959, Colonel Kokolo was
killed in his home.*

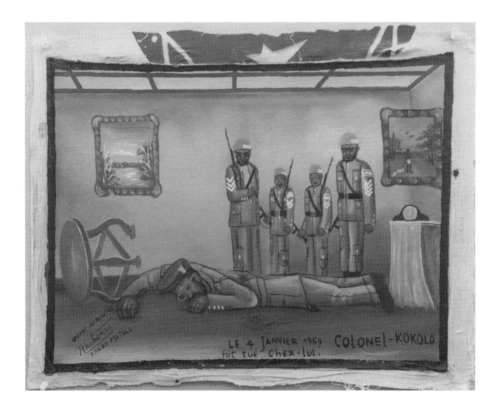

Then many people killed each other, and there was Kokolo who had taken a command. Kokolo was a headstrong person and a troublemaker. He made the people fight in this war. . . . Eventually, he was followed to his house and killed. But it was not the UN soldiers who killed him; it was the Belgian paratroopers, and even soldiers of the Force Publique. That's how it was; I read up on it to get it right. . . . After Kokolo was killed, Kinshasa stayed calm. After all, we were in a state of slavery.

T: The scene is Kokolo's house. You see that I put in some paintings. One of them I signed "Laskas" [a fellow painter], the other "Tshibumba." The table in this room was overturned, and Kokolo lies on the ground. The soldiers are standing over him. . . . I wrote "United Nations" on their helmets, but in fact it was the Belgians who killed him.

Painting 42 Vanderstraeten repeatedly refers to J. Kokolo (spelled *Nkokolo* in other sources) as an adjutant, and notes that he was a Mukongo and a close ally of Kasavubu. He played a key role in the rapid Africanization of the Force Publique during and after the July mutiny. On July 8, 1960, he was appointed acting commander of Camp Léopold at Léopoldville; on the 10th he left for the Luluabourg and Elisabethville garrisons to oversee Africanization there. On July 11 (two days before declaring independence), Katanga authorities prevented Kokolo and his delegation from leaving the airport in Elisabethville and making contact with the garrison and forced him to return (Vanderstraeten 1985, 238, 240, 389, 397). Vanderstraeten makes no mention of an assassination of Kokolo.

Kasavubu in Court

Kasavubu before the tribunal.

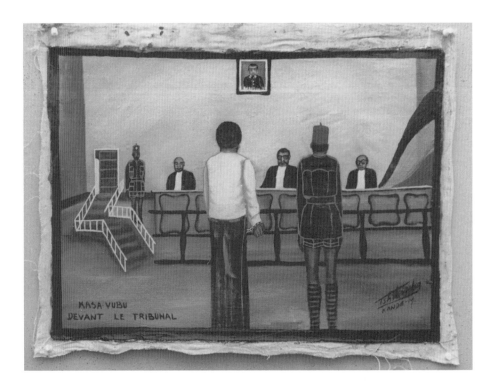

After the death of Kokolo, Kasavubu was locked up because of the things he had spoken about in public in Kinshasa. He was tried for being active in politics and for having started to demand independence. . . . But his mistake was that he did not demand independence for all of us Congolese. He wanted independence for the province of Kinshasa, for the town of Kinshasa, and only for the Kongo people. To achieve his version of independence he created his political party, the Abako. I am not sure how this developed in his mind, whether it was an association of Kongo or what. At any rate, the whites were against his party; they arrested him and tied him up with a rope. The picture shows him before the tribunal. I think you see him standing there, defending himself, and next to him a policeman wearing the old uniform.

T: This is Kasavubu before the court. . . . Up there, that's a portrait of Baudouin.

F: Of Baudouin?

T: Sure, he was our king at the time, so we had to put up his portrait. . . . So the judges tried him, but then they let him go.

Painting 43 After the January 4 uprising in 1959, the Abako was banned by the authorities. Its leaders were arrested on January 5, except for Kasavubu. He had gone into hiding but surrendered himself on the 7th (Vanderstraeten 1985, 29). Van Bilsen's biographical portrait of Kasavubu indicates that he was convicted, together with Kanza and Nzeza, for instigating the riots but was subsequently freed by Minister Van Hemelrijk and brought to Belgium (quoted in Geerts 1970, 349).

Painting 44 [see color plate]

Lumumba in Buluo Prison

At Buluo, before flying to the Round Table in Belgium.

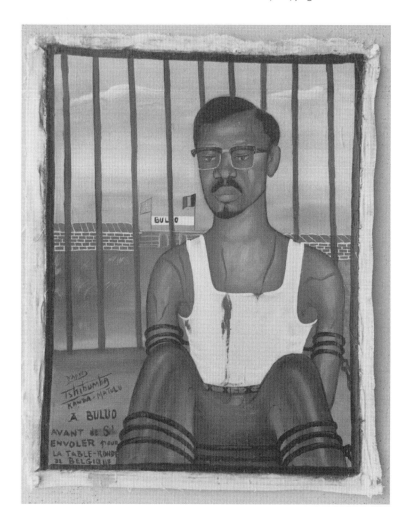

When Kasavubu's trial was over it turned out that in another place, there was another person who demanded independence. That was Lumumba. The independence Lumumba demanded was for the whole Congo. He said: "I want the black people to be independent. Now, the kind of independence I am demanding for them should mean a united Congo, a strong country and," he continued, "a free country." They locked him up, too, and beat him up something fierce. As you see, they hit him. You can see how I show this in the painting here. Indeed, he was covered with blood from the flogging. And they dragged him away from Kinshasa, which is where he had gone, and brought him to Lubumbashi. After they had brought him to Lubumbashi they put him in prison, at Buluo. They actually called the people together and told them: "A black man has arrived and he demands that the people be independent." But we

did not hear what he had to say. The word was out that people should just stay put and that the house of independence should wait and be built slowly until it reached the necessary height—that was the way independence was to come. No one really knew what Lumumba thought about it. . . . Lumumba had founded his political party; it was the MNC-Lumumba. Its members included Kalonji and many others.

T: In Buluo prison Lumumba was given a terrible flogging. You can see how he was beaten up, and the blood that is flowing. His clothes were torn, and the bars show that he is inside a cell, and the background is outside. When they locked him up they did not remove the ropes, and he is sitting on the floor.

F: Was that in Likasi?

T: In Likasi. Haven't you seen the prison there?

F: Yes, we have seen it.

T: That's the place.

F: And then they had to set him free.

T: They set him free.

F: Why?

T: He was freed because the Round Table demanded it. Kalonji, Kasavubu, all of them said: "He has to come, because he was the one who started all this. Where are we to go from here? We may embark on something we don't know. He should come and explain to us well what we are about to set in motion here."

Painting 44 A congress of the MNC-Lumumba was set for October 23–28, 1959, in Stanleyville but was prohibited by the mayor, who mobilized the military. Riots broke out on the 30th. Twenty were counted dead, and Lumumba was arrested. Even his adversaries realized that this amounted to his consecration as a political prisoner and asked that he be freed. While in prison he did a lot of reading and continued to direct his party. In November, the ministry of colonies and the leaders of the Abako, the Parti Solidaire Africain (PSA), and the MNC-Kalonji agreed to hold a Round Table as a sort of constitutive assembly. When the king visited Stanleyville in December he had a huge welcome from people believing he had come to free Lumumba (Willame 1990, 51–52).

Lumumba Flies to Brussels

*After his liberation from Buluo,
Lumumba flies to the Round Table.*

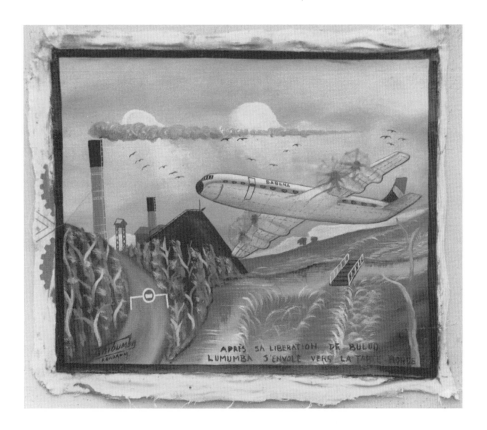

Then they all went to the Round Table. They traveled to Brussels to participate in the Round Table. But when they were at the Round Table they made one condition. "No," they said, "we cannot go along with holding Round Table talks without Lumumba. He was the one who gave us the idea to pursue independence." So the Belgians actually freed Lumumba. After he was set free, he flew to Brussels to attend the Round Table. The picture shows the plane on which he left Lubumbashi. Because he was imprisoned in Shaba.

T: Lumumba took off from Lubumbashi. I think you might know that road there; you may have walked it. It leads to a bridge over the Lubumbashi River. So Lumumba's plane takes to the air and he leaves. That is how I thought it up. . . . What I painted is what I imagined. I put lies and truth into that painting when I composed it.

Painting 45 Despite his popularity, Lumumba stood trial (defended by a French lawyer, Jean Auburtin) and was sentenced to six months hard labor on January 21, 1960. He was transferred to Katanga the following day. Three days later he was liberated and flown to Brussels by demand of the participants in the Round Table. There he applauded the decision, made on the day of his liberation, to grant independence on June 30 (Willame 1990, 53).

The Brussels Round Table

The Brussels Round Table of 1960.

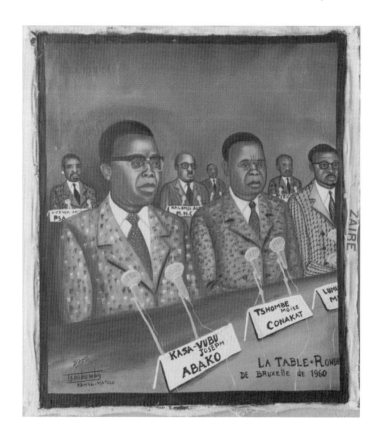

So Lumumba participated in the Round Table of 1960. There were many political parties, for instance, the PCA, the MNC-Lumumba, the Conaco, the Abako . . . some of them I can't even recall. Then, at the Round Table, Kalonji rejected Lumumba's party and set up a party for himself, calling it the MNC-Kalonji. Finally, the leaders returned to Zaire, that is to say, to the Congo.

F: So now we see the Round Table.

T: I think you can see Mr. Lumumba here, Kashamura, Moïse Tshombe, Albert Kalonji.

And here is Kasavubu, and Gizenga over there . . . all those who participated in that conference. There were microphones in front of them in the room where they met so they could make their speeches. . . . That was in 1960, but I don't know which month it was.

F: This was in 1960?

T: It was in 1960, the Brussels Round Table, but the month I don't know. And then, on June 30, they gave us independence.

Painting 46 The meeting took place in January–February 1960. G.-H. Dumont documents it in great detail and also reports on the insistence (of varying degrees) among the participants to have the imprisoned Lumumba in Brussels (1961, 30–32). Of the parties Tshibumba names, the Conaco is identified in the narrative and note to Painting 82; in that narrative the PCA is said to be part of the Conaco, but no further identification was found.

The Proclamation of Independence

Zero hour. Proclamation of Independence on June 30, 1960.

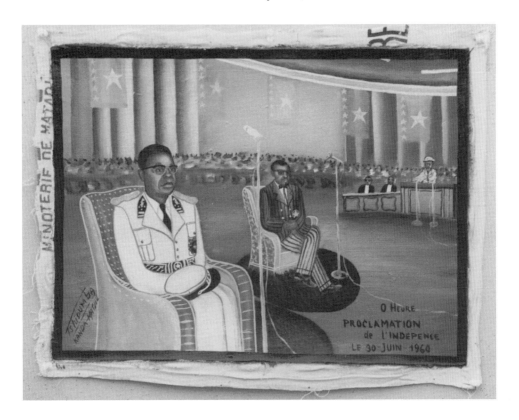

fter they had returned to the Congo, inde-
pendence was declared on June 30, at "zero
hour." That is to say, it was on June 29, as we
would count it in Swahili, where we'd say "on the
twenty-ninth at midnight." But in French they say
"at zero hour" because it is already the next day. In
other words, it was on June 30, '60.

ꜰ: What was the building where this happened?

ᴛ: It was in Kinshasa, but I don't know which
building it was. It is depicted on a bill of money;
perhaps it was the one where the monument of
Leopold II stood that I showed you earlier.

· · ·

ꜰ: Who read the proclamation of independence?

ᴛ: The king, Baudouin. He proclaimed indepen-
dence. Next to him are the magistrates, then
Lumumba and Kasavubu, and the people in the
background. Since you asked me earlier, I believe
they were assembled in the Palais de la Nation;
that is where they proclaimed this independence.

F: Is that the flag of the Congo?

T: That's the flag of the Congo. When independence was proclaimed, the Congo had six provinces: Katanga, the Kivu, Eastern Province, Equator, Léopoldville, and Kasai Province.

F: I see, so this star . . .

T: This one star . . .

F: But they put six stars.

T: This one star stands for unity; that's how it was.

F: Kasavubu is wearing a uniform.

T: Kasavubu's dress marks his rulership. Because he was the head of state, they gave him that uniform.

Paintings 47–48 A photograph of Lumumba and the Belgian prime minister signing the act of independence was published widely at the time (see reproductions in Geerts 1970, 71; and Willame 1990, following p. 256).

Lumumba Signs the Golden Book

Long live the 30th of June. Zaire independent.

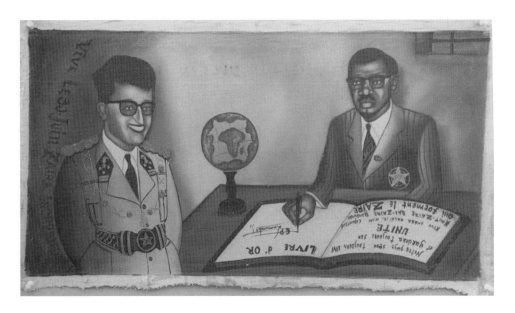

Then Lumumba put his signature to independence in the presence of Baudouin. After independence was signed he was made prime minister; Kasavubu was head of state.

T: So Lumumba was given a book to sign.

F: Was that at the same time when independence was proclaimed?

T: The same day. Because, as prime minister, Lumumba represented the government. So he agreed to sign the Golden Book, under the names of all the provinces. . . . But in this painting I wrote down their current names.

F: So those are the current names?

T: Yes, this is what the provinces are called now, because I wanted to sell this painting. Had I done it for this History I could have written down the names of the provinces as they were called then. As you can see, I wrote "which form Zaire" and not "which form the Congo."

Lumumba Makes His Famous Speech

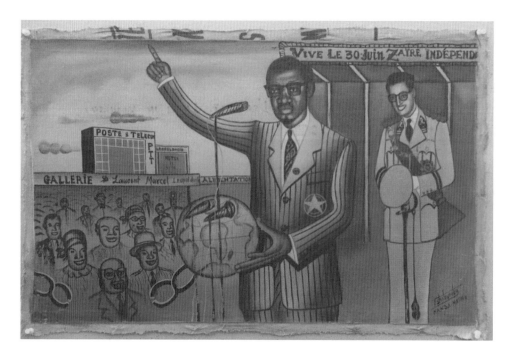

On the morning after, there was a crowd of people assembled in the square in front of the post office at Kinshasa. This is the sort of big open space where they organize demonstrations or celebrations. Lumumba was standing in front; Baudouin was behind him. On that day Lumumba brought up a lot of grievances in his speech. In fact, he cursed Baudouin. And he insulted him every which way because he had before his eyes the outrage of slavery as it is represented in that picture of flogging in a colonial prison that you have seen. He was enraged about the slavery we lived under, and he said a lot about it. As a result, Baudouin left the Congo; he departed immediately, full of anger.

T: That speech — some people say this is when Lumumba signed his death warrant. . . . When he insulted Baudouin in his speech, that is when he died. Others deny that and say that Lumumba's death was a matter of Shaba politics. There were many things about his death that we don't know. But I think it was Shaba politics.

F: How did he insult Baudouin?

T: Simply by what he said. For instance, what he had observed in Europe, that they were cheating us. "You are rich in Europe," he said, "but we are poor"; that's how he talked. But he said a lot and I don't really know that speech, I did not hear it at the time. And many people were there, women and men . . .

F: And Baudouin just listens.

T: Baudouin listens and smiles.

F: He had to smile.

T: That's what they say, I believe. A king has to smile even when it is difficult. He must put on a little smile.

Painting 49 Lumumba made the speech that caused the scandal during the proclamation ceremony, in the future house of parliament, before the king and numerous Belgian and international dignitaries. A photograph shows him speaking into a microphone, with Joseph Ileo (president of the Senate) and Julian Kasongo (president of the Chamber) sitting behind him at an elevated table; the king is not visible (Vanderstraeten 1985, pl. 10). A photo of Kasavubu giving his speech on the same occasion shows him standing in front of microphones with King Baudouin sitting on his left side (Geerts 1970, 70).

Here is a brief excerpt from Lumumba's speech: "We were insulted, we had to suffer beatings morning, noon, and night because we were niggers. Who is going to forget that a black person would be addressed *tu*, not, of course, because that is how one addresses a friend but rather because the respectful *vous* was reserved for whites? Our land was taken away from us on the basis of ostensible legal texts that recognized only the right of the strongest" (cited in Willame 1990, 110–11).

Painting 50

Whites Fleeing the Congo

"All Belgians must leave the Congo within twenty-four hours" (Lumumba).

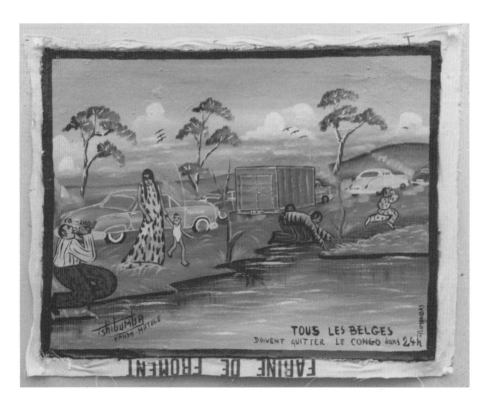

So Lumumba was now the prime minister. As prime minister in Kinshasa, in 1960, he issued an order: "All the Belgians living in Zaire—or rather the Congo—they must all leave. Within twenty-four hours, they should be on their way. I don't want to see whites anymore," he said. "I don't want to see any white person in the Congo."

T: At that time I think I was in Likasi and I actually saw this. What happened was, my father had gone to work. When he was supposed to be back, we began to wait for him but we did not see him. . . . He had gone away, he was on the road that leads to Zambia. His white employers had told him, "Let's go, you are going to drive us." So he left. The red truck I painted—it was a Ford—was the one he drove away in. On the road there was a lot of suffering—not enough water, not enough to eat. As you can see, some whites got out of their cars; one of them is holding a child by the hand, they are about to die there. One of them wants to wash a little, get some fresh air, just to get into Zambia. And this other one brought a

bottle to get a little water, and now he's drinking. That one with this garment they wear, what is it again? A something-or-other shirt — the one they sleep in?

F: A nightshirt . . . or pajamas?

T: Ah, pajamas, yes. He wants to wash himself, wearing pajamas. Other cars are rushing by like the wind.

. . .

T: It was four o'clock in the morning when we at home saw that the soldiers were leaving their garrison, barefoot. And there were their wives,

carrying their belongings. "What's going on?" The word was out: "The whites are exploding." "Exploding, exploding — where?" "They are just exploding, you've never seen anything like it . . ." Meanwhile we were waiting for Father, but there was no sign of him. When it got to be six o'clock we concluded that he had been killed. A few days later, one of his fellow workers told us that he had gone to Zambia with his white employers. . . . After the second week of fighting, we saw him return in good health, and he went back to work as usual.

Painting 50 What Tshibumba recalls must have happened during the Force Publique mutiny in July 1960. While officers and militiamen took precautions to disarm the Congolese soldiers who rebelled in places like Jadotville and in Camp Massart at Elisabethville (Willame 1990, 175–76), panic broke out among the whites: ten thousand fled to Northern Rhodesia between July 12 and 14 (Willame 1990, 175–76). Vanderstraeten dates the beginning of departures to Saturday, July 9, 1960. A mutiny among the local Force Publique soldiers started that same evening, amid rumors that "the whites are going to attack." Metropolitan forces — among them Tshibumba's "paras," who were stationed in Kamina — were called in to quell the revolt (Vanderstraeten 1985, 281–88).

Painting 51

Congolese Troops Fighting
Belgian Paracommandos

The Force Publique against the Belgian paras. Monument of the Pioneers at Jadotville in 1960. July 11, 1961.

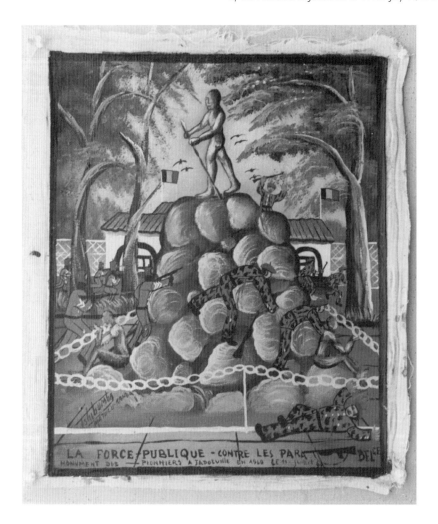

You see, that was the time when war broke out. The war started when people heard that the paras at Kamina, the Belgian paras stationed at Kamina air base, had taken off. It was around July 11, 1960, the date when the independence of Katanga was declared. The paras took off from Kamina and arrived here to go into battle. And they had a violent fight with the Force Publique, now the army of the newly independent Congo. In fact the Force Publique won that war, they were victorious—that is, all the Belgians ran away. Soon after that, politicians in Katanga conceived the plan to elect Moïse Tshombe as the head of Katanga. He was to be the head of Katanga.

F: What about the monument in the picture?

T: This was a monument that used to stand there. I was there and I saw it before it was torn down on January 17 in, I think, 1967. But around 1960, it represented the pioneers of colonization in the town of Likasi. It was like a souvenir of those times; that is why they built it. It was at this monument in Likasi that the Belgian paratroopers and the soldiers of the Force Publique fought each other, causing many casualties. It was before this pile of stones that white soldiers were killed. Then they all fled and the Force Publique remained victorious. We thought this was the end of the troubles, and the people stayed calm. The next morning, when I was in school, people were fleeing. . . . Then they said, "We summon you to the military camp." There they began to hand out weapons, everyone was given a gun and a uniform, and that was it. They said, "Now you are Katanga soldiers". . . . But eventually the Belgian paratroopers tricked the soldiers of the Force Publique. They first told them that everything was settled, then they made them prisoners.

Painting 51 The context of these events was the elimination of the former Force Publique, considered a foreign body in Katanga after its secession on July 13, 1960 (see Gérard-Libois 1966). Belgian troops had arrived on July 10, 1961, to control the local Force Publique involved in the mutiny. In Jadotville the paracommandos, with reinforcements from Elisabethville, tried to retake the town on the 12th but were met several times with gunfire from Force Publique troops loyal to the central government (those Tshibumba identifies as the new Congolese National Army). The paracommandos were forced to retreat. On the morning of the 13th (Independence day in Elisabethville), further reinforcements, including air support, came from Elisabethville, and Jadotville was retaken by the Belgians without further resistance (Vanderstraeten 1985, 392).

The Deportation of the Congolese Troops

The soldiers of the Force Publique were put onto railroad cars.

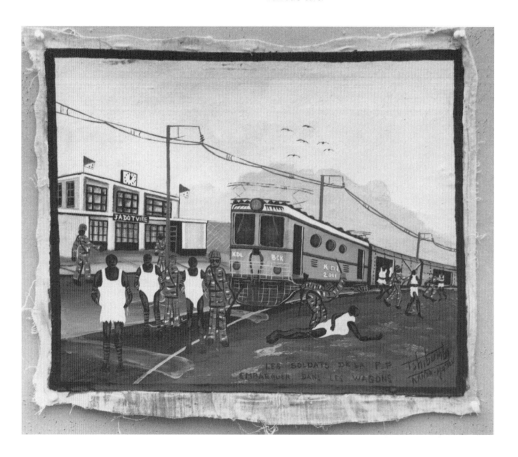

When Tshombe was the head of Katanga many people were called to join the military. They sweet-talked the Force Publique soldiers who had fought that war: "There is no problem, just stay. There is no problem and we have no evil plans. You are soldiers, just like our own soldiers." But one day the soldiers woke up to find themselves being tied up with ropes. . . . They were made to board a train—in this picture, at Likasi station. They were put into freight cars, with a little food. And they were beaten up. As you can see, one of them lies on the ground and is being beaten. The paras and the soldiers of Katanga—they were now called the Katanga Gendarmerie—grabbed them, made them board those freight cars, and locked them up. "Have a good trip home," they said. So they went home to their regions of the Congo. One came from Kisangani, another from the Kasai, another from Bukavu, others from regions downstream. They went away.

T: After the Belgian paratroopers had captured the soldiers of the Force Publique they went with them to the station. They beat them, tied them up with ropes, and cut them with knives. "Get into the cars," they were told, and then the cars were locked. "Go home," they said, "you've been discharged." Katanga was left behind, as you can see from its flags on top of the station building.

. . . I, who am telling this story, was then living in Likasi. I follow the events as I saw them in Likasi.

Painting 52 Disarming of the Force Publique troops proceeded, and by July 18, 1961, the first trains left Elisabethville, Jadotville, and Kolwezi carrying the dismissed soldiers and their families toward the Kivu or the Kasai. Only the Force Publique troops stationed near the Ndzilo hydroelectric power plant refused to surrender without orders from Léopoldville. Three Belgian companies and Harvard jet fighters attacked and, after much fighting, took the camp (Vanderstraeten 1985, 394).

Luba against Lulua

The Baluba against the Lulua.

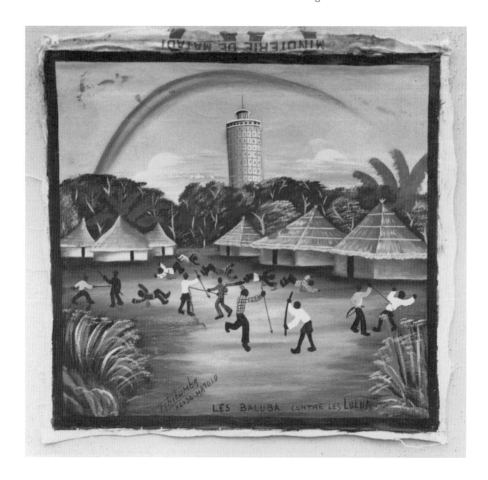

So there was trouble in Katanga. But we must say here that there were conflicts everywhere. While Lumumba was prime minister and Kasavubu head of state, there was quarreling everywhere. In the Kasai, the Luba and the Lulua were at war. "You Luba," the Lulua said, "get out, go home." It was terrible; they began to slaughter each other.

F: Now we see Luluabourg.

T: Kananga, at that time Luluabourg . . .

F: The picture shows Luba and Lulua killing each other.

T: Lulua and Luba. It happened when Kalonji declared himself chief. At that time *mwanza nkongolo* appeared — what do you call it? The rainbow. We call it *mwanza nkongolo.*

F: What does it mean?

T: *Mwanza nkongolo?* That it is about to rain . . .

F: Yes, but why did you put it in this picture?

T: Because in the Kasai region it rains a lot. So when they were about to fight each other, there was rain. Then the rainbow came and the rain disappeared. . . . Anyway, the Lulua told the Luba: "You, Baluba-Kasai, go back to your home country. We, the Lulua-Kasai, want to be alone in our country," and so they fought each other. The Lulua had their own chief, Kalamba, Kalamba Mwanankole. The Baluba had Kalonji. . . . What you see there in the picture is the Kananga water tower, and those houses belong to a small village outside Kananga.

Painting 53 To follow Tshibumba here and later, the reader needs to keep in mind that the term *Luba* (singular, *Muluba*; plural, *Baluba*—although in academic writing the stem is generally used alone) refers to a vast group of closely related languages and their speakers in the south central and southeastern regions of Zaire. A major division is made, regionally and linguistically, between Luba-Kasai (speakers of Tshiluba) and Luba-Katanga/Shaba (speakers of Kiluba). Within the Kasai, developments initiated by early colonization resulted in an opposition between Lulua (who had their territory around Luluabourg/Kananga) and Luba (who had migrated to that region in great numbers from the south). Lulua aggression took on organized form after the founding of an ethnic association, Lulua Frères, in 1952. Actual campaigns to stem the Luba flood began in 1954, intensifying after Lulua victories in the 1957 elections, and mass deportation of Luba was first proposed in 1959. Lulua-Luba conflicts flared up in most major urban centers of the Congo, claiming hundreds, perhaps thousands, of victims. Around the time of independence, the Lulua chose to be allied with MNC-Lumumba; the Luba constituted the rival branch, MNC-Kalonji (Geerts 1970, 165–66; Cornevin 1989, 373–74. On the history, see Mabika Kalanda 1959; on the colonial origin of many ethnic designations, see Turner 1993a).

The Luba Kingdom and the Building of Mbuji-Mayi

The Baluba kingdom. The building of Mbuji-Mayi.

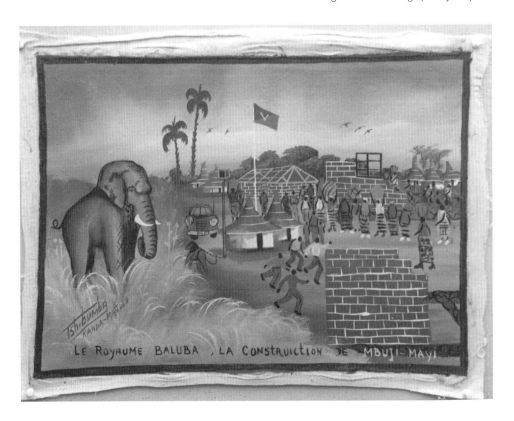

So the Luba people went to their home region. They went home and set out to build their own town. The place they had come to was just bush; there was only uncultivated land there, covered with trees. They began to cut down the trees; they built houses and founded their town, Mbuji-Mayi. Before they had arrived, the place was called Bakwanga.

[This picture returns later in the series, as Painting 76; the discussion of the painting appears at that point.]

Painting 54 By 1960 some 250,000 Luba had returned to their homeland between Bakwanga and Ngandajika (Geerts 1970, 166). An inside view of the spirit of Mbuji-Mayi as a "symbol of the rise of a new consciousness" may be found in Ngandu 1990. The autonomous state of South Kasai, as Kalonji's kingdom was later called, lasted till September 1962. See also the note to Painting 79.

Painting 55

Luba-Kasai against the National Army

Attack by the Baluba-Kasai against the Congolese National Army.

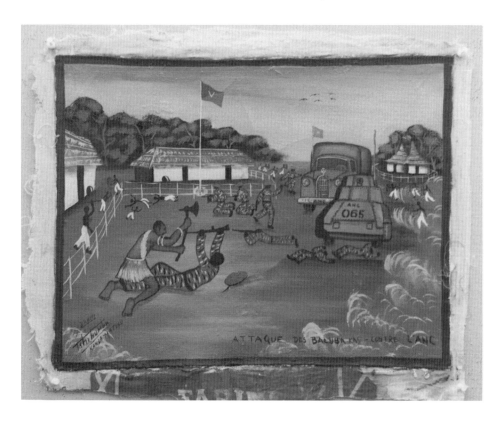

ow, at that time Kalonji ruled in Mbuji-Mayi. He was the chief. Tshombe was the ruler in Katanga. The two were linked in friendship. Because they were friends, Lumumba sent the soldiers of the national army against the Luba. "Go," he told them, "fight against the secession of Katanga; I don't like it. Take Katanga and return it to the Congo. There should be a united Congo." The troops got to the Kasai, not expecting any trouble, when they were suddenly attacked by the Kasaians. They were attacked, and this spelled death for lots of people, I think.

F: About the Luba attacking the national army — where was that? In Mbuji-Mayi?

T: It happened all over the Kasai, especially in the area that was then called South Kasai. What happened was that the Congo was divided up in regions. Like in the Kasai, there were the Lulua who had their territory; also the Kabinda, the Tetela, the Luba-Kasai — each had its territory. It was one big squabble.

· · ·

T: The fighting between the Luba-Kasai and the national army took place when Kalonji was already in power there.

F: And what does the V on the flag stand for?

T: Victory. The flag was red and green, with the victory sign. . . . That was because it was Kalonji's greeting. Whenever he met his people he made this little sign. . . . That's why they put that V on the flag. . . . So they fought the soldiers of the national army, who were passing through on their way to Katanga. But when they got to that place the Luba told them, "You are not coming through here; let's fight." That is what happened. . . . After the massacre, Kalonji stayed home in his place.

F: Is the scene in the picture in some specific place?

T: It could be Ngandajika; they fought there. Or Luputa; they fought there, too. And they also fought in Mbuji-Mayi itself. Many, many people died.

F: The houses I see there, is this in a village?

T: Yes, it's in a village.

F: And what are those little round openings?

T: That's for the chickens. Because back home we don't leave the doors open. So, as you can see, we make these passages that stay open, and that is where the chickens go in at night.

Painting 55 When last attempts to prevent the secession of Katanga failed, a military offensive, beginning August 22, 1960, was organized by the central government, then led by Lumumba. Coming from garrisons in the lower Congo, the troops had to pass through the Kasai in the area of Bakwanga/Mbuji-Mayi. This is how Willame describes what happened: "In the morning of August 28, the ANC [Congolese National Army] units were attacked by Luba civilians, armed with hunting rifles, machetes, and bicycle chains. They were recent refugees to South Kasai, after violent confrontations that had broken out between them and the Lulua. . . . They saw in the arrival of the ANC yet another episode of anti-Baluba repression. The fighting went on for several days and resulted in more than three hundred dead in massacres around Bakwanga, in particular in a Catholic mission, where women and children were killed" (1990, 192).

Katanga Independent

On July 11, 1961, Katanga becomes independent.

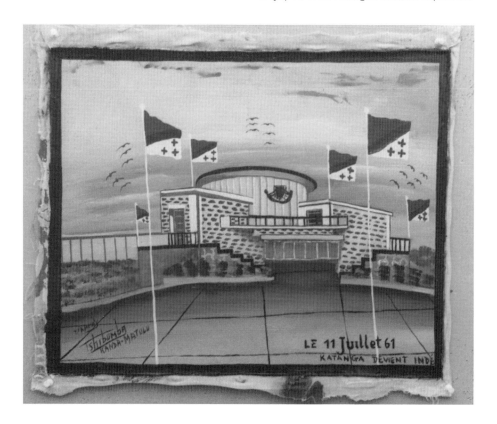

So it happened that on July 11 Katanga declared independence for its territory. I think you know this building in the picture. It is a building here in Lubumbashi. It used to be the Cinquantenaire; now it is called the Building of June 30. It was there that the Katanga assembly met. From among its members, the Katanga government was formed. Munongo was prime minister. No, he was minister of the interior, and this man Mutaka wa Dilomba was president of the assembly.

T: This building was then called the Cinquantenaire, because it was put up for the fiftieth anniversary of the town. This was where the Katanga chamber of representatives met. Let's just say it was the parliament. It was in that house that Tshombe assumed power . . . and therefore he put it on a bill of Katanga money. The date on the picture marks the proclamation of Katanga independence.

Painting 56 During the upheavals following the proclamation of Congolese independence, the Belgian government stayed in close contact with authorities in Katanga through its "diplomats" and its unconditional offer of technical assistance. It supported the secession de facto, although it never accepted it de jure (Willame 1990, 181–82).

Fighting at a Railway Overpass

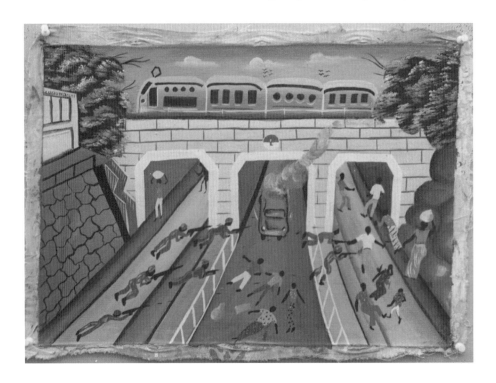

Once the independence of Katanga was de-
clared, there was war between the various
ethnic groups in Shaba, and they began to kill each
other. Those from Katanga began to kill members
of ethnic groups from downstream: Kasaians, Luba,
Tshokwe, and other groups. This happened while
there were political parties, each with its own
leader.

T: Indeed, those people ran away. To illustrate
this general exodus I have here a picture by Mr.
Kabuika. It shows the railway overpass; below is
the route they took.

. . .

T: As soon as Katanga became independent, on
July 11, they began searching houses. Depending
on where you came from, they might shoot you,
and you'd die. So, because the situation had
become so difficult, people fled and went to live
in Foire Camp.

F: Why was it called "Foire"?

T: I think because it was the place where at
one time they had held the *foire* of Katanga,
the Katanga Trade Fair. There had been lots of
events, spectacles, and celebrations. So when the
people fled there they said, "Now we are going
to have our own fair." "The Fair of the Baluba,"
that's what they called the refugee camp. It was
at a place called "Ocean" . . . way out, past the
Bel Air section of the town of Lubumbashi. The
graves are still there today.

Painting 57 This incident must have occurred during the cleanup operation undertaken by UN troops against the
Katangese toward the end of 1962 (see note to Painting 58 below).

The United Nations Is Called In

Appeal to the United Nations.

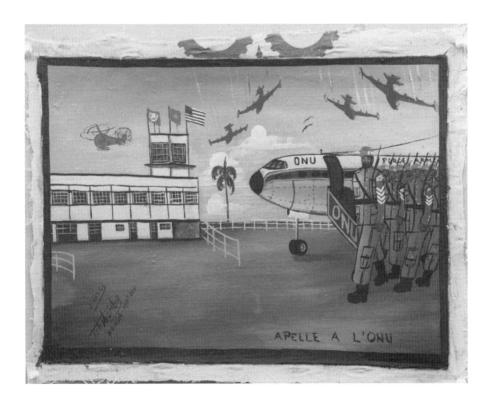

Then there is one picture called "Appeal to the UN." They called the UN in because of the many conflicts that had erupted in the Congo.

F: Who made the appeal to the United Nations?

T: Lumumba did. And then the United Nations troops came and arrived at Kinshasa, at Ndjili airport. . . . And there is the American flag, beside the flags of the UN and the Congo, because the Congolese were supported by the Americans. . . . There was a celebration that day, that's why there were three flags. . . . The planes there are Canberra fighters.

F: And those red-skinned United Nations soldiers?

T: Red-skinned, you're right. It's just a color I chose. But it is correct in the sense that they were not of our color.

F: Who were they? What nationality?

T: There were Indians, Ghanaians, Ethiopians — there were many nations.

Painting 58 Although the first United Nations troops arrived in Léopoldville in July 1960 (see the Associated Press photo of a Ghanaian contingent coming off an Ilyushin plane, in Willame 1990, following p. 256; also Vanderstraeten 1985, plate 36, which shows that both Russian and American planes brought the Ghanaians), this painting probably depicts the deployment of UN troops to fight the Katanga secession. The operation, called Rumpunch, was initiated on August 28, 1961, by Conor Cruise O'Brien, Dag Hammarskjöld's envoy. All strategic points in Elisabethville were occupied. Several actions followed until, toward the end of 1962, it was decided to finish with the Katanga army. (The cleanup action began on December 28.) With Joseph Ileo's arrival as minister resident of Katanga on January 23, 1963, the Katanga secession was over (Geerts 1970, 151, 161).

The Refugee Camp

In Lubumbashi, from 1961 to 1963, refugee camp. The Baluba, Tshokwe, Kasaians, and many other groups.

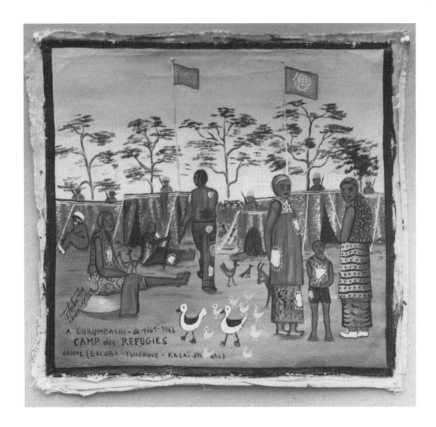

There was a lot of war in the Congo, and when they saw there was no way out, all the people fled to the place were the United Nations troops were stationed. There they built the camp called "Foire." People stayed there, suffering and dying. People died of starvation and many other causes.

т: As you can see here in my picture of Foire Camp, there were ducks, goats, and chickens that people had taken along when they fled. What I painted here are the dwellings, made of empty sacks, flour sacks or something like that, which they would put together. And then, on the ground there, they dug holes and got into them. Among those refugees, all or most were in favor of national unity. They were for a united Congo, and the UN flag was also flying there. Among them were old people, women, and little children, and every day there was dying.

Painting 59 The camp was set up by the United Nations as a refuge for the Luba-Kasai, who were under attack by the Katangese for their loyalty to the central government and cooperation with UN troops. In a short time, some 75,000 refugees were assembled. The camp became a place of violent conflict and terror; neither Katanga gendarmes nor UN soldiers dared to enter (Geerts 1970, 152; photographs in Delière 1973). Whether in reality it was a concentration camp never became clear in public debates at the time (see *Forty-six Angry Men* [1962?], and especially *Camp des Baluba* [1962?]; for a Katanga version of a UN report on the Luba camp, see Katanga, n.d., *Livre blanc . . . sur les événements*).

The Secession in North Katanga

North Katanga during the secession.

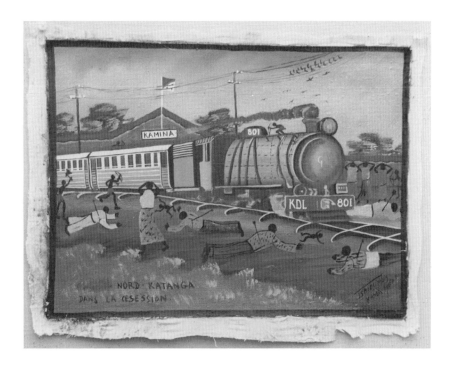

Among the people in the camp were those from downstream, Kasaians and other ethnic groups who were dying in that place. "No," they finally said, "we cannot bear suffering like this; let us escape and go home to our country." What happened was they got as far as Kamina, and there they came up against Kasongo Nyembo, the local ruler. . . . He sent out his people. Among them were Katanga soldiers, because he was siding with Katanga. He also sent his warriors and set out to kill those refugees, even the children, but not the women. Only those who could not walk well had to die. You see the women lamenting, their hands joined on their heads, lamenting their husbands who were dying.

T: The picture shows Kamina station; if you've seen it before, I think you will agree that this is an accurate representation, because I lived there for a long time. At that time they had this steam engine, model 801; electrification had not yet gotten that far.

• • •

T: I forget the name of the man who was Kasongo Nyembo — paramount chief of the Luba-Katanga — at the time. He died recently; he was killed here in Lubumbashi in his house.

F: Just now?

T: Yes, very recently, in 1972 . . .

Paintings 60–61 On Chief Kasongo Nyembo, born Emmanuel Ndaie, as a partisan of independent Katanga, see Young 1965, 193. The Fouga Magister jets that had made up the air force of the national army were captured by the Katangese the day after the declaration of Katanga independence on July 11, 1960 (Willame 1990, 98). On December 31, 1961, Kongolo, a town in northern Shaba that had sided with Katanga, was retaken by the ANC. On July 11, 1962, North Katanga was proclaimed a province of the Congo.

Fighters Strafing a Village

Fouga Magister jets ravage North Katanga.

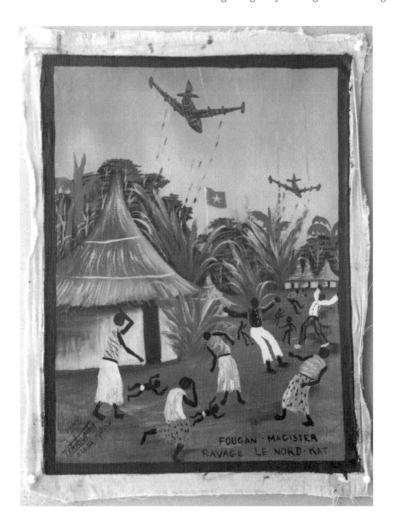

What I am going to describe to you now is another example of how Katanga was involved in killing people. It is history. The Katanga government bought airplanes. Those airplanes were Fouga Magisters, French training jets. . . . What happened is this: People would be in a village when these planes would come and drop bombs. The villagers had no guns, nothing to go to war with; they were just there. The fighter planes would just destroy the houses the people had begun to build, and lots of people died.

T: The attacks by Fouga Magister fighters happened in the region of Malemba Nkulu and Kabongo, up north. They were directed against those Baluba-Katanga who rejected Tshombe's politics. "We are for unity," they said, "we are for Lumumba." That is when they sent the Fouga Magisters to kill them. In the picture you see many people dying, writhing on the ground.

Katanga Troops on a Train at Luena

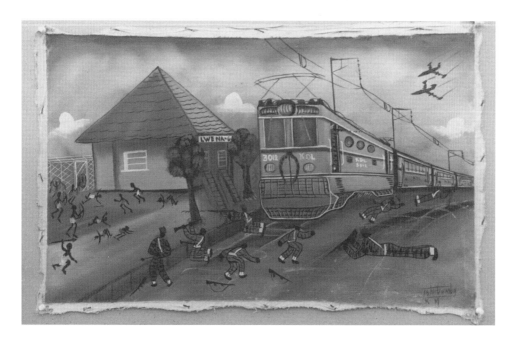

And then the soldiers of Katanga began to march and invade that part of the country in order to take North Katanga. They got there and there was a long war; people died at Luena. Whenever people appeared here and there, the Katangese would just kill them. Fighter planes made sorties to drop bombs.

т: The scene is at Luena station, where Katanga soldiers are getting off the train. They are headed for the border, where they will meet the Luba who, in order to prevent them from entering their country, have cut the rails. So they start killing each other in that place. The Katangese are shooting, and they have support from planes.

Painting 62 Disarming of the Force Publique troops stationed in Katanga (and presumably loyal to the new ANC) took place starting July 23, 1960; they were sent home on indefinite leave (Willame 1990, 336).

Painting 63 [see color plate]

The Katanga Women Protest

Demonstration by the Katanga women.

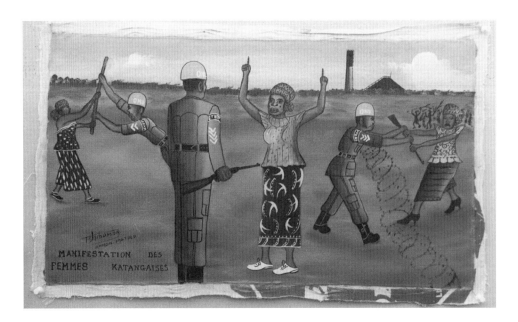

Here you see the women of Katanga, how they took to the streets one day. "Let's go to where the UN troops are stationed," they said, "near the refugee camp, and stage a demonstration." This was a long story. What happened? One day, they set out to annoy the UN soldiers. The UN soldiers didn't say a thing. When the women got there, they threw rocks at the UN soldiers, beat them with sticks, and pushed them around. Now, their commander was called, I think, something like *matou*, tomcat. At any rate, he gave orders to stop the women. That day many, many people were killed. Some of them were deposited in the morgue. For instance, among the young people there was one by the name of Kapenda. She also died in this fighting, because she had called for a demonstration.

T: The women beat the UN soldiers with — what do you call them? — those sticks you use to pound grain; in Tshiluba we call them *mwishi* . . . Anyway, the UN soldiers got angry and started to shoot, and they killed many. So these were the events in this part of the series. Perhaps you regret that not much more is left. But I believe there is still a lot to come.

F: [*chuckles*]

T: Because that's history.

Painting 63　On July 17, 1962, "thousands of Katangese women participated in a protest march organized by the [Katangese] authorities. They broke through a roadblock set up by Indian UN soldiers, flooding from all sides the military, who did not dare to fire on the women. Twenty-one UN soldiers were wounded in this confrontation, and one Katangese woman was said to have been killed" (Kestergat 1986, 130. See also the United Press International photo of women attacking a UN soldier, p. 126; and in Geerts 1970, 154, a similar photo from the Luba camp, which might have served as a model for this painting).

Paintings 64a and b [see color plates]

The Kasavubu-Lumumba Conflict

The Kasavubu-Lumumba conflict.

They had Kasavubu as president. Because he was president, there was conflict among the leaders. That's how it is with the leaders, and they have their secrets that we cannot know. I think the event depicted here took place in what is now called the May 20th Stadium; it used to be Baudouin I Stadium. Lumumba and Kasavubu went there, and Kasavubu was going to speak before the people. In this gathering, Kasavubu publicly showed his resentment against Lumumba. He said that, from this day on, Lumumba was no longer going to be prime minister. After this was said, Lumumba left the stadium in anger and went on the radio. He, too, said what he had to say. I think if you listen to Radio Kinshasa, every June 30, Lumumba's speech is rebroadcast; he maintained, in essence, that Kasavubu was a straw man. Whatever went wrong between the two, Lumumba spoke out. I think it was immediately afterward that an order for his arrest was issued.

F: So what we see here is Kasavubu, wearing a uniform.

T: That was his official dress; he was the president of the Republic . . . he had to wear this.

F: And Lumumba?

T: Lumumba, being prime minister, could wear a suit. And there are the people. The political parties we had at that time are also shown.

F: I see, the Abako . . .

T: The Abako, the CRA.

F: What does CRA mean?

T: I don't really know. And there were the MNC and the PNP.

F: And what does PNP mean?

T: Sorry, I don't know the meaning.

F: And ATCAR?

T: Oh, that was the Association of the Tshokwe, but the rest I don't know . . .

F: So there was conflict between Kasavubu and Lumumba. Did they fight it out in front of the people?

T: They did not really fight, it was just that Kasavubu declared before the people that, as of that day, Lumumba was dismissed as prime minister. The people couldn't believe it. And Lumumba put up resistance. He went on the radio and declared that Kasavubu was no longer head of state. But according to the constitution, the prime minister had no power whatsoever to make such an announcement. So they sided with the head of state . . .

F: Now we have another version of this painting here.

T: It's just the same. Although there are some differences, it has the same subject: the conflict.

F: I see that Lumumba is wearing a different suit.

T: That's because it's not in color, whereas the other painting was.

F: Why is that? Did you run out of colors?

T: No, no, I could have done it in color. I just wanted to work out a different idea.

Paintings 64a–b

Party acronyms:

ABAKO	Alliance des Bakongo
ATCAR	Association des Tshokwe du Congo, de l'Angola et de la Rhodésie
Cartel	Cartel du Katanga
CRA (= CREA)	Centre de Regroupement Africain?
FEDEKA	Fédération du Katanga? (There was also a FEDECO, Féderation Générale du Congo)
MNC	Mouvement National Congolais (with two wings: MNC-Lumumba and MNC-Kalonji)
PNP (= PNCP)	Parti National Congolais du Pool
PSA	Parti Solidaire Africain (with two wings: a federalist wing, under Cléophas Kamitatu; and a unitarist wing, under Antoine Gizenga, in conjunction with Pierre Mulele)

For a complete list, see Centre de recherches et d'information socio-politiques 1964.

Painting 65

Lumumba Is Arrested at Lodja

The arrest at Lodja.

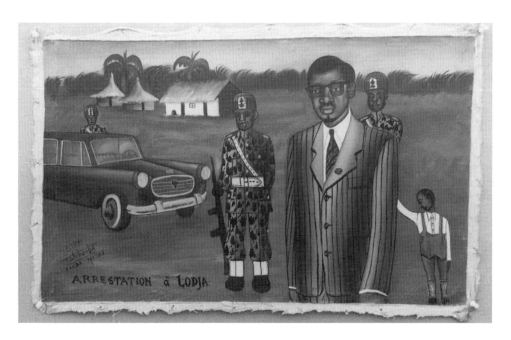

ARRESTATION à LODJA

Lumumba, who was at home at the time, left the same day and fled in a black Peugeot 403. He fled from Kinshasa to the Kasai, to Lodja, where he was arrested on the day of his arrival and locked up. When they picked him up he had his child with him, so he was arrested together with his child, and I think there were others involved. I know there was Nendaka, Nendaka Victor—that was his former name. And there were other persons who tied Lumumba up and brought him back to Kinshasa.

T: You can ask me about the things you see in this painting. Just keep asking.

F: So Lumumba has his Peugeot 403.

T: The Peugeot 403 is an old model . . .

F: It seems that Lumumba was arrested near the town.

T: No, it was in the town.

F: And who were the soldiers?

T: They belonged to the Congolese National Army.

F: But who actually made the arrest?

T: I think—and here I follow what is now being talked about—it was Colonel Tshatshi. He was sent to arrest Lumumba there. It was like a mission, and he could not refuse to go. You cannot refuse, you just take off and go there.

F: What kind of "mission" was this?

T: He had orders. If you are a military man and they give you an order to arrest a relative, even your own father, you'll do it.

Painting 65 One of the most widely circulated, detailed, and reliable accounts of the final episodes of Lumumba's life is Heinz and Donnay 1969. After he was dismissed from office, Lumumba fled Léopoldville in a blue Peugeot owned by Kamitatu and driven by Mungul Diaka. The convoy of three cars, joined by other refugees, among them Pierre Mulele, got to Port Francqui on December 1, 1960, where a first attempt was made to arrest Lumumba. The convoy continued until it reached the Sankuru River near Lodi (not Lodja). According to one version of the events that followed, Lumumba, after having crossed the river, went back for his wife and child. He was then arrested and brought to Mweka. From there he was transferred (suffering beatings and humiliations that were documented on film) via Léopoldville to the garrison at Thysville, then commanded by Boboso, a supposed relative of Mobutu's (see Vanderstraeten 1985, 442–59; and Heinz and Donnay 1969, 3–47).

Lumumba Is Brought before the People

*Lumumba before the people in the stadium formerly
called "Baudouin I" in Léopoldville.*

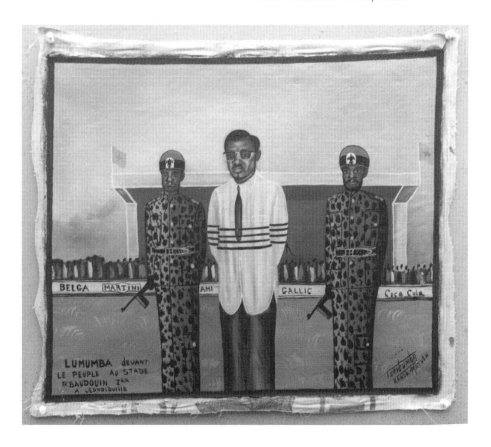

Now to another painting, which shows
Lumumba before the people in the Baudouin I
Stadium at Léopoldville. There was a big crowd
and what happened there—those are things that
concern only the big shots . . . But whatever is
history I shall take upon myself to pursue for the
sake of history. At any rate, they displayed Lumumba
in front of all the people and said: "This is a bad
man, we are going to lock him up and send him to
Bulambemba." Bulambemba, I think you know, is a
prison in the Zaire River. The water flows by and
the prison is in the middle.

т: So after arresting him at Lodja they brought
Lumumba to Kinshasa. But as I told you before,
what happened there is one of those things that
concern the big shots.

ᴇ: Mm-hmm.

т: Fact is, Lumumba was tied with a rope. They
had taken off his jacket, and his shirt was hanging
out of his pants.

ᴇ: Why was that?

т: Why did they pull his shirt out? It was just
one of those things. At any rate, the two soldiers
standing next to him with guns in their hands

belong to the *justice militaire*, whereas those in the preceding picture were from the military police.

F: So Lumumba is being presented to the people.

T: It happened before the people. As I told you, what happened there is the big shots' affair. But I explained that already. Lots of things happened there, because many big shots were there in the stadium.

Painting 66 The sources consulted yield no trace of a public display of Lumumba as prisoner in a stadium. The island of Bulambemba was one of several Force Publique camps near the mouth of the Congo guarding the naval base near Banana (Vanderstraeten 1985, 215–17, with map on 216; neither he nor Willame mentions that there were plans to bring Lumumba there).

Paintings 67a and b

African Calvary

Africa's Calvary.

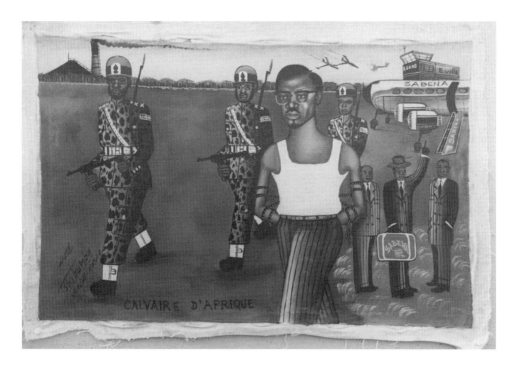

Having announced that they were going to send Lumumba to Bulambemba prison, they made him get on an airplane. As it turned out, the plane could not follow the route to Bulambemba or Kisangani, where they could have locked him up. Rather, it took the route to Katanga. On arriving in Katanga, Lumumba suffered a beating right at the airport. They beat him, tied him with a rope, and made him suffer. That is how he arrived in Shaba, as shown in the painting titled "Africa's Calvary". . . . They tied him up with a rope and brought him to Lubumbashi, to Luano airport. As you can see, it was a Sabena plane that brought him. They made him get off the plane, and Katanga gendarmes took him prisoner and escorted him off, slowly.

F: Here again we have two versions.

T: One in color, the other not. It's like the photographs your wife took of me. She said she would photograph me in color as well as in black and white. And that's how I did it, in color and in black and white. But they are the same. If you have questions, I'll answer them.

F: So we see Luano airport.

T: This is the control tower, and there is the Sabena plane. Lumumba is tied up with this rope, and those are agents of the Sûreté . . . The soldiers are Katanga gendarmes; you can tell from the copper crosses on their epaulets, instead of stars . . .

F: One of those agents looks like Tshombe.

T: No. When they brought Lumumba, Tshombe was not here in Lubumbashi; he was traveling. The ones who were there were Kibwe and Munongo.

119 *Central Government and the Struggles for Power*

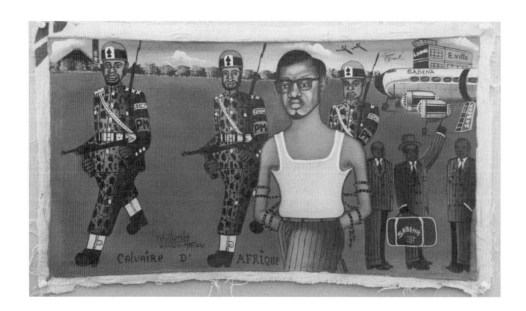

Paintings 67a–b After Lumumba was arrested at Lodi, he was held in the garrison of Camp Hardy in Thysville. A few days later he was brought to Léopoldville. There was some confusion as to what should be done with the prisoner. Plans were conceived to deliver him to his enemies, either in the Kasai or in Katanga (Heinz and Donnay 1969, 57–67). Around January 15, 1961, after deliberations in which Victor Nendaka played a prominent role, it was decided to take him to the Kasai. An intricate scheme involving three planes (known to, and approved by, the Belgians) was changed at the last moment. Lumumba, Maurice Mpolo, and Joseph Okito were flown via Angola to Elisabethville (Vanderstraeten 1985, 461). Waiting at the airport were the Katanga ministers Godefroid Munongo, Jean-Baptiste Kibwe, and Lucas Samalenge, as well as Pius Sapwe, head of police in Elisabethville (Geerts 1970, 107; Heinz and Donnay 1969 has the most detailed account of Lumumba's transfer to Elisabethville, 69–120).

The Deaths of Lumumba, Mpolo, and Okito

On January 17, 1961, Bob Denard killed Lumumba, Mpolo, Okito.

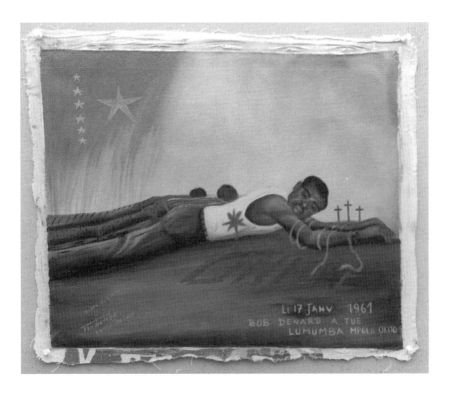

They went with Lumumba to a certain house near Luano airport. That house belonged to a Belgian settler who had by then sold it to the government of Katanga. That is where they went with him, and what happened there—let's just say it is something that concerns the big shots. At any rate, Lumumba was brutally beaten, and he was not alone. Two persons were with him; their names were Mpolo and Okito. So they beat him up, and we heard that they killed Lumumba, together with Mpolo and Okito. However, even though they say they killed him, there is not a single person who knows for certain that Lumumba died, that he really died. Even now, it's a matter of dispute among the people. Some say he died, others say they hid him —we just don't know. We don't know. There is not a single person who spoke the full truth. But

the fact is, he died. That is what the picture shows you: "On January 17, 1961, Bob Denard killed Lumumba, Mpolo, and Okito."

. . . About Bob Denard—beyond this picture, I could explain more, because I read a book by a French author who followed the life of Lumumba and the way Lumumba died. He said, for instance, that they went with him to that house there, and he told how they beat him at the house and how there was a white lady present. She was from the Red Cross. I forgot her name, although at the time I was a member of the Red Cross in Likasi, and she was our president. I knew this lady well. So they said that she too was there when they killed Lumumba. Actually, it said this in a newspaper report that came out when I was in Kambove. . . .

That paper, the *Essor du Katanga,* appeared in 1965 or '66. It said that Tshombe and Munongo killed Lumumba. He was killed on the road; Bob Denard stabbed him with a blade that was something like nine millimeters wide; that's how he killed him. . . . So he died, but we don't know where his body lies. There are suspicions. Some say they threw it into sulfuric acid, or what do you call it? If you put a human body or whatever in it, this acid leaves only a liquid and some solid residue, and that's it. That is what some people said. In any event, you see that I painted three crosses back there. I am saying—I, speaking for myself, as the artist Tshibumba—that in my view, Lumumba was the Lord Jesus of Zaire. Above I painted six stars, because he died for unity. And I think you see the blood that is flowing from his side, how it spreads and writes something on the ground: Unity. What this means is that Lumumba died for the unity of Zaire. He was against dividing people into different tribes. What he wanted was that a person should remain a person, an idea also held by the leader today.

F: Who was this Bob Denard?

T: He was a Katanga mercenary, he worked for Katanga.

F: And Okito and Mpolo?

T: Mpolo was a member of the Congolese National Army, but I don't know what his rank was. The same goes for Okito.

F: Where is this scene? I don't recognize it; is it out in the bush?

T: The actual place? In my thoughts it was inside a house. But then I did it this way in order to make the death more visible. Were I to present the scene inside, the colors would not come out and it would not be as impressive. . . . And the three crosses you see there, that is my idea. Because when I followed his history, I saw that Lumumba was like the Lord Jesus. He died the same way Jesus did: between two others. And he was tied up the way Jesus was. It was just the same.

Painting 68 Lumumba met his companions when he was brought to Thysville, where they were already imprisoned. Joseph Okito was president of the Senate; Maurice Mpolo, minister of sports. For a richly documented but inconclusive reconstruction of Lumumba's death, see Heinz and Donnay 1969, 129–51. On the disposal of the bodies, they cite one witness (a European officer of the Katanga army) who reported, "The mining company simply supplied us with the sulfuric acid we asked for. The corpses were entirely dissolved. There was nothing left of them" (150). The presence of a representative of the Red Cross is not mentioned in either Heinz and Donnay 1969 or Geerts 1970 (the latter gives an "exclusive" version of the events, taken up by Willame 1990). Nor do any of the sources connect Bob Denard with the murder, although some European mercenaries seem to have been present. Denard entered the Congolese scene in 1964 as one of several mercenary commanders charged with fighting the rebellions. According to Geerts, he was a French intelligence agent and an enemy of Jean Schramme, the most prominent among the Belgian leaders of mercenary troops (1970, 213).

The Deaths of the Innocent Children

The Katanga secession. The death of the innocents.

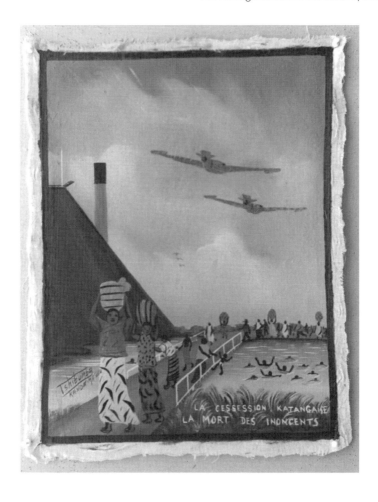

Following Lumumba's death there was a time of much fighting in Zaire, as we can see in this picture showing an event that happened here in Katanga. In Kinshasa, after Lumumba died he was replaced by Cyril Adoula; no, it was Joseph Ileo. So Joseph Ileo replaced him—that's another picture I could bring you—anyway, Lumumba was replaced, and I think war broke out in Shaba. A ferocious, senseless war was fought. Then Joseph Ileo was removed and Cyril Adoula put in his place. After Cyril Adoula had come to power, the war continued even more ferociously. I think it was under Cyril

Adoula's regime that the UN had arrived. You have a picture inscribed "Appeal to the UN." So the UN was already in the Congo. What happened is this: The United Nations troops went to war against Katanga. It was at that time that an event took place which I call "The Katanga Secession. The Death of the Innocents." This is what "The Death of the Innocents" means: When this war was fought, mothers began to leave Kenia township—now it is called Kenia Zone—and they got to the Lubumbashi, the

river Lubumbashi. Here at the Lubumbashi they began to throw their children into the river. What happened was that if a woman found that her child was getting too heavy and wouldn't stop whining, she told herself, "It's going to give me away." So she just took it and threw it into the water there. What you see in the picture is how those children died, and I inscribed it "Death of the Innocents" because they did not know what all this was about, they just died.

F: . . . So we see the smokestack and the slag heap and a bridge. And women . . .

T: Who are carrying baskets on their heads.

F: And they are fleeing.

T: They are fleeing the war.

F: Where are they going?

T: Some are going to the village of Chief Kanyakaa; others take to the bush. There was suffering of every kind imaginable . . .

F: So they killed their own children?

T: A woman would kill the very child she had given birth to. She would untie it from the wrap she was carrying it in and throw it into the water.

F: Did you see this with your own eyes?

T: This was something that really happened. Some people saw it, and others took photographs . . .

F: Is that so?

T: Yes.

F: Where did it happen?

T: Well, I did not actually see it. But photographs were taken . . .

F: And what about the title of the picture, "Death of the Innocents"?

T: It means that it was the death of angels, a human being who does not understand what is happening and meets a senseless death.

F: When they were talking about this event, did people call it "Death of the Innocents," or what did they say?

T: No, it was me, I thought it up.

F: OK, fine, but are people still talking about this affair?

T: They talk about it all the time. They talk about it all the time. Some express their amazement, others say it was something terrible to have happened. . . . The day I painted this picture there were some women at my house there, and they said, "I could never do a thing like that." "You would do it," I said, "when death comes near, you are just going to do it." Yes, that's how it is.

Paintings 69–71 The event depicted in Painting 70 probably refers to Katanga attacks on ethnic groups loyal to Lumumba and the central government and could have taken place as early as July 1960. So far I have found no trace of either the "Death of the Innocents" or the "Monster" in published sources, including several memoirs of mercenaries and United Nations military men that I have been able to consult.

Katanga Soldiers Shooting People in Jadotville

In Jadotville, the Balubakat against the Katangese.

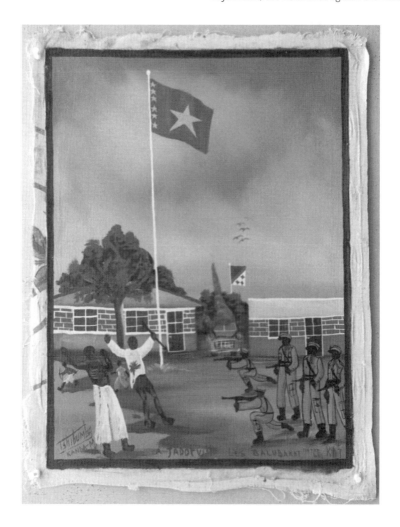

At that time there were many ethnic organizations in Katanga. One of them, in North Katanga, was called the Balubakat. The members of the Balubakat did not get along with the government of Katanga; they were absolutely opposed to it. I think they were the ones who then raised the flag with the six stars in Likasi. They said, "We follow only Lumumba's line. He may be dead, but we want what he stood for." On that day the Katanga gendarmes and the Katanga police went out to kill many, many people. A certain Miketo Pierre, who was a police inspector in Likasi, was also involved. He directed the policemen and the gendarmes in that massacre.

T: This picture shows supporters of the Balu-bakat, actually Baluba-Katanga, who were living at Jadotville.

F: What was the year?

T: It was in 1962, because in 1963 the Katanga secession was over.

F: That's right. And those people are flying the flag of the united Congo because they want to show . . .

T: . . . we are against the secession; we don't like the Katanga flag. The Katanga flag was in the center of town.

F: Those uniforms with the red scarves belonged to the Katangese, right?

T: They were Katangese, and it was the uniform of the police.

F: And what about that vehicle that's burning over there?

T: That was *tembo*, the elephant. Because it was big and had this nozzle up there we used to call it *tembo* whenever it came by. It went back to the time of the Belgians, to colonial times. The Belgians had left it behind. It used to be driven around on June 30, Independence Day.

Painting 71

The Monster of the Secession

The monster of the Katanga secession.

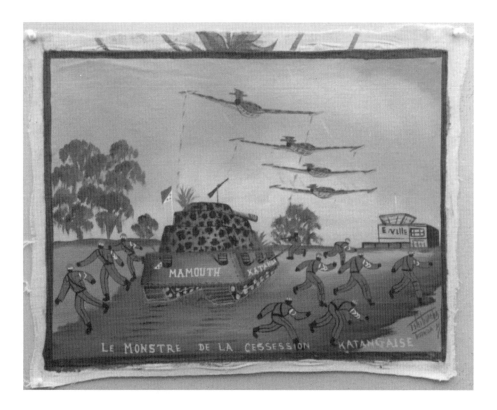

The war just went on. In the second part of the war, Katanga came up with something that was amazing. This thing was built in the Comekat factory at Likasi, actually in the ore-crushing shop. There they built a big iron vehicle. The armor was made of iron plates with sand in between. You could shoot a bullet at it, or whatever, and it could not penetrate. This iron vehicle they called "Mammoth." A mammoth is an elephant from way back in prehistoric times. At any rate, it actually moved, and as it moved around, attempts were made to destroy it, but they did not succeed. Even when a fighter plane dropped a bomb on it to destroy it, the thing just kept moving around. I think you see that over there, facing the Mammoth, I put a UN soldier who is down on one knee. That UN soldier, I believe, was the one who saved the entire UN contingent. He aimed his gun inside that iron vehicle, through a hole, and a bullet entered and exploded. All those who were inside died on the spot. After that, I think, Katanga could go on no longer. There had been a lot of fighting, but then the second Katanga war came to an end.

F: Did you see the Mammoth with your own eyes?

T: I used to go to the place where they were building it and watch. My father worked in Likasi. There was not much fighting in Likasi, so we had a gang and would roam the town. We did not know about pro- and anti-secessionists; we were just friends, small children, although not really that small, because we were already in the fourth grade.

F: So the Mammoth eventually got to Lubumbashi.

T: It did, and there they fired at it, and there was an Indian who got the Mammoth, as I told you. In those days the Luba people had a song about Indians from India who came by Sabena and helped defeat the Katangese . . . Because the UN soldiers had been running away from the Mammoth; only this Indian soldier had the courage to say, "If I die, I die." Then he put his rifle right into the nozzle of the cannon; he fired and there was an explosion, it blew up the bombs, or whatever was inside.

Painting 72

The Massacre of the Luba at Kipushi

The Baluba in the historic massacre at Kipushi.

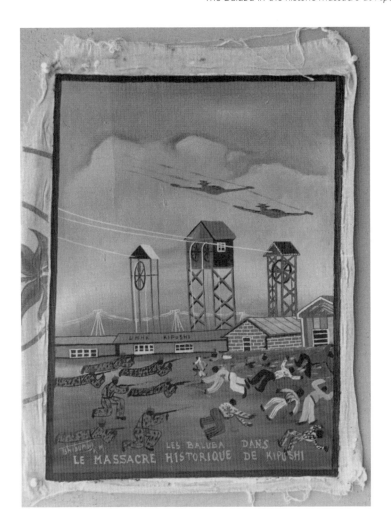

At that time Munongo was minister of the interior, Tshombe president of Katanga. Something happened in Kipushi that sounds like a made-up story, but it belongs to history as we tell it. One day, I believe it was in the afternoon, there was a quarrel between a woman and a man, wife and husband. They quarreled at the entrance to the market. That fight developed into a brawl, and it was said that the Kasaians went on a rampage. They followed them all over Kipushi, and lots of people,

many, many were killed. Ah, many, many. This massacre was something I don't think I can explain. Let's just say it was a slaughter of people. So I put it into this History because it was an important event. They even killed small children, helpless babies, just for the sake of killing. And then Munongo arrived and called the people together at the territorial administration building of Kipushi. Many people went there and became victims of a massacre.

F: Did this happen on the grounds of the mine, or outside of it?

T: It was in the settlement. They would come and take you with your whole family from your house.

F: So this was not in the mine.

T: No, I represent the mine so you can see that it happened in Kipushi, which is a mining town. . . . Those tall structures we call pits. Nowadays, when we want to draw Kipushi or tell of something that happened in Kipushi, we do Pit Number 5 . . .

F: So they just killed people.

T: Many people.

F: I seem to see only men.

T: No, you can also see women who were there, and even children. What happened was that if those killers caught you at home they would get you outside the house. If you were a grown-up and living with your own mother they would say: "Stay with her, she should be your wife. Do to her what you did to us . . ." And then after you had done it, they still killed you. It was bad. It was one big massacre, something to think about.

Painting 72 The massacre may have taken place around March 11, 1960 (i.e., before Katanga independence or secession), in the context of ethnic confrontations along Conakat (Confédération des associations tribales du Katanga)/Balubakat/ MNC-Kalonji lines (with the Tshokwe playing a prominent role). These troubles were promoted by Munongo and were aimed at discrediting Lumumba as leader of the independence movement (see Willame 1990, 170–71).

Painting 73

The Death of Dag Hammarskjöld

The tragic death of Mr. Dag Hammarskjöld.

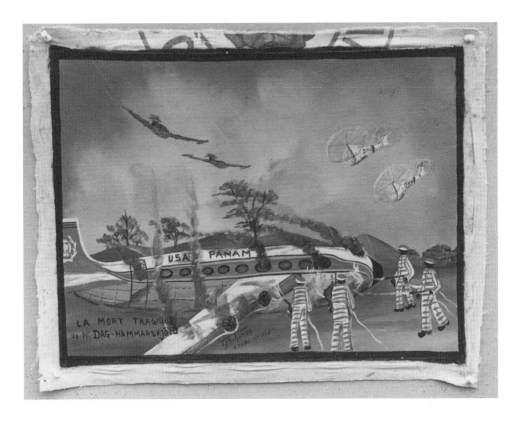

Because many such events took place, they came to the attention of the United Nations. At that time the secretary general was Dag—I don't really know how to pronounce his name, it was something like Amarzhold, or Amarshol. He left for Shaba to try to negotiate some kind of truce. Let's just say that this was another affair of the big shots. But we know that it is historic. What truly happened was he took off in a plane that followed a route over Zambian territory, near Ndola. Then he, too, died. What you see there are the firemen who tried to put out the fire in the plane and rescue the bodies; all of the passengers had died.

F: On the plane I see written "U.S.A. Pan Am."

T: Because it was an American plane. That's why I say U.S.A., United States of America, and I also drew the United Nations emblem. That is to say that it came from America. Then, as it neared its destination, the plane broke down, so the pilot wanted to land in Zambia, not in the bush on this side of the border. But when it got there it was in flames and crashed. And there are Canberra fighters patrolling above the site, and then helicopters came with rescue workers.

F: What kind of person was Hammarskjöld, where was he from?

T: I don't know his nationality, but neither do I know that of the other secretaries general of the United Nations. The name Hammarskjöld sounds like he was — what was it again? I completely forgot, although I had read about it once in the *Tintin* comics.

Painting 73 This episode took place on September 17, 1961. The plane was a four-engine DC-6B, registered SE-BDY, chartered by the United Nations from a Swedish company and christened "Albertina." It took off from Léopoldville at 4:50 P.M. Shortly after midnight, it approached the airport of Ndola in Zambia, not far from the Congolese border. The plane was cleared for landing but disappeared during the final approach. The search was not started until the following day, because at first it was thought that Hammarskjöld had changed his mind and asked to go to some other destination. The wreck was found twelve and a half miles from the airport; sixteen passengers were dead, and the single survivor died three days later. A commission investigated the crash and concluded that human error was responsible (one of pilots was drunk and overtired, see Geerts 1970, 155–56; see also the most recent reexamination of the event, Rösiö 1993).

Jason Sendwe's Tomb

President of the Balubakat.
Assassinated by rebels in 1964.

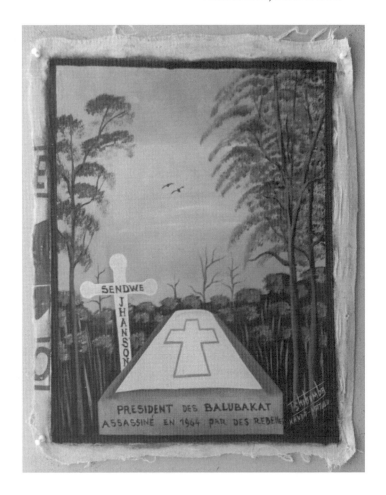

Now to another chapter from that time when the Shaba, or rather Katanga, war was still going on and on. This is about Jason Sendwe. He was the leader of the Balubakat. That was his political party. I think he also was caught and killed. They just killed him. After that came the death of Chief Kabongo. At any rate, they killed Sendwe and cut off his head. Then Sendwe was buried. I think, at one time, if we follow history, Mobutu visited his grave and honored him with some sort of posthumous medal.

F: We see a grave in the bush. Where is this place?

T: It's in Kalemie, which used to be Albertville in the old days. That's the place where they buried Sendwe. And then Mobutu came and honored him with some kind of medal.

F: Did the rebels kill Sendwe, is that it?

T: Well, the rebels killed him, but there are suspicions that others were involved. Because

there was also Chief Kabongo's death, which coincided with that of Sendwe. People were angry at him because he went to make peace with Tshombe: "We were in the refugee camp and many of us died," they said; "now you're going and talking to those people." So they killed him. Some say it was the rebels, but it had to be the Luba themselves . . .

F: Did you know Sendwe?

T: Just by sight. In 1962 he was in Likasi. They carried him around in a *tipoy* chair and he waved to the people. We went there. It was raining a little that day, and there were many of us. We were waiting until he finally appeared at the edge of town, coming from Kambove. . . . Later I saw him in photographs.

Painting 74 Geerts 1970, 187, has a photograph of Sendwe in leopard regalia; the caption reads: "On June 22, 1964, Jason Sendwe was found murdered." Sendwe, at the time president of the province of North Katanga, was caught in Albertville by the *jeunesses* (bands of young guerrillas first organized in 1961 by Gizenga in Stanleyville) on May 27, 1964. Eventually, the Congolese National Army and Gizenga's troops accused each other of the murder of Sendwe (Geerts 1970, 186).

Planes Attacking the Lubumbashi Smelter

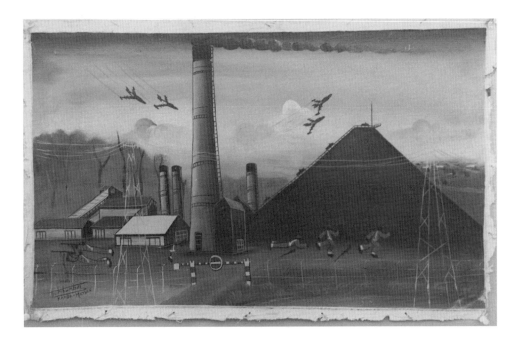

At that time the war just kept going on and on. Then they got to the last battle and took Shaba. The Shaba affair was finished.

T: The smokestack of the Gécamines smelter at Lubumbashi marks the one place where there was fighting throughout the entire Katanga war. It's a long story, but let me give you just this one incident: There, way up on the smokestack, was a man who was exploding. He had joined the Katanga army even though he was a Kabinda, that is, from the Kasai. Eventually, when this fit of rage came over him, he climbed to the top of the smokestack here and began to fire his Katanga mortar, aiming in every direction, right into the communities of Kenia and Katuba. He was killing people. Finally, he himself was killed.

F: Was he crazy?

T: He was just—I don't know, was it rancor or what? Eventually he was killed, but not right away. They caught him, tied his hands together, and dragged him away behind a jeep. They dragged him really fast, and he was getting torn up on the ground; his flesh was torn to pieces and he died.

F: Who did this?

T: The Katangese. He was a Katanga soldier himself; he had joined the Katanga army.

F: I see.

T: But eventually he just couldn't take it anymore and exploded . . .

F: And what are those planes there?

T: They were Canberra fighters that belonged to the United Nations; Katanga had the Fouga Magisters.

F: So those Canberras attacked the mining company.

T: They did; there was fighting, bombs were dropped, all the soldiers ran away, and that was the end of the war.

Painting 75 Who bombed whom is difficult to determine. Geerts notes that after a falling-out with the Union Minière du Haut Katanga, Tshombe had the mining company's headquarters in Elisabethville bombed on December 17, 1961. But that same day the smelter was attacked by the United Nations (possibly by artillery); see Geerts 1970, 159, with a photograph of the smelter on p. 160.

The Building of the Town of Mbuji-Mayi

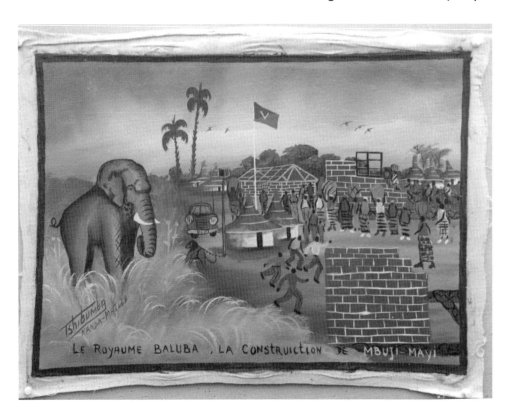

[Here Tshibumba returned to Painting 54, which had served in an earlier chapter of his story]

The Katanga affair was over, finished. But my story is set in the Kasai as well as in Katanga. In the Kasai, too, things were happening. What went on there was this: At that time—you have one picture where you see that the Lulua and the Luba were fighting each other—when the fighting was over, the Luba were chased away to their home country. "Go home," they were told. They left Kananga, which was then called Luluabourg, and went home to Bakwanga. So they got to Bakwanga. You see some women carrying loads on their heads and also some men over there. You see the elephant I painted, which is to say that the place was right in the bush. It was bush; there was nothing. So those people got there and settled. They began cutting trees and building a town. Today this town is called Mbuji-Mayi.

T: So when the Baluba were chased away from Kananga they went back to their home country. But the point is that the whites did not build Mbuji-Mayi. They constructed Bakwanga, a town for the Formière mining company. And all they built there were those tiny little houses for their workers. . . . So the Baluba gathered from all directions: the ones from Kananga and those who were expelled from Shaba. They all came,

as did those from Bukavu, from Kisangani, from Mbandaka, from Kinshasa; they all came to this one place. There they found themselves in the middle of the bush. So they cleared the bush, cut down the trees, and said, "Let's build." And if you go there today you will see a big city.

F: I see the Victory flag flying.

T: It's Kalonji's flag, the flag of the Baluba kingdom.

F: People are busy with construction work. The women carry loads.

T: On their heads.

F: I also see houses of different types. There are some huts, like in a village.

T: Ah, those they built when they first arrived, huts like those our ancestors used to build. Then they got some money together and began to buy bricks.

F: I see. And there were even cars?

T: There were cars, everything. There was even television. Anything that money could buy . . .

F: And there's a monkey on a leash.

T: People had monkeys that they kept on leashes.

F: What for?

T: It's an animal you can walk around with. Some people like that sort of thing.

F: Really? They like to walk around with a monkey?

T: Even I myself have one.

F: Is that so?

T: Yes, in my house in Likasi . . .

F: So it's on a chain, and this thing, what is it?

T: It's a pole, and the monkey has his little house on top.

F: His little house where he lives. Well, well, a monkey. So it all goes to say that people had everything.

T: They had everything.

Kalonji, Emperor of South Kasai

*Kalonji (Albert), Emperor of South Kasai. Autonomous
state. First Luba kingdom in the twentieth century.*

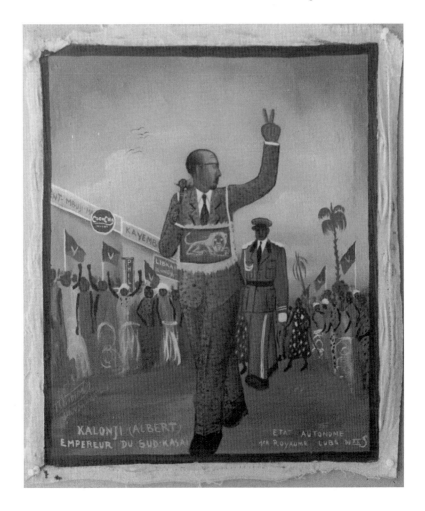

The ruler whom they installed was Kalonji
Albert, ex-Albert. Before he became chief,
Kalonji Albert had been president of South Kasai.
Then he called himself king and finally emperor.
As I say on the painting, this was "the twentieth-
century kingdom of the Luba." Because the Luba
had had a kingdom long before. This one was their
kingdom in the twentieth century. It was Kalonji's;
he founded this kingdom of his.

F: I see that the emperor is wearing a Western-
type suit, although he's carrying a hatchet.

T: A hatchet in his hand, or rather on his
shoulder.

F: What is that supposed to show? That he is the
ruler?

T: Well, it's like nowadays with Mobutu, who
carries his staff. And Kalonji used to have one,
too. And he used to walk around accompanied
by two women, you see them there? They would

carry the staff for him. . . . On his chest he has a piece of raffia cloth, embroidered with a lion's head. In our country this signifies he is a ruler. It's like the leopard-skin hat that Mobutu wears . . .

F: And what is the place shown in this picture?

T: It's Mbuji-Mayi. Look at the houses they built, and at the signs: Coca-Cola, Philips. There were also bookstores.

F: And the names "Ilunga" and "Kayembe"?

T: Ah, that is what we now call Zairianization. It started with the Baluba.

F: In Mbuji-Mayi.

T: It was the people. The people themselves began with Zairianization. There were no whites. People just arrived, built the town, and brought wares to stock their shops with.

F: Not even Greeks were there?

T: No, not a single Greek. It was just the people.

Painting 77 Geerts 1970, 166, has a photo of Kalonji in regalia and notes, "A. Kalonji had himself solemnly proclaimed 'Mulopwe,' king, in the tradition of the Baluba." This took place on March 31, 1961 (168). Apparently he repeated the ceremony during the Coquilhatville Round Table (a conference attended by most Congolese leaders working toward a federal structure of ethnic-based states, except for Gizenga, who had set up his own regime in Stanleyville). On its first day, April 23, Kalonji announced that from then on he would be emperor of the Kasai (124). The secession of South Kasai was declared (with support from Belgian military and the Forminière diamond mining company) by Kalonji and Ngalula during the first days of August 1960 (Willame 1990, 187), but throughout, Kalonji played a many-sided game: he did not break with Léopoldville and maintained good relations with Katanga (Geerts 1970: 167–68).

Painting 78

The Kanioka Revolt

In South Kasai, the Kanioka revolt.

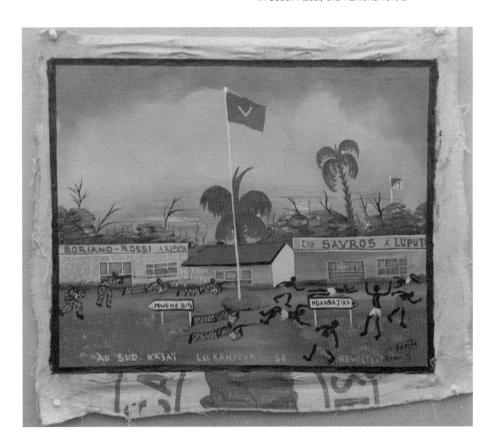

So the kingdom of the Kasai, of South Kasai, was founded. In its territory there lived Kanioka, Kabinda, and Tetela peoples. Some among them were for Kalonji's rule, others against. The Kanioka, for instance, did not want to be part of a united Congo; rather, they had the ambition to set up their own province, that of Mwene Ditu. It was to be called Southern Province and to belong to Katanga. That is why they used the flag of Katanga. The Kasaians, those who were on Kalonji's side, rejected this. Kalonji traveled to Mwene Ditu and to Luputa. So when he got off the train, this is what he saw:

There was the road, and here the KDL railway station at Luputa. Those are shops, and this is the road to Ngandajika and that one goes to Mwene Ditu. What happened was the South Kasaian military came and killed many Kanioka. After that massacre, all the Kanioka fled. There was nothing they could do about it; Kalonji's kingdom took over, their country was under Kalonji's rule. It was part of South Kasai.

F: So there was fighting between the Kanioka and the Luba.

T: And Kalonji's gendarmes. What went wrong between them was this: the Kanioka said, "We are going to take Mwene Ditu, Ngandajika, and Luputa — all places that are on Kanioka soil — and make them into the Southern Province." And that province would be annexed to Shaba.

F: Right, because there in the background I can see the Shaba flag.

T: They raised this flag, saying, "We are Shaba people; that is where we want to go."

F: So the picture shows the square in front of the railway station.

T: Yes, and in front of those shops — Rossi, for instance.

F: Is that a real shop?

T: Yes, and Savros at Luputa. When you go there and get off the train at Luputa station, you will see those shops. . . .

F: I also notice that the Kanioka are dressed like . . .

T: . . . like warriors. That's the way they used to dress, also on other occasions. They would put on raffia skirts and *minyanga* rattles on their arms, and that was it. They are a people who really knows how to fight with arrows.

Painting 78 I have found nothing in published sources on these specific incidents. Yoder 1992 traces the general history of the conflict between Baluba and Kanyok.

The End of the Luba Empire

Coup d'état. The end of the Luba kingdom.
General Tshinyama.

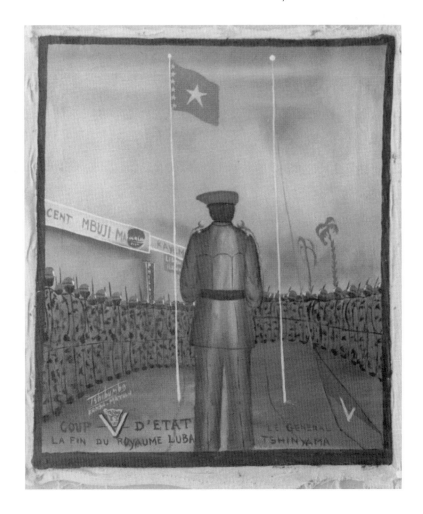

I could describe at length how Kalonji's kingdom took over, but I am taking a short cut by leaving out some pictures. The truth is that among the Luba, the Luba-Kasai, and the Kanioka, the matter was settled. Now back to Kalonji. There was friction among the soldiers. Some of the Luba soldiers belonged to the Bena Tshibanda group, others to the Bena Mutwa wa Mukuna. They no longer got along with each other. Whatever agreement they had came to an end. Now, the emperor belonged to the Tshibanda; the general and commander of

the army was a member of the Mutwa wa Mukuna. The minister of the interior, Joseph Ngalula, was Mutwa wa Mukuna. So there was no mutual understanding anymore. The general saw what happened when Kalonji became the ruler. Kalonji's relatives began to kill Bena Mutwa wa Mukuna. "We are the bosses now," they said; "you have nothing to say anymore." As a result of the killing there was open conflict, and General Tshinyama staged a coup

d'état. He removed Kalonji from power. Kalonji left the same day and took refuge here in Katanga. The general planned to settle things by handing South Kasai over to the Congo, as a province of the Congo. What happened is that the powers in Kinshasa appointed Joseph Ngalula governor. With that, I believe, the affair was settled. And as I explained to you, the history of Katanga had already ended. The secessions of the Kasai and Katanga were finished.

F: So now to General Tshinyama's coup d'état. Is this once more in Mbuji-Mayi?

T: Yes, in Mbuji-Mayi, on the same street . . .

F: What does "Mbuji-Mayi" mean? "Mbuji" means . . .

T: "Mbuji"? That is our name for a goat. And "Mayi" is the word for water. But the name of the town really comes from French *bouche*, or mouth, because that was what the whites called the mouth of the river there, *embouchure*. So the people called it Mbuji-Mayi.

F: Now to Tshinyama. In the inscription, you put the victory sign right between "coup" and "d'état."

T: "Coup d'état" means the end, the end of the kingdom. And the kingdom was Kalonji's, right? He first had the lion as his emblem of rulership. But later he had the leopard, inside his victory sign. He had that put on his postage stamps, just the way I painted it.

F: How many months did his kingdom last?

T: Kalonji's kingdom? It began in 1961 and was over in 1962; that's how it was. No, it ended in 1963.

Painting 79 The falling-out between Kalonji and Ngalula apparently went back to Kalonji's proclaiming himself king on March 31, 1961. By September 28, ten of the thirteen Kasaian deputies to the Léopoldville national assembly had deserted Kalonji. In December he was tried and sentenced (in Léopoldville) to two years in prison. He escaped and lived in exile until he returned as minister of agriculture in the Tshombe government of 1964 (Geerts 1970, 168). From his exile in Spain, Kalonji published a memoir (1964).

Painting 80

Tshombe Prime Minister

After the resignation of Mr. Ileo and Mr. Adoula, Tshombe becomes the Congolese prime minister, and the flag changes.

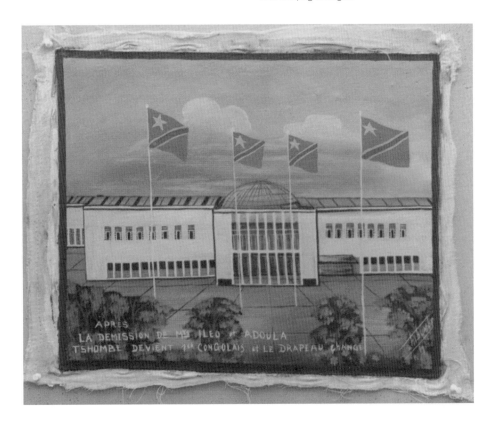

Meanwhile, Kasavubu was head of state, Adoula prime minister. Then they removed Adoula from office. After that, they called on Moïse Tshombe. He had fled to Madrid, in Spain. They said, "Come back and take the office of prime minister here in Zaire." Indeed, he did not hesitate; he left right away and came to the Congo. In the Congo he took the office of prime minister. I must tell you that I am covering these events with just one picture. Since you told me you were about to leave, I took many shortcuts. In my mind I have a great number of pictures that would fit here to show how Tshombe was given power and how he was received by Kasavubu.

F: So now we get to Adoula's resignation. What I see seems to be the parliament.

T: It's the Palais de la Nation. . . . I told you before that in this series I have been leaving out many paintings. I took shortcuts, and this painting is one of them. When I thought of the pictures I had in mind then, you told me you were about to leave, and I realized I could not do them all. So I painted this picture, because it was in this building, in the Palais de la Nation, that all the events first took place. . . . They dismissed Ileo,

they dismissed Adoula, and after that they called in Tshombe. Then they changed the flag. It used to have six stars; now they put one star and this red bar.

F: What was the meaning of the red bar?

T: They used to say it stood for the blood shed by the martyrs of independence.

Painting 80 In 1964, while the rebellion in the east spread and the national army grew more and more disorganized, a constitutional commission was at work in Luluabourg. On April 11 a new constitution was adopted, the first one entirely formulated by Congolese. The Adoula government stepped down on June 30, 1964. Adoula himself was not a viable candidate for presidency under the new constitution. As the threat of rebellion in the east increased, Mobutu sent a Belgian journalist, Pierre Davister, to Madrid to convince Tshombe to return, which he did on June 26, 1964. By July 10 he had presented his government, which was to remain in power until the presidential elections set for the beginning of 1965 (Geerts 1970, 192–95). On September 7 a new name was adopted for the country: the Democratic Republic of the Congo. (Geerts reproduces a photograph of Tshombe with the new flag in the background on p. 195.)

Tshombe Returning from the Brussels Talks

*Give me three months, and I shall give you
a new Congo.*

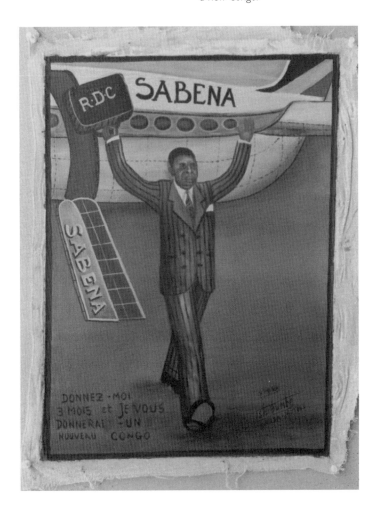

After Tshombe had risen to power, there was the affair of the unsettled claims between Belgium and the Congo. This matter of claims was a political issue, so complicated the politicians themselves did not understand what it was really about. Tshombe went to Belgium. When he arrived—whether this is true or a lie, that is the big shots' business—he was given an attache case. I put the inscription "RDC" on it. With that case he arrived in Kinshasa. Now, before he took power, Tshombe had told the people of Zaire what it says on the painting: "Give me three months and I shall give you a new Congo." That was really what his trip to Brussels was about. In Brussels they gave him this attache case. With that attache case he came back and told the people of Zaire, of the Congo, that the matter of claims was settled. This was a political trick; neither we nor others know the truth about

it. Let's just say it was something that the Belgians kept secret in their minds. They kept it secret from the Congolese, who were not to understand clearly that this was a political maneuver designed to lead nowhere. The Belgians had decided to stall about the matter of claims. Well, that's politics.

T: So at that time Tshombe ruled. He was talking with the Belgians about the claims the two countries had against each other.

F: Now, what about this attaché case of his? It says RDC.

T: That is to say, République Démocratique du Congo. That case was given to him when he went to Belgium. I guess you have heard President Mobutu say in a speech that Tshombe was a liar. He deceived us. They had put shit into that attaché case he came back with from Belgium . . .

F: Mobutu really called it shit?

T: He did. In his speech he said, "Look, Tshombe cheated us about the claims, he lied." Well, that's politics, isn't it? Mobutu's politics.

F: And then it says on the painting: Three months and I'll give you a new Congo.

T: Give me three months, and I'll give you a new Congo . . . And they gave him three months: rebellions broke out and there was death everywhere.

F: Did you ever see Tshombe?

T: I saw him quite close up; he even shook my hand near the swimming pool in Likasi, where we used to live. Every time he came into town I had to go and greet him as a member of the Katanga Fanfare. I know Tshombe's Katanga national anthem and could sing it right now, and many other songs. He would stop in Likasi every time he came through on his way to Lubumbashi, and we saw him and often we had to wait for him. But one person I never saw was Lumumba. I never saw him.

Painting 81 At issue were Belgian claims on property as well as the public debt of the colony. The Congo wanted the former returned and the latter written off. A first accord was signed by prime ministers Cyril Adoula and Paul-Henri Spaak in March 1964 and another by Tshombe and Spaak on February 6, 1965. On that occasion, Spaak presented Tshombe with a small black leather case as a symbol of the negotiated transfer of assets and debts. Geerts, who reports this, also notes that this gesture was to have a considerable effect on Tshombe's success in the elections (1970, 260; see a photograph of Tshombe with the case on p. 261). The words quoted in the inscription on the painting are from Tshombe's speech in a Léopoldville stadium after taking over the transitional government: "Just before he discovered America, Christopher Columbus told his tired sailors: 'Three days, and I give you a new world.' To you, who are tired too, I say: 'Three months, and I give you a new Congo'" (Geerts 1970, 196). On June 30, 1966, Mobutu rejected the agreement and called for a new hearing (ibid., 260).

Painting 82

The 1964 Presidential Election

Presidential election 1964.

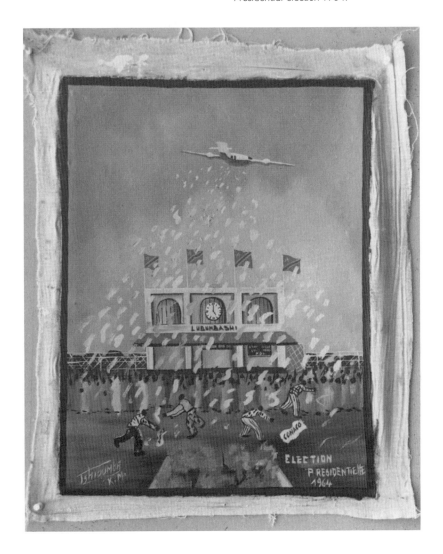

Not much later, there were presidential elections. The picture shows the presidential election of 1964. The race was between Kasavubu and Tshombe. Now, this was the situation: Kasavubu had his party, the Abako, founded long before then. Tshombe formed his political party, the Conaco. What happened is that the Conaco incorporated all the other political parties in Zaire. The Kalonji faction, the MNC-Kalonji, was part of the Conaco, and so was the PCA, all those political parties I could name, as well as others I don't know about; they were all part of the Conaco. With the help of the Gécamines, or rather the Union Minière, Tshombe carried the election. He won the election.

T: The scene is in front of the railway station in Lubumbashi. . . . An airplane was circling overhead and dropping leaflets.

F: On the plane I can read "H2."

T: H2, but that was on the model I used, so I wrote it, too. It's what the planes use to announce themselves at airfields. The leaflets were campaign material for the Conaco . . .

F: And what was written on them?

T: Lots of things — "Vote Conaco, it is your party." "You will have a good life if you vote for the Conaco." And lots of songs were performed, for instance by Franco, who now calls himself Luambo Makadi. On one of his records he sang, "Vote Conaco!" And it's true, Tshombe was victorious.

Painting 82 The elections, scheduled for the beginning of 1965, were delayed. In February, Tshombe entered the arena by bringing together forty-nine parties and ethnic associations in one organization, the Convention Nationale Congolaise (Conaco), in Luluabourg. The elections — which were not "presidential" but rather constitutional, that is, of members of parliament who would then elect the president — began on March 18, 1965, in East Katanga and went on for two months in other parts of the country. Tshombe was supported by 122 of the 167 members. He was the obvious candidate for president, but Kasavubu remained a strong candidate too, since by the former constitution he was still president. Kasavubu announced his candidacy in June 1965.

Led by Victor Nendaka (elected for Tshombe's Conaco), an opposition to Tshombe's candidature was organized as the Congolese Democratic Front, with Kamitatu as its spokesman. The parliament was convened on September 20 for an extraordinary session to vote for the presidency of the Chamber and the Senate. The Conaco won the former, the Democratic Front the latter. In a regular session of the parliament on October 13, 1965, Kasavubu announced that he had dismissed Tshombe as prime minister (Geerts 1970, 228–39).

Regarding the airplane in the election campaign, Kestergat reports that Tshombe distributed a planeload of Katanga cigarettes among the population in Coquilhatville (1986, 101–2). On the life and work of Franco, see Ewens 1994.

Painting 83 [see color plate]

The Mulelist Uprising

In the Kwilu region, the Mulelists against the Congolese National Army.

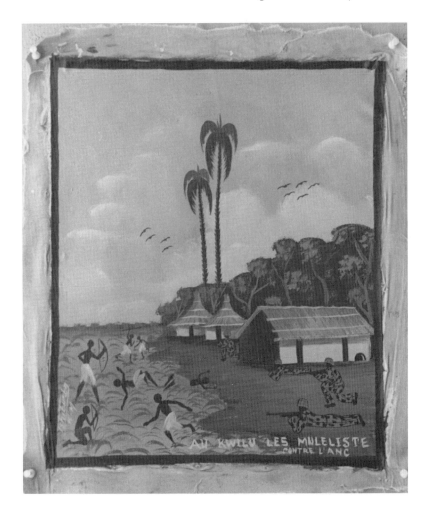

Because Tshombe had won the election with financial backing from the mining company, there inevitably was conflict in the aftermath. War broke out in the Kwilu; it was the war of the Mulelist uprising. The followers of Mulele rose, and there was a bloody war. "Let us take the Congo by force," they said, "and not accept this election." Tshombe just wants to stay in office; he used to be a secessionist. The Mulelists opposed all this.

T: Now we are in the Kwilu region. If you have questions, I'll answer them.

F: I see there are warriors; are they followers of Mulele?

T: Yes, they are Mulelists.

F: Didn't they have guns?

T: No, they just had bows and arrows, and they began to kill people. But the Mulelists, to be historically accurate, were allied with the Japanese, or rather, there were Chinese among

them. That was Mulele's army, and it devastated that whole area. They took many towns; in fact, they almost took Kinshasa. But by some fluke — I don't know how it happened — the Congolese National Army chased them away and captured many of them. And Mulele, instead of fleeing to some other place in Africa or to Europe, went to Brazzaville, where he was captured. But I don't

really know that story well; it is something that concerns the big shots.

F: The big shots, eh?

T: Well, when we get to certain points we just say: Those are the affairs of the big shots, of the people in power; they don't concern us.

Painting 83 Pierre Mulele was secretary of the PSA and minister of education under Lumumba. Later he represented Gizenga's regime in Cairo, until the latter recognized the Adoula government in 1962. He then went to China, where he was trained in guerrilla warfare. In July–August 1963 he was back in Kwilu, his native region. With Chinese backing, he organized a resistance movement. Military action against the Mulelists, who fought with traditional weapons, began in September 1963. Eventually, the rebellion spread to Kwango, Lake Leopold II, and the Kasai. The national army failed to control the movement (Geerts 1970, 176–80). Around 1967 Mulele disappeared, but he turned up in Brazzaville when Mobutu announced an amnesty and the liberation of political prisoners (August 29, 1968). Informed by authorities that he was covered by the amnesty, Mulele came back to Kinshasa with pomp and circumstance. When Mobutu returned from a trip to Morocco on October 2, 1968, he declared that the amnesty did not apply to Mulele. On October 8, a military court pronounced the death sentence. Mulele was executed on October 9 (Geerts 1970, 343–44).

Painting 84

The Rebellion in Stanleyville

The rebellion in the Congo.

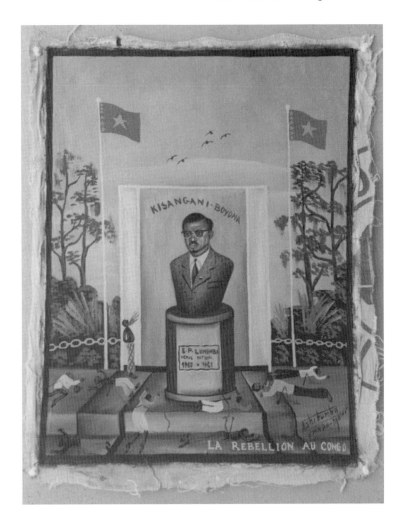

Nguebe, Soumialot, and those others whom I think you may know, they also staged a revolt in Kisangani. But instead of rising up for a good cause, they just grabbed people, killed them, cut their heads off. There you see some who were doused with gasoline and set on fire; that's how it was. There was desolation; they could not get enough of this killing. But kill as they might, lots of people were passed over.

T: The scene is in front of a monument in Kisangani, the former Stanleyville.

F: And what is Boyoma?

T: Boyoma, it's a part of Kisangani.

F: And there they still had the six-star flag?

T: They did, and they died for the sake of unity. Because at that time, before each went after his own political interests, the politicians of Zaire all agreed that Lumumba's program was a good one. He was well liked; all the people loved him.

F: What they did there, was it aimed at the whites, or who were the people they killed?

T: Whites and Africans. Above all, they killed many Africans.

F: And who did the killing shown in this painting? The Mulelists?

T: No, not the Mulelists. It was the followers of Nguebe, Soumialot, and others whose names I forgot; they killed the people. Because Nguebe was some kind of general, but I am not quite sure.

Painting 84 Tshibumba is possibly referring to the secession of the Northeast under the regime of Gizenga, a movement that began in March 1961, as a continuation of Lumumba's opposition to Ileo in Léopoldville. On August 2, 1961, Adoula became a compromise candidate and set up his first government. He went to Stanleyville on August 18 to convince Gizenga to give up his position. Both attended a conference in Belgrade in September. Several incidents (especially the killing of thirteen Italian pilots in Kindu and, on November 11, 1961, of thirty missionaries in Kongolo by soldiers commanded from Stanleyville) discredited Gizenga. An order for his arrest was issued by Adoula on January 13, 1962. On the 13th, 14th, and 15th there were "bloody incidents" in Stanleyville. On January 20, Gizenga was brought to Léopoldville and put under house arrest (Geerts 1970, 127, 131–32).

A photograph showing Tshombe paying his respects to Lumumba's monument in Stanleyville is reproduced in Kestergat 1986, 152. The monument consisted of a stone or cement cube covered by a flat roof protruding on all sides. In the middle of the front panel, behind glass, was a full- or three-quarter-size painted portrait of Lumumba, his left hand raised, his right hand partially covered here but shown as resting on a globe in another photograph, reproduced in Reed 1965, following p. 88. The caption to the latter photograph reads: "Monument to Patrice Lumumba, the Congo's first Premier. Here the Simbas [i.e., the rebels] executed scores of Congolese in orgies of human sacrifice and cannibalism." But there must have been several such monuments in Kisangani (either at the same time or successively). In Jerry Puren's mercenary memoir, another photograph of the "bloody shrine to their hero, Patrice Lumumba, in Stanleyville" looks smaller than the one shown in Kestergat and definitely has a different portrait: Lumumba holding the globe, with the lone star of unity in the upper left corner (1986, 111). I discovered another picture of a monument, which was destroyed by antirebel mercenaries in about 1967, in Talon 1976, 182. These portraits of Lumumba hint at the beginnings of popular historical and political painting one decade before genre painters in Shaba would paint such portraits, obviously copies of those displayed in the Lumumba monument (or monuments).

Painting 85

November 24: Mobutu and Party Symbols

One Chief. One People. One Party.

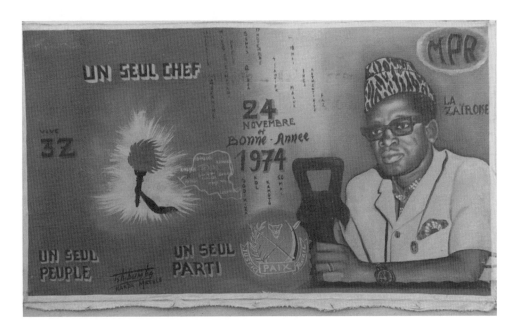

Now, in this whole history that I just told you about and that you have before you in my paintings, there was this one person, I think, who did not like what was happening. This man saw how bad it was, that there was no one able to give some direction to politics in Zaire. It was a catastrophe; people had died for nothing. It was beyond comprehension. This person was Mobutu Sese Seko, as he calls himself now; he used to be Mobutu Joseph Désiré. On November 24, he was fed up with all this, and being a military man, a general, he seized power. I don't know whether it was a coup d'état or what. Let's say it was a takeover by the military high command, which then took power in Zaire. On November 24, it seized power and condemned everything that had happened up to then. Usually the date is given as November 24. Actually it was at midnight on the 23rd—that's the way we count it here, saying "the 23rd" or "midnight 23rd." But for French speakers, "the 23rd at midnight" becomes the 24th.

т: The day of November 24 marked, as it were, the birth of Mobutu Sese Seko, a person sent to us by God. That is what we, the people, began to hope for. As things stood at that time, we were saying, "Perhaps this is the year they'll come and kill me. Will I be able to raise my children?" Truly, all we saw was that on November 24, Mobutu took over. We had our doubts, every one of us. "Oh well," it was said, "he is someone from the lower Congo; what do you expect? There will be trouble." Others said, "Oh, perhaps . . ." But we did not know. But we soon saw that he knew how to take control of things, as he does up to this day. We have peace and tranquillity, we live well in our homes and when we travel . . . I no longer walk around fearing that someone will shoot me with an arrow or someone is going to

chase me. Now you begin to walk with strength, telling yourself, "I live in my own country."

F: And what does this mean, "Long live the three Zs"?

T: "Long live the three Zs"? That stands for Zaire, the currency; Zaire, the river; Zaire, the country . . .

F: The date you put on this picture is 1974, but it was in September 1973 that I got it.

T: It was in December 1973, because this one I did for the New Year.

Painting 85 Mobutu staged two coups: the first on September 13, 1960 (after the dismissal of Lumumba, in whose entourage he had risen to a certain prominence, mainly because of his military and secret service contacts [Willame 1990, 407–18]); the second in 1965. On September 13, 1960, he mobilized rebellious officers from several regions as the "high command of the Congolese National Army," dismissed the rival governments of Lumumba and Ileo, and dissolved the upper and lower houses of the legislature, at the same time neutralizing the president, Kasavubu, in a "peaceful revolution" (Willame 1990, 419–20). The radio announcement of the second coup was prepared during the night of November 24–25, 1965. Mobutu's famous thirteen-point declaration aired at 5:30 A.M. on November 25. The coup was enthusiastically endorsed by all parties in the parliament. Mobutu announced that his tenure would be five years. The monetary reform took place on June 24, 1967. On October 27, 1967, Mobutu assumed the post of prime minister. On October 27, 1971, the Democratic Republic of the Congo became Zaire; the flag was changed on November 19 and a new national anthem was adopted on December 8. On January 4, 1972, Mobutu decreed the change of place names and personal names (Cornevin 1989, 446, 470). On Mobutu's "second republic," see Vanderlinden [1980].

Mobutu Rolling Up His Sleeves

Salongo *means to love work*

On the morning of the 24th, Mobutu called the people to the stadium he had renamed "Tata Raphael." He called together a large crowd and explained his concerns to them. But you can get the documentation and read that speech yourself.

F: Isn't this a picture of the slogan "Let's roll up our sleeves"?

T: That's what it is: "Let's roll up our sleeves."

F: There used to be a song about that.

T: Ah, indeed.

F: But on the picture you put *salongo*.

T: Because on that day Mobutu proclaimed the first *salongo*, national cleanup day. On the day he took power he proclaimed *salongo*. But it was not something he copied after his trip to China, as has often been said. He did not copy the Chinese model. He had the idea long before. . . .

Actually he knew that it went back to one of our ancestors, in the Bangala region. . . . When one of our ancestors would teach an example of work to his child, he would say, "Salongo alinga mosala," which means that the people here in the Congo loved to work. And that work was productive, it made you live well . . . Just as I am working hard to come up with paintings, without tiring. That is my *salongo* . . .

F: And those people listening to Mobutu, are they Europeans?

T: No, they are Africans, ministers and members of parliament. They smiled when they saw that he actually rolled up his sleeves . . .

F: I see that Mobutu wears a red beret.

T: Yes, that is the beret of the paratroopers, with their insignia. It shows that he is a much decorated man.

Painting 86 The painting is inspired by (but not an exact copy of) the one-Zaire bill of the new currency, which itself reproduced an Associated Press photograph (the bill is depicted in Geerts 1970, 251, and Cornevin 1989, 444; the press photo appears in Kestergat 1986, 170). On the slogan "Let's roll up our sleeves," see Geerts 1970, 250–52.

The MPR Makes Lumumba a National Hero

Thanks to the Popular Movement of the Revolution, Lumumba National Hero.

I was very young then, and I heard what Mobutu had to say because at that time I began to understand French well. He declared: "In Zaire, from this day on, not a single political party will be allowed. You have divided the country into seven provinces and there are forty-four—forty-four!—political parties. From this day on, all that is over. Watch me, how I am going to act. For five years I am going to see whether this is good or bad." And then he declared in Lingala, his own language: "See how we got Lumumba, our brother, killed. It seems a pointless death, right? He was a person of intelligence. But we all failed to appreciate the insights he had. Now it turns out that he was right. Therefore, today I declare Lumumba a national hero." And he went on to talk about how they killed him—as it appears in those paintings I explained to you—in that house in Lubumbashi, down there near the Luano airport.

F: I see that you show Lumumba near that famous house. And here inside a window—or is it next to a window?—I see a man's face.

T: It is Lumumba's face.

F: Is that Lumumba?

T: Well, it's a little trick I used. When you go to this house—you can do this tomorrow—you will find a portrait of Lumumba inside. Underneath there is an inscription: "A country needs its martyrs; I offer myself as the first one." Lumumba himself said this.

F: The National Hero.

T: And those planes are to show that the airport is nearby. One of them is about to land.

Painting 87 The appropriation of Lumumba for Mobutu's party ideology occurred in 1966–67. His rehabilitation and the erection of a monument in his memory in Kinshasa were announced by Mobutu on June 30, 1966 (Willame 1990, 477). In this context a documentary on the death of Lumumba was prepared by a group of his Belgian supporters (published under the pseudonyms Heinz and Donnay). The report was initially ordered by Mobutu, but when it came out it was confiscated by the Sûreté—the equivalent of the FBI—in July 1967 (Willame 1990, 477–78), an understandable measure given Mobutu's role in sending Lumumba to Elisabethville and Lumumba's posthumous role as the hero of anti-Mobutu rebellions. In the English version of their report Heinz and Donnay quote an Associated Press dispatch: "Colonel Mobutu, with folded arms, calmly watched the soldiers slap and abuse the prisoner [Lumumba], pulling him by his hair . . . " (1969, 46). On the house near the airport, called *le pondoir* (chicken coop) and owned by a Mr. Browez, see Heinz and Donnay 1969, 119–20. Geerts 1970, 108, has a photograph of it, with the caption, "The farmhouse was the property of a Belgian colonist, Mr. Browey [*sic*], at that time in Europe."

The Mercenaries Landing at Bukavu

The mercenaries of Bukavu.

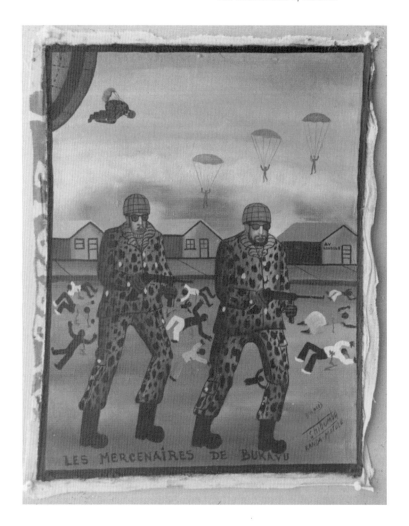

LES MERCENAIRES DE BUKAVU

So Mobutu was in power. Since, in following the course of history, we break it up into chapters, we may say that there was another chapter he did not like, namely that Mr. Moïse Tshombe was living in Spain. Mobutu did everything to convince him that he should return to his high office. Tshombe did what was in his power to hire mercenaries, whom he sent to Bukavu. It was night, and suddenly the people heard airplanes approaching and descending.

And as the planes descended they saw, to their great surprise, paratroopers jumping. As soon as they came down there was fighting, and they took the town of Bukavu. Actually, it is not clear whether they really took the town. At that time we did not have soldiers, or maybe they were just disorganized. It was the time when Tshombe began to make every effort to invade the country he considered his. Indeed, they killed a lot of people. You see them in the background—women, men, and children; they were just massacred.

F: Have you ever seen this, paratroopers jumping from a plane?

T: Oh, I've seen it.

F: Really?

T: Because I used to live in Kamina, where they had their exercises all the time. They would be dropped. And I saw others who were called specialists. They would be dropped in teams of four to extinguish a fire on the ground. They would set a fire with branches, and smoke would rise. Then the four of them would be dropped and come down. I saw it . . .

F: The faces in this picture look like they were Belgians, or not?

T: No, the mercenaries would come from wherever they could buy them; even a Zairian could be a mercenary in Zaire.

F: Is that true?

T: Certainly; a Congolese from Congo-Brazzaville could also be a mercenary in Zaire. Even I, if someone buys me, I can go and fight as a mercenary. You cannot say that the typical mercenary was Belgian; they were of all nationalities.

F: When did this attack on Bukavu take place?

T: The mercenaries in Bukavu, that was in 1967. It was the year when the Zaire currency was introduced. So that was in 1967.

Painting 88 This painting most likely refers to the taking of Bukavu by the Belgian mercenary commander Jean Schramme (see note to Painting 89), leading a group of mercenaries, Katanga gendarmes, volunteers from Denard's commando, and others on August 8, 1967; but that operation was carried out on the ground, not from the air (Geerts 1970, 308–9).

Jean Schramme Flees

Jean and his friends flee toward Rwanda.

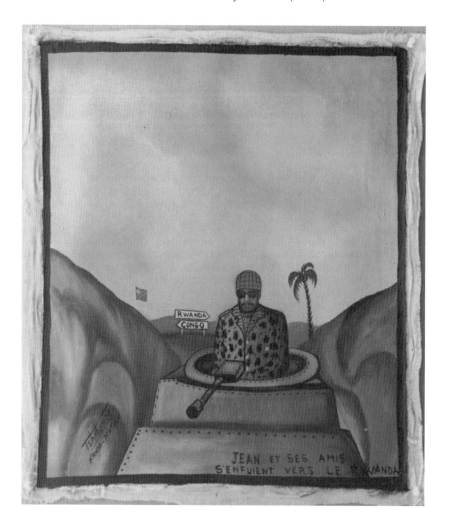

But what happened, according to history as I understand it, was that there was strong support from the Americans, who entered the fighting. Together with the ANC—the Congolese National Army, as it used to be called—the mercenaries hired by the Belgians who lived in Bukavu were driven out. They left and fled. I inscribed this picture "Jean and his friends flee toward Rwanda." They fled to Rwanda. So when they had fled to

Rwanda and showed up near the border, Mobutu made a request to Kayibanda, who was then president of Rwanda: "These people should not cross." Kayibanda refused, saying, "They will be allowed to cross. They are war refugees, and I have nothing against them." But that meant trouble between the Congo and Rwanda. Kayibanda issued condemnations—let's say, he treated the Congo without respect at that time. Mobutu was enraged and even broke off diplomatic relations.

F: So what we see here is another man, Jean . . .

T: Jean Scrum, or something like that. I don't know how to pronounce his name.

F: What is this vehicle they are fleeing in — a tank?

T: Yes, a tank taken from the Congolese National Army.

F: Was this in the mountains?

T: It was a road through the mountains. That was where he passed when he escaped from Zaire. That flag over there is in Zaire; it marks the border between Rwanda and the Congo.

F: Is Schramme still alive?

T: Wasn't he an American?

F: Oh, no.

T: At any rate, he is alive, as is Bob Denard.

F: Where, in Belgium?

T: I saw Bob Denard in a newspaper printed in Belgium. He was standing in the door of a house. He's alive, all right.

F: And Schramme, too?

T: He is, too. It was rumored by some that he is still fighting in Angola.

Painting 89 Jean-Marie Schramme, the son of a lawyer from Bruges, was a settler in the Maniema, did his military service in Kamina as a paracommando, and returned to the Maniema in 1956. In 1960 he joined Katanga and became a military instructor. After the end of the secession, he spent twenty months in Angola with the former Katanga gendarmes. When these were integrated into the national army he was hired as the commander of a special unit, the Leopard Battalion, deployed in the reconquest and pacification of Simba rebel territory (Geerts 1970, 210–12). The Bukavu episode in 1967 marks the end of mercenary activities when, after a mercenary mutiny, Schramme's unit and what remained of Denard's were evacuated to Rwanda (Geerts 1970, 213).

Tshombe Is Arrested in Algiers

The arrest in Algiers (Tshombe and his end).

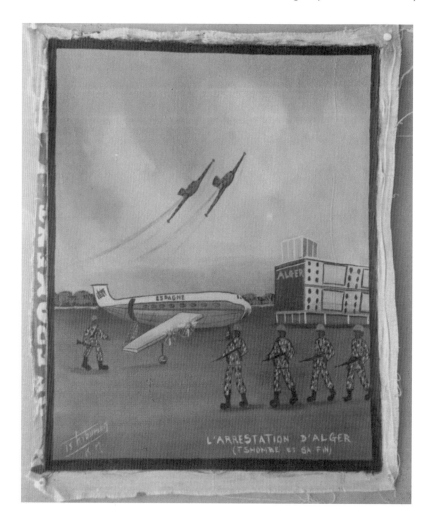

L'ARRESTATION D'ALGER
(TSHOMBE ET SA FIN)

Not much later, Tshombe over in Spain heard the news: "The mercenaries you sent took Bukavu. Don't think they ran away." We don't know who it was who worked on Tshombe and deceived him in the hopes that he would travel. Tshombe wanted to leave Spain immediately, get to Bukavu, and return to office as president of Zaire. What happened is he left, but on his plane there was one white person of Spanish extraction who had a gun. He disarmed the pilot and told him,

"Let's land here in Algiers." And so it was; they landed in Algeria. When they had landed in Algiers, Tshombe was confined to the plane until they had sent soldiers to take him out. After that, he was imprisoned. What happened then is, I think, something that concerns the big shots, as I have told you before. We heard bits and pieces. It was said that it was in June, between the 27th and—or rather on the 30th—that Tshombe died. Right now, all of us here know that Tshombe is dead.

F: The picture just shows an airplane.

T: Tshombe is inside that plane, but that is one of those shortcuts I told you about. If there were time I could show how they arrested him and put him on trial and how he was made to wear blue prisoners' clothes. . . . There were photographs of him. In the end they sent Nendaka to negotiate Tshombe's extradition and bring him here. But the Algerian government refused. Not much later we heard that Tshombe had died.

F: And that is another matter that concerns only the big shots.

T: So it is, nowadays. But we don't know how he died.

F: We don't know . . .

T: Or whether he is alive; we don't know.

Painting 90 What exactly happened is still unclear for Geerts in 1970, especially the role Nendaka played (286–88). Tshombe received the death penalty from a court in Kinshasa on March 6, 1967. On June 30, 1967, during a flight on a British plane chartered by a French secret agent who had infiltrated Tshombe's entourage, the plane was hijacked by the same agent. He forced the two pilots to head for Algiers. Shots were exchanged between the French agent and Tshombe's European aide, but the plane landed at Boufarik airport, some twenty miles outside Algiers. Earlier the pilots had signaled the hijacking on the radio, so this secret mission was public by the time the plane arrived. Mobutu's emissary, Bernardin Mungul-Diaka, was waiting there and asked for immediate extradition. On July 21, 1967, the Algerian Supreme Court granted the request. Nevertheless, Tshombe remained under house arrest in Algeria until his death on June 29, 1969. Murder was suspected immediately. Eleven physicians attested on his death certificate that he had died of a heart attack. This was confirmed by an autopsy on June 30. His body was brought to Brussels, where he was buried on July 5, 1969 (Geerts 1970, 288–94).

Pope Paul VI Approves Mobutu's Policies

Pope Paul VI agrees with Mobutu.

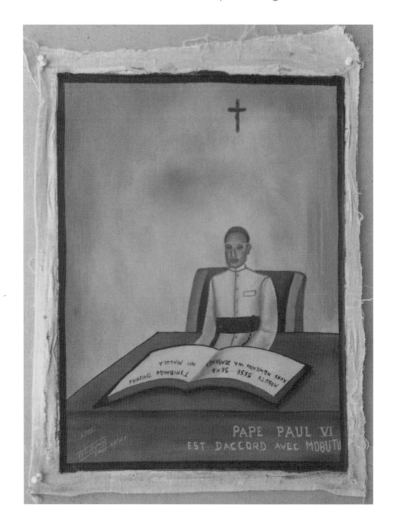

The way I divide up history, after Tshombe's death comes a chapter on General Mobutu's policies in this country and on the considerable progress they brought about, as well as the fact that he has had a firm grip on his rulership. As one of his policies, he promoted "recourse to authenticity." Now, recourse to authenticity was meant the way he had formulated it earlier, and it was not really a mistake when he sometimes spoke of "return to authenticity." So, seeing that at one time he did say "return to authenticity," Monseigneur Malula, the bishop of Kinshasa, misunderstood. He burst out immediately: "No way, there cannot be a return to authenticity. That would be so difficult as to be impossible. Just look at Kinshasa; we would all die were we to go back to the ways of old. It cannot be done." So there was open conflict between religious leaders and the government. It's true, Mobutu harassed Malula in every way imaginable. Malula

fled Kinshasa, or rather Mobutu had him removed. Malula traveled and said that he could not meet with Mobutu, and he went to the pope. And the pope said, "No, I agree with Mobutu; I am on his side in terms of what he said about recourse to authenticity. Everything he proposed should be accepted; for instance, this matter of African names." As he said, "From now on I am no longer Mobutu Joseph Désiré, I am Mobutu Sese Seko Nkuku Ngwendu wa Zabanga." That is his name now. Everyone who lives in Zaire—for instance, Tshibangu Tshishiku, the rector of the university—changed his name. "And you, Malula," Mobutu said, "you, too, are to be called only Malula and that other name that came from your ancestors. There is nothing at all wrong with that."

T: There was a fight between Malula and Mobutu; you wouldn't believe it. Malula kept saying, "This is impossible, I cannot believe this business about 'authenticity.'" But what happened is that the pope went along with it. I believe it was on the day he gave his approval that they organized the Torch Parade, or *marche de soutien*, a demonstration in support of the government. Everywhere in Zaire. I was in Kamina at the time. What it meant was that all the people marched through the streets chanting, "The pope approves, the pope approves. He has nothing against changing the names of the Zairians."

Painting 91 The conflict with Cardinal Malula flared up in 1972 over the issue of Christian names. Malula's residence (which the regime had built for him) was confiscated, and he had to go into exile at the Vatican. He returned after three months. The sources do not mention an intervention by the pope, but the Zairian church eventually accepted the "authentic" names (see Callaghy 1984, 304–5; Young and Turner 1985, 67, 69).

The Party Monument at Kipushi

MPR monument at Kipushi. Long live the 20th of May, birth of the Popular Movement of the Revolution, the great Zairian family with the president and founder Mobutu Sese Seko.

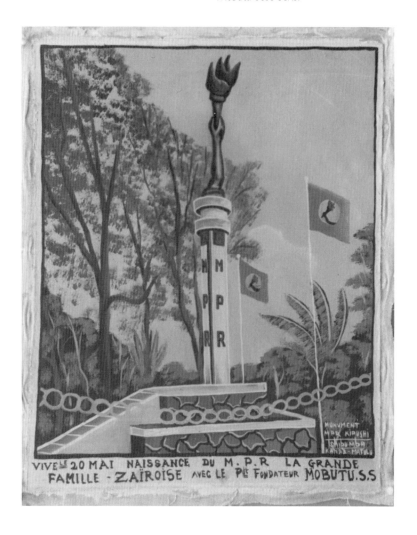

I think I can go back now to the MPR, the Popular Movement of the Revolution, which we mentioned earlier. On May 20, Mobutu decided to unveil the torch of the Revolution. In this painting I show the Kipushi party monument. Because I live in Kipushi and see it all the time, that is the one I chose to paint. After all, I am doing this history as a resident of Kipushi. If I lived in Lubumbashi I would

have done the monument that is there. Should you prefer the one in Likasi, I'll do it, or the one in Kolwezi; all of them I could do. Many could be painted, but they all represent the one and only MPR. This is what it says on the painting: "Long live the 20th of May, birth of the Popular Movement of the Revolution, the great Zairian family with the president and founder Mobutu Sese Seko Nkuku

Ngwendu wa Zabanga." With that inscription I'm referring to an occasion on which Mobutu said that everyone of Zairian descent, old or young, belongs to the MPR. Even if you don't agree. You may disagree and refuse to enroll, but everyone is a member of the MPR. So there you are. Mobutu replaced the flag that you saw earlier, the one with the star and a bar through the middle, and unveiled the green flag, with a torch in the middle of a yellow circle.

F: As you said, you could also do the party monument here in Lubumbashi.

T: Oh, I could do the one in Lubumbashi or any place. But I live in Kipushi, so I did the one in Kipushi. If you like, I can bring you a small photograph of it. It's exactly the same.

Painting 92 The Popular Movement of the Revolution (MPR) was founded on April 17, 1967, and its program proclaimed on May 20 in the "Manifeste de la Nsele" (Cornevin 1989, 441–42). An article on the inauguration of the party monument at Kipushi on Saturday, May 19, 1973, appears, with a photograph, in *Mwana Shaba*, no. 215, July 15, 1973. Tshibumba's picture was probably based on this photograph. The angle is the same, but the painting omits the spectators that are visible in the photograph and adds the party flag on the right.

Mobutu's Speech before the United Nations Assembly

The United Nations' most-applauded speech.

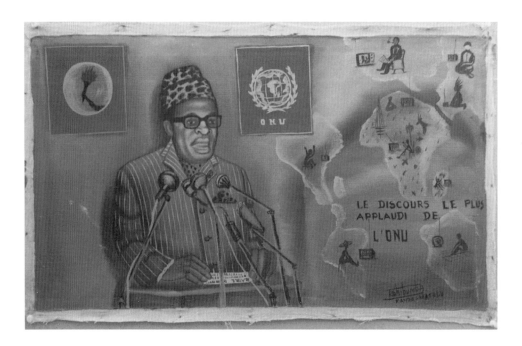

It was on October 4, if I am not mistaken, that Mobutu traveled to the UN. There he gave a speech, and that speech remains truly historic. Even I, when I thought about it, told myself, "It is true." So what Mobutu has in mind is true—or else it is a lie. But that's something I keep to myself. What is true is that he started out with ideas that were correct. So he spoke, and we all agreed; not a single thing was disputed. And it was a speech of which this one gentleman said—someone from the UN, I forget his name—that of all the speeches ever made at the UN, it was "the one that drew the most applause." It was Kissinger, if that's the name. Yes, he was the one who described it that way. As you can see, everywhere in the world people were listening. The white man in Europe listened. He watched it on television. The same in Asia, with the yellow people. And farther down in Asia, there are the Indians; they, too, listened, on the other side of the Suez Canal. In Africa there were Arabs and blacks among those who listened. In Oceania, they listened. Also in America, in Mexico—everywhere they listened, everywhere in the two parts of America, South and North.

F: I can see that you put every race of people in its place.

T: In its place.

F: Here in North America, who are those people?

T: You mean in South America.

F: No, North America.

T: There, in America, those are Negroes.

F: Negroes?

T: American Negroes.

F: And this Indian?

T: He has the headdress of the redskins.

F: What?

T: Like the redskins have, with feathers.

F: And he lives in Asia?

T: Yes, in Asia.

F: Then comes the European.

T: No, that one is yellow. Those are the Chinese and Japanese.

F: And down in Oceania?

T: In Oceania? Let's say those are dark people; they have skin the color of chocolate. And over here are the Mexicans and Brazilians.

Painting 93 Mobutu's address to the United Nations assembly on October 10, 1973, is published in Mobutu 1975, 2:360–89; for the passage cited in the inscription, see 263. The speech is mentioned only in passing in Young and Turner, for its announcing the rupture of relations with Israel (1985, 64).

Zairianization

Measures of November 30, 1973.

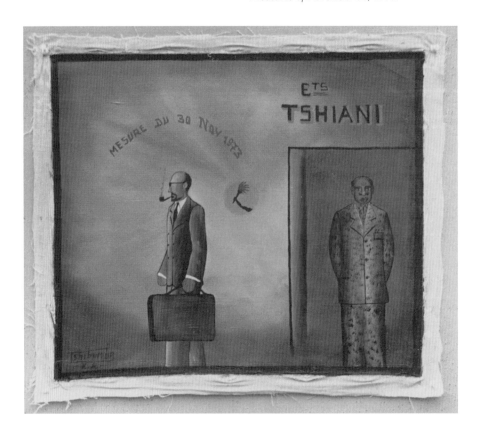

Soon after that, on November 30, 1973, Mobutu conceived and—how shall we put it?—carried out the "Measures of November 30, 1973," the so-called Zairianization, a term I have trouble pronouncing. Anyway, what he said was that everything must be in the hands of those who were born in Zaire. That means all kinds of work—for instance, wherever there was a directorship, it should be held by a black person. As far as shops were concerned,

a black person should run them. "You, the Greeks, should go home," Mobutu said. "Don't go in anger. We will not rob you of your possessions; we will begin to reimburse you in yearly installments, as determined by the owner." But exactly what was said I don't really know. I think the expatriates just left, and those people took over the shops. So you see here in Lubumbashi we have the "Etablissement Tshiani." It's a well-known name, and I put it there because of their ad I heard on the radio. The painting shows the entrance to a store, and what's happening is that the white man is going away and leaving the shop to the new proprietor.

F: Now we get to the famous "measures" — the whites are leaving.

T: Well, to be honest, this is a picture I did in a hurry. I was planning to show both the white man and the Zairian with their wives and children.

F: But there was no time. . . . "Tshiani," why did you choose this name?

T: Tshiani is an establishment here that I know quite well.

F: What was it called before it was Zairianized?

T: Tshiani? I really don't know.

F: So maybe it had belonged to Kasaian traders.

T: No, not to Africans. I just don't know.

F: So the white man is leaving with his suitcase.

T: With his suitcase; his possessions stay behind.

Painting 94 The measures collectively referred to as "Zairianization" were announced by Mobutu on November 30, 1973. They "provided for the seizure of a vast swath of the economy which had remained in foreign hands: Most commerce, most of the plantation sector, many small industries, construction firms, transportation, and property-holding enterprises" (Young and Turner 1985, 326–27; on its implementation and consequences, see 326–50).

Happiness, Tranquillity, and the Joy of Living in Peace

Happiness—tranquillity—joy of living in peace.

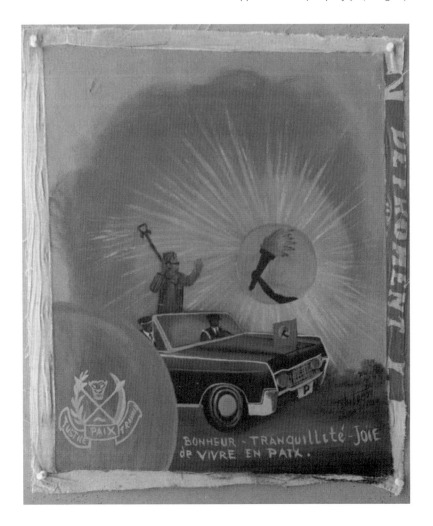

A nd now the last picture. I won't tell what its meaning is, the meaning of this picture. You see the rays that come from the torch there that's like the sun? It lights up the whole of Zaire. That's in the story. It lights up the whole of Zaire. It means that we now live in happiness, tranquillity, and joy. I inscribed this picture: "Happiness, tranquillity, and the joy of living in peace." We have justice, peace, work. That is something like our motto. Indeed, I now come to the close of my History. Regarding this project we have met to discuss today, I have followed the entire course of history. I did so without guile. The aim I had was to tell the history of our country. There is nothing bad about that, nor is what I am doing politics. When I work I have in my mind this child who is going to grow up

and will confront that history. Even our president knows how Zaire used to be, that it later became the Congo and then Zaire again. On October 27 he gave the name "Zaire" back to it, and we were all happy about it. I think I have finished. There is nothing else to say. I wish you a good trip, and that I may remain well.

F: So we come to the last picture.

T: Happiness.

F: The president drives around in his car.

T: With his stick — his "pilgrim's staff" — his chief's hat, his *abacos* [Zairian suit], and a scarf around his neck. That, as he has said, is what our authenticity looks like. It is an African idea. Just because the whites brought the material does not mean we follow their ideas when we dress. We arrange our dress the way we see fit. You know the emblem "Justice, Peace, Work," and the flag radiating light. It's about all of us, even the car; it means that we are all in this light that he shines on us, as I said, in peace and tranquillity.

Painting 95 This picture could have been inspired by a photograph showing Mobutu's "triumphal entry into the city of Lubumbashi" in *Mwana Shaba*, no. 207, November 15, 1972. Mobutu stands in an open limousine, his arms raised, waving a staff in his right hand.

The Martyrs of the Economy

June 20. Martyrs of the national economy.

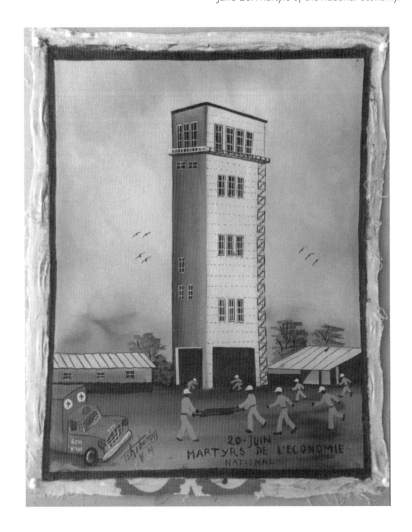

F: So, today we are meeting one more time to talk about those last paintings you brought.

T: That's right, the last paintings. Here is what I've brought you. On this one it says, "June 20, the martyrs of the national economy." It's about something that really happened. The place is where the Gécamines stadium used to be. They tore it down because they found ore in the

ground, and that's where they built pit number 5. And when pit 5 was declared finished, in June 1972, and the miners began their work down there, they had an accident. I don't know what went wrong down there with their work, but it killed six miners, and one other suffered a fracture. When he heard the news, the president of the republic, Mobutu, happened to be traveling—I can't think of which town he was in, I forgot—and left immediately from wherever he

was to go to Lubumbashi, to Kipushi. He wanted to see what had happened and greet the bereaved. And some money was distributed among the people who had to endure loss, the wives of those miners. Then he left. Not long after that, the one miner who had suffered a fracture in the accident also died. I think that is what I have to say about this painting. Their graves are now in Kipushi. If you go there you will find them near the entrance to the compound of the Gécamines mining company.

F: Did you see it happen?

T: No, at that time I was in Likasi.

Painting 96 On August 15, 1972, *Mwana Shaba* published an article and photographs of Mobutu's visit to the survivors of the Kipushi accident (which occurred on June 20, 1972). The headline proclaims, "Six miners gave their lives for the success of the Gécamines, the progress of Zaire, and the happiness of all Zairians." In addition to the six fatalities, twenty-nine workers were injured. Mobutu's visit was on June 27, 1972, and he is said to have come to Lubumbashi from Conakry, in Guinea.

Painting 97 [see color plate]

The Key to the Future

Key to the future. Mysterious dream of the artist Tshibumba Kanda Matulu. 100 years for Mobutu.

T: This picture shows something I called "The Mysterious Dream of the Artist Tshibumba Kanda Matulu." Really, it goes back to our conversation the other day. What you told me was, "Could you give me the future of the country?" I think the future of the country is something of great importance. We usually regard those who foretell the future of the country as prophets. A scholar, for instance, can think about the future, and he, too, can speak out about it. So I went inside my house and thought about the future in every way I could, but I failed. Finally I grew tired, and I put my radio at the head of my bed. Then sleep took hold of me and I dreamed of this and that, always with the idea that I should receive the future, but was it going to happen? I failed miserably. I listened to the music that was playing; it was already midnight. As the music was playing, it brought me a dream. I dreamed of this building, the way you see it. I didn't really see that it was a building, it was in a dream; and the colors I chose, all this was in the dream, and it did not sit still. I would look, and there it appeared differently again. Now, the music they began to play — it was the night program about the Revolution — they began to sing a song, "Let us pray for a hundred years for Mobutu." Now, the vision I had was this: There

were those skeletons that were coming out of this building, here and there, on both sides. Then this one here approaches. Then mournful singing started in female voices; that was over there, on the side of the building. So sleep had gotten hold of me, and I dreamed of those skeletons. They just kept walking around, and I started to run away. Running like mad, I came in my dream to a small village. The painting of that little village is still at home. It's there in my house. I was woken up in the morning, and I told myself, I am going to put this on my canvas. You see the skeleton standing there. Then they played another song that really woke me up, a song that Tabu Ley used to sing long ago: "soki okutani na Lumumba: okuloba nini." Now I thought about those dreams that had come to me in the light of authenticity: If you dream, it means that we, let's say, we as Africans, live with the spirits. Let's say we believe in our spirits. And I thought about the saying we have: If you go too far, where will you get to? You are going to meet Lumumba; what will you tell him? Then I thought that I may be locked up because of this, or something else may happen to me, and I was really scared. And then I thought about it and finally I came up with a picture I could show you. It's in my house; when you go to Kipushi you will find it there. It's a bit provocative. Now the tall skeleton just stood upright at the time. Then I woke up and began to tell my wife about it. So I was full of fear. When I tried to think about other paintings I could do, I failed to come up with any. Then I thought: No, I'll do that painting exactly like the dream that came to me. Because what Mr. Fabian asked me was whether I could do the future. While such thoughts went through my head, I set out to dream what was asked for. Actually, I did not consciously think anything, the ideas I had came as a surprise, such as when those skeletons appeared there. In my sleep I ran as fast as I could, and I was startled to hear that they were singing this song, "Kashama Nkoy." That was the song they began to sing.

F: "Kashama Nkoy"?

T: "Kashama Nkoy"; it's a record by Tabu Ley. Now, singing in Lingala, he said, "soki okutani Lumumba: okoloba nini?" Which is to say, in Swahili: If you were to meet Lumumba now, what would you say? I woke up with a start and told my wife about it.

The World of Tomorrow

The world of tomorrow will be full of people.

T: Now, in the morning I could not work again, I did not have a single idea how to go about the task. That was when I thought: Here you are, there is this dream, and there is what you told me. I will try to do this my way. I picked up a brush, but it was impossible. I made an attempt with a painting like the one you see here. It has no clear message, nothing that keeps it together; nor does it have the savor a picture should have — in short, it has no style. What I thought was that the world, like our country here, will be full of people, I know this quite well. That is what we are heading for. And those people, when there are so many of them, it means that all our young women will simply be destroyed. There will be no more marriage. What will happen is that a person, even a small girl, will run around. Little children will be abandoned in the street. People will be many, and it will be difficult to get food, because the people will be disorganized, they'll be like madmen. Some will smoke drugs, that's what is going to happen. Let's say we will simply lose our way.

Painting 99

The End of Religion

In the future, there will be no religions.

т: But our losing our way will come from God. Then no one will believe anymore that God even exists. I think this will happen in the churches; we will lose the churches. How are those churches going to be lost? Their being lost simply means that they will be taken over in the name of the MPR. The party will be God here in Zaire. All the people will have only ideas that come from Mobutu. The religions will be lost, as I show you in this painting. Those churches will be temples of the party. What will happen is that revolutionary songs will be sung, all those songs like the ones we have now. People will begin to dance in there, and in the end I don't know what God himself will think about all that's going to happen. The world will not be as I have been describing it to you in my History. All those houses of God will be temples of the party. And people will sing there, drink beer, and have a good time. But we don't know what God is going to think about that. And whether it is the end of the world we are heading for, none of us knows. That was a thought I had.

Paintings 99–100 Without using the term, Tshibumba refers in these pictures to "the presidential doctrine of Mobutism [which] was ostensibly approved by the Political Bureau on 11–13 July 1974, and was publicly unveiled shortly thereafter as part of the new constitution" (Young and Turner 1985, 215; on Mobutism as a religious cult, see 170–71). See also Callaghy, who quotes the journal *Zaïre-Afrique* (no. 91 [January 1975]: 25): "Henceforth, the MPR must be considered as a Church and its Founder as a Messiah" (1984, 173).

"I Believe in Mobutu, Almighty Father"

"I believe in Mobutu, Almighty Father."

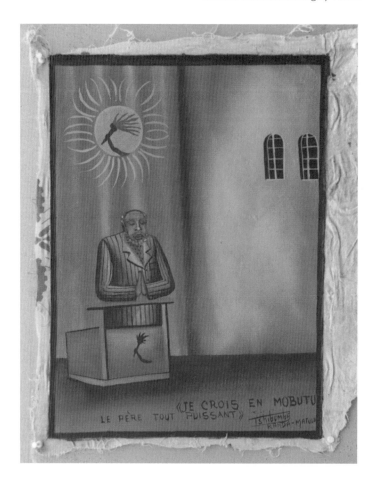

T: When someone enters a house of God, I think he will kneel; there is no other way. And he will begin to pray. Instead of "In the name of God," he will say, "In the name of Mobutu." Something like, "I believe in Mobutu, Almighty Father." I am not talking nonsense when I speak of this, because right now, you can already see it a little. For instance, there's a song in the Catholic religion. It is now being sung—it is the song that says, if I may sing it to you, "I praise the Lord, Almighty Father, Creator of heaven and earth." Now they changed it, and some have begun to

say, "I praise Kuku Ngwendu, Mobutu, Sese Seko wa Zabanga." You understand, this is why I think that when the future arrives, everyone will lose the path of religion. They will go to the house of God, kneel down, and pray for the Revolution. It scares me to envision how the world will progress. But I am unable to figure out what will happen at that point.

F: The person who appears in the picture, is that an old man?

T: He is an old man. Those people—all of us here will be old. I will get there, and perhaps I am going to act just like that.

The Four Positions

In the future, the four positions.

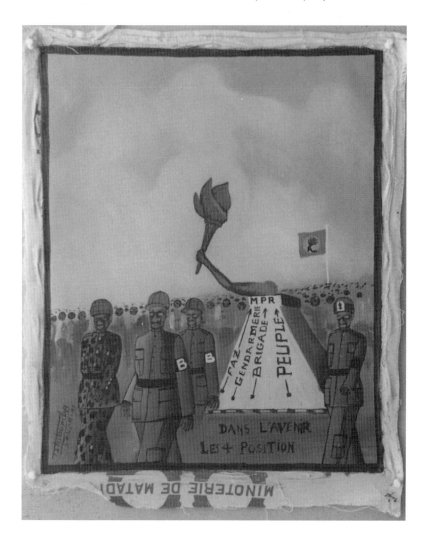

F: So now the final painting.

T: The last one. Now, I think that after that, after many years — remember, I wrote "A Hundred Years for Mobutu" on that first picture — I think that the people who are alive now will have died. But we should know that there are four positions, which means four roads. But the father of the Revolution is Mobutu. We here are like someone's children. We are growing up. The day our father dies, we, all the children, will rise up against each other. This one is going to say, "I get the father's wealth." Another one says, "I get the father's wealth." For instance, right now we have the armed forces, the FAZ. We have the gendarmerie, the brigades, and the people. What is going to happen is that there will be demands from the FAZ: "We should have the power." The

gendarmes will say, "We should have the power." Because among them are the paratroopers and others. And the brigadiers, the brigades, are going to say, "We should have the power." The people, for instance the politicians and some others, will make the same demands. I think there will be big trouble, and I am unable to explain this to you. But it is the future that will explain things to us. There you are, that is how far I got with my thoughts.

F: Well, thank you. Thank you.

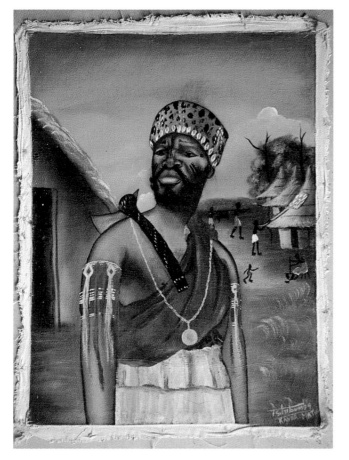

Painting 1 (above)
Landscape

Painting 3 (left)
Traditional Chief

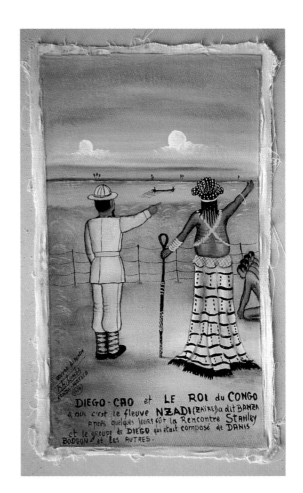

Painting 5 (right)
*Diogo Cāo and the
King of Kongo*

Painting 9 (below)
Stanley Meets Livingstone

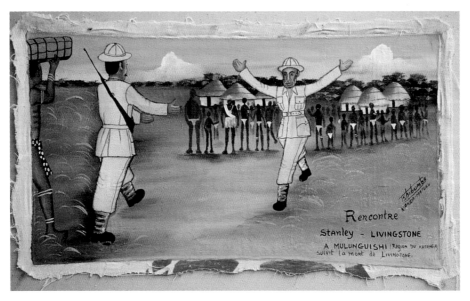

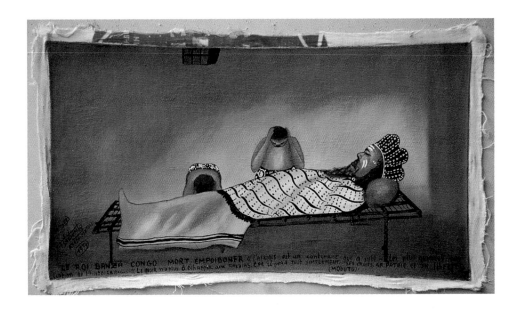

LE ROI BANZA CONGO MORT EMPOISONER «L'Afrique est un continent qui a subi... le plus grand... ... de l'histoire... « Le noir n'a plus à échapper aux rhexias. Car il peut tout simplement... ses droits sa patrie et sa liberté... (MODUTU)»

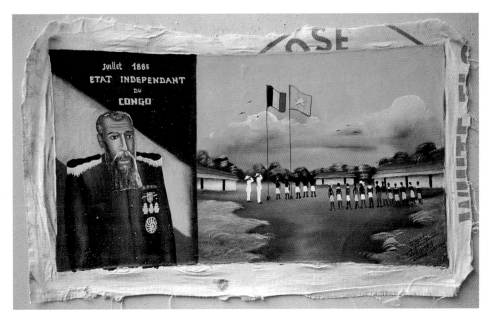

Juillet 1885
ETAT INDEPENDANT
DU
CONGO

Painting 14 (top)

The Poisoned Banza Kongo

Painting 20 (bottom)

The Congo Free State

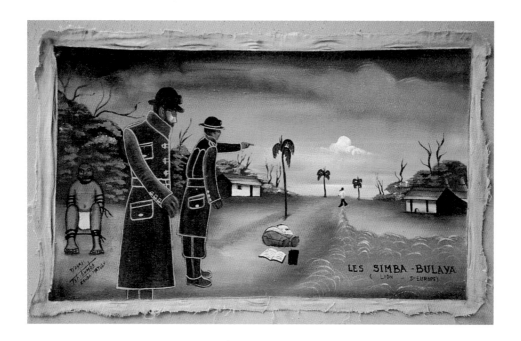

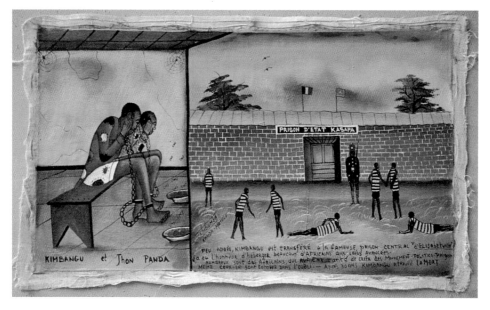

Painting 22 (top)
Lions from Europe

Painting 26 (bottom)
Simon Kimbangu and
John Panda in Prison

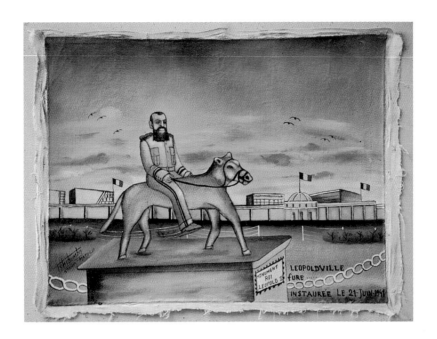

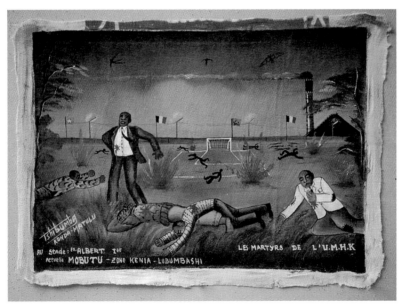

Painting 27 (top)
The Monument to Leopold II

Painting 28 (bottom)
Victims of the Miners' Strike

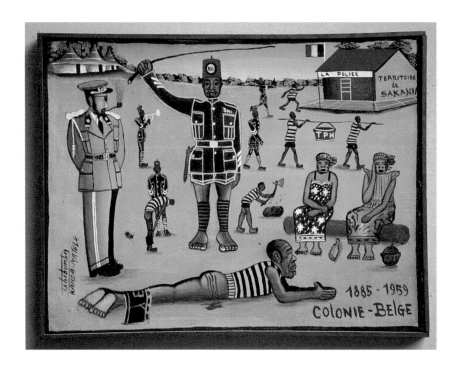

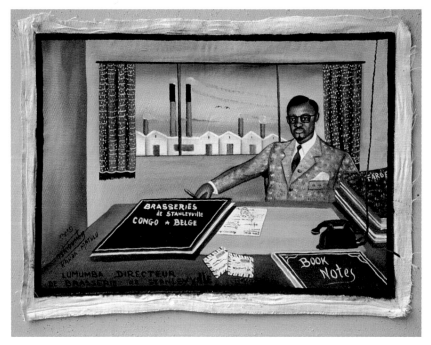

Painting 34 (top)
Colonie Belge: *Under Belgian Rule*

Painting 36 (bottom)
Lumumba, Director of a Brewery

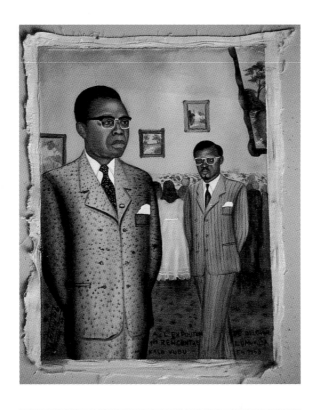

Painting 39
Kasavubu and Lumumba
Meet at the Brussels
World's Fair

Painting 44
Lumumba in Buluo Prison

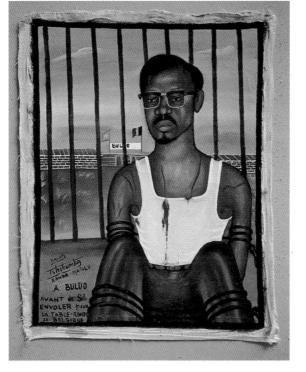

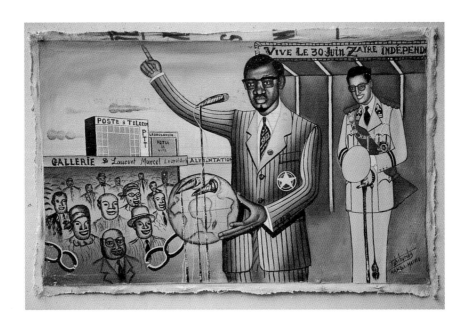

Painting 49 (top)
Lumumba Makes His
Famous Speech

Painting 54 (bottom)
The Luba Kingdom and the
Building of Mbuji-Mayi

Painting 62 (top)
Katanga Troops on a Train at Luena

Painting 63 (bottom)
The Katanga Women Protest

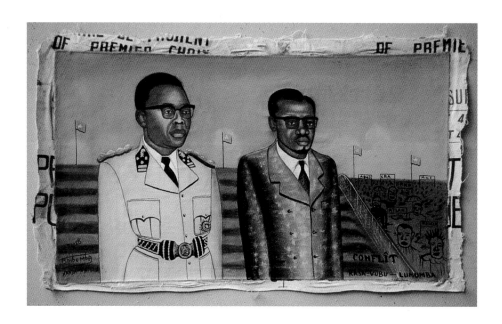

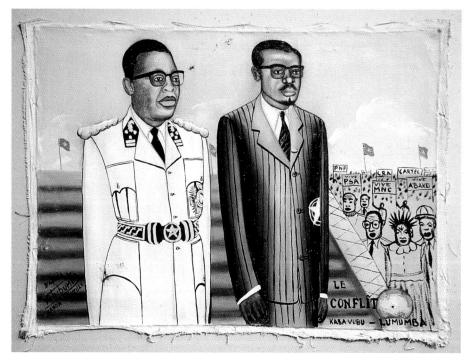

Painting 64a (top)
*The Kasavubu-Lumumba
Conflict*

Painting 64b (bottom)
*The Kasavubu-Lumumba
Conflict*

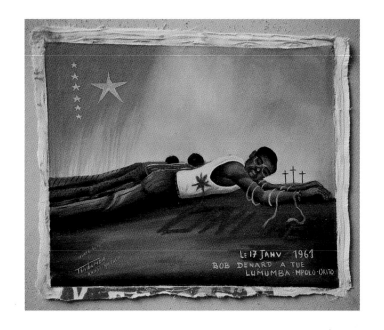

Painting 68
The Deaths of Lumumba,
Mpolo, and Okito

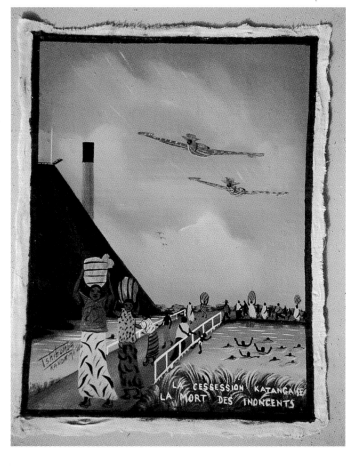

Painting 69
The Deaths of the
Innocent Children

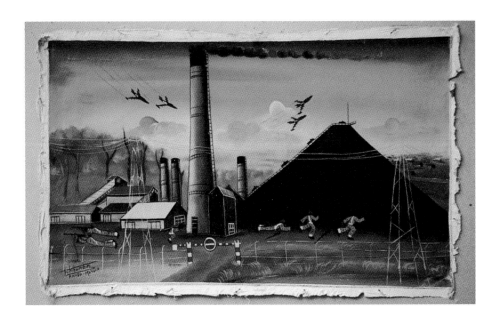

Painting 75 (above)
Planes Attacking the
Lubumbashi Smelter

Painting 83 (right)
The Mulelist Uprising

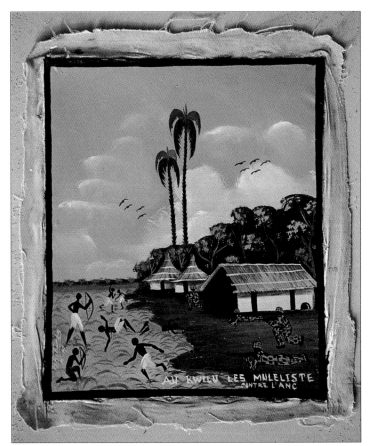

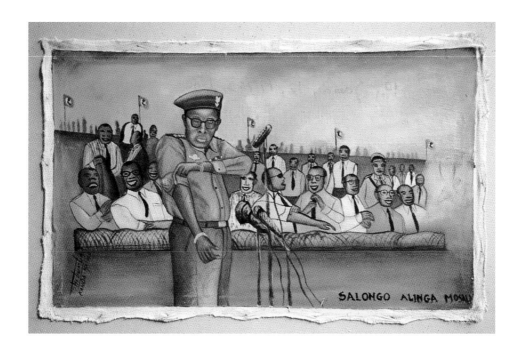

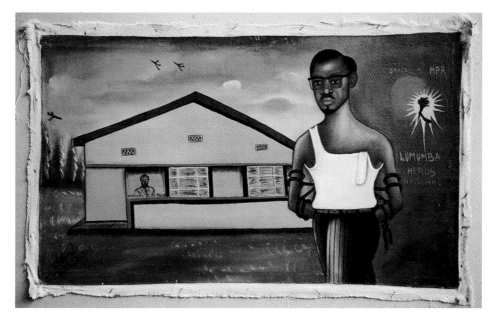

Painting 86 (top)
Mobutu Rolling Up His Sleeves

Painting 87 (bottom)
*The MPR Makes Lumumba
a National Hero*

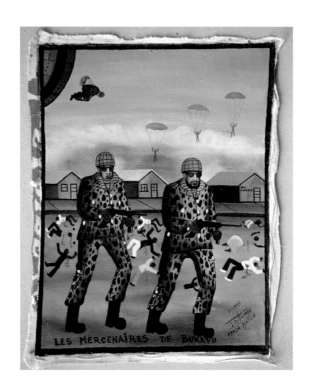

Painting 88
The Mercenaries
Landing at Bukavu

Painting 91
Pope Paul VI Approves
Mobutu's Policies

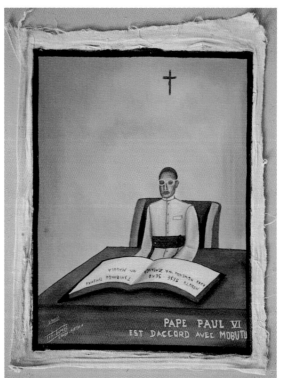

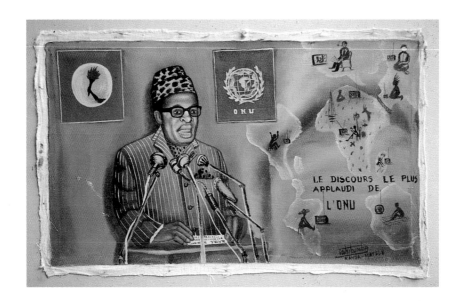

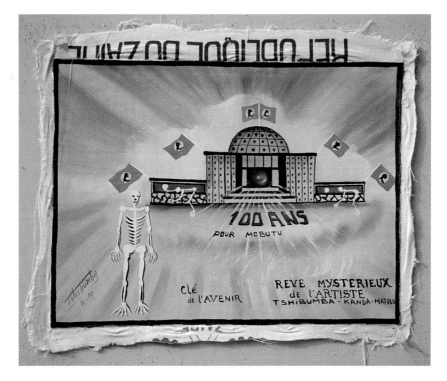

Painting 93 (top)
Mobutu's Speech before the
United Nations Assembly

Painting 97 (bottom)
The Key to the Future

Two genre paintings of
Mamba muntu: *a mermaid
(top), as portrayed by
Kabuika; a crocodile person
(bottom), as depicted by
L. Kalema. (See Part II,
Figures 1.19–20.)*

PART II

All Was Lost:
Ethnographic Essays on
Tshibumba's History of Zaire

INTRODUCTION

The second part of this book offers an ethnography of the work presented in the first part. In a time when sociologists, political scientists, historians, and even philosophers of science approach their subjects "ethnographically," it is perhaps not superfluous to state what an anthropologist — or at any rate, this anthropologist — means by "ethnography." An ethnography is, first of all, a piece of writing that addresses those questions that must be asked when anthropological theory is to be related to information, experiences, and insights gathered through the research practices which themselves are commonly called "ethnography." Such writing is usually, and most authoritatively, based on fieldwork (often also called "ethnography"). This firsthand information may be anything that is produced by the people studied: objects and ornaments, statements and stories, gestures and movements, sounds and images. Ethnographies may differ in genre, ranging from systematic analyses to narratives, from detached reports to autobiographical accounts. Some are spiked with tables and diagrams, others with anecdotes and recollections, still others with dialogue and quoted texts. More likely than not, an interesting ethnography will employ most of these devices.

Conventions of anthropological writing have changed over time. Experimentation with genre is currently much discussed; distinctions between scientific prose and "literary" writing have become blurred. In my opinion, this literary turn and the new sensitivity to ethnography as *writing* have sharpened the critique of anthropological discourse and practice. Nevertheless, the quality of an ethnography, including the generic choices made by its writer, should be judged by epistemological criteria. Narrative and poetic skills are valuable, but they do not guarantee that a piece of anthropological writing makes a valid contribution to scientific knowledge.[1]

Anthropologists tend to establish their authority by interlacing their treatises with careful ethnographic descriptions, thereby controlling, as they write, dosage and timing. Too much ethnography could bore the reader (and discredit the writer as a theoretician);

1. A collection of essays edited by Clifford and Marcus (1986) and Geertz 1988 have become the standard references in this debate. Among recent critical responses, see Comaroff and Comaroff 1992. I state my own position in Fabian 1991b, chapter 11; see also chapters 10, 12, and 13).

too little of it may cast doubts on the writer's competence as a researcher (if he or she claims to make a contribution to empirical knowledge).

Introductions to ethnographies are among the more standardized, predictable conventions of anthropological writing. They usually make the assumption, justified or not, that the reader is ignorant of the material that is to be analyzed and interpreted. Clearly, the present ethnography cannot start with the assumption of ignorance. Having contemplated the images, listened to the narrative and conversations, and consulted the notes in Part I, the reader may still yearn for an authoritative chapter on the political and social history of Zaire. Such an account, assuming it could be given by someone whose picture of Zaire is more coherent than mine, would undermine what I have tried to achieve in Part I: Tshibumba's work should speak in its own voice, one both familiar and strange, pleasing and troubling.

There is another possible expectation that I must dispel: I do not consider the voluminous information provided in the first half of this book to be a presentation of data from which we can now proceed to analysis and interpretation — to another plane, as it were. Rather, as in my previous attempts to understand the emergence of contemporary culture in the Shaba region of Zaire,[2] I think of interpretation as a continuation of the interpreted discourse by other means. Shaba popular paintings and Tshibumba's History of Zaire are cultural *products*. The task of ethnography is to work out and describe their *production*.

Much of our attention will be devoted to the efforts Tshibumba had to make in order to detach himself from the strictures of genre painting. Therefore, it is all the more important to remind ourselves that he began as a genre painter, never ceased to be one, and conceived his historical project in constant confrontation with genre painting. The fame he has achieved is richly deserved. His paintings have qualities that make them worthy of exhibition as objets d'art, irrespective of their context. His work has found enthusiastic as well as knowledgeable critics and interpreters, who have established his presence in the literature on contemporary African art and beyond.[3] Most of what has been written about Tshibumba is valuable, with insights borne out by the evidence hitherto available: the more or less extensive collections of his historical paintings, notes presumably based on conversations with him, and one scenario for his History of Zaire written in French.[4] More recently there have been essays that focus on a single paint-

2. See Fabian 1990a, 161–65; 1990b, 257–63.
3. A comprehensive source is a collection recently edited by B. Jewsiewicki (1992). In addition to the essays assembled there and those featured in several exhibition catalogs, other writings include Biaya 1988; Brett 1986; Fabian 1978; Fabian and Szombati-Fabian 1980; Jewsiewicki 1986a, 1986b, 1987, 1988, 1991a, 1991b; Jules-Rosette 1984, 1990; Szombati-Fabian and Fabian 1976. Cited as an example of the capacity of Zairian popular painting to generate "memory," Tshibumba's work has now entered the mainstream of art-historical discussion; see Küchler and Melion 1991, 4.
4. B. Jewsiewicki has kindly made a copy of the scenario available to me. It consists of seventy-two pages, handwritten in what appears to be an exercise book. It is dated Lubumbashi, September 1, 1980, and signed by Tshibumba with his illegible autograph — the same he used in 1974 to sign receipts — which is different from

ing — and why not? Every painting of Tshibumba's offers food for thought and, if enough interesting questions are brought to the task, could serve as the subject of a monograph. This book, however, has a different aim. I do not even attempt to analyze a single picture at length; not only would I be out of my depth with such an undertaking but, more important, I need all the space and energy given to this book to accomplish the ethnographic task I have set myself.

Given the prominence of painting in the first part of this study, it is inevitable that this book will be classified as a book on African art, which it is, if at all, only indirectly. Part of taking an ethnographic approach has been the decision to work "from the bottom up," to let theoretical issues take shape in the course of describing the project. This has saved me from having to make a choice among available theoretical paradigms in the subdiscipline called anthropology of art, as well as from constantly having to check my interpretations against art history and criticism, although I have sought illumination from, and also confrontation with, these fields when I found them useful. Anthropologists of art now entertain the idea that their best contributions might be made by bracketing the concepts of art and aesthetics as Western preconceptions (see Coote and Shelton 1992, introduction). I sympathize with the intention, even though I doubt that the theoretical and conceptual abstinence it implies is possible or even desirable, given the autocritical role anthropology must play if it is to be worthwhile. Above all, such bracketing presupposes non-Western producers of objects and discourses who do without terms and concepts that designate their products as art and specify criteria of appreciation; clearly Tshibumba does not fit that category. What he *says* about art and aesthetics — or for that matter, about painting — remains of secondary importance compared to his ambitions as a historian. What he *does* as a painter is absolutely essential to his work as a historian. The objects he created are part of the pragmatic context of this language-centered ethnography of Tshibumba's History of Zaire.

What, then, is the contribution I hope to make with this study? To begin with, presenting Tshibumba's first full series of paintings covering the history of Zaire together with the recorded texts is bound to put ethnographic flesh on a skeleton of interpretations assembled from collections and other documentation that have been available so far. I regret that for practical, economic reasons alone it is not possible to include in this volume the Swahili transcripts of the narrative and conversations. Their documentary

his signature on paintings. It is impossible to determine exactly how many paintings were planned to go with this account, but the outline as well as much of the detail are essentially the same as in the History of Zaire that I recorded with him (an assessment that contradicts Jewsiewicki's, however; see 1986b, 200). Like the recorded account, the written one is preceded by a reflection on historiography. The most noticeable differences show up in the first section, on prehistory and early history. The king encountered by Diogo Cão is now Nzinga Kuwu (see the note to Painting 5 in Part I); there are chapters — some of them consisting only of a headline — about the kingdoms of the Luba, Kuba, Pende, Luba-Shankadi, and Lunda. The bulk is again devoted to the troubles preceding and following independence (often with more detail than in the oral account). At the end, the story is brought up to date for 1980. As an afterthought, Tshibumba then adds a note on what he must have experienced as the most pressing problem at the time: tribalism.

value will surely increase as studies of Shaba popular culture and language proliferate. I refer to them in the following essays and give brief excerpts whenever they are necessary to an argument or might otherwise help to understand Tshibumba's thought.[5] In short, what this book offers will serve the growing interest among historians of Africa and historians, critics, and anthropologists of art for ethnographic context and methods. Furthermore, by introducing Tshibumba through Shaba genre painting, I hope to show why his work is not properly appreciated when one ignores that he was not unique in his ambitions to transcend the well-defined and relatively closed system of accepted genres. Other painters tried to leave these confines by portraying recent political events.[6]

There is also a theoretical issue I wish to raise with my work. Like every discourse, the one that has been pronounced on Tshibumba construes its subject. The critique to which our constructions must be submitted does not question that they are constructs. Who is still prepared to maintain that we do nothing but accurately represent data and then analyze them? We must, however, be willing to discuss how we arrive at our constructs and what or whom we claim them to represent. In the light of these questions, ethnographers cannot simply be suppliers of interesting material. Our ambition is, or should be, to represent the people we study—groups as well as individuals—in a way that does not erase their presence as historical subjects and agents. Whether this study establishes Tshibumba as an artist according to the standards of current art criticism or as a historical figure worthy of being included in African historiography does not concern me here. I take a frankly "disciplinary" approach, as much as this is possible in a field that knows little discipline. My responsibility as an anthropologist is to represent Tshibumba and his work in such a way that they add to or deepen our knowledge of the culture in which they emerged.[7] In this particular case, a painter realized an extraordinary project because he received support from expatriate researchers. He has since "arrived" on the public scene before this book could appear. That does not preempt our ethnographic labors. On the contrary, anthropology's critical contributions are called upon precisely whenever representations of other cultures—their producers as well as their products—are being appropriated by discourses for whom otherness is not a concern. There is more to Tshibumba and to popular culture in Shaba than the painter's current fame leads us to suspect.

5. There are plans for a complete publication of the texts in a series tentatively titled "Archives of Popular Swahili."

6. Often these were scenes from the passion of Lumumba. In the collection of genre paintings at my disposal I also find a series of three (originally four, as indicated by the numbering) that depict the uprising of Katanga women against UN troops (cf. Painting 63 in Part I).

7. I admire my colleague M. Bal for the daring and sophistication she displays in her programmatically *interdisciplinary* study of Rembrandt (1991). She made me a present of her book and I read it—after writing this one—but I cannot even begin to annotate my presentation and interpretations of Tshibumba's work with references to theoretical agreements and acknowledgments of priority. More interesting would be to bring up points of disagreement, but I don't think this study, which I experienced as testing the limits of my abilities as an anthropologist, is the place to discuss them.

Here, then, is a summary of the issues explored in Part II: In the first chapter I place Tshibumba's work in the context in which (and, as we shall see, against which) he painted. The two chapters that follow describe the making of his History of Zaire. In Chapter 2, I describe the process by which the idea of a painted and narrated history of Zaire became material and textual reality. After considering the ethnographic events that resulted in the recordings, we turn to Tshibumba's pictorial language — that is, to those recursive iconic elements and symbols that invite semiotic interpretation, to his technical skills, and to his aesthetic conceptions. Chapter 3 shows, with the help of the concept of performance, how Tshibumba mobilized all these features as well as popular genres, such as music and storytelling, as sources of memory and how he staged individual paintings and linked sequences as enactments of plots. I conclude with two chapters that examine what Tshibumba has to say (and show) about the meaning of history (Chapter 4) and about the nature of historical knowledge (Chapter 5).

Most of the fragments of Tshibumba's narrative quoted in Part II were not lifted from the edited versions in Part I but translated again from the original. Certain interpretive points demanded closer adherence to the original, especially when Swahili or French terms were included. Moreover, it is part of the approach taken here to reject the idea of a given text; every new context in which the original is used may result in a slightly different translation.

Genre and Popular Painting in Shaba

In the Preface I introduced Tshibumba as one of many genre painters who produced a vast corpus of pictures (usually acrylic on canvas, but any substitute for either would do) that was encountered in 1972–74 during ethnographic research in the urban industrial towns of Shaba, the southeastern part of Zaire. A first proposal that this phenomenon should be understood as genre painting was formulated not long after the research was concluded (Szombati-Fabian and Fabian 1976). We established a preliminary list, or system, of genres, based more on immediate experience than on careful analysis of paintings and recorded conversations with painters. The proposed schema (see Table 1.1 below), accompanied by warnings against its indiscriminate use in other contexts, was evidently convincing enough, as it was soon adopted by researchers working in other parts of Africa.

Although I have by no means finished processing the ethnographic material, I am now in a better position to take up two issues. First, I would like to spell out more explicitly the reasons for working with the notion of genre in approaching popular painting in Shaba and to note a number of problems and corrections with regard to the proposed schema of genres. Second, I hope to show how Tshibumba's History of Zaire must be seen as both steeped in and marking an extraordinary departure from genre painting. Insights gained in the course of the present study strongly support the basic assertions made in the 1976 article. These new findings are especially valuable when it comes to appreciating the enabling as well as constrictive aspects of genre painting. They also help to ask more precise questions regarding the political and critical significance of Shaba genre painting.

GENRE IN SHABA POPULAR PAINTING:
THINKING THE PAST, REMEMBERING THE PRESENT

When popular painting in Shaba first became an object of study, the procedure that was followed — if indeed the enthusiastic but rather unsystematic pursuit of these newly dis-

covered ethnographic sources might be called such — was more one of ethnographic fieldwork than of museum collecting. Inquiry was directed first of all at *practices* — of producing images, selling paintings, decorating houses, telling stories. As *objects*, paintings were studied (and acquired) only to the extent that they were part of those practices. Admittedly, a rather vague idea of resemblances in function and content with genre painting in seventeenth-century Europe was partly behind the argument that these pictures represented "genres." I recall being struck by two similarities: Sociologically and economically, genre painting seems to have been part of the processes of *embourgeoisement*. It emerged under such conditions — notwithstanding important differences — in both seventeenth-century Holland, for example, and African urban centers (at least until general pauperization set in after the oil crisis of the seventies). More fundamentally, or practically, genre painting seemed in both cases to be tied to changes in material culture. The differentiation of living space in private residences and the desire to display signs of affluence — in this case on empty walls — created a place for pictures. Of course, these were just hunches. Eventually, the ethnographic (linguistic, folkloric, literary) rather than the art-historical meaning of the term "genre" was decisive.[1]

At about the time when Shaba popular painting was discovered, I had used the concept of genre in an attempt to understand the process by which the communicative practices of the Jamaa, a religious movement in Shaba, generated and determined its teachings in form and content (Fabian 1974, reprinted in Fabian 1991b). The theoretical

1. The history of its use in art history and criticism shows that, depending on its pragmatic, rhetorical deployment, the term "genre" underwent semantic changes — roughly from a formal category to a designation of specific content. Often "genre" has been a pejorative epithet in arguments about the purpose, value, and significance of painting. Even when recognized masters painted genre pictures, at least some aspect of their work, usually the content depicted, was qualified as common, lowly, or even vulgar. Starting with M. Friedländer (1963; first published in 1949), authors of monographs and exhibition catalogues have found it impossible to come up with a really comprehensive definition. Some nevertheless tried, and an interesting one to ponder and argue with is the following:

> A considered definition of the word based upon its original meaning, its historical usage, and its current significance might take the following form: "A genre painting offers a scene of everyday life wherein human figures, being treated as types, are anonymously depicted."
>
> In defining *genre* it is necessary to include reference to the anonymity of the figures, which are portrayed as types rather than as unique personalities, to distinguish genre painting from both the Portrait and the Conversation Piece. In the latter categories, as also in an historical painting, the protagonists are identifiable figures. . . . Were identifiable personages, instead of typical ones, depicted, the painting would fall into the historical category. (Washburn [1954])

"Everyday life," used by Washburn as a descriptive qualification of the scenes portrayed, seems to replace the term "genre" in Langdon 1979 (which also speaks of ordinary life, or low-life scenes). Applying the term to Dutch painting of the seventeenth century, Blankert also invokes "scenes of everyday life" and then proposes the following definition: "A genrepiece is a painting featuring human figures who are all anonymous and intended to be anonymous" (1987, 16). He credits Washburn (rather than Friedländer) with introducing the concept of anonymity in defining "genre" (31n. 3) and then proceeds to show how unsatisfactory such a definition really is, especially when it comes to separating genre from historical painting (an issue that will be central to our discussion). "Everyday life" comes up once again in the subtitle of the most recent work I was able to consult (Johns 1991, xi).

problem for which I sought a solution was the status of "texts," that is, of various verbal performances and exchanges that were recorded during field research on the movement. Genre became the concept that allowed me to relate certain recursive features of text to certain equally recursive features of speech events. It made it possible to argue that these texts were not only tokens, representations of a "system of beliefs," but the actual products of a practice of what the movement itself designated as "thinking." In such a perspective, genre connotes genesis and production rather than class and classification. Genre serves to approach creative processes as involving differentiation of form and content while at the same time stressing the recursive, hence limited or "rule-governed," nature of such differentiation. Genre aims to catch the seemingly contradictory idea of predictable creativity, a kind of creativity that a community can share.

Applied to Shaba popular painting, genre served above all to conceptualize the explicit understandings as to content and form that the artists shared with the buyers of their paintings. During field research it soon became clear that a limited number of *sujets* were reproduced, often in great numbers. While there was considerable variation, the style was always figurative,[2] that is, not given to the decorative, mildly abstract generalizations that had been established as typically African in colonial art schools and workshops. That this expressed a conscious, aesthetic choice directed against painting styles promoted during colonial times can only be surmised.[3] But numerous discussions with painters and their customers made it clear that figurative representations were appreciated because they were required by the nature and purpose of genre paintings: to serve as "reminders" of past experiences and present predicaments. *Ukumbusho*, an abstract noun formed from a causative verb, can clumsily but most accurately be translated as "a quality capable of triggering memories." The term came up in conversations, easily and often, whenever people were asked what they liked in a painting.

Ukumbusho circumscribes not only the function (purpose, intent) of genre painting but also what could be called its semantic domain. The subcategories to which individual genres were assigned in our "system" were taken to be levels of memory. The result looks like a classificatory scheme. However, it would be mistaken to assume that it was produced by formal procedures of more or less arbitrary labeling and more or less justified lumping. The system did not develop by cataloging the paintings of a collection, ordering them according to resemblances or distinctive traits, and then figuring out relationships between the classes thus established. Paintings as such were not the

2. This is another term that requires operating instructions. I find it easier to state what figurative painting is not: It is not abstract, in the sense that all elements of a picture have recognizable references to elements of the world that is depicted. It is not realistic, in the sense that a faithful rendition of what the eye sees is not what these painters aspire to.

3. For a discussion of continuities and discontinuities between precolonial and colonial painting in Zaire see Jewsiewicki 1991a and b; and Vellut 1990. For illustrations see also Cornet et al. 1989 and Musée royal de l'Afrique centrale 1992.

object of research. They became relevant as but one aspect in a much larger inquiry into the emergence of a distinctive popular culture whose expressions included many other media, such as music, storytelling, and theater, as well as the less obvious expressions in clothing, architecture, sports, and religion. Shaba popular pictures were discovered in physical settings and economic as well as communicative contexts: hanging on the walls of living rooms or shops; being carried around by painters in search of buyers; being discussed and interpreted. Painters were invited to speak about their work and their lives, and many of these exchanges (almost all of them in Shaba Swahili) were recorded. With very few exceptions, the pictures that were eventually "collected" were acquired in the context of these documented exchanges.

In sum — although such statements are always open to debate — the structures (or differentiations) that we designated as genres and located on levels of memory were not imposed for analytic convenience only. They were grounded in a shared local discourse, in the structuring of common memories. When frequently repeated events (of speaking as well as painting) show recurrent features, one is, I believe, justified in calling these features generic structures. That the stability the term "structure" connotes is always relative (for example to regional, ethnic, or personal differences in experiences with colonization) does not discredit the notion of genre; it underlines that it is meant to convey a transitive and, indeed, generative meaning of structure (as in "structuring"). Its uses as a device to accommodate vast numbers of pictures in a relatively elegant schema is, as it were, a fringe benefit, and a precarious one at that. As far as I can tell, genre painting in Shaba really bloomed during just one decade (roughly the years of relative calm and affluence, from the consolidation of Mobutu's regime in 1966 to the so-called invasions of Shaba starting in 1976). Because this period is just a moment in terms of history, a synchronic representation of genres as a system can be spuriously convincing. To show that even during their brief existence the structures — and strictures — of genre were being worked on and, as in Tshibumba's case, consciously contested, a processual, historical framework is required.

With these qualifications in mind, let us now take a look at a simplified version of the list of genres that were current in urban industrial Shaba in the early seventies (Table 1.1; cf. Szombati-Fabian and Fabian 1976, 5, table 2). The English labels are descriptive; most are translations of Swahili terms or phrases. Artists and buyers obviously had no difficulty designating a given genre, but one cannot claim that they shared either a completely fixed canon or some sort of definitive terminology. "Folk classifications" do not have to resemble ethnosemantic paradigms in order to work. Though there was agreement about what counted as *ukumbusho*, there was no evidence that customers selected pictures according to the "levels of memory" that we distinguished and labeled in order to establish some sort of sequence. Nor can it be determined whether the genres we distinguished were evenly distributed among the estimated five hundred paintings that were sold each month in Lubumbashi alone.

Table 1.1 　　*Genres in Shaba Popular Painting*

LEVELS OF MEMORY	GENRES	EXAMPLES
Things ancestral	The bush	Fig. 1.1
	The village	Fig. 1.2
	Hunting and fishing	Fig. 1.3
	Powerful animals	Fig. 1.4
	Chief, mask, elder	Fig. 1.5
	Biblical scenes	Fig. 1.6
Things past	Arab slave traders	Fig. 1.7
	Oppressors	Fig. 1.8
	Belgian colony	Fig. 1.9
	War/independence	Fig. 1.10
	Katanga secession	Fig. 1.11
	Rebellion	Fig. 1.12
Things present	Portraits	
	Political	Fig. 1.13
	Family	
	Personal	
	Commercial paintings	
	Shop signs	
	Crédit est mort	Fig. 1.14
	Hairstyles, food	Fig. 1.15
	Nudes	Fig. 1.16
	Cityscapes	
	Smelting plant	Fig. 1.17
	Railway overpass	Fig. 1.18

On the whole, this list has stood the test of time. As far as I can tell, nothing major has been omitted, nor have entries been included that should not be given generic status. A few minor corrections and comments will be necessary, but first I must note that perhaps the most popular of all genres, the mermaid (*mamba muntu*, less often called *mami wata*; Fig. 1.19), could not be placed inside our scheme. Being the most visible genre, it was the first to catch our attention. As argued in Szombati-Fabian and Fabian 1976, 5–6, *mamba muntu*, and the oral lore that goes with it, functions as a "reminder" par excellence. It is impossible to connect it to only one of the three levels of memory that were distinguished; it serves rather as a "totalizing symbol" of urban existence. It was also the most conspicuous marker of a class boundary between the consumers of genre painting and a middle class that would acquire some of the more generalized reminders of things ancestral but rarely anything from the other categories—and never, as far as we could tell, a mermaid picture.

Mermaids are among the most ancient and widespread symbols in Africa. Over the ages they have gained global currency, yet they remain the foremost image of African

culture on both sides of the Atlantic. In Shaba, mermaids are always depicted with a snake, and sometimes with a man; the watch, the comb, and other finery are never omitted, and the mermaid's face is rarely that of an African woman. Incidentally, the term *mamba muntu* is not gender-specific and is thus somewhat ambiguous. *Mamba* means "snake" in many of the local languages; in Swahili its primary meaning is "crocodile"; *muntu* is the word for "person," although it may in certain contexts be narrowed down to "African male." Kalema, one of the genre painters working in Lubumbashi, let these linguistic considerations inspire an extraordinary version of the genre picture (Fig. 1.20). The lore on which the paintings are based centers on encounters between the mermaid and (in Shaba) a male protagonist who, as the result of a pact, suddenly acquires wealth. It can easily be understood how a symbol that highlights sex and money — or rather the precariousness of male-female relations and the mystery of the acquisition of wealth — could have captured the imagination of the urban masses. But here we must leave it at that. The ramifications of the mermaid complex in traditional lore, its links to transnational and transcultural magic beliefs and practices, and its amazing iconographic history are too complex to be treated in the context of this study.[4]

Returning to the list of genres, it may be surprising that "level" — a spatial, in fact architectural, notion — was chosen to mark the major categories of popular memory rather than a temporal division, such as age or period. The choice was made intuitively, a few years before I discovered Frances Yates's *Art of Memory* (1966). After the fact, it is tempting to apply what Yates says about the spatial, predominantly visual organization of memory, especially in a case like this one, where visual images play such a crucial role. But it would be ill-advised to present *ukumbusho* as just another visual systematization of memory. Resemblances stop at the crucial premise of mnemonic devices in the ancient arts of memory, which held that the relations between images (or places) and the contents to be remembered be arbitrary. That is not how paintings serve *ukumbusho*. Nevertheless, the generic architecture of popular painting and the ancient arts of memory do have one thing in common: both were conceived to support rhetoric and oral performance. The latter will occupy us throughout these essays.

"Things ancestral" point to a rural past that is distinct from life in the cities but nonetheless present or coexistent, much as the dead are experienced as coexistent with the living. The village and the bush, hunting and fishing, political structures and ritual life are not just remembered nostalgically; they are invoked as the foundations on which present life and consciousness grow, or should grow. "Things past" comprise a limited canon of historical events of an almost emblematic nature. Those who buy these paintings

4. See Salmons 1977 and the recent comprehensive studies Drewal 1988 and Wendl 1991, which have references to the voluminous literature on the subject. For an attempt to understand *mamba muntu* paintings and lore in Shaba as belonging to a discourse whose "dispersal" (Foucault) can be discovered in other domains of popular culture see Fabian 1978. My earlier interpretation of the key role played by this genre is supported, and expanded, in Biaya 1988.

Figure 1.1 *Animals in the bush, by B. Ilunga*

Figure 1.2 *Village scene, by Ndaie Tb.*

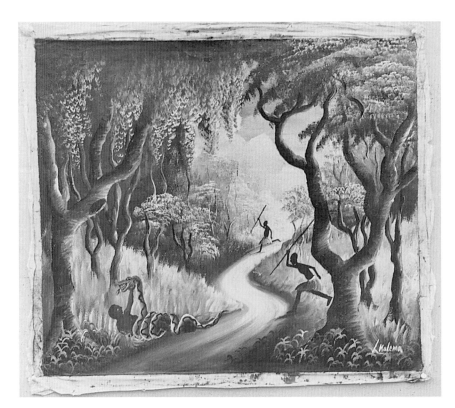

Figure 1.3 *Python hunt, by L. Kalema*

Figure 1.4 *Leopard, by Kabuika*

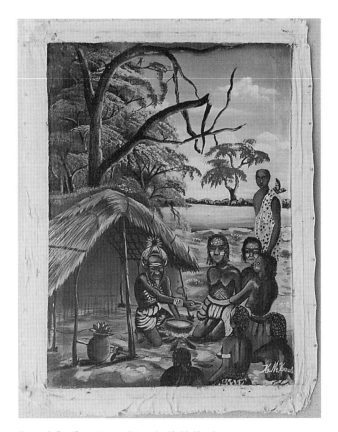

Figure 1.5 *Consulting a diviner, by K. M. Kamba*

Figure 1.6 *The flagellation of Christ, by Y. Ngoie*

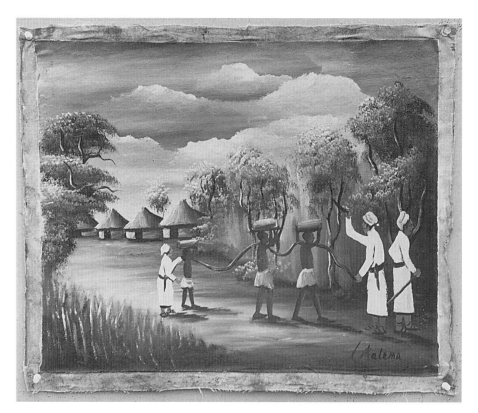

Figure 1.7 *Arab slave traders, by L. Kalema*

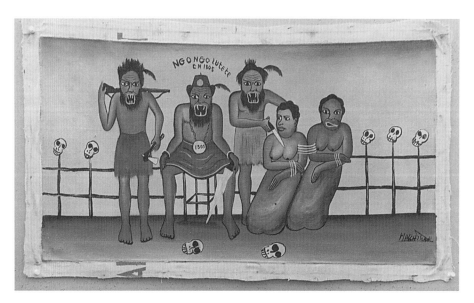

Figure 1.8 *Chief Ngongo Lutete, by Matchika*

Figure 1.9 Belgian colony, by C. Mutombo

Figure 1.10 Attack on a refugee train, by Kapenda

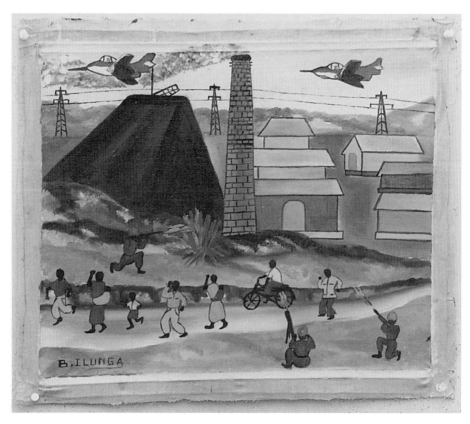

Figure 1.11 UN fighters attacking the Lubumbashi smelter, by B. Ilunga

Figure 1.12 Soldiers fighting rebels, by Matchika

Figure 1.13 Portrait of Patrice Lumumba, by Makabu Mbuta

CITOYEN UNIKONGOSHE KO | WEKA UMU CITOYENNE | HELA LAISSES MON | BANDIT- KONYO-NGIVI-BECILE
SAVONS TALIPA LE IS MIYE | MUKONO KWA MUKONO | COSTUME TRANQUILLE | UNASEMA FRANÇAIS PAKU
NIKO MTU MSURI NALI- | KONGOLE UKU APANA | TU N'AS PAS PEUR QUE | KONGOLA ULIISEMA KA?
PAKA MA NDENI SANA | | ÇA COÛTE CHER. | LETA MAKUTA YANGU.

Figure 1.14 The good and the bad businessman, by Y. Ngoie

Figure 1.15 Barber's sign, by Ndaie Tb.

Figure 1.16 Nude, by Luaba Tshimanga

Figure 1.17 *The Lubumbashi smelter, by L. Kalema*

Figure 1.18 *Railway overpass in Lubumbashi, by Ndaie Tb.*

Figure 1.19 Mamba muntu *(mermaid), by Kabuika [see color plate]*

Figure 1.20 Mamba muntu *(crocodile person), by L. Kalema [see color plate]*

feel no need or desire to have them establish a more or less complete chronological sequence. All the paintings are, as it were, equidistant to the present; each one is fully capable of evoking the past and serving as a trigger for stories about specific memories. "Things present" depict life in town — persons, activities, and places in the city. Images of present existence are offered as reminders; the way to relate to the present is to remember it, to make it part of the realm of *ukumbusho*.

A remark is in order on one term that was frequently encountered in the course of research. In conversations in Swahili, the French loanword *paysage* tended to crop up when speakers referred to paintings on the level of things ancestral.[5] People also called *paysage* the kind of art that, they observed, was appreciated by the middle class and by expatriates. The uses of this word suggest that popular painting had incorporated "landscapes," a genre that, though capable of creating a nostalgic mood, is otherwise difficult to fit into what we assume to be a discursive system of memory. Expatriates and the new middle class liked these generic evocations of Africa. How could such pictures serve the consumers of popular art as "foundational" reminders of things ancestral? Perhaps we have here a case of visual polysemy — of the same pictures conveying different meanings. On reflection, I would take the term *paysage* to mark not a genre but a boundary, a distinction between genre painters and others who produce landscapes (with or without "typical" events, such as hunts or bushfires) but would not be caught painting a mermaid, the Belgian colony, or the Lubumbashi smelter.[6] Moreover, those genre pictures that an outsider might view as landscapes are never, to my knowledge, devoid of humans and human activities, or at least of traces of human presence (such as buildings, roads, bridges, and the like). Even in the few instances that are "peopled" only by animals, the latter are engaged in activities and relations among one another (congregating, feeding, fighting). I think it justified to surmise that, like the genre "powerful animals," these scenes evoke the animal stories and fables of traditional lore.

Among the paintings depicting things past we noted six genres, but the list was not meant to be comprehensive. I would like to make two qualifications. First, these pictures — even ones of the most frequently reproduced *sujets*, such as the Belgian colony or the attack on the refugee train during the troubles of Congolese independence and the Katanga secession — were often "customized," that is, fitted with some marker of the customer's personal memories: colonial buildings might be inscribed with the name of

5. When urged to come up with a Swahili equivalent, respondents would offer descriptive terms based on the aspect of landscape that they thought was prominent in this type of painting (*pori*, bush; *bilima*, mountains; *kijiji*, lake or pond; *mawingu*, clouds or sky).

6. The following discussion is based on internal evidence from Shaba genre painting, where *paysage* marks a social (and political) class boundary and thereby signals relations of power. This, as well as the likelihood of *paysages* having been more prominent in colonial times (certainly in the work of expatriate painters), supports W. J. T. Mitchell's interpretation of landscape as a "global phenomenon, intimately bound up with the discourses of imperialism" (1994, 9). Political significance would also explain why the paintings of the colonial Desfossés school, although most of them were not landscapes, were often globally referred to as *paysages* by popular genre painters and their customers. *Paysage* would then mean "the kind of painting that was promoted by colonialism."

the buyer's birthplace; the train might be shown at a familiar railway station; fighting scenes might be set in a specific town. Second, the genre called "oppressors" (that is, African as distinct from Arab and European oppressors) was dominated by one figure, Chief Ngongo Lutete. It is now clear that for people of Tetela origin, perhaps for most Kasaians, the awesome potentate was as much a reminder of African defiance of Arab and European rule as he was a symbol of slavery and cruelty.

On the level of things present, it is interesting that some of the same sites that serve as reminders of wars in things past (with scenes of fighting soldiers or airplanes attacking) are here represented as landmarks of urban life in the present: the smelter, for instance, or the railway overpass. The group designated as "commercial paintings," however, poses a problem. In the towns of Shaba, shop signs were nowhere near as prominent as, for instance, in West African cities. Furthermore, paintings of plates of food or of nudes belonged in restaurants, bars, and dance halls, not in private homes. In Shaba we saw relatively few of them; such pictures were usually painted as murals. By contrast, the most popular genre in the commercial category—*crédit est mort,* depicting the good and the bad businessman (Fig. 1.14)—was among the most profitable *sujets* produced by genre painters. Its typical place was a wall inside a business, often a small shop or a *buvette,* a semiprivate drinking place, where the distinction between shop and living room was blurred. Clearly this genre may be seen as a powerful reminder of the predicament of poorly paid wage earners, as well as of shopkeepers who eke out a living selling their wares at a minimal profit to customers who are insolvent much of the time.

Such are the outlines of the system of genres as it was encountered in the early seventies in the cities of Shaba. With the exception of the Belgian colony and, to a lesser extent, the mermaid, I have not thoroughly examined any single genre; notes were taken from recorded conversations with painters and consumers, but these recordings await transcription and translation before they can be properly interpreted. Nevertheless, this sketch of Shaba genre painting will give us a richer understanding of the context—the discourse of *ukumbusho* and its attendant practices—from which the project of a history of Zaire emerged.

Before we turn to the relationship between popular memory and Tshibumba's *histoire,* a brief overview of the art scene in his day might be of interest. Expatriates and members of the middle class were eager customers of painters who had received professional training in the colonial Elisabethville school of Pierre Romain-Desfossés, at the Académie des Beaux-Arts in Elisabethville, and at various missionary schools where art education was part of the curriculum. Some of these painters, notably Pilipili Mulongoy, Bela, and Mwenze Kibwanga, had achieved international fame and were active at the time. Others were rediscovered in the course of our research, such as the late Mode Muntu, whose well-deserved international fame is growing. Still others, with B. Chenge as a foremost example, were highly successful in supplying the Zairian upper class in Lubumbashi and Kinshasa with striking "modern" African art. Furthermore, we en-

countered *peintres-artistes* in Lubumbashi and Kolwezi who found customers for their rather academic oils (mostly of landscapes, bushfires, and the like). One of them, Kabinda of Kolwezi, claimed to have been trained by Desfossés (but probably was not); another, Kanyemba Yav, adopted a Desfossés-like style without making such a claim and produced pictures that rival those by Pilipili. Of course, there were also the painters of "exotic" African *sujets* on dark velvet, the kind omnipresent in tourist and airport markets throughout the continent. We have one documented case of a painter of tourist art, C. Mutombo, who turned to genre painting but kept exhibiting his landscapes at the Lubumbashi airport. And there was the truly remarkable Muteb Kabash, a Kolwezi house painter, who defies categorization with his astoundingly fresh and colorful animal scenes (and an occasional mermaid) on rubberized canvas, a material recycled from filters at a local zinc plant.[7]

GENRE PAINTING AND TSHIBUMBA'S HISTORY OF ZAIRE

As I explained in the Preface, a project such as the History of Zaire could not have been realized within the economic and social constraints that operated on Shaba genre painting. On the local market, a genre painter would never find a customer able to buy more than two or three paintings, nor would any customer have the space at home to display more than a few pictures. Since our aim is to understand the process whereby his History was realized, every bit of information that documents how Tshibumba confronted and struggled with generic constraints deserves our attention.[8] At the same time, this evidence is bound to clarify the nature of these constraints. Rules, as is well known, are often best understood by their violations.

Tshibumba's own reflections provide a starting point. When we discussed the picture of Kamakanda, the war hero (Painting 29), I tried to get more information on the protagonist's identity and the source of the story:

> F: What tribe did Kamakanda belong to?
>
> T: I don't know, he was a Congolese.
>
> F: Where did you get the story of Kamakanda from?
>
> T: I got it from the old people; they know it very well. He died, but so did many others. But the way I see it, were I to do paintings of all of them, it would be difficult to sell them.

7. Examples of the work of Pilipili, Mwenze, Kabinda, Mutombo, and Muteb Kabash were published in Fabian and Szombati-Fabian 1980. Many of the works by these painters acquired in the seventies are now in a collection owned by I. Szombati. On Desfossés and his school see also the catalog of a recent exhibition at the Africa Museum in Tervuren (Musée royal de l'Afrique centrale 1992). On tourist art in general see Graburn 1976, and on the fluid boundaries between popular and tourist painting see Jules-Rosette 1984, 1990, 1992. The coexistence of popular, tourist, and academic art in the third world is also documented in Ströter-Bender 1991.

8. Here I mean "generic" as an adjectival form of "genre" (i.e., belonging to the system of genres). Its wider connotation — of "general," as opposed to specific — is an issue that will be taken up presently.

This brief exchange highlights a fundamental characteristic of genre painting as well as a fundamental conflict Tshibumba had to face as a historian. Notice that he spoke from the perspective of a genre painter whose production had to pass, on the market, the test of compliance with generic rules. Historical accuracy would have required depicting many more specific events and persons, but such paintings would have found no buyers, because they would not have met the generalized expectations created by *ukumbusho*. Genre generalizes, and discursive generalization finds its concrete expression in a kind of commodification of painting. This is not to say that generic differentiation in Shaba popular painting can be reduced to the latter's commodification. The passage quoted also shows that Tshibumba did not realize his historical ambitions simply by opposing the specific to the general. Generalization worked in his mind when he met my question about the ethnic identity of Kamakanda with a response that was, under the circumstances, a political statement, because it affirmed Congolese unity. Generalization was also already involved in the painter's sources. When he had Kamakanda stand for "many others," he was following oral lore that had selected Kamakanda to represent African heroism in the colonial army.

On another occasion I approached the question of genre more directly. We had talked about the picture of an air attack on the Lubumbashi smelter (Painting 75). I knew that paintings of the smelter — *mumbunda na mampala*, the smokestack and the slag heap — were among the most popular in Lubumbashi, and I thought this was a good moment to probe more deeply.

> F: Isn't this the sort of picture that people demand all the time? [I ask] because now you have painted quite a long series. But before you began with it, weren't there just three or four paintings that people would usually buy?
>
> T: That's what they'd usually buy, yes. Now, as to those other paintings I brought you.
>
> F: Mm-hmm.
>
> T: They are my own idea [*mawazo yangu*, lit. "my thoughts"]. But if the state would give us the freedom, we would be able to work in such a way that, I believe, people would seek to buy many paintings. But as things are now, we are afraid of other people,[9] you understand? If you come up with something [different] you may be told, "Oh well, what you are bringing is old stuff." As I told you, our brothers buy paintings to put them in their homes and enjoy the colors. A person may put a picture on the wall because of the color, but they don't give much thought to the meaning of the painting.[10]
>
> F: I see.
>
> T: It's like when I came inside your house here I saw those paintings by Mwenze [*points to them*].

9. *Batu bengine* in the original, which could also be translated as "certain/some people."
10. What I translate as "they don't give much thought" appears in the original as *abakumbuke*, lit. "they don't remember." What Tshibumba wants to say is that pictures of that kind are not perceived as "reminders."

F: Yes.

T: I saw that what he painted were animals [*banyama*].[11] But some among the brothers see only the animals [*nyama*], and that gives them joy. They don't know the meaning he put into the painting, that it is a scene in the bush, there are trees, birds are alighting, animals are fleeing the fire.

F: Mm-hmm.

T: I suppose that is what I see [in the painting].

F: Mm-hmm.

T: But that is not what people think.

F: Mm-hmm.

T: Now, when you do those paintings that are different, [then you get reactions like] "Oh, why do you do them like that, this is a bad idea [*mawazo mubaya*, lit. 'bad thought']."

F: Mm-hmm.

T: When you asked me [to do such paintings] I was glad to go along. I am going to show, I told myself, that we have enough intelligence to work in this manner. It is just that our brothers put a brake on us [*beko natufreiner*, from French *freiner*], especially the authorities.

F: Mm-hmm.

T: A person will see [a painting] and say, "Why do you paint Lumumba as a prisoner? That's bad. And why do you do this or that? This is bad." Take for instance the picture of Lumumba I did for you, the one where he has died.

F: Mm-hmm.

T: If I were to show this picture in Lubumbashi, I am sure . . . many, many people would come [*claps his hands*] to see it.

F: Mm-hmm.

T: But in that crowd you would hear some who say, "But this sort of stuff, this is bad." Instead of buying it and carrying it off to keep it, such a person will say that it is a bad idea.

These comments pose a minor problem but add major facets to our understanding of genre. First to the problem. After confirming what I had put into my admittedly leading question — only a few kinds of paintings are in popular demand — Tshibumba made an observation that appears to challenge our basic premise that *ukumbusho*, meaningful shared memory, makes painters paint and buyers buy genre paintings. He surmised that visual pleasure motivates people, not an understanding of the depicted event. Notice that he did not suggest that this is what motivates the painters whose pictures are appreciated for the pleasure, rather than the meaning, they provide. In fact, I heard in his remark an expression of solidarity with the painter Mwenze, a product of the Desfossés

11. The plural prefix *ba-* usually designates the class of human persons. I take this apparent linguistic slip to indicate that Tshibumba thought of these animals as persons, that is, as actors in animal stories. In the sentence that follows the plural is rendered without the prefix.

school, whose work was designed to fit a conception of African painting as being visually striking and pleasing rather than intellectually provocative.[12] Might this mean that Tshibumba's opinion of genre painting is closer to the one held by some art historians than to the discourse- and memory-centered interpretation we are exploring?[13] I don't think so. His deprecating remarks are valuable because they remind us that the "consumption" of visual cultural products is indeed aesthetic — appealing to sensual pleasure. But the context that triggers them in the quoted passage highlights, rather than negates, the importance of *ukumbusho* in his work as a genre painter. It is also quite likely that the "other people" whose reactions Tshibumba reported were members of the middle class, that is, customers for *paysages* rather than genre painting.

This last point brings us to the salient message of the text: apart from the classificatory, logical strictures inherent in generalization, genre painters face political constraints. Authorities have an interest in controlling the challenge, indeed the subversive potential, of popular memory. Totalitarian regimes everywhere must discourage remembering that leads to thinking. And people who are terrorized or coopted are quick to denounce provocative painting as "a bad idea." Of course, the really interesting question, which we will consider at various times in these essays, is that of the relationship between semiotic rules and political rule. That any discourse embodies power is plausible and easily stated. Careful analysis based on detailed historical and ethnographic knowledge is needed to understand how this works in practice.

When we now turn to examining relationships and conflicts between genre painting and the History of Zaire as seen in some concrete instances, we should keep in mind that Tshibumba was a genre painter and did not cease to be one when he painted the History of Zaire. In fact, he simply integrated into the historical series a number of paintings from his genre repertoire. This is most conspicuous in the first two segments, titled "Prehistory" and "The Lost African King: Origins of African History" in this volume (Paintings 1–4). Here are four pictures that belong to genres on the level of things ancestral in our schema. Also easily recognizable as genre pictures representing things past are *"Colonie Belge"* (Painting 34), "Fighting at a Railway Overpass" (Painting 57), and "Planes Attacking the Lubumbashi Smelter" (Painting 75).

That it was possible and expedient to use existing genre paintings for the historical project could not have been demonstrated more conclusively than by the insertion of Painting 57. This version of a popular genre, *bulalo* (the bridge), was not even painted

12. Quite likely, it was on this occasion that I first realized just how much narrative and — considering the stories of violence, fear, and resistance — political meaning Desfossés painters such as Mwenze and Pilipili managed to hide beneath the colorful and decorative surfaces of their paintings. See the discussion, with illustrations, in Fabian and Szombati-Fabian 1980, 280–82.

13. A succinct statement by Svetlana Alpers offers an example of the former position: "In this consideration of the Dutch narrative mode, as in my book as a whole, I am in disagreement with an influential essay by J. A. Emmens which argues that in seventeenth-century Holland the word was valued over the image, or hearing over sight" (1983, 264n. 42).

by Tshibumba but by his sometime apprentice Kabuika. In our conversation, Tshibumba stated that the painting was Kabuika's and commented on what it depicts. Why was it included? To give Kabuika a chance (or a plug)?[14] For mere convenience, because Tshibumba did not have time to do that scene? Was it a gesture of deference, on the part of the historian, to popular memory? A closer look at this seemingly straightforward case shows that the integration of genre in fact meant its adaptation to the historical narrative. When we first encountered it as a genre, we assumed that the *bulalo* scene was to recall fighting between United Nations and Katanga troops at this strategic point in the city — a generalized reminder of the troubles during the Katanga secession. However, in Tshibumba's comment on Kabuika's version, the scene is said to recall the underpass as a bottleneck that people from the Kasai fleeing the city had to get through on their way to the Foire refugee camp. The scene thus shows Katanga soldiers shooting refugees. Genre is similarly historicized in one of the pictures that follows, "The Secession in North Katanga" (Painting 60). Superficially it looks much like the genre picture *mashua*, depicting an attack on a train carrying refugees. But here the painter added an inscription, identified a specific locality (a station with a name), and in his comment indicated who was actually responsible: behind the bands of youthful rebels, known as *ba-Jeunesse*, who terrorized the rail connection between Katanga and the Kasai was the Luba chief Kasongo Nyembo, a supporter of the Katanga secession.

An interesting case is Painting 62. Because it was untitled and carried no inscription, like most of the genre pictures inserted in the series, I initially mistook it for just another *mashua*, the attack on the train. But in the event depicted the train brings the attackers, and the narrative that goes with it rules out any confusion with the genre painting of the refugee train. My mistake was perhaps understandable, since this picture was in a batch acquired before the project of a complete history took shape. That poses an interesting question: if it was not a genre painting, what did Tshibumba try to sell it as on the local market? A glance at the acquisition dates shows that nineteen paintings were bought from Tshibumba between November 1973 and January 1974, that is, almost nine months before he came back in September 1974 with pictures that were to go into his History. Of those nineteen, nine were typical genre paintings, four of which became part of the historical series. Ten were of a political nature (six about Lumumba, three about Mobutu, plus the odd Painting 62, just discussed). All of those were placed in the series. Not included in the series were two mermaids, a landscape, and a couple of lions, as well as a version of *Waarabu*, the Arab slave traders. This last would have easily fitted the historical narrative. It is conceivable that Tshibumba preferred to cover the topic with scenes of battle and an execution from colonial times (Paintings 12 and 13) rather than emphasize

14. Kabuika, also written Kabwika, was with Tshibumba during our first recorded conversations (see the Prelude). This picture has no signature (one of two such cases I know of). It was among several genre paintings acquired from Kabuika, almost certainly the same day Tshibumba inserted it into the series (October 25, 1974).

oppression of Africans by the Arabs, as do genre pictures that always show a slave caravan. Perhaps Ngongo Lutete (Painting 11), yet another genre picture, took the place of *Waarabu* in the series. As noted earlier, it evokes ambiguous memories of an African potentate who participated in the slave trade but was also celebrated for defying Belgian rule.

Be that as it may, Tshibumba had found or created a demand for certain topics that were not usually part of the generic canon — a demand equal to that for genre pictures. Scenes from the life of Lumumba, such as the signing of the Golden Book (Painting 48), his famous independence speech (Painting 49), and especially "African Calvary" (Painting 67), he produced and sold in large numbers. There were signs that other painters were beginning to offer their versions of these topics. Something was going on here: Tshibumba was breaking out of the confines of genre by competing for buyers with his historical and political pictures. Genre struck back, so to speak, by quickly incorporating such topics. The period during which this could be witnessed and documented, however, was too short to support more than the suggestion that Tshibumba's departure from genre was not sudden and that it preceded the project of a complete history of his country.

When Tshibumba came to the Léopoldville uprising of January 4, 1959, in his narrative, it turned out that he had the choice of two pictures to represent the event. One was destined for the genre market (Painting 40); the other was done for the historical series.[15] Surprisingly enough, Tshibumba chose to speak about the genre version. Tshibumba drew my attention to the fact that, in the version that was "to be sold,"[16] Lumumba is waving the flag of Mobutu's party, and he excused himself for this anachronism. The anachronism, embarrassing to the historian, was a concession that had to be made by the genre painter. Tshibumba also pointed out that this painting really is two pictures in one: a portrait and an event. As the portrait of a statesman, the picture would belong to a recognized genre; the Léopoldville uprising was not, as far as I can tell, part of the canon. What we may have here is a glimpse at one of the ways by which Tshibumba had begun to infiltrate genre with historical painting. Conversely, the generic portrait takes on historical significance by being combined with the representation of an event. In our conversation Tshibumba said that Lumumba's portrait was to recall his speech at a rally that led to the uprising. Then he added another twist to this account of the relationships between genre and history. To my observation that this painting looked rather sketchy, Tshibumba responded by insisting that anything goes in art ("art . . . comes in many kinds") — but, by implication, not in history.

A similar occasion for reflecting on the tension between history and genre painting was provided by Painting 48, "Lumumba Signs the Golden Book." Again, Tshibumba

15. The historical version is not part of the collection at my disposal. However, the two can be compared on the basis of our recorded conversation.
16. The formula "to be sold" (*ya kuuzisha*) is not so much a declaration of intent as a statement attesting to the success Tshibumba had selling versions of this picture on the genre market.

excused himself for an anachronism. The names of the provinces inscribed in the book are the ones that were instituted by the Mobutu regime. They were different at the time of independence. Because the picture was "to be sold," political correctness took precedence over historical accuracy.

As these and other instances attest, for all that the History of Zaire represents an extraordinary departure from genre painting, it stays connected with generic *ukumbusho*. Tshibumba draws on the memory of the people; he wants to "help" and educate that memory. Moreover, in its overall organization, his History resembles the system of genres in at least the following ways: Both share a mythical, foundational prehistory; both remember history basically as history of colonization. Both are "presentist" in that remembering (*kukumbuka*) shades into thinking (*kuwaza*); memories are significant to the extent that they comment on the present. The social perspective is in both cases essentially that of the urban working class. Finally, like genre paintings, the pictures in Tshibumba's series presuppose a narrative background structured so that every painting that is seen can become a story that is told.

After all that has been said about genre painting and popular memory as the context of Tshibumba's History, we must not forget that he also perceived himself within, or in contrast to, another context, that of academic and journalistic history-writing. Our conversations reproduced in the Prelude show Tshibumba as a reader of books and newspaper articles. At one point he recalls how he anticipated in one of his paintings a report in the press. Around the time when we got together for our first session of recording his History (October 6, 1974), *Elima*, one of two major newspapers, began to feature and popularize the work of the newly constituted National Society of Zairian Historians.[17] The motor behind this association was the history department of the National University of Zaire at Lubumbashi, which sent out scores of young researchers to tap people's memory in the towns and villages of Shaba. Whether newspaper reports and research activities actually influenced Tshibumba is a matter of conjecture, but it is more than likely that he was aware of them. He certainly did not think of his work as a historian as confined to domains that his academic contemporaries would probably have qualified as folkloric or artistic.

17. On September 16, 1974, *Elima* had devoted a whole page to an interview with Lumenga Neso, a professor at a teachers' college (Institut supérieur pédagogique) at Gombe, titled "History and African Renewal." An editorial by the interviewer, Yamaina Mandala, provides a programmatic introduction to the interview, the central issue of which is the teaching of history in Zairian schools. An anonymous note announcing a meeting of the Shaba regional branch of the National Society of Zairian Historians (planned for February 1975) appeared in the October 31, 1974, issue. It gives a summary of the program, devoted to the "three stages [*étapes*]" of the history of Zaire, which reads like an outline of Tshibumba's history.

Painting, Talking, and Writing:
The Making of the History of Zaire

Through Tshibumba's History of Zaire we hope to understand culture as practice rather than as a system. From such a perspective, historical connections, conditions, and consequences are of greater interest than, say, logical or aesthetic structures. Of course, a product of culture that would neither be affected by context nor have any form or structure is not imaginable. Theoretical choices can be made, however, regarding the nature of things cultural as objects of anthropological research. Are they above all signs or symbols that represent reality and acquire their significance within a system of signs? Earlier I emphasized production as a key concept of the approach advocated here. Now I would like to take that concept as literally as possible and give an ethnographic account of how the History of Zaire was *made*. Precisely because a corpus of striking pictures makes up the most palpable part of this oeuvre, the temptation is strong to focus right away on images and take semiotic shortcuts in their interpretation.[1] It may be easy to forget just how deeply these visible objects were embedded in thought and reflection, in stories and conversations, all of them realized through a series of events that occurred at a certain place, during a certain time, involving certain persons. In a case that is as well documented as this one, there are few gaps that need to be filled by sociologizing or aestheticizing.

How images and words relate to each other has been a perennial problem in the interpretation of narrative painting. It is indeed a central question and will be addressed in every one of the essays that follow. However, while the question is central — leading us back again and again to the core of our project — the issue is neither clear nor simple. It may regard the relationship between (visible) images and (audible) words; or between painting and talking; or between paintings (objects) and comments and interpretations (discourse). Then there are questions regarding illustration and text, painting and writ-

1. This is not to imply that semiotic analysis inevitably cuts interpretation short. An example of the contrary is R. Adorno's work (1986) on an illustrated Andean "chronicle" from 1615. Its author, an Inca of noble descent, wrote this document (in Spanish and Quechua) and drew the pictures as an act of resistance to colonial historiography. Although they are separated by three and a half centuries, Guaman Poma's *Nueva Corónica* and Tshibumba's History show remarkable resemblances that invite systematic comparison.

ing, depicting and inscribing. Each of these queries has exercised the minds of special-ists. Each has generated a voluminous literature and fields of inquiry with their own his-tory and current agenda of research.[2] Obviously, trying to bring all these aspects together into a coherent interpretation would not be a realistic project. Nor is this brief catalog exhaustive. It passes over the higher-level philosophical questions of reality and its rep-resentations, as well as more specific ones that may be raised, say, within a linguistic ap-proach. Should the search for meaning be semantic (lexical) or syntactic (grammati-cal)? Also ignored, at least for the time being, are the notoriously difficult questions on the value of a painter's statements about his work.

In the face of such overwhelming complexity, I have chosen to proceed as follows. In the first section of this chapter I describe the pragmatic context from which the many questions of signification and meaning emerged and to which their interpretation should be related. In the next section I take up signification in a more limited, semiotic sense by examining recurrent symbolic elements. With the exception of a few genre pictures that Tshibumba inserted in the series, his pictures combine painting and writing; this topic is considered in the section on inscriptions. Finally, I close with some observations on Tshibumba's ways with, and thoughts about, perspective, color, and style.

IMAGES AND WORDS: PUTTING TOGETHER A HISTORY

What brought images and words together in this History of Zaire was action or, more precisely, interaction between a painter and an ethnographer.[3] Interaction started with a chance meeting that lead to a transaction, when the first paintings were bought. But that transaction was from the beginning embedded in and, as the texts reproduced in the Pre-lude show, soon overshadowed by, communicative exchanges. Furthermore, although the first meeting was a matter of chance, in the sense that it was not planned — one day in late 1973, driving home from work at the university, I saw a person carrying paintings and decided to stop and take a look at them — it soon turned out that the contact it es-tablished would not remain casual. The painter and the ethnographer were engaged in quests that converged: Tshibumba, the genre painter, had begun to break out of the confines of his métier to establish himself as a historiographer. Now he had found a "customer" whose interest was not limited to pictures. For my part, I had begun to real-

2. For references, see Bal 1991 and Mitchell 1986.
3. The singular "ethnographer" here reflects the recorded exchanges. However, the wider project on which this study is based was conducted in cooperation with I. Szombati, many Zairian painters, and a few student assistants. I. Szombati had conversations with Tshibumba, though not recorded in Swahili, and assembled notes and important photographic documentation of his work and social background during several visits to his home in Kipushi and his family's place in Likasi. At about the same time (1973–74), several expatriate col-leagues were beginning to get interested in the painter (V. Bol, J.-P. Jacquemin, B. Jewsiewicki, T. Turner, J.-L. Vellut, E. Vincke, C. Young, and perhaps others). They began to buy his pictures and, in some cases, had con-versations about his work; several among them also published on Tshibumba (see my bibliography).

ize that my research on expressions of popular culture was as much an ethnography *with* as an ethnography *of* the people I studied (although it would take many years before I put it into those words; see Fabian 1990b, 43). I had found an "informant" whose place was not on the other side of the divide set up between those who question and those who respond.

That ethnography is made, not found, is an insight shared, to some degree, by most ethnographers. That the making of ethnography occurs in communicative exchanges is by now also widely accepted. It may be unusual, though, to have this documented as a process at the end of which objects as well as verbal exchanges come together as a coherent cultural product that contains messages as well as interpretations, statements as well as reflections, and — a point that will be made in a separate chapter — confrontation as well as exchange. By "process" I mean more than the fact that the pictures and recordings were assembled gradually over some time. What I want to bring out in this chapter is that this History of Zaire was in effect produced through a series of events. It follows that an understanding of these events is necessary, or at least useful, to establish the pragmatic context that will give us the ground to stand on in a potentially groundless interpretive endeavor.

What were these events like? Some information on our meetings is given in the Preface and in a few comments to the texts in the Prelude. We can now relate these in a bit more detail, roughly following a long-established list of "components" that has proved useful in the description of speech events.[4]

The physical *setting* was mainly the living/dining room of a European-style house that I rented while teaching at the Lubumbashi campus of what was then the National University of Zaire. The room was sparsely furnished, with a lot of space on the floor as well as a large dining-room table on which to deposit the paintings. On the walls, several paintings by artists from the Desfossés school were displayed. (These artists are mentioned briefly in Chapter 1, where it becomes clear that Tshibumba was very much aware of them.) Because of the space it provided for exhibiting the pictures, the recording of the narrative took place in the living room. On one or two occasions we retreated for the comments to a smaller room, where we had more privacy. That Tshibumba came to visit us, rather than the other way around, was for practical reasons. Most of the pictures were painted and the recordings made during the final months of my stay in Shaba. Apart from teaching, I had administrative duties and could not have traveled regularly to Kipushi, where Tshibumba made his home. Above all, the physical conditions for

4. I should note that in reporting on the circumstances of our meetings, I rely on memory and on information contained in the recordings. Although, as I have said, I soon realized how interesting these encounters were, they had not been planned as a research project. How exactly they related to my sociolinguistic pursuits was not immediately clear to me, nor was it foreseeable that they would become the subject of a book-length study. As regards the general description of our sessions in terms of components, see Hymes 1974, 53–62. For the larger sociolinguistic situation in Shaba see Fabian 1991a.

exhibiting and recording (space protected from the curiosity of neighbors and passersby and a reliable electrical current) made the house in Lubumbashi the obvious choice. Without making it a rule, I had previously used my home to record conversations with many others (workers, other painters, popular actors).

Although we usually shared a beer or a soft drink, the *scene* or *occasion* was defined, albeit never explicitly, as work rather than conviviality. The meetings always took place during daytime and lasted for about two hours. Neither the time nor the duration was appropriate according to local practice, in which stories are told in the evening and sessions may last all night long. There was another thing that made the setting and occasion exceptional, at least for Tshibumba. Being inside the home of an expatriate was, at that time, an experience few Africans had, unless they worked for expatriates. It was even less usual for Africans of the lower class to be engaged in work that called for lengthy conversations on serious matters. I remember that our cook, Kondoo Marcel, was always intrigued by our sessions, even though he and I had regular discussions about the state of the world over a bottle of beer or two. The difference was in the *key*; our pre-dinner chats on the back porch were free-roaming banter, whereas with Tshibumba we were talking about topics that included serious, perhaps even dangerous, matters.

Tshibumba and I were the only *speakers* and *participants* — with a few exceptions that left their traces in the recordings in the form of brief interjections or questions (usually directed at me). I. Szombati was present during some of the sessions. The voice of Tshibumba's fellow painter Kabuika can be heard briefly during the first conversation. A few times the recording was interrupted by arriving visitors.

The *channel* of communication was oral; the writing on the pictures and, in one case (the story of Simon Kimbangu, Paintings 25 and 26), a lengthy passage from a newspaper were read aloud. With the exception of the latter, which was in French, the linguistic *code* we shared was a Shaba variety of Swahili. This was a matter of conscious choice; we could have used French. I had conducted all my research in local Swahili and addressed Tshibumba in that language without giving much thought to the possibility that he might have preferred French. It turned out he was comfortable with my choice, although — in a manner that was typical of speakers of his age and educational background — he would frequently borrow from French and thus occasionally switch codes.

The term "code," though handy in this summary description of components, needs qualification. Even if, as I just pointed out, employing a code is a matter of selection, neither the selecting itself nor the choice made is neutral as regards attitudes, mood, and content. There were few, if any, expatriates with whom Tshibumba could have had long conversations about culture, history, and politics in the language that embodied his own life experience in a multilingual urban environment. This made our exchanges exceptional, rather intimate, and perhaps even slightly conspiratorial. In Shaba, local Swahili is learned at home, at work, or on the street. It is not formally taught, and when its literate speakers write in Swahili they usually switch dialects, trying to express themselves in a variety that approaches the East Coast Standard, however imperfectly and symboli-

cally. In other words, our conversations, apart from being factually oral, were in addition marked as oral by the linguistic code we used. Sociolinguists might point out that orality is best dealt with under *channel* (see above), but here we have a case of a code that, at least in its natural setting, does not permit a choice of channels.

Last, but certainly not least, there was the presence during our conversation of Tshibumba's paintings as objects (part of the setting) but also as a medium of communication. This aspect brings up other nonverbal modes of communication, such as gaze and body language. Sound recordings preserve very little of this important dimension, although the fact that we sometimes moved together or sat down facing each other or the paintings before us clearly contributed to the shape of the recorded texts.

The *roles* assumed by the speakers, the *content* or *topic*, and the *genre* of discourse are other components of speech events that can be distinguished analytically but are almost impossible to keep apart in description. The role a speaker assumes or is assigned may determine what he or she talks about; the topic may require that it be expressed in a given verbal genre, and so forth. At best, these distinctions make us sensitive to the intricate interplay of social relations, intellectual content, and linguistic form that determine the shape of speech events. However, here we are not engaged in generalizing about, and establishing rules that are valid within, a larger speech community. When two speakers face each other in a specific event, describing their actions in terms of social roles makes limited sense. Quite likely, Tshibumba as much as I displayed certain outer signs (for instance in dress and body language) that may have been typical for the roles we played in the larger society — the popular artist and the expatriate academic. On the other hand, to establish communication that would go beyond enacting our roles was one of the *purposes* (to name another component) of these events. That purpose could not have been attained had we not been able to create and recreate our roles as we conversed.

Similarly, the topics of our exchanges and much of the content (that is, what was actually said about the topics) were made up as we went along. Much of the content, but not all of it: The pictures before us, Tshibumba's knowledge and memories, and the ethnographer's research interests were givens, in the sense that they contributed to the form of our exchanges throughout the recorded sessions.

As regards genre, the texts exhibited in Part I are distinguished as narrative (the portion immediately below the painting, in sans serif type) and conversation or commentary (introduced by "T" or "F").[5] On the whole the distinction is valid, but it requires qualification in our specific case. First, even the most cursory look at the transcripts on which the edited texts are based shows that the narrative, almost as much as the commentary, was structured as a conversation. When Tshibumba told the history of Zaire he addressed a listener. He chose patterns of intonation, inserted pauses and brief ques-

5. The contrast between narrative and conversation has been much explored in linguistic approaches to prose texts, for instance in the pioneering studies by E. Benveniste ([1956] 1971) and H. Weinrich (1973) on tense, person, and time; see also Fabian 1983, 82–86, where I examine the implications for ethnography.

tions, and prompted responses that gave a dialogical structure to his narrative, often to the point where generic distinctions seemed to break down.

To illustrate this, here is a fragment from the narrative in a transcript and its literal translation.[6]

THE CONGO FREE STATE.

Transcript:

T: mawazo ya kwanza: ya Léopold deux: aliwaza kutupatia: indépendance/ na ile indépendance: aikukuwe kweli/

F: mm/

T: [*aside*]...?...: na ile indépendance haikukuwe kweli/ ilikuwa vers mille huit cent quatre-vingt-cinq/

F: mm/

T: mais utaweza kunihurumia sawa vile mu histoire: eh: dans deux jours: radio ya Kinshasa: apa sasa mu mille neuf cent septante-quatre: radio ya Kinshasa ilisema kama: eh: mu informations ile nali: shikia/ ilisema kama: indépendance ya Zaire ilikuwa ya: ya Congo: ile: nani Léopold deux alisigner: ilikuwa mille huit cent quatre-vingt-quatre/

F: mm/

T: mu Vivi/ et pourtant: kuko: kunapatikana mama moja: ule alikuwa pa ile wakati: balipandisha: balisema indépendance ya mille huit cent quatre-vingt-quatre quatre-vingt-cinq/

F: mm/

T: mais d'après l'histoire mi nalifunda ni mille huit cent quatre-vingt-cinq/ bon ni mambo ya radio ile ilisema/

F: mm/

T: bon: kufwata kwa histoire: ni mu juillet mille huit cent quatre-vingt-cinq: njo alisigner: indépendant/ ni kweli: sawa alisigner indépendant: bantu balikuwa chini ya butumwa ya: bazungu/ bazungu balikuya: kidoogo: sana/ na baliweka: busultani yabo/

F: mm/

Literal translation:

T: At first Leopold II had the idea to give us independence. But that independence was not real.

F: Mm.

T: [*aside*]...?...[7] That independence was not real. This was around 1885.

F: Mm.

6. On the problems and method of transcription see Fabian 1990a, 4–6, and 1990b, 97–100. Instead of punctuation, a few signs are used to mark the most salient intonation patterns: ":" for sustained clause; "/" for full clause, or descending tone; and "?" for question, or rising tone. An incomprehensible word or phrase is indicated by ...?.... French items are rendered in French orthography, although when spoken they are often, but not always, adapted to Swahili phonology.

7. Tshibumba mutters something to himself while he hesitates for a moment, probably because the similarity of this picture with the preceding one (compare Paintings 20 and 19) made him uncertain about the sequence.

T: But you must excuse me, because two days ago, in [a program on] history, or rather on the news, I heard Radio Kinshasa say—now, in 1974—that the independence of Zaire, that is, of the Congo, the one that was signed by Leopold II, was in 1884.

F: Mm.

T: At Vivi. They even found a woman who was there at the time [and had her present] when they raised [the flag to mark] what they called the independence of 1884–85.

F: Mm.

T: But according to the history I learned, it was 1885. All right, this is something the radio said.

F: Mm.

T: All right, to get on with the history, it was in July 1885 that he signed independence. It's true, he signed independence, but the people were slaves under the whites. When the whites first arrived, there were only very few of them, and yet they set up their government.

F: Mm.

What I meant by the conversational structuring of narrative texts can easily be shown in a general way when this passage is compared with the edited version in Part I, Painting 20. There the text is exhibited as a monological, continuous story. Here, Tshibumba's account appears to be interrupted six times by "responsive sounds" such as "mm." However, these were not random interruptions. Intonation patterns and other markers that are audible in the recording but get filtered out of my transcription would show that the responses were prompted and that such prompting followed a certain rhythm. We simply adopted a pattern that is characteristic of storytelling in this area. Far from interrupting delivery, it is used by speakers and audiences—more or less consciously and skillfully—to sustain (and enjoy) the flow of narration.

In other words, a hearer's responses do not as such make a text conversational. Conversation involves taking turns. How this happens, and how frequently, could be shown with the help of other passages from the narrative. I chose this example to keep matters simple. Often my responses were not quite that minimal. I sometimes reacted with expressions of disbelief ("Really?" "Is that so?") or with requests for repetition or clarification, and so forth. In these cases there can be no doubt that the narrative was interspersed with conversation. It still remains difficult to determine exactly where generic boundaries are transgressed. In one place, our example suggests that even minimal responses can be a form of turn-taking: namely, when Tshibumba follows my "mm" with a "bon" (translated as "all right"), signaling that he resumes the narrative.

Furthermore, apart from vocal interruptions that affect the flow of narrative delivery (albeit not negatively), there are also topical interruptions of the narrative sequence itself. At one point in this fragment Tshibumba actually excuses himself for interrupting his story with an aside about something he just happened to have heard in a radio news broadcast. Then he resumes his account by announcing that he will now go on with the story. Both kinds of interruptions are really devices to sustain the narrative and its deliv-

ery, and they clearly indicate a dialogical and performative conception of narration. The listener is prompted to give vocal signs of his physical presence; his intellectual (or communicative) presence is emphasized precisely by asides that seemingly interrupt the story.

Conversely, in exchanges that were presented as commentary or conversation Tshibumba reverted to narrative whenever he wanted to add to his account or when he felt that a story would be more effective than an explanatory comment. Probably there is no oral narrative that is not somehow structured dialogically when it is performed, certainly not in the culture of storytelling from which Tshibumba came. I neither recall nor can imagine purposeful conversations with the people who agreed to talk with me — the kind of exchange we usually call an interview — that were purely conversational (or purely informative). Anecdotes, proverbs (apropos or not), and in a religious context, instructions, testimony, and even prayers put a strain on the dichotomy between narrative and commentary, without discrediting the distinction altogether.

The texts called narratives were recorded during the first part of each session. We were standing between, or rather slowly moving along, rows of paintings that Tshibumba had laid out on the living room floor. As he told the story, I held the cassette recorder between us and made responsive sounds. Incidentally, the twenty to thirty pictures we covered in each of the sessions were not numbered. Did Tshibumba arrange them in a sequence as illustrations of a story he had in his head, or was his story made to fit a series of pictures he had imagined? Later on we will discuss a few clues that make it possible to address that question more directly. What is important here is that during our meetings, features of narrative (such as the structuring of a story in terms of episodes, a certain linearity in the progression from episode to episode, the authority of the narrator that rests on his synoptic or synchronic control of a plot he develops in parts and steps) were physically present; they were embodied in the pictures laid out so that they could be inspected individually but also taken in at a glance. Narrative was enacted, as it were, when narrator and listener moved along the paintings.

The texts designated as commentary or conversation were recorded in a different situation. We would sit down next to each other, before a table on which the paintings were now put in a batch following the sequence established in the first part of the session.[8] Our relation to the pictures as objects changed. Since they were no longer visible simultaneously as a group, they had to be manipulated, either pulled from the batch or turned like the pages of a book. This difference is reflected on the recording and in the transcribed texts. For instance, whenever we took up a painting I announced its descriptive label and numerical identification. My remarks were "for the record," in anticipa-

8. Stacking the pictures in batches was possible because the wooden frames on which they had been stretched while painted had now been removed, so as to reduce the volume for shipment. In retrospect, this purely practical accommodation represents a rather radical change or intervention along the road that led to this study. See the Preface, where I remark on how the series was destined from the start for reproduction in a book.

tion of later study, and qualify as comments in the strict sense of the term. Furthermore, I now asked questions about specific details. There was constant turn-taking and some skipping backward and forward. We digressed, stopped for reflection, clarification, and asides, and as already noted, Tshibumba frequently added bits of narrative to the account that had been recorded earlier. What I have characterized as the sometimes conspiratorial nature of our conversations alludes to another distinguishing feature, which will be taken up in later interpretations: When Tshibumba pronounced the narrative in the living room before an exhibition of his work, we experienced the setting as somehow public; sitting down at a table, and in some of the sessions moving the scene to my study, created the conditions for a more private but also more critical discourse.

IMAGES AS WORDS: TSHIBUMBA'S PICTORIAL LANGUAGE

The question of how Tshibumba's History was "put together" can have two more meanings. One of them — how did he construct his narrative? — will be dealt with in later chapters, when we take up issues such as performance, plot, and message. In a more limited sense, one can also ask what kind of elements the painter put together to make a given painting represent a historical event. When posed by an anthropologist, this simple question is usually fraught with heavy theoretical assumptions, among them that things cultural have their meaning as signs, and that we approach this meaning as we would that of linguistic signs. Semiotically speaking, the relationship between signs and the reality they signify, if any, is neither natural nor necessary; it is arbitrary and has to be such, because signs signify (represent, make statements, inform) in a system — a language. Meaning is produced by the relationships that result when signs are combined. In analyzing, say, a painting, such an approach should enable one to go beyond what it depicts and work out what it signifies, by virtue of combining significant elements in certain relations.

I do not have a structuralist conception of language and do not favor extending such a conception to other aspects of culture.[9] Still, when I look at Tshibumba's series it is evident that, apart from whatever else he does, he employs elements that have the character of signs. Every painting contains elements that are not created ad hoc and do not depict a distinct part of the world, the way a portrait depicts a person. These signs are like the words of a dictionary; while each of them has its own meaning, or semantic value, they also make statements by the way they are combined.

For the purpose of our discussion, certain elements — less than a picture but more than, say, a line or partial surface — will be called symbols, with "less" and "more" denoting

9. Moreover, I do not subscribe to a theory of culture that is served by semiotic analyses. This should not be misunderstood as a dogmatic position. My choice is dictated by ethnographic considerations, some of which may well be served by a semiotic approach as exemplified in Jules-Rosette 1988/89. See also, in the same issue, a critical essay on African art systems by S. Preston Blier (1988/89).

their function rather than their dimension. Some symbols, such as the smokestack and slag heap representing the Lubumbashi smelter, almost fill an entire picture. Others may appear in tiny detail, such as the Belgian colors on a pin Kasavubu wears on his lapel (Painting 38, "Kasavubu Is Elected Mayor"). When I noticed the pin, Tshibumba commented, "[That's] because he was mayor during Belgian times." A minute detail can perform a complex function, such as invoking a period in political history, because it is a symbol.

Symbols are prefabricated, in the sense that they are not made for the occasion but taken from a repertory. Tshibumba confirms this interpretation in a remark on Painting 37, "Lumumba Meets Kwame Nkrumah." "Where is this airport?" I asked. "In Ghana," Tshibumba responded, "but because I don't know the national flag of Ghana I couldn't put it there. I would have drawn it had I known what it was." [10] Because they are prefabricated, symbols are, as it were, movable and exchangeable. They are not tied to the specific event or topic represented in a picture; the same symbol may be used in different pictures. That does not exclude the possibility of stereotypical associations, such as between flags and scenes of war.

Many of the symbols Tshibumba uses come from an international, transcultural repertory. Flags, again, would be a case in point, but probably also the trappings of modern life, such as means of transportation, features of dress, weapons, and urban architecture, as well as the writing in Latin script that appears on practically all of the pictures. I would also put into this category most of the symbols that an outsider recognizes as typically African, be they traditional and authentic or not.

Culturally specific symbols form another category. Knowledge of the culture is required to decode, say, gestures of mourning and distress (hands placed on the head in Painting 14, "The Poisoned Banza Kongo"; or a palm against one cheek in Painting 34, "*Colonie Belge*"). Conversely, when Tshibumba makes symbolic use (as a subtle political comment) of a European posture such as crossing of the legs (see the missionary and the judge in Painting 25, "Simon Kimbangu in Court"), this symbol is not fully understood unless the viewer knows that it denotes disrespect in the local culture. Or take the raised arm with the index finger extended: culturally objectionable as an obscene insult, it thereby becomes a sign of defiance (see the Katanga women in Painting 63, the Katanga official in Painting 67, and, most dramatic, Lumumba in Painting 49). By contrast, a European depicted with an index finger extended may simply be pointing at something, as is the case, for instance, with Diogo Cão in Painting 5. Here Tshibumba in fact emphasizes cultural difference: Banza Kongo, standing next to Diogo Cão, appears to make the same gesture. But he points like an African, palm down, with all fingers extended.

In some instances Tshibumba must have sensed the limits of my cultural competence.

10. An interesting linguistic detail may offer a glimpse at how Tshibumba thought of the use of symbols. What I translate as "drawn" appears in the Swahili text as *kuandika*, to write.

How was I to know, without his explicit comment to that effect, that in Painting 36, Lumumba as the director of a brewery assumes a *pose ya kucheka*, literally "a pose of laughing"? Lumumba is not laughing, or even smiling. Nor does he appear ridiculous. What Tshibumba encodes in the posture is a kind of contentment or sense of achievement, to which mirth — as I had learned previously — is a culturally appropriate response.

One thing that ethnography does, or should do, is teach the semiotically clever interpreter lessons of humility. Take the rainbow in Painting 53, "Luba against Lulua." For most Westerners, I believe, the rainbow is a symbol of peace. As such, the rainbow in the sky would be in "meaningful" opposition to the fighting on the ground. Or is it the other way around? Are we to conclude that Tshibumba used the rainbow as a symbol of peace because he opposed it to a scene we know to be a fight? He was literate and knew the Bible; it was at least possible that he intended the rainbow to symbolize peace. Fortunately, further guesswork is unnecessary, as the following excerpt from our conversation about the painting shows:

T: . . . it is the time of [Tshibumba interrupts, or rather completes, this declaration with an indexical gesture, pointing to the rainbow] — this is *mwanza nkongolo*. What do you call it, *arc-en-ciel* [rainbow], right?

F: Yes.

T: So you see. We call it *mwanza nkongolo*.

F: *Mwanza nkongolo* [I let the term melt on my ethnographer's tongue].

T: Right.

F: What is its meaning? [By now I suspect some kind of deep significance, vaguely remembering an association in Luba mythology: rainbow–snake–mythical hero Nkongolo.[11] But Tshibumba cuts off my speculations.]

T: [The meaning] of *Mwanza nkongolo*? That it is about to rain.

F: [I don't give up so soon.] Yes, but why did you put it in this picture?

T: Because in the Kasai region it rains a lot.

F: *Mwanza nkongolo* [appears] when it's about to rain? [Surely the rainbow appears when it stops raining.][12]

T: Now was the time when they were able to fight each other. Had it been raining [they could not have fought]. Because the *arc-en-ciel* [appeared], it meant that the rain had disappeared.

11. To quote but one of many possible references on the Luba genesis myth, in this case a Luba-Shaba version: "He took the name of Nkongolo ('The Rainbow'). Nkongolo was red, and wherever he travelled the land turned red. Nkongolo was noted for his cruelty, for when he stood up he leaned on spears which pierced people lying at his feet" (Reefe 1981, 24). Presumably the term *nkongolo* for "rainbow" at least connotes the mythical chief. If that is so, the image it evokes would certainly fit the scene in this picture. In Luba mythology, the rainbow was sometimes imagined to result from the union of two spirits, male and female, being impersonated by snakes, who usually live in different rivers (see Van Avermaet and Mbuya 1954, 283; also Studstill 1984, a monograph on the rainbow motif in Luba thought).

12. Tshibumba's remark in the original, *kama mvula anataka kupika*, leaves no room for a translation that would have been less strange, as it seemingly inverts the natural sequence of events. In retrospect, Tshibumba's "mistake" may be expressive of the kind of ellipsis that often occurs in Shaba Swahili. "Being close to rain" may refer to a state before and after the appearance of the rainbow in the rainy season.

Tshibumba does use the rainbow as a symbol, but where I look for myth and metaphor, he shows me a metonym: rainbow = rain = rainy country = the Kasai. Of course, it may be that an archetype-like association between rainbow and snake was operative without Tshibumba being conscious of it, and that goes for many other "deep" symbols in his paintings (take the suggestively Freudian smokestack and slag heap motif, for instance). Maybe, but exchanges like the one just quoted have made me wary of semiotic interpretations of cultural products that are supposed to work without having to consult their makers.[13] Almost all logical oppositions make sense, but the structural sense they make does not exhaust their meaning. Culture is logic with a history.

Matters are different in cases where the painter himself arranges symbols in structural oppositions, such as in Painting 54, "The Luba Kingdom and the Building of Mbuji-Mayi," where a wild elephant and a domesticated monkey face each other over the border between bush and town. Or take Painting 83, "The Mulelist Uprising," where soldiers dressed in combat fatigues aim their rifles from a village at warriors in open country, clad in loincloths and armed with bows and arrows. Notice also that in both cases the bush/village (or country/town) relationship is represented as a left/right opposition, at least from the viewer's perspective. However, while Tshibumba uses similar arrangements in other paintings,[14] binary oppositions are but one of the many ways in which he combines symbols. In examining some of these ways, we will also be able to take an inventory of at least the more conspicuous classes of symbols he employs.

Tshibumba displays and combines certain symbols in such a way that they not only make emblematic statements but also tell a story or offer a comment. This applies especially to flags and official emblems, which appear in more than half of the paintings. Single flags (or multiple ones of the same kind) usually identify the political regime that is enacted in, or dominates, the scene represented—the Belgians, the unified Congo, secessionist governments, and Mobutu's Zaire. But often different flags are displayed, and their juxtaposition serves as a comment on the depicted scene. In Painting 70, Katanga soldiers are shooting people in Jadotville. They are in power; the townsfolk are the victims. Yet the flag of the united Congo dominates the picture, whereas the Katanga emblem almost disappears in the background. On one level, this effect is created by perspective; on another, it highlights what the fighting was about and makes a statement about Tshibumba's own political (Lumumbist) position. The Belgian flag and that of the Congo Free State are flown side by side in Painting 20. When I remarked on the pres-

13. For instance, when I undertook a rather involved semiotic analysis of Tshibumba's "Colonie Belge" (Painting 34), it was obvious to me that the buildings in the upper portion of the painting were structurally opposed as village (left) versus colony (right); see Szombati-Fabian and Fabian 1976, 12. That was before I consulted the recorded texts. It turns out I had actually questioned Tshibumba about these buildings, and he had told me that what I took to be a village was the camp de policiers, the police barracks.

14. See the scenes of fighting in Paintings 30, 55, 62, and also the oppositions of village/forest and river/land (Paintings 1, 3, 5, 16). Actual fences chiefly separate compounds from the surrounding country (Paintings 5, 11), airfields from the public (Paintings 31, 58), and the smelter from the town (Painting 75), and barbed wire contains the refugee camp (Painting 63).

ence of two flags, Tshibumba explained: "It shows that the Congo was an independent state but under domination [by the Belgians]." Clearly, this is not just a binary opposition marking a relationship but a kind of syntagma, a critical statement analyzing that relation. In Painting 24, "The Founding of the Mining Company," two flags appear on top of the slag heap. Again, that the Belgian flag looks larger than that of the mining company behind it is dictated by perspective. But there was more to this in Tshibumba's mind, as he revealed in his comment on the painting: "[The mining company] was a state within a state, a government within a government." A concise summary of a complicated political situation was given when Tshibumba added the American flag to those of the Congo and the United Nations in Painting 58, "The United Nations Is Called In." Tshibumba spelled it out in our conversation about the picture: The American flag signals the fact that in their appeal the Congolese "were supported by the Americans. . . . There was a celebration that day; that's why there were three flags." The one-plus-six stars that appear in the sky in Painting 68, "The Deaths of Lumumba, Mpolo, and Okito," are those of the Congolese flag (first prominently displayed in Painting 47, "The Proclamation of Independence"). They stood for "one country, six provinces." Here they become a symbol that repeats, or projects, the word *unité* that flows from Lumumba's starlike wound onto the ground. In Painting 73, "The Death of Dag Hammarskjöld," Tshibumba makes an astute observation on the relations between the United States and the United Nations when he paints a Pan Am plane with the UN emblem.

In the chapter of Tshibumba's History that I titled "The Luba Empire of Albert Kalonji," the paintings illustrate something that goes for the entire series. Flags (and other symbols) are made to tell a story or convey a comment not only by their being represented or juxtaposed but also by the way they are replaced or change from one painting to another. In the story of the rise and fall of the Luba politician Kalonji, his secessionist flag with the characteristic V-sign (borrowed from Winston Churchill, as Tshibumba remarked) dominates the scene of the founding of the new Luba capital Mbuji-Mayi (Painting 76, which also serves as Painting 54). Six flags with the V-sign line a street in Mbuji-Mayi when Kalonji, in full imperial regalia, leads a victory parade (Painting 77). His flag dominates the scene in Painting 78, which shows the successful repression of a revolt against his regime. Notice that the flag of secessionist Katanga appears above some trees in the background, signaling that the Kanioka rebels wanted to set up their own province as part of Katanga. But Kalonji's reign was brief. By Painting 79 his flag has been lowered, hanging limply near the ground while the emblem of the united Congo is raised and dominates the picture. Something interesting happens in this painting when Kalonji's emblem turns up as part of the inscription at the bottom.[15] There it is inserted between *coup* and *d'état,* as if to indicate that what the symbol

15. Emblems and symbols must have been on Tshibumba's mind when he painted this sequence. When we talked about it, he explained to me at length Kalonji's emblem and his regalia (see the text in Part I) and also pointed out the Coca-Cola and Philips signs. Painting 79 was one of the instances where Tshibumba identified his iconographic source: a postage stamp issued by the "emperor" Kalonji.

signifies is being squashed by what the phrase signifies.[16] Perhaps it is no accident that this concern with flags and emblems also informed the painting immediately following this series (Painting 80). Here one of the more confusing and complicated changes of government in the history of the country is symbolized, rather than depicted, by a public building (about which more presently) and a new national flag, which in this case is commented on in the inscription on the painting: ". . . the flag changes."

Before we consider a few other classes of symbols, I would like to offer an observation that may be for semioticians to ponder. A flag is a symbol; painted, it is also the icon of an object. Without losing its symbolic function, a flag can take on additional meaning when it is placed here rather than there, raised or lowered, carried or flown from a pole, or — in the most dramatic case — torn and trampled on (see the Belgian flag in Painting 41, "Troops Intervene in Léopoldville").

Somewhat like flags, uniforms (especially in their details, such as insignia marking a historical period, unit, or rank) may take on meaning that is symbolic. A generalized explorer's outfit (pith helmet, white suit, gaiters) serves to mark Europeans, from the famous Diogo Cão at the end of the fifteenth century to the hapless Lieutenant Bodson at the end of the nineteenth, as members of one and the same category (see Paintings 5, 6, 7, 9, 10, 12, 17, 18, 19). When we got to discussing Painting 9, "Stanley Meets Livingstone," I remarked that the two were dressed the same way. "They are wearing their work clothes," Tshibumba explained, "like those of the military. In fact, they [Stanley and Livingstone] were members of the military. . . . They were hired people." While uniforms generalize, their parts may have the opposite effect. When we looked at Painting 49, "Lumumba Makes His Famous Speech," I noticed that the people in the crowd were rendered rather schematically. Accordingly, this section of the painting is colored in shades of brown, except for a red fez with a golden star worn by a man in the background. When asked about this, Tshibumba said that he was a policeman "from the time before, from the old [colonial] times. In the evening of that same day they took off that uniform and dressed in gray." Superficially, the soldiers that appear in the scenes of Lumumba's arrest (Painting 65) and his presentation to the people (Painting 66) look as if they belonged to the same unit. Tshibumba himself points to differences (namely the helmets) that mark the former as members of the military police and the latter as *justice militaire*.

Next comes the broader category of clothes. Few things are more obviously symbolic, or signlike, in a culture than the way people dress. As a feature that pervades the series,[17] it offers a topic that is impossible to exhaust within the frame we have set ourselves in this chapter. The general impression one gets is that Tshibumba's treatment of dress os-

16. A similar sandwiching of an emblem — in this case that of Mobutu's party — occurs in Painting 87, "The MPR Makes Lumumba a National Hero."

17. Only in four paintings are no people visible (Paintings 45, 56, 80, 92), though inscriptions and comments indicate that they are present. Then there is Painting 97, "The Key to the Future," which is peopled by skeletons.

cillates between figurative accuracy and a degree of abstraction. Presumably these opposed styles of representation correspond to two concerns he has as a historian: He wants to give authenticity to the events he depicts, and that asks for specificity and detail. But he also wants his paintings to tell a story as a series. To show change and development from one period to another, an element such as clothing must be able to serve as a symbol that generalizes and condenses. Tshibumba himself pointed this out in an unsolicited comment on Painting 21, "The Hanging of Chief Lumpungu," as compared to Paintings 19 and 20, showing the beginning of Belgian colonization. In the latter two (and in earlier pictures, such as Paintings 1, 2, 3, 5, 6, 7, 9, 10, 11, 13, 15, 16) Africans wear loincloths, raffia skirts, and wraparounds. The people who are made to watch the hanging of their chief "had already begun to dress well — shorts, shirts, and all that. Except at first they did not wear shoes." What "dressing well" meant to Tshibumba remains ambiguous. Possibly he had in mind the sort of "decent dress" promoted by missions and colonial employers as proof of progress and civilization. Yet in earlier statements he insisted that Africans "knew how to dress" before the Europeans came (see the narrative to Paintings 1–3), and his choice of words in discussing the hanging scene is clearly ironic: "kaputula: semishi: allez/." Distinctly colonial terms for shorts (*kaputula*) and shirts (*semishi*), and the verb that concludes the description (*allez*, go — a colonial imperative par excellence), express the distance Tshibumba maintains from these tokens of progress.

Later, in our conversation about Painting 28, "Victims of the Miners' Strike," we returned to this topic. By that time people were wearing (European) clothes, "with shoes and everything." A telling detail that went without comment shows one of the victims dressed in a white jacket and brown trousers that are both mended with patches. This condenses — as a good symbol should — a message Tshibumba spells out when he traces the uprising to frustration among the mine workers. They were the most advanced urban Africans at the time yet were unable to live up to their status because of the low wages they were paid.

Differences in dress may be displayed in binary oppositions or, as we have already seen, in sequences. The former is a recurrent feature in paintings depicting colonial and postcolonial uprisings and rebellions, which are staged as confrontations between the military in battle gear and the warriors in traditional garb (see Paintings 30, 55, 62, 78, 83). Changes in dress may tell a story within a story, such as in the series of paintings about the life and passion of Patrice Lumumba. He looks prosperous in a suit and tie (Paintings 36, 37, 39, 40, 46–49, 64a, 64b, 65, 84).[18] His humiliation as a prisoner is represented by showing him in an undershirt, sometimes torn or bloody, or with his shirt pulled outside his pants (Paintings 44, 66–68, 87).

18. In Chapter 1 I noted that the MPR flag carried by Lumumba in Painting 40 was anachronistic. So are his clothes, the *abacost* imposed by Mobutu. Dress may have encoded a gesture of defiance when Tshibumba nevertheless portrayed his hero on the left side of the picture in a "counterrevolutionary" suit and tie.

Monuments are another class of symbols that appear throughout the series (seven, possibly nine, times).[19] An equestrian statue of Leopold II (Painting 27) marks the definitive establishment of Belgian rule; a replica of the Atomium, the landmark of the 1958 Brussels World's Fair, serves as the backdrop to a Belgian minister announcing the end of Belgian rule (Painting 35); a monument to colonial pioneers in Tshibumba's hometown, Jadotville (now Likasi), becomes a place of postcolonial strife (Painting 51); Jason Sendwe's tomb is a symbol of his tragic and obscure end (Painting 74); postindependence atrocities are committed around Lumumba's monument in Kisangani (Painting 84);[20] the party monument in Kipushi, the town where Tshibumba lived when he painted the series, commemorates the founding of Mobutu's Popular Movement of the Revolution (MPR; Painting 92); and the powers that will rule the future Zaire are grouped around a similar monument (Painting 101). The monuments command a central position in each painting, although only two of them are actually the topic (Paintings 27, 92). Might they be a somewhat literal indicator of Tshibumba conceiving history as "monumental"? We will discuss this point, together with an explicit statement by Tshibumba, in the section on inscriptions, below.

How monuments assume a symbolic function in this History can be seen in the comments to Painting 74. To state the obvious, namely that Sendwe's imagined tomb — it is clear from the context that Tshibumba never saw the actual site — commemorates an important person in postcolonial history, is to miss much of what the painting was intended to accomplish. Here a subject that is in itself anything but picturesque (that is, worth depicting) invites reflection on a contrast: The flat, white tomb and cross are surrounded by vegetation that marks this location as "bush." There are no people around; except for some birds flying by, nothing is happening. It is as if the eventlessness of the picture was designed to accentuate its function as a reminder, *ukumbusho*, of momentous events. The title Tshibumba gave the painting in our conversation — the *death*, not the tomb, of Sendwe — and the inscription, "assassinated by rebels in 1964," evoke a story of desperate politicking and violent death. Like Sendwe's body under the slab, that story is covered up yet known and talked about, as becomes evident in Tshibumba's detailed comments on the painting.

Public buildings and places, including railway stations, airports, stadiums, administrative offices, and various commercial and industrial establishments, are almost as pervasive as flags (appearing in about forty pictures). Buildings may stand for complicated events, such as the Katanga secession. The prestigious public forum depicted in Painting 56 was planned during colonial times to commemorate the fiftieth anniversary of Elisabethville in 1961. It then became the seat of the Katanga assembly. We already

19. Paintings 27, 35, 51, 74, 84, 92, 101. Paintings 87 and 97 feature buildings that could also be interpreted as monuments.

20. Notice that Tshibumba represents as a bust on a pedestal what was actually a painted portrait in the monument to Lumumba in Stanleyville; see the note to Painting 84 in Part I.

noted a similar function assigned to the building in Painting 80, which depicts the Palais de la Nation but stands for the changing fortunes of politicians who move in and out of it. Tshibumba's comment on this picture was especially interesting. When I tried to get exact information on the building's location and purpose, he was vague. He had never seen it. He knew that it was located in Kinshasa and somehow connected with government, but that was about all he could tell me.

Similar to monuments and public buildings is the category of landmarks. *Mumbunda na mampala*, the smokestack and slag heap that stand for the smelter, appear on seven paintings, sometimes in the background to indicate proximity to the city of Lubumbashi (see Paintings 67a and b). Even when they dominate a scene (see Painting 75), they are an emblem of the city and the region, not the subject of the painting. In Painting 24, which shows the smelter under construction, the subject is the founding of the mining company. Even in Painting 69, where a partial view of the smokestack and heap actually mark the location of the scene, the smelter is made to serve a symbolic function that is encoded in the bridge nearby (see the commentary on this painting in Chapter 3). Other landmarks are the water tower that stands for Kananga (formerly Luluabourg; Painting 53), the pit entrances that identify the mining town of Kipushi (Paintings 72 and 96), and the railway bridge that marks a notorious site of trouble in Lubumbashi (Painting 57).

INSCRIPTIONS: PAINTING AND WRITING

Writing is omnipresent in Tshibumba's History of Zaire.[21] As we have just seen, he works with recurrent symbolic elements in ways that approach pictography, or writing with pictures. In fact, books, documents, and notes could themselves be seen as a category of recurrent symbols. They appear in nine pictures and are explicitly referred to in the narrative that goes with Painting 5, "Diogo Cão and the King of Kongo," where Cão is said to have written down information in a book. Books are depicted in Painting 6, which shows Livingstone taking down information; Painting 36, where the ledger of the brewery is placed on Lumumba's desk (as are letters, a notebook, and a dossier); Painting 48, where the "Golden Book" symbolizes independence; and in Painting 91, where the opponents' names in a conflict about naming (Mobutu and Cardinal Malula) are inscribed in a book that the pope has in front of him. Identity papers (referred to since colonial times simply as *mikanda*, letters or papers) are centrally placed in Painting 22; election leaflets are shown in Painting 82; legal papers are carried in a case by Tshombe

21. Writing also covers most of the flour sacks that were cut up as canvases by the genre painters, among them Tshibumba. Our illustrations show the canvases as they were photographed after they had been taken off their stretchers (see n. 8 above). Many reveal writing on the edges (usually names of the brand, the mill, and the country), sometimes providing a painting with an unintended caption (see, for instance, "République du Zaïre" for Painting 97).

in Painting 81; and speech notes are held by Kasavubu in Painting 38 and Mobutu in Painting 93.

But writing was also involved in the making of this History in a more narrow sense: every one of the hundred paintings has some writing on it. In the case of the genre pictures that were inserted in the series, it may be only the artist's signature or a brief caption (such as for Painting 34, "Colonie Belge, 1885–1959"); most of the others carry inscriptions of varying length, up to about forty words. Although, as we shall see presently, it is possible to assign these writings to a number of categories, Tshibumba did not adopt a standard formula or procedure; he employed writing as part of the creation of a painting. A schematic overview of different kinds of inscription is given in Table 2.1.

Inscriptions are one of the features that distinguish Tshibumba's History from genre painting. To all indications, he consciously chose a "graphic" style because he felt it was appropriate to the task at hand: historio-graphy. What determined that choice? What were the models on which a literate painter defining himself as a historian could draw? Two answers come to mind immediately. One is Tshibumba's familiarity with illustrations in the (history) books and the newspapers and magazines he read. Perhaps this was his principal source of inspiration (an interpretation that is plausible, especially in light of the influence of photography on Tshibumba's work, discussed in Chapter 3). But the fact that the titles, captions, and legends he provides are integral parts of the paintings invites a second hypothesis, namely that Tshibumba, an avid reader of comic strips (see Chapter 5), adopted the conventions of that genre. This would explain the integration of writing and drawing or painting within the same frame, but it leaves us with the question why certain conventions of the comic strip are not used at all (such as the speech-bubble or other renditions of dialogue), and others (such as a continuous inscribed story) only in a few cases (the series formed by Paintings 5–10 might be an example).

A clue to a deeper connection was provided by the artist himself in our conversation on "being a historian who paints" (see the Prelude). His remark was recorded as part of an introduction to the historical narrative. We had discussed differences and relations between writing and painting, when he offered the following statement, here quoted in the original and in a literal translation:

> nasema mambo: kwa peinture/ c'est que naonyesha mambo: kwa peinture: sawa mufano: vile ilikuwa/ eeh? siandike hapana/ mais naleta na mawazo: nakuonyesha kama ni: mambo fulani: ilikuya hivi/ iko sawa nafanya monument/

> I tell things through painting.[22] That is to say, I show things through painting, like it was, right? No, I don't write, but I come up with [it] with the help of ideas. I show you that this is such and such a thing, this is how it was. It is as if I were making a monument.

22. "Things" is a convenient translation for *mambo*, if one keeps in mind that the term does not signify "objects" but "matters, affairs."

Table 2.1 Inscriptions on Paintings

1: A	27: ADG	53: AC	79: ACG
2: A	28: ACF	54: ACG	80: AD
3: A	29: ACD	55: ACG	81: AEG
4: A	30: ACEG	56: AD	82: ACG
5: ABCDF	31: ADEG	57: none; painting by Kabuika	83: AC
6: AD	32: ABDG	58: ACG	84: ACG
7: ADE	33: AEF	59: ACF	85: AG
8: ABDG	34: ACG	60: ACG	86: AE
9: ACF	35: AC	61: AD	87: ACEG
10: ACD	36: ACG	62: AG	88: AC
11: AC	37: ABCG	63: ACG	89: ADG
12: ABC	38: ACG	64: ACG	90: ACFG
13: AD	39: ACG	65: ACG	91: ADG
14: ABCE	40: ACG	66: ACG	92: ACG
15: ADF	41: ACG	67: ACG	93: ACG
16: ABDF	42: ADG	68: ADG	94: ACG
17: AD	43: ACG	69: AC	95: AEG
18: ADF	44: ACG	70: AC	96: ACG
19: ABCEG	45: ADG	71: ACG	97: ACEG
20: AC	46: ACG	72: AC	98: AD
21: ADG	47: AC	73: ACG	99: ADG
22: ACF	48: DG	74: ACG	100: AE
23: ADG	49: AG	75: A	101: ACG
24: AD	50: ADG	76 = 54	
25: ACDEFG	51: ACF	77: ACG	
26: A C? E G	52: ACG	78: ADG	

LEGEND

A: THE ARTIST'S SIGNATURE. Tshibumba signs in six different ways: "Tshibumba K. M." (ten times), "Tshibumba Kanda M." (seven times), "Tshibumba Kanda Matulu" (forty-nine times), "*oeuvre du peintre* Tshibumba Kanda Matulu" (four times), "*peinture de l'artiste* Tshibumba Kanda Matulu" (once)," and "*d'après* Tshibumba Kanda Matulu" (thirty-two times). So far I have been unable to detect a rule to this variation. There is some indication that signatures, like paintings, came in batches, but this is difficult to determine, because not all the paintings were done in the sequence in which they appear in the series. Nor can I explain why the formula "work of the painter" appears on certain pictures. They represent major events (the arrival of the Portuguese, Painting 5; the beginning of Lumumba's international political career, Painting 37; the killing of Colonel Kokolo, Painting 42; and the death of Lumumba, Painting 68), but the series contains many other events of similar importance. In the case of Painting 25, "Simon Kimbangu in Court," Tshibumba's signature is preceded by "painting by the artist," conceivably, but not necessarily, because in this instance he used and identified the photo of a theatrical performance as his model. Perhaps he wanted to emphasize a contrast between painting and photography. In our conversation about this picture, he took care to designate the play's author/director as a fellow artist, and he even included his byline, as a co-creator, in the inscription.

(continued)

Table 2.1 (continued)

There remains Tshibumba's intriguing choice of *d'après*, a convention that usually identifies a picture as a copy "after" a known master, whose name is then given. It is often found on woodcuts and engravings in illustrated books (where Tshibumba may have seen it). Here, however, it is followed by the painter's signature. Did Tshibumba think of a given painting as the copy of a model? Such an interpretation might be construed for genre pictures, which almost by definition are copies; much more likely is that Tshibumba used the expression as a formula of oral discourse (as in *d'après moi*, "as I see it") in order to emphasize his authorship not only of the painting but also of the historical narrative for which he takes responsibility.

One expects an artist's signature to be the one feature in a painting that remains constant, certainly within a period of a few months. That it varies as much as it does is one of several clues supporting the interpretation of Tshibumba's oeuvre as one in which writing was an integral part of painting. The placement of the signature further supports this view. Most often the writing is oblique, but it can also be parallel to one of the edges. Usually it appears in the lower-left or lower-right corner, but in some cases it is close to the center of the lower edge or higher up on the right edge. It is always large and prominent, and in a few cases Tshibumba uses a light color against a dark background. These different practices all indicate that the signature was part of the composition of a painting.

B: A DATE (below the signature, with a circle drawn around the numerals) appears on eight paintings. Why only these pictures are dated is not clear. Seven of them belong to the first batch of thirty-four. This would indicate that Tshibumba decided at one point to omit dates, but that still does not explain why he provided them for the eight pictures on which they appear. Perhaps he initially wanted to show that he was familiar with a practice he perceived to be characteristic of "high art" (as far as I can tell, Shaba genre paintings were never dated). But he really did not have much use for it; the entire series was painted during a few months, hence all the dates would have been the same. Of course, that leaves one with the question why he thought dates were redundant, whereas (with one exception, Painting 48, which probably was accidental) he inscribed his signature with so much flair and relish.

C: A TITLE (more than a word, but less than a full sentence) is inscribed on fifty-nine pictures, but on fewer than ten is it the only writing (apart from the signature).

D: A CAPTION (usually a descriptive sentence) occurs on thirty-one pictures. As it stands, the distinction between C and D is a matter of syntax (although in some cases it is debatable whether a phrase should count as a sentence). The main reason for making the distinction is to draw attention to the fact that Tshibumba's titles are not the kind of gesture by which an artist imposes an interpretation on his or her creation (or withholds it when a painting is exhibited "untitled"). In this History of Zaire, titles are tokens of a narrative, fragments of which are noted down in the sentences I called captions.

E: QUOTATIONS are inscribed on thirteen paintings. About half of them come from speeches by Mobutu; one is by Lumumba; two are attributed to Belgian royalty; two are taken from an article on a play about Simon Kimbangu; one quotes a popular song; and the last one is an imagined prayer pronounced by the person shown in the painting.

F: A BRIEF COMMENT, NOTE, OR PARENTHESIS is added to the title, caption, or quotation on eleven pictures. I take this to be yet another indicator of the discursive rather than classificatory function of these inscriptions.

G: WRITING ON OBJECTS DEPICTED (such as buildings, vehicles, books, and paintings) is found on fifty-eight of the paintings (the vast majority covering the colonial and postcolonial periods).

Table 2.1 (continued)

Tshibumba perceived the settings of his History as inscribed. Writing was part of the environment he painted, but that is not to say that his intentions were limited to "realistic" representation. Once again, a remarkable characteristic is variation. Inscriptions appear on factories, railroad stations, airports, train engines, cars (twenty-two times), books, cards and posters, street signs, uniforms, suitcases (eleven times), commercial buildings (nine times), colonial and postcolonial administrative buildings and prisons (eight times), monuments (five times), pictures (five times), and emblems (four times). Incidentally, maps (including a globe) occur in five paintings. Two cases of inscription are extraordinary: In Painting 68, the death of Lumumba, the hero's blood writes "unity" on the ground as it flows from his side. In Painting 85, "November 24," the entire background, in fact most of the painting, is filled with emblems, slogans, and acronyms, graphically representing Mobutu's regime and its exploits (currency and toponymic reforms, a new national anthem, nationalization of large companies).

Variation also characterizes the semantic functions of inscriptions. They include registration numbers on vehicles, names of companies, place and country names, commercial brands, and shop signs. In a few cases they carry messages that may be understood only by those "in the know." For example, in Painting 49, "Lumumba Makes His Famous Speech," one of the buildings in the background is inscribed PTT (Post and Telecommunications), obviously a reference to Lumumba's troubled early career (see the note to Painting 36 in Part I). Another building is labeled "Gallerie Laurent Marcel Léopoldville," seemingly a made-up commercial sign—unless one knows that Laurent-Marcel was Tshibumba's Christian first name. What amounts to a kind of second signature was also a token of his admiration for Lumumba.

Tshibumba searches for the right expression—*kusema*, to say or speak; *kuonyesha*, to show; *kuandika*, to write; *kuleta*, to bring, fetch, give—until he finds what he has been looking for: when he paints, he makes *monuments* (used as a loanword from French in the original). Extending this statement to the issue at hand, we could say that Tshibumba's writing on, or in, paintings is epigraphic, in the classical sense of the word. As in-scription, it becomes one with the object on which it appears and takes on a character that is entirely different from either description — that is, the representation of the object in another medium — or transcription — the representation of speech by means of graphic signs. Epigrams are writings of a special kind; when they are read they give a voice — hence sound — to objects that could otherwise only be seen or touched.[23]

23. My observations here are inspired by the fascinating work of J. Svenbro on ancient Greek writing and reading (1987, 1989), not to suggest for a moment that his findings can simply be transposed to the kind of literacy in which Tshibumba participates (about which see Fabian 1990a, 1993). When I read S. Alpers's chapter "Looking at Words: The Representation of Texts in Dutch Art" (1983, 169–221), I was struck by scores of correspondences and convergences with the observations I have made on Tshibumba's work alone. But her overall interpretation is dictated by her resolve to turn traditional views of Dutch seventeenth-century painting inside out. My conclusion, that Tshibumba's inscriptions give voice to paintings, is diametrically opposed to her thesis that — with the exception of Rembrandt — Dutch art of the period was thoroughly visual rather than narrative.

In the extreme case where a painting depicts nothing but a monument, the voice that speaks through the inscription partakes in the event-character of all speech and makes events of monuments. Two examples, both discussed earlier, illustrate this. In itself, Painting 74, "Jason Sendwe's Tomb," is about as eventless as a picture can be. But a momentous event is inscribed in, and pronounced by, the epigram on this monument: "Assassinated by rebels in 1964." Similarly, Painting 80, "Tshombe Prime Minister," presents us with a bleak, monumental building. Some vegetation in front of it and flags flying above it are the only signs of life. The inscription summarizes, by evoking three events, a tumultuous period in the history of the newly independent Congo. In a third example, Painting 97 ("The Key to the Future"), the central inscription is presented in such a way that it becomes part of what radiates from the mysterious center of a monumentlike building. It would seem that making an inscription "radiate" (by means of perspectival writing) is about as visual as one can get—until we learn that "100 ans pour Mobutu" is a quotation from a popular song (more about this in Chapter 3). The mysterious building *sounds* as much as it radiates.

When Tshibumba's inscriptions are approached as speech, several peculiarities are more easily understood. One is his tendency to transform names into sentences, titles into fragments of narrative, sometimes adding second-level notes or explanations. Another is his use of quotations, that is, pronouncements by a speaker that the painter addresses to a viewer. Still another is his use of French, which, by standards applied to written language, is faulty in almost every instance (at least in the captions, quotations, and additional comments)—a characteristic that becomes immaterial as soon as one hears what he writes. As far as I can see, not a single inscription is rendered ambiguous, let alone incomprehensible, by grammatical or orthographic mistakes.

And finally, there is the remarkable fact that, with the exception of a few quotes in Lingala, Tshibumba writes his inscriptions in French rather than Swahili, the language in which he narrates his History and in which we converse about it. Like many other speakers of Shaba Swahili, he is not used to writing the language he speaks. The option to switch in writing to a "high" form of Swahili—often used by somewhat older people who had some schooling in Swahili—was not open to him. That is why French would be the obvious choice. Again like other speakers of Shaba Swahili, Tshibumba might also have chosen French for stylistic or rhetorical reasons, perhaps as a matter of prestige, given the social hierarchy of languages in multilingual Shaba. Since he wanted to educate his fellow countrymen, French, the language of schoolbooks, would express his didactic intentions. Moreover, his conception of the history of Zaire, indeed his political position, was decidedly national, not regional. Such a perspective, too, would dictate the use of French. I am sure there are other possibilities one might consider. Strangely enough—given the wide range of issues we discussed—the matter never came up in our conversations. If I were to make a conjecture, I would return to the insight that the French writing on the paintings is epigraphic, that is, basically intended to give these

pictures a voice. Tshibumba chose the linguistic medium that, in his perception and experience, held the prospect of making his voice heard among the largest number of those he wanted to educate, especially among those intellectuals — represented by the ethnographer — he wanted to challenge with his vision of Zairian history.[24]

PERSPECTIVE, COLOR, AND STYLE

Perspective, like other aspects of Tshibumba's pictorial language, interests us here inasmuch as it gives us insight into the making of his History of Zaire. At issue is not whether he is adept or inept at drawing according to the rules of central perspective, but rather how he uses this convention — and others, as we shall see — of representing three-dimensional space in giving shape to his History.

My own observations — which, I hasten to say, are those of a nonexpert — can be summarized as follows: Without a doubt, Tshibumba is familiar with central perspective, in the sense that he is able to create on a flat surface the illusion of depth by means of lines, or by arranging objects or persons along lines, that meet at an (imagined) vanishing point. It is also obvious that his knowledge is mimetic, a matter of experience, rather than of geometric construction. As far as I can see, he reinvents perspective for every painting, but he rarely deviates from habits he acquired when he taught himself to paint. Photography was probably the most important influence, especially in forming a conception of how to frame a scene (a point easily forgotten: perspective needs a frame). Although framing is a subject that certainly regards the making of this History, it will be taken up in Chapter 3, in a context that I think is more revealing than this discussion of perspective. One aspect, however, can be addressed now, because the answer is very brief. In the first batch of thirty-four pictures, only one has a black frame painted around it (Painting 4), whereas such a frame is found on more than two thirds of the subsequent pictures. I noticed the frame when we came to Painting 41 and asked Tshibumba about its significance. There was none, except that at a certain moment he thought a frame looked nice and then painted frames on batches of pictures.

Because central perspective arranges the objects and persons in a picture according to rules, we are inclined to attribute special meaning to "violations" of perspective, mainly to those where the artist does not respect, or exaggerates, the reduction of size along the vanishing lines. Tshibumba's History offers many obvious examples (and others that are arguable), a mere inventory of which could fill many pages. Just to give an idea of the complexity of such an undertaking, here are a few rapid observations: In Paintings 10 and 14, showing the deaths of Livingstone and Banza Kongo respectively, the mourners

24. But this last reason could not have been the only one. Tshibumba had used French to inscribe paintings he sold on the popular market before he painted the History of Zaire (Painting 34 is an example, as well as several pictures of the life and death of Lumumba that he had produced, like genre pictures, in great numbers).

appear too small (hence too far removed) in relation to the body and the space suggested by the rest of the picture. In Painting 12, "Arab Defeat," the first of the whites who are shooting is, in relation to the lower edge of the painting, farther removed from the viewer than the two fleeing Arab figures in the foreground, yet he is depicted much larger. Central figures may indeed be disproportionately large, such as the dying soldier in Painting 30, but then proportions seem to be "correct" in Painting 29, which is very similar in composition to Painting 30. In Painting 36, which shows Lumumba as director of a brewery, the left corner of the desk seems to reach beyond the corner of the room. And then there is Painting 34, *"Colonie Belge,"* frequently discussed as proof of Tshibumba's "naive" ways with perspective. Secondary actors are depicted small, no matter where they are on the picture's plane. In pictures like "African Calvary," Paintings 67a and b, the perspective is at once "correct" (Lumumba and the gendarmes) and "naive" (the Katanga officials). And so on and so forth.

These examples, numerous though they are, do not amount to a style that could be called typical of Tshibumba. I would not rule out that some of these deviations were painted for effect; most of them simply testify to the creative, hence always somewhat unpredictable, work that went into each picture. General conclusions regarding Tshibumba's conception of History that some observers have come up with merely by speculating on his ways with perspective cannot possibly be upheld as soon as the sample is larger than a few of his paintings.[25] He does not work with perspective as a technique independent of the depicted content. Nor do we find in Tshibumba's work the sort of stylized disregard for perspective we associate with, say, naive art (assuming that neglect of, or insecurity about, the rules of perspective is one of the criteria for such a qualification). In other words, he "signifies" when he conforms to the rules but also when he violates them.

Central perspective is in any case a technique of drawing; painting has many other means to create the illusion of depth. Colors and hues could be discussed in this regard, but that is a subject to which I bring no more competence than the average viewer. Furthermore, my observations would have to be limited to the few pictures reproduced here in color. I would therefore prefer to address other aspects of Tshibumba's use of color. Tshibumba worked on a white latex base, on which he first drew rough pencil sketches. Then, using acrylics and a cheap brush, he filled the canvas, starting from an upper corner. Like other popular painters, he constantly had problems of supply, and his choice of colors in certain paintings may simply reflect what he did or did not have available at the moment. I once saw him mixing white pigment with the ink drained from a ballpoint pen to obtain the blue that he needed to paint his skies; traces of that "technique" are visible in several paintings in the form of blue smudges.[26]

On a few occasions—mostly when colors struck me as odd or remarkable—we talked

25. See Dupré 1992 and Biaya 1992 for examples of essays on perspective that consider only a few of Tshibumba's paintings.

26. See Paintings 32, 53, and 56. I report this practice from memory; however, on several occasions, I. Szombati documented Tshibumba's technique in photographs and on 8-mm film.

about his choices. Tshibumba, it turned out, was not really eager to discuss this subject. He was quick to state that the choice of color was a matter of artistic freedom (for instance in his comments on Painting 28 and the two versions of Painting 64). The most detailed exchange occurred when we looked at Painting 27, "The Monument to Leopold II." I remarked on the grayish sky, expressing my suspicion that he had run out of blue. Tshibumba denied this, saying that the gray color was to indicate *temps*, which may refer to the time of the day (the option I took in my translation) but also to the weather. Then he went on to describe the color of the statue as *jaune*, yellow. I saw it as some kind of brown (there is yellow in the flags elsewhere on this painting). We then settled on "brass-colored."

I hesitate to draw a conclusion that is probably expected from an anthropologist at this point, namely that Tshibumba worked with a culturally specific classification of (and terminology for) colors. The problem with yellow that was just mentioned may indicate that he divides the spectrum differently somehow — but different from what or whom? Like other speakers of local Swahili he tends to switch to French for certain color terms (for instance, *bleu, vert, jaune*) that are not part of the triad black-white-red, often said to be typically African. Such a triad seems to be operative in several conspicuous cases (and probably in many inconspicuous ways). One example is the skin color of a unit of United Nations troops arriving in the Congo: they are neither white nor black, hence red (see Painting 58 and our discussion of this). The triad is also at work in Painting 93, "Mobutu's Speech before the United Nations Assembly." The map of the world that forms the background in the right portion of the painting is represented as a triangle: black = sub-Saharan Africa, white = Europe,[27] and red = Asia and North Africa (doubly encoded in skin color and a "redskin" headdress). Surrounding these central figures are yellow for the Far East, black for North America, reddish for South America, and brownish for Australia. Still, if an example were needed to illustrate how little a terminology may tell us about the capacity to make conceptual or aesthetic distinctions, it would be Tshibumba's rather inarticulate ways in describing color.

By contrast, the degree of variation in his use of color is, once again, remarkable. Tshibumba likes strong colors, but they are never garish. A striking blue sky covers the upper part of many pictures; in others there appear white or dark clouds. Orange or yellowish horizons suggest sunset or sunrise, and in some cases grayish or bleak, off-white colors dominate. In a great number of paintings birds are visible in the sky. This, too, is a device by which he suggests depth. As far as I can tell, Tshibumba did not consciously work with a color scale, and only in a limited way with hues, to create illusions of proximity or distance.

All in all, his paintings have a posterlike quality, a style that fits propaganda in its negative as well as positive, educational functions. To be effective, posters require a degree

27. Notice that only Europe and Africa are identified by additional symbols: the former by the pipe, the easy chair and what may be a newspaper, the latter by symbols of nature (a palm tree, the head of an antelope) and industry, both traditional (a copper cross for central Africa) and modern (an oil rig for West Africa).

of schematization, a kind of language of recurrent signs (see the section on "Images as Words" above). Like other popular painters, Tshibumba tends to use the same conventional techniques over and over when he represents, say, trees, patches of vegetation, roads, items of clothing, or architecture. As a result, these items become somewhat like theatrical props that can be moved, but also changed, from one scene to another. There is one subject for which he seems to have devised a system. When he paints people he consistently uses three distinct conventions. Persons in the foreground (usually the protagonists of the story) have volume, suggested by hues and shadowing. A second plane contains persons drawn in outlines that are then filled in with colors, but in such a way that the surfaces appear flat. On a third plane, the one most removed from the viewer, people are reduced to black or, at any rate, dark lines and perhaps colored dots that indicate clothing. To be sure, these differences are in part related to size — stick-figures are small, protagonists large — but the point is that the three planes are represented as distinct and discontinuous; their representation works by contrast, and transitions are lacking. In that respect they display characteristics of a code or language.

In addressing the issue of Tshibumba's style, a terminological decision has to be made. Among the available labels, figurative, realist, and possibly also representational seem to be the strongest candidates (discounting evaluative attributes such as naive). Sticking to a choice made in Chapter 1, I would say that Tshibumba, like all the genre painters, opted for basically figurative representation. Put negatively, this means he did not, as a rule, aim for impressionist dissolution (figures and other features are always clearly outlined, often literally with lines that result in a drawing that is then colored in). He does not tend to expressionist emphasis or exaggeration in shape or color (as do Muteb Kabash and perhaps Mutombo). He does not adopt a decorative style, like that of Pilipili, Mwenze, or Kanyemba. But is realism the difference that remains after all these (and possibly other) subtractions? Does the hyperrealistic execution of detail make mannerists and surrealists realists? On closer examination it turns out that, at least in depicting people, Tshibumba runs the gamut from photo-realism (in his portraits) to abstraction, or at least extreme reduction (in his background figures). I opt for figurative as a label because I think that, as a designation of style, it covers not only detail but the entire composition. When the latter is taken into account, it is clear that Tshibumba's pictures are never photo-realistic either in fact or in intent. Composing, or *kutengeneza* (about which more will be said presently), always takes precedence over depicting (as does narration over representation, staging over encoding, and so on).[28]

28. An interesting question in this context is the relation between popular painting and traditional art. We have statements by Tshibumba and others that stress continuity between *kuchonga* (carving), which they see as a traditional sculptural art, and *kufwatula* or *kupenta* (translatable as "colored drawing"), terms they use for their own work. Above all, these assertions of continuity invite thought on abstraction, that is, nonfigurative representation that is supposed to have been a dominant characteristic of traditional art. If there is continuity, where is abstraction in figurative popular painting?

In Tshibumba's comments, style (*style*, a loanword from French) is the term most explicitly discussed, among a number of others that are part of his aesthetic vocabulary. Style, he told me (during our conversation that appears in the Prelude), is what a painter must have or find and what distinguishes his work from that of others. In that respect painters are like musicians. Although it indicates differentiation, Tshibumba nonetheless seemed reluctant to think of style as a mark of distinction. His references to examples of style use no evaluative or descriptive adjectives (good vs. bad, figurative vs. decorative). When I tried to make him identify his own style, my efforts to get a clear response were to no avail. In the end, perhaps just to please me, he said that his style was in his manner of mixing colors, but in a comparative statement he makes immediately following this brief remark, he turns to another concept, *kuf(u)atirisha* (to draw), as being characteristic of a painter's style.[29]

The only instance in which style does seem to function as an evaluative term is illustrated in a remark on Painting 98, "The World of Tomorrow." Tshibumba was dissatisfied with the painting; his remark, here translated literally, was, "It has no meaning (*maana*), it has no head (*kichwa*) — let's say, none of the sweetness (*butamu*) of a picture; it has no style (*style*)." In this one sentence Tshibumba offered four aesthetic terms, only two of which come up in earlier and later conversations: *maana* and the French loanword *style*. As for the other two, *kichwa* is probably a political metaphor (something like a governing principle), and *butamu* is a gustatory term commonly applied to music or dance, for instance, either to express general appreciation or, more specifically, to indicate a degree of intensity that the music and dancing should acquire to be savored.[30]

A term that occurs repeatedly is *kutengeneza*, a verb whose meaning in ordinary language is "to arrange, to put into order, to repair."[31] Tshibumba used it to designate embellishing and, above all, composing a picture. At one point he evoked a connection between beauty and composition in these terms (*kuwa muzuri*, "being beautiful," and *kutengeneza*) when he talked of the liberty he took in placing the bodies of Lumumba and his companions in the open, even though they were killed inside a house (Painting 68). "In my thoughts [*ku mawazo yangu*]," he said, it happened inside, but he wanted to *kuonyesha* — to make visible in an impressive manner — a scene that would have been difficult to do as an interior. In a similar vein, Tshibumba occasionally designated his artistic activity as *représenter*, to represent. One instance, despite its seemingly prosaic implications, is of particular interest. We were talking about Painting 72, "The Massacre

29. *Kufuatirisha*, corresponding to *kufuatisha*, derived from *kufuata* (to follow), is glossed in the Oxford *Standard Swahili Dictionary* as "to copy carefully, make a copy of." In a later exchange in this conversation I asked Tshibumba to comment on the work of Ilunga, another genre painter. Tshibumba seemed to base his evaluation of him as a beginner on the fact that he had not yet progressed from drawing to real painting.

30. That *kusikia butamu*, to feel sweetness, may also designate response to a theatrical performance is documented in Fabian 1990b, 84.

31. But see A. Lenselaer, who notes the extension of the term to mean ". . . organiser, rendre confortable, apaiser" (to organize, to make comfortable, to put at ease; 1983, 532).

of the Luba at Kipushi," when he pointed out that the event did not take place in the mine, but he chose to put the pit entrance in the scene although it did not really belong there: "We represent [*tunareprésenter*] . . . [the mine] so that you know it was in Kipushi." He thus asserts his freedom of presentation, as opposed to "realistic" or factual representation.

On the whole, Tshibumba was not given to speculating about aesthetics in an abstract way. The closest he came to evoking a concept of aesthetic beauty was in some rather casual remarks on "body art," or traditional practices of tattooing, and the filing of teeth, which he designated as ways to express ideals of *beauté zaïroise* (Zairian beauty) or *beauté culturelle* (cultural beauty).

What makes a painting? As we have seen, such a question raises scores of others. What makes this series? I have tried to tie together a potentially countless number of lines of inquiry by insisting on the ethnographic, pragmatic context in which the question is being asked in this study. What I hope to have shown in this chapter are the communicative and material conditions, the outlines of a pictorial language (at least the most apparent technical means), and some of the aesthetic notions that went into the making of Tshibumba's History of Zaire. In the next chapter we shall see, with the help of a few striking examples, how conditions, material, and techniques produced this History through actual events in space and time.

THREE

Beyond the Written and the Oral:
Performance and the Production of History

ETHNOGRAPHY AND PERFORMANCE

Archival records . . . are cool sources . . . memories are hot. . . . But historians, who by listening to a person's memory become involved in a performance, in a dramatic re-creation of the past, have the option to cool down the oral. . . . We turn the talk into a text that can be filed away, fed into a database, reduced to a synopsis, and quarried for one-liners. It becomes a source like any other. But we can hardly fail to notice that we had to put a lot of effort into transposing it into the realm of the written. And its origins may never be completely forgotten, and may remain an unsettling presence in our written text.

(Neumann 1992, 282)

For many years I have been studying and describing the distinctive vernacular culture in and around the urban centers of southeastern Zaire. I have tried my hand at interpretations of popular language, religion, painting, music, literature, and theater. Academic conventions and territorial divisions (and, of course, the fact that one cannot do everything at once) made me look at these endeavors as separate projects. In this study I am faced with a task in which all of the above seem to blend.[1] Creators of popular culture (especially virtuosi such as Tshibumba) achieve a synthesis of many different forms of expression with ease and elegance. What they accomplish poses a problem for the ethnographer who wishes to represent cultural synthesis in an account whose coherence results neither from imposition (in the form of a grand scheme of classification), nor from reduction (to the laws or rules of a theoretical scheme), nor, for that matter, from a "poetic," metaphorical interpretation with the help of some kind of master-trope. From what, then? I have been searching for a guiding concept capable of joining metonymically, contiguously, popular culture as practice and the practice of its ethnographic presentation. In an ethnography of power based on proverbial speech and the production of a theatrical play I came up with performance as a notion that allowed me to connect the two ac-

1. For a review of popular arts in Africa that takes a similar comprehensive approach, see Barber 1987. I am currently completing a series of essays summarizing my work on popular culture in Africa, tentatively titled *Moments of Freedom: On Anthropology and Popular Culture* (forthcoming, University Press of Virginia).

tivities (Fabian 1990b). Without trying to push beyond its useful limits a concept whose very fashionableness should make one cautious, I will now explore how far it can take us in gaining a deeper understanding of what I have called the making of Tshibumba's History of Zaire.

For better or worse, inquiries into popular history are expected to be part of an established discipline, the study of "oral tradition." Once this is accepted as a point of departure, every step that follows will meet obstacles in the form of distinctions and oppositions, all of which were devised, at various times, to shore up the one difference that seems to have mattered most — namely, that between oral and written history, easily aligned with that between popular and academic knowledge. The following list may help to evoke what I mean by "obstacles" — keeping in mind that this is a *list*, a concatenation of pairs of concepts in contrast to each other.[2]

tradition	vs.	history
oral		written
narrative		descriptive
local		universal
tribal		national
poetic		scientific
genealogical		chronological
repetitive		cumulative
performative		informative
etiological		explanatory

Applied to Tshibumba's oeuvre, some of these distinctions make (some) sense, but none can be maintained without many qualifications. For the processual understanding we seek, dichotomies are incapacitating. Attention to performance can help us to overcome them.[3] Specifically, it will make it possible to address two issues: the process by which the painter constructed and joined his pictorial and his verbal accounts (a problem not usually faced by investigation into oral tradition); and the process by which painter and ethnographer, through communication and interaction, reached shared understandings about this particular construction of the history of Zaire (an epistemological issue that, I believe, cannot be separated from ethnographic description and analysis). Remember

2. Of course, it is only fair to note that these oppositions appeared (and made sense) in different research contexts and that they are based on diverse criteria.

3. As I propose this, I realize that by now performance occupies the very center of, for instance, J. Vansina's radical revision of his classic on oral tradition (1985), and this insight has been incorporated in other recent textbooks and monographs (Finnegan 1992, Okpewho 1992, Tonkin 1992). The more far-reaching revision, however, has been to abandon the root distinction between tradition and historiography as enterprises that are situated on different levels, tradition serving as the source (data), historiography being concerned with formulating knowledge. See Vansina, who proposes "historiology" as a common term (1986, 109), and many other contributions in the volume where his essay appears (Jewsiewicki and Newbury 1986).

that our approach in this study stresses production of knowledge over representation of knowledge. Investigation of knowledge as production requires some kind of actual presence, of being in touch with its producers and products. Study of knowledge as representation almost by definition requires the absence of that which is to be known.

Attention to performance means noticing everything (well, as much as possible) that helps us to approach the artist's and the ethnographer's work as action or as events that occur in time and space, in physical and cultural settings, in the presence of objects as well as persons. Such an approach demands that we consider how narratives are not just constructed but how they are performed; how conversations are not just carried on but performed; how a series of paintings is not just lined up but performed in what is aptly called a "show." In doing so, we become better able not only to understand how painting is joined with storytelling but also to show what happens in the ethnography of such creations.

A SENSE OF DRAMA AND THE CREATION OF PRESENCE

Performances are staged, often planned, and, to some extent, controlled events that seem to occur apart from the flow of whatever happens in the everyday world of the participants. (They are, in fact, often literally set apart, as in cultures that physically separate performers from audiences.) This definition opens a line of thinking *jointly* about performance and history, or rather historiology (speaking or writing about history). Almost everything I have just attributed to performances also characterizes the setting apart, from among myriads of happenings, what eventually will count as "history."[4] Performances may go wrong or be considered poor, something that has caused many of those who use the concept to limit it to a domain called "art" (verbal or nonverbal); others, to whom tension and intensity are necessary ingredients of performance, tend to use "drama" as a synonym.[5] Such limitations need not be imposed when performance is considered epistemologically, but I am willing to admit that a focus on artfulness and drama catches something that should be preserved whenever the concept is applied to theories of knowledge. For the exceptional events we call performances in a more limited sense have, paradoxically, the capacity to create a sense of reality that may be absent in the humdrum happenings of "real life." "Absent" is the cue that puts us onto what I think performance is about: presence — presence, furthermore, that is shared; strictly solitary performances are unthinkable.

4. Of course, there have also been attempts to counteract the theatricality of most historiography, ranging from Enlightenment "philosophical history" to the Annales-school studies of the inconspicuous in the *longue durée*.

5. On performance and verbal art, see especially Bauman et al. 1977, as well as Bauman 1986; on drama, Turner 1986 and, inspired by V. Turner, Schechner 1988. For an argument against limiting performance to the Aristotelian conception of tragedy, followed by an exploration of Tiv ethnic and national consciousness "as performance," see Harding 1990.

What I am after is best illustrated by an event that occurred during ethnographic work with Tshibumba. In his narrative he had gotten to Painting 75, depicting an air attack on the Lubumbashi copper smelter during the United Nations campaign against the secession of Katanga (1963?). We were huddling over the picture and the microphone, enclosed, as it were, in our projects, when something happened in the world outside that left the following trace in the text that now represents the recording:

T: All right. At that time the war just kept going on and on [*looks for the painting*].

F: Yes.

T: The war continued. All right. I think that they got to the last battle and took Shaba. The Shaba affair was finished.

F: [*An airplane flies overhead. F. signals to stop the narrative*] because of the plane; it makes all that noise.

T: Oh là-là, là-là.

F: ...?...

T: Mm-hmm. Press [the stop button], stop it, or else you...?...

F: No.

T: Mm-hmm.

F: Let's go on.

T: Ah, all right. Shall we go on?

F: [*far from the microphone*] Wait, I'll take a look [*steps outside to look, returns*]. Yes, it's going away now.

T: Is it?

F: [*The door slams.*] We got to the death of — what was it again?

T: We had gotten to the [painting of the] smokestack of the Gécamines, or rather Union Minière.

When I listened to the tape years later, this episode struck me as a marvelous piece of unintended dramaturgy: the noise that interrupted our conversation was that of a small plane diving or circling at low altitude — just the acoustic background that fitted the painting Tshibumba was taking up at that moment. Neither of us remarked on that coincidence at the time, but this irruption of the outside world had more than the prosaic effect of interrupting the flow of the story. The accidental sound effect may have been the reason Tshibumba's narrative comment on this painting was particularly elliptic, as if spelling out what the attack was about were no longer needed.[6] But more than that — and this is what the anecdote is to show — what I called the irruption of the outside

6. Another reason, however, may be that Tshibumba here inserted into his historical series one of the most popular genre pictures. He knew that I had seen many other examples and could presume that not much comment was called for.

world made us conscious of our copresence in the midst of our divided preoccupations of speaking and recording, representing history and documenting representations of history. Undoubtedly, it was the timing (that particular noise occurring at that particular moment), an essential feature of performance, that made us step outside the narrative and discuss what to do about the recording. The incident also shows that Tshibumba was not passively submitting to observation; he monitored the recording and was as concerned about its quality as I. Because "time out" from the project we were engaged in was also recorded, we can now document how the sharing of time, a condition of communication at all times, may be intensified at certain moments whose significance will be realized only once the researcher has become sensitive to the performative aspects of ethnography.

The noisy airplane was not the only extraneous event that left traces in the recordings. At times we were also interrupted by our dog's incessant barking, by visitors arriving, by our cook asking for some instruction, and so forth. All of this affected the product — the text that is now the document of our work. Interruptions intensified our "acting together" to produce Tshibumba's History of Zaire (or, to be precise, this documented version of it).

The coincidence of an airplane circling over a house where two people were talking about a picture of planes that once flew over roughly the same location (the copper smelter was only about a mile away) illustrates the intrusion of real time into story time (and, by that token, the anchoring of story time in real time). It also was an instance of what I would like to call the intrusion of materiality into the immaterial world of representation. Noise establishes physical presence. It is a problem for electronic engineers and theoreticians of information (and, in their wake, for semioticians who are concerned with the purity of messages).[7] The ethnographer who has become sensitive to the fact that much of cultural knowledge is not only informative but also performative may consider intrusions of materiality as precious glimpses on the working of intersubjectivity in the production of knowledge.[8]

This notion can be illustrated, once again, by "traces," preserved in both the recording and the texts, of the physical presence of paintings as objects. Throughout the sessions the recorder caught the noise, as well as the pauses, hesitations, and occasional repetitions and repairs of dialogue caused by "rummaging": picking up, pulling out, and moving paintings as we proceeded through the series. One example of how the presence and manipulation of the paintings shaped the recorded text is documented in the first few lines of the fragment cited above: Tshibumba began his comment; then there was a pause that I filled with "yes." Then, marking time, he repeated himself before going on.

7. On this last point, see Eco 1976, 33–36, but also the earlier and more complex statements on noise and process — inspired by Gregory Bateson — by A. Wilden (1972; see the index, s.v. "noise").
8. On the distinction between informative and performative (which partially overlaps with that between semiotic and pragmatic), see Fabian 1990b, 5–6.

More obviously significant were numerous occasions when Tshibumba would, as it were, cross the line between narrating or commenting and viewing the painting that was before us at that moment. One of them was recorded at the end of his comments on Painting 36, "Lumumba, Director of a Brewery." Tshibumba talked about the extraordinary achievement of an African occupying a leading position during colonial times. He pointed out the accoutrements of directorship — the telephone, the mail, the stationery — when I noticed a small hole in the canvas:

> F: [*pointing*] There is a hole.
>
> T: Oh, a tiny hole; it's the canvas.
>
> F: It's the canvas.
>
> T: What happens is that you paint around the damage, and that makes the hole appear.
>
> F: [*chuckles*]
>
> T: [*embarrassed*] Oh là-là.[9]

A similar interruption was recorded when we got to Painting 85, an important one of Mobutu:

> F: So now we get to "November 24" [*takes up the painting*].
>
> T: All right.
>
> F: [*marking time*] Twenty-fourth, twenty-fourth, we see Mobutu. [*There was some fluff on the surface, and I must have signaled to Tshibumba that I noticed this.*]
>
> T: All right. The day when I did this painting [I was working] with some very bad paint, right? If you wipe it with an oiled cloth it will be all right.
>
> F: Yes.
>
> T: All right. November 24 was the day that was, as it were, the birth of [Mobutu] Sese Seko . . .

The two instances differ in that the first mobilized sentiments (amusement, embarrassment), while the second prompted some practical advice about conservation. In a purely informative approach to the textual record, neither exchange would seem to have much significance. But it should be clear by now that these and similar turns of conversation were caused by the presence of the paintings as objects that contributed to shape our undertaking as performance — that is, its realization in shared space and time. Being amused, being embarrassed, being practical — all these are pragmatic aspects that are essential to the ethnographic process.

9. On several other paintings such faults in the material were camouflaged and thereby often highlighted. One example is Painting 64b, where Tshibumba painted the ball at the end of the banister around a hole in the canvas.

Performative acts that create or intensify copresence pervade all oral texts; they were prominent in Tshibumba's narrative and our conversations. They included variations in stress, pitch, volume, speed, intonation patterns, register, and even linguistic code. Then there were audible gestures, such as clapping hands for emphasis or rubbing palms to indicate finality. At times, Tshibumba actually performed little sketches. When we were talking about Painting 23, "The Arrival of the Railroad at Sakania," I asked about the poles and wire along the rails:

> T: Ah, the poles. Those are telephone poles.
>
> F: Telephone poles.
>
> T: Mm-hmm.
>
> F: They always followed the railway.
>
> T: That's true, but the telephone inside . . . [*laughs*]
>
> F: Mm-hmm.
>
> T: [*imitating the action*] You would crank it, crank it, crank it, crank it, crank it . . .
>
> F: [*laughs*]
>
> T: [*shouting*] Hello? Nothing. You crank, you crank. Hello?
>
> F: [*laughs*]
>
> T: No answer. Nowadays it's modernized.

Aside from many similar episodes where performative takes over from informative talking, the texts also contain examples of performances in the more narrow sense of the term. Like other popular historiographers,[10] Tshibumba deployed numerous genres of verbal performance. He told anecdotes, gave quotations, inserted references to his sources, and made surprising asides which often became vignettes that illuminated complex relationships. Sometimes he added whispered comments to his narrative or actually took on the voices of actors depicted in a painting. An instance of such impersonation was Painting 16, "Msiri Kills Katanga's Son." Because little of it is preserved in the edited version in Part I, here is a literal translation of that passage:

> F: What about those people in the back?
>
> T: Those people, they are people from the village. They were watching. [Msiri] did not act secretly; he just grabbed [his victim].
>
> F: Mm-hmm.
>
> T: Now you see one of them saying [*whispers*], "Yayayaya [expression of distress], he kills."
>
> F: Mm-hmm.

10. See those in Fabian 1990a, 213–15.

T: [*still whispering*] This other one [says], "Eh, he just kills." Still another: "Yaa [expression of disgust], so that's the kind of person he is." Another one: "Ah, ah, ah, ah [expression of disbelief], those people are incredible."

F: [*laughs*] [11]

T: "They just kill [*claps his hands*] ...?..." [*ends whispering*].

To give just one more example of Tshibumba performing a scene in a painting: We were looking at Painting 26, "Simon Kimbangu and John Panda in Prison," when I pointed to the right portion of the painting:

F: So those are the people that were locked up.

T: They talk . . . "What's new?" "I don't know." And eventually they kept together in their group. One day they would go to sleep. Next morning [*claps his hands*] one of them is missing. "Where is he?" They don't know where he went. Next day, [*claps his hands*] . . . and so it went with all of them, until no one was left.

Two popular performance genres seem to have been especially important to Tshibumba in creating his pictorial as well as verbal account; both became a topic in our conversations when we explored how history is remembered. First, for Tshibumba, as is the case for Shaba genre painting in general, painting as an activity and paintings as objects are steeped in practices of storytelling. As reminders (*ukumbusho*) they must have the capacity to activate memory by telling (occasioning, generating, facilitating) a story. Perhaps it was this increased attention to narration that caused Tshibumba to frame many of the stories he used as sources with recollections of their actual performance. He referred to "elders" in general, and repeatedly to his own father and mother; he also re-called conversations in his family (and performed parts of the dialogue). One striking example occurred when we were looking at Painting 69, "The Deaths of the Innocent Children." The painting depicts one of the most gruesome recollections of the troubles around the Katanga secession. Women were fleeing the city, and when they got to the bridge over the Lubumbashi River many of them panicked and simply threw their children into the river, where they drowned. I expressed disbelief:

F: Did you see this with your own eyes?

T: This was something that really happened. Some people saw it, and others took photographs . . .

F: Is that true?

11. Though inappropriate as a comment on the story, laughter here acknowledges Tshibumba's skills as a verbal performer.

T: Yes.

F: Where did it happen?

T: Well, I did not actually see it.

F: Mm-hmm.

T: But photographs were taken. . . .

F: And what about the title [of the picture]: "Death of the Innocents"?

T: It means that it was the death of angels, a human being who does not understand what is happening and meets a senseless death.

F: When they were talking about this event, did people call it "Death of the Innocents," or what did they say?

T: [No.] It was me, I thought it up.

F: I see.

T: I had this thought of the small children . . .

F: OK, fine, but are people still talking about this affair?

T: They talk about it all the time. They talk about it all the time. Some express their amazement, others [say] . . . it was something terrible to have happened. . . . The day I painted this picture there were some women at my house there, and they said, "Ts [an interjection indicating distaste], I could never do a thing like that."

F: Mm-hmm.

T: "You would do it," [I said], "when death comes near, you are just going to do it."

F: Mm-hmm.

T: Yes, that's how it is.

This exchange directly confirms the relevance of oral lore to Tshibumba's construction of history. It also shows that he does not simply transpose into painting what is being told as a story. When I questioned him about the caption of the picture I anticipated an answer by suggesting that "Death of the Innocents" might be a popular label. Tshibumba quickly asserted that it was his idea. He was the one who decided to stage this event as a reenactment of a biblical episode. Characteristically, he made the link that gives mythical proportions to a historical incident without much concern for representational correspondence. The biblical story and the historical event differ in almost every detail, except in what he considered the essence: babies having to die in a situation of political oppression. And that was enough to justify the picture's title. Incidentally, his recollections offer another example of coincidence between the work of representation and real life, much like that of the airplane circling above us while we were looking at the picture of an air attack. The story of the mothers killing their children was being discussed while Tshibumba was putting it into a painting. When he recalled the episode he relished the element of timing, by which the reaction of his women visitors was linked to his work on the series in a joint performance.

A second performance genre that manifestly contributed to Tshibumba's work was popular music. Songs,[12] especially those that are sung or played again and again during a certain period, can be powerful vehicles of memory. In his comments on Painting 82, on the 1964 presidential election, he recalled many recorded songs that had been commissioned by various political parties, especially one by the great singer Luambo Makadi (better known as Franco). The picture gives such a vivid image of an electoral campaign (it shows an airplane dropping leaflets over the square in front of Lubumbashi railway station) that one can almost hear the music blaring from loudspeakers everywhere.

Traditionally, songs had a specific and prominent place in performances of oral lore, and there is at least one example where Tshibumba illustrates this literally. Once again, the occasion is a picture of fighting during the troubles of the Katanga secession (Painting 71). An armored vehicle used by the Katanga forces appears in the center, which aptly connotes its significance in stories remembering that time. This legendary home-made tank,[13] called Mammoth, was supposed to be unassailable, until one daring United Nations soldier, an Indian as everyone recalls, managed, with courage and stealth, to insert the nozzle of his gun in an opening in the armor. The shot caused an explosion, killing the crew and immobilizing the "monster." Tshibumba told the story with gusto and then actually sang a political song of the time about the arrival of "Indians from India" on Sabena (the Belgian national airways). Significantly, this song was in Luba and thus occasioned a code switch that is typical when songs punctuate the telling of stories (*arisi*) and other kinds of verbal performance in Shaba Swahili.[14]

How deeply significant recorded popular music could be for Tshibumba's creative imagination was documented during the last of our four sessions. The series had reached the count of ninety-five paintings when Tshibumba declared it completed. After he commented on the last of those pictures, the conversation lingered. While we kept talking it occurred to me that it might be interesting to see and hear how Tshibumba thought the story would go on. Could he do some paintings of the future of the country? Tshibumba's response was enthusiastic but indirect. My calling on him as a "prophet" (his term) made him stress that he had been speaking the truth all along. Depicting the future would be difficult but not essentially different from painting the past. As he put it,

12. It is difficult to find fitting terms for Zairian popular music and its commodified products. What I call "songs" might be translated as popular tunes or hits, except that these hits are always also appreciated for their lyrics and their political, often critical messages. Their popularity is not restricted to one age group or class. Nor would recording "industry" be an accurate designation of popular music production in Zaire at that time. There was local commercial recording (by now much of it is done in Europe), but it would be wrong to project the economic mechanisms and power relations of global music industries on the Zairian situation in the seventies. On Zairian popular music see Bemba 1984; Bender 1991; Ewens 1991, 1994; and Pwono 1992, to name only a few book-length studies.

13. It was built, probably under the direction of European personnel, in one of the subsidiaries of the Union Minière du Haut Katanga at Likasi, Tshibumba's hometown, where he watched its construction.

14. This pattern is confirmed by a work-in-progress on urban storytelling carried out by Marjolein Gijsels; on switching to other languages for songs in a theatrical performance, see Fabian 1990b, 272.

both depended on his capacity to think (*kuwaza*). Tshibumba understood my request as an intensification of the kind of reflexive thought that he repeatedly claimed was the principal source of his History. Incidentally, the predominantly reflexive character of the paintings he subsequently produced expressed itself in the performance features of our fourth and last meeting. What needed to be said about the paintings was such that this session was not divided into a continuous (narrative) and a discontinuous (explanatory) part.

The request for paintings of the future was made on November 12, 1974; on November 21, Tshibumba returned with a batch of six pictures. The first one showed a past event (an accident at the Kipushi mine). It was the next one, Painting 97, titled "Key to the Future: Mysterious Dream of the Artist Tshibumba Kanda Matulu," that caused Tshibumba to invoke popular music. Although his comment is quoted at length in Part I, it will be useful to take another look at the passage that interests us here in a less edited version:

> **T:** . . . I went inside my house and thought every which way I was capable of. I failed. Just as I was about to go to sleep I put my radio down at the head of the bed. Then sleep took me. After sleep had taken hold of me, I dreamed this and that, always with the idea that I should receive the future and what it would be like. But I failed completely. I just listened to the music. It began to play and it was already midnight.
>
> **F:** Mm-hmm.
>
> **T:** As the music was playing, it brought me a dream. I dreamed this building, the way you see it. I didn't really see that it was a building; it was in a dream, and the colors I put—all this was in the dream—but it did not sit still.[15] You [= I] would look, and it was just different. Now, the music they began to sing—it was the night program about the Revolution[16]—they began to sing a song, "Let us pray for a hundred years for Mobutu."[17] All right. Now, the vision I had [*mawazo ile naliona*, lit. "the thought I saw"] was this: There were those skeletons that were coming out of this building, here and there, on both sides.
>
> **F:** Mm-hmm.
>
> **T:** Then this one [here] comes. Then mournful singing started in female voices; that was there on the side of the building. So sleep had carried me [away], and I dreamed those skeletons . . .

There followed a short passage in which Tshibumba told of another painting inspired by this dream. He had left it at home because he felt it could get him into political trouble if he were to be caught with it. Then he returned to "Mysterious Dream."

15. The referent for this last "it" is ambiguous in the original: it could be either the building in his vision or the colors.

16. Lit. "the revolution of the night," probably referring to the usual "revolutionary" party jargon that went with many radio programs at the time. The verb *kuimba*, "to sing," can also mean "to play [music]."

17. Walu Engundu, who is preparing a Ph.D. thesis on Zairian popular song, identified this as a line from a "revolutionary song" performed by the Groupe Kake of Kinshasa during *animation*, the dancing and singing of praise songs for the party that accompanied all public occasions at the time.

You see the skeleton standing up. Then they played another song that really woke me up, a song that Tabu Ley used to sing long ago: [in Lingala] "soki okutani na Lumumba: okoloba nini" . . .

Once again he interrupted the story, this time with an aside on the significance of dreaming in traditional African culture. Then he resumed his account exactly at the point where he had inserted his reflection.

> Now the tall skeleton just stood upright at the time. Then I woke up and began to tell my wife about it. Also, I was full of fear. When I thought about things [other paintings] to do, I failed [to come up with any]. Then I thought: No, I'll do that painting exactly the way my dream was. Because what Mr. Fabian asked me was whether I could do the future. All right. While such thoughts went by me, I set out to dream what was asked for. Actually, I did not consciously think anything, the ideas I had came as a surprise, [for instance] when those skeletons appeared there. In my sleep I ran as fast as I could, and I was startled to hear that they were singing this song, "Kashama Nkoy." That was the song they began to sing.
>
> F: "Kashama Nkoy"?
>
> T: "Kashama Nkoy"; it's a record by Tabu Ley.
>
> F: Mm-hmm.
>
> T: Now, he was speaking in Lingala; in Swahili he [would have] said: [*first repeats the Lingala phrase*] "soki okutani Lumumba: okuloba nini?" Which is to say: If you were to meet Lumumba now, what would you say? All right. I woke up with a start and told my wife about it.[18]
>
> F: I see.

This passage not only illustrates the importance of music, a popular performance genre, for Tshibumba's "thinking," but it also tells us a great deal about almost all the issues raised so far.

Tshibumba here confirms what was said about the performative connection between two different forms of expression in popular culture: popular painting and popular (recorded) music. The actual link between a specific song and a specific painting may appear as one of straightforward illustration. In that case, the song could be classed among the various sources (narrative and iconic) that Tshibumba used in the construction of his History. But this would miss a deeper, more significant connection. Tabu Ley's song is not merely depicted; it is the trigger that activates "thought" and actually makes of

18. I am told Kashama Nkoy was a politician from Bandundu and an opponent of Mobutu who became the victim of anti-Lumumbist purges. In the song, Tabu Ley Rochereau mourns his boyhood friend. It is to the deceased friend that the singer directs his question: "Soki okutani na Lumumba oloba nini papa?" (When you meet Lumumba, what are you going to say, Father?) The transcription is by Walu Engundu, to whom I owe the information on this matter. The song appears on *Rochereau et l'African Fiesta National* (Sono Disc SD/13, Paris 1970).

conceiving the painting a performance (see the vivid description that Tshibumba gives, not one of a static image but of a changing, dynamic vision). By stating that this specific popular song is one that Tabu Ley "used to sing long ago," he illustrates an earlier observation regarding the capacity of popular tunes to mobilize memory, perhaps not so much as a source but as a motive or force that is needed for the construction of history. Almost incidentally, this episode also highlights the nature of performance as a communicative event. Twice Tshibumba mentions discussing the painting with his wife. A picture (like a dream!) is never only to be seen, it is to be talked about as well. Finally, Tshibumba's comments situate his project in a cultural and political environment. He takes care to show how his artistic work is rooted in African conceptions of dreaming, and he expresses fears about the political statement his visionary painting contains. "One hundred years for Mobutu" is anything but flat praise for the dictator. Sometime in the future *he* will have to "meet Lumumba" and account for his deeds to the true hero of the Revolution.

At this point I anticipate an objection: Except for the first one, all the quotations given so far come from Tshibumba's explanations for individual paintings, not from his historical narrative. Looking at my notes, I find that this is probably not just an accidental result of the selection I made here. Does it invalidate our observations about the role of performance in the construction of history? Not at all, I believe. As I have already pointed out, the recorded narrative, having been realized orally, is thoroughly performative. More specifically, I would argue that it is in the comments on each painting — that is, in a situation where the present object may take precedence over the need to give a continuous account of a (sometimes remote) past — that Tshibumba reveals, as it were, not only the performative props that keep the narrative together and running but also the performative aspects of composing the pictures and arranging the series.

STAGING AND COMPOSING A PAINTING

Having seen how performances figure as inspirations and sources for Tshibumba's History, we can now move on to ask whether the notion of performance can help us better understand the composition of certain paintings as well as their placement in a sequence.[19] What such a move involves is illustrated by Painting 25, which shows the prophet Simon Kimbangu facing a colonial court of justice. The painting is particularly interesting, and our conversation about it was quite revealing. It was one of the rare occasions on which Tshibumba volunteered the information that he had used a model,

19. Our brief remarks following the text fragment about "The Deaths of the Innocent Children," above, already showed that it is difficult to keep those two aspects — performance as inspiration for a painting and painting as performance — apart.

and the only instance in which he indicated the source on the painting itself. In his comments he told me that his model was a photograph of a theatrical play staged by a group of students. The picture had appeared in *Mwana Shaba,* a monthly paper published by the Gécamines mining company.[20] In other words, in staging this particular scene, he followed a picture of an actual performance of that scene. Tshibumba's comments made it clear that he did not simply copy a press photo, which would have been a matter of convenience rather than artistic inspiration. This is what came up in our conversation:

> **T:** It was [the photo of] a play by Elebe Lisembe. It was his accomplishment [*claps his hands*] to come up with the idea [*aliweza kuwaza ile mawazo,* lit. "he had the power or strength to think that thought"], and I believe he was thanked by the newspaper in the presence of his teachers, right?
>
> **F:** Mm-hmm.
>
> **T:** Now, as regards his play, as you can see, I, or let me rather say he, performed his play with black people.
>
> **F:** Mm-hmm.
>
> **T:** But when I painted [it] I put in white people and black people, which is how it was.
>
> **F:** Mm-hmm.
>
> **T:** That's right. I added the flag.
>
> **F:** Mm-hmm.
>
> **T:** I added the portrait of Leopold II.

It is significant that Tshibumba took care to name the author and pointed out how successful the play was. He established a link from one artist to another when he began his comments by paying the playwright a compliment.[21] But then, although there was no need to do so, he pointed out the changes he introduced. In the play, African students acted all the parts; in the painting the members of the court are shown as whites, which they actually were. The flag and portrait were added to evoke colonial times. In this way, although he did not depict the actual court that sat in 1921, Tshibumba showed that he was concerned with historical accuracy. Photographic accuracy in copying his source would have violated his historiographic standards. Not so much the image of a performance but its "idea" (*mawazo*) went into the composition of this painting.

But there is more. The portrait of Leopold II in this picture is an anachronism in 1921, and that would seem to contradict the painter's concern with historical accuracy. Tshi-

20. For details, see the note to Painting 25. Remember that Tshibumba lived in the mining town of Kipushi and had easy access to the company paper.

21. Actually, Tshibumba had identified the source of this picture earlier, when we talked about an illustration in a history book that had inspired Painting 17, "Msiri Kills Bodson." Already at that point he made sure the author of the play got his credit: "I wrote there at the bottom [of the painting] that this was a play by Elebe Lisembe."

bumba gives us a clue for resolving that contradiction. Leopold's icon succinctly evokes a complex connection that he made explicit in his comments. When he got to talking about the missionary on the far left of the painting, he remarked, "It is said [*soi-disant*] that de Hemptinne was present at the trial." Here he drew on local knowledge in the form of yet another performative source. He referred to widely shared popular stories, or legends, surrounding the figure of Monseigneur de Hemptinne, vicar apostolic and later archbishop of Elisabethville. His striking resemblance to the Belgian king was commonly explained by the belief that he actually was Leopold's illegitimate son. Using Leopold's portrait to make de Hemptinne visible to the knowledgeable viewer was inaccurate by the standards of chronology; it was, however, an accurate reminder of the prelate's prominent place among colonial oppressors, establishing him as the logical religious counterpart to Kimbangu, a leader of religiously inspired resistance to colonial rule.[22]

A technical connection between performance and historical painting is, of course, the need to stage scenes when a picture is composed. We may assume that such staging is a feature of almost all the paintings of this series. From time to time it was commented on when we looked at certain pictures. Rarely was Tshibumba as explicit as when he talked about his rendition of the massacre of the striking mine workers (Painting 28). The commentary that goes with this picture in Part I leaves no doubt that he actually approached the scene like a theatrical producer — arranging the lighting, determining the placement of the actors, working out poses, and including something like visual sound effects in the form of painted explosions. He explained how he chose the colors to fit the mood and put bats and other night birds in the sky, creating a sense of doom. An eerie effect is produced by trees on the left and right margins appearing to be lit from below. The flags lining the stadium and the smoke from the factory stack are blown in opposite directions: movement seems to be canceled out or suspended. Some of the victims are frozen in mid-fall, and bodies are piled one on another while the viewer's gaze is sucked in by a soccer goal in the dead center of the picture, next to its vanishing point. All this adds up to an almost operatic scene that may remind us of conventions of Western historical painting, except that theatrical staging here is not a question of style. Tshibumba is not a "historical painter" but an artist who paints history. Staging this scene like a performance is a means of deepening and intensifying the horror of a historical event that is alive in popular memory.

Does the effect of suspended, frozen action created by staging a scene not contradict the point that was to be made — that the composition of a painting may in itself be performative? Performance is action in real time; how can a painting, a static icon, be a performance? I would respond by arguing that such a question confuses two claims, one of which was never made while the other remains unaffected. A picture is not a perfor-

22. On highlighting de Hemptinne's role in colonial oppression in the *Vocabulary of the Town of Elisa-bethville*, by André Yav, see Fabian 1990a, 85–87, 97, 142, 148. See also Fetter 1976, index, *s.v.* "de Hemptinne."

mance, but it may be a document showing how the painter conceived of his task—which was something to be accomplished in real time—as being performative rather than merely informative. Tshibumba produced rather than reproduced; he realized (as in French *réaliser*, to produce a play) rather than merely visualized historical events.

TIME, TIMING, AND THE PAINTING OF HISTORY

When we explore analogies (or homologies) between painting and a theatrical performance, we should look not only at individual scenes but also at their sequence and the arrangement by which scenes form a play. In general terms such a connection is easily made. In fact, it is impossible to conceive of Tshibumba's History other than as a kind of drama.[23] At issue in this chapter, however, is not performance in its restricted meaning of a dramatic, staged performance (although we have also looked at that aspect). The ambition here is to demonstrate that a wider, epistemological conception of performance helps us better understand the production of Tshibumba's History, as well as some of the ways in which this product is connected to other expressions of popular culture. Matters get really complicated, but also interesting, when we look at his creation and our ethnographic work in the light of a crucial feature of performance: timing.

Let me begin with a simple observation. As far as I know, when Tshibumba did this first History of Zaire, he had no written script or scenario.[24] There was no worked-out story before he painted from "memory," from personal and common knowledge. During our recording sessions, he arranged pictures in a sequence before he narrated the history he had painted. This was not always easy—a few times he got confused and actually corrected the placement of some pictures in the series—but on the whole, his emplotment of the History of Zaire, his alternating between epic, lyric, dramatic, and plain expository modes, was achieved by means of arranging individual pictures in a sequence. As a historian, albeit one with the ambition to present a counterstatement to received colonial historiography, he did use a chronological scaffold. It is precisely when chronology is put into focus that his creative, and indeed performative, intent can be shown to take over and cause him seemingly to confuse and contradict, invent and conflate, "objectively" established dates and periods.

Take his depiction of the encounter between the Portuguese seafarer Diogo Cão and Banza Kongo (Painting 5). The image itself has numerous layers of significance; others are added by the inscription. Although Tshibumba correctly identified the beginning of

23. C. Young (1992) used the subtitle "History as Tragedy" for his recent essay on the historical paintings by Tshibumba in his collection (more about this in Chapter 5). See also Harding 1990 and an article by G. Dening on the "theatricality of history making" (1993), which offers much food for lateral thought on our subject.

24. He was, however, a "writer" who had kept a diary in the past and took notes related to his work, a few of which he consulted during our meetings. Years later, Tshibumba wrote down a version of his narrative of the history of Zaire in French; see the Preface.

the colonial era with the arrival of the Portuguese at the mouth of the Congo, he seemed to be confused, in fact way off, by making Belgians who worked for King Leopold's International African Association and later the Free State contemporaries of Banza Kongo and Diogo Cão. This is factually wrong; it also challenges academic periodization poetically and dramatically, if the latter is taken to refer to the staging of history as drama. We tend to see fifteenth-century Portuguese discovery and rule and nineteenth-century colonization as discontinuous or, at any rate, quite different in nature. To the colonized this need not make sense; it is more meaningful, and critically valid, to stress connections and continuity.[25]

Another example shows that such chronological telescoping (as it is sometimes called) is not a fluke but a matter of staging history. It may indeed express what the Greek-derived term connotes: vision that reaches farther. The British missionary and explorer David Livingstone appears in several pictures. In one of them (Painting 6) he is said to have met "already in the sixteenth century" a caravan from Katanga carrying copper crosses.[26] Again, Tshibumba was factually wrong, but he was correct in situating knowledge of an African copper industry somewhere at the beginning of European penetration and in depicting Livingstone as being keenly interested in such knowledge.

Tshibumba shared these creative ways with chronology with other popular historians of the same region, for whom timing, a requirement of performative delivery, becomes more important than dating.[27] But whereas other historians could respond to this requirement with the particular construction of their verbal narratives, Tshibumba had to accomplish performative timing chiefly in his pictorial series.

Photography was one of Tshibumba's sources of inspiration. It influenced his paintings in many ways that an expert would need to analyze more closely. Here I can only point to some fairly obvious photographic elements in Tshibumba's work. One instance of photographic technique, the snapshot, was already described when we looked at his portrayal of the Union Minière massacre (Painting 28). What the snapshot achieves, especially in a series, may be the opposite of what it seems to do: while seeming to freeze action, it dramatizes time and timing that are involved in depicting action. Many paintings in the series resemble snapshots, photographic takes in the midst of action.[28] They are evidence for the artist's intent to convey excitement and heighten attentiveness.

The photographic quality of much of Tshibumba's painting is illustrated by two pic-

25. On the Portuguese as a cultural category of mediators between whites and blacks, see MacGaffey 1978, 108–9.

26. Traditionally, these *croisettes* were a form of currency in regions far beyond Katanga/Shaba. They became emblems of the region in colonial times and especially during the Katanga secession, when they appeared on coins, paper money, and the state seal.

27. How this happens and what it achieves is shown in greater detail in Fabian 1990a, 193–201.

28. In one instance, when commenting on Painting 5, "Diogo Cão and the King of Kongo," Tshibumba actually stated that he had composed the picture like a *prise de photo*, a photographic shot. This was in response to my question of why we see the protagonists from the back.

tures that are extraordinary because they came, and were included in the series, in two versions: in color and in black and white (Paintings 64a and b; 67a and b). What I remember appreciating at the time was having these duplicates (and a few others not included in the series) as documents of the way Tshibumba reproduced his topics. He had no such archival interests when he presented them side by side. The two versions of Painting 64, "The Kasavubu-Lumumba Conflict," suggest that the photographer/viewer took his shots while moving toward the persons, who remain still and unchanged (if one overlooks that Lumumba is wearing a different suit in the closer view).[29] As we looked at Painting 67, "African Calvary," I noticed that the effect was like that of two photographs taken successively of one and the same action, or of the same persons approaching the photographer/viewer who stood still while snapping his shots.

I have just glossed "snapshots" as photographic takes in the midst of action. Extending this definition as "takes in the midst of vision" strikes me as a way of describing how Tshibumba framed his pictures — that is, how he decided what should be inside the edges of a painting. The model of photography emphasizes the aspect of timing that is involved, and actually exhibited, in framing. How this works is best seen in the many cases where the frame, or edge, of a picture cuts off a scene, an object, a person, or even an inscription. This last is perhaps the most convincing evidence: In Painting 38, "Kasavubu Is Elected Mayor," the inscription on one of the buildings, "Caisse d'Epargne," is cut to "CAISSE D EP"; Painting 40, of the Léopoldville uprising, has a building labeled "MAGASIN DE VI"; and in Painting 46, "The Brussels Round Table," Lumumba's — the hero's — name card is cut off. Occasionally the cutting-off that results from framing gave rise to questions and unexpected comments: In both Paintings 77 and 79, set in Mbuji-Mayi, the shop sign on the left begins in the middle of a word and is then partially covered by a Coca-Cola sign. The result is "CENT MBUJI MA." Tshibumba told me that the full phrase would be "innocent Mbuji Mayi."[30] Another indication of Tshibumba's photographic gaze was revealed by sheer accident in comments on Painting 18, "Msiri Is Beheaded." When I asked about the white man on the right edge, I was told that he was an explorer and happened to be the one visible among several others who preceded him — and who were therefore outside (the frame of) the picture. Notice also that the left edge of the same picture cuts through Msiri's body. Just as the freezing of action in a snapshot can

29. But why is one picture in color and the other in black and white? Had Tshibumba simply run out of colors? He denied this. No, in the case of "The Kasavubu-Lumumba Conflict," he chose to work in black and white to realize (*kutengeneza*) another idea. For "African Calvary," he insisted that he had just done what he saw my co-researcher doing when she photographed him twice, once in color and once in black and white. Notice that in both cases, the two versions were acquired months apart (see Appendix: Iconography).

30. Unfortunately, I did not pursue this: Innocent Mbuji-Mayi? Is this just a name, or some kind of message? There must be something special about it; why else would only the second half of the inscription appear graphically, so that it has to completed verbally? Is this an evocation (albeit truncated) of the "innocence" of beginnings?

be dramatic, so too can the framing of a scene actually accentuate movement and, thereby, the performance character of a scene.[31]

Given the influence of photography on Tshibumba's painting, it would be surprising if he had not also drawn upon film and television. To be sure, this is again a topic for specialists, but no special expertise is needed to see that he makes use of cinematographic techniques such as flashbacks and cuts in order to solve the problem of depicting events, or series of events, consecutively although they took place simultaneously in different parts of the country. My breakdown of Paintings 50–84 by "chapters" (see the listing in the table of contents) highlights the "cuts" Tshibumba uses to establish narrative control of simultaneous histories. That he was inspired by film or television rather than by novels is a guess; we know too little about Tshibumba the reader.

In order to speed up his series Tshibumba also used a device that resembles time-lapse photography. This was something that came up repeatedly in our discussions. Tshibumba called it *kukatirisha*, to cut [short], and it was important to him to point out that such shortening was, as it were, a matter of commission rather than omission. He would have been able, he told me several times, to represent a given period with many more paintings, but there were always several reasons to take shortcuts: He did not expect me to buy everything he could offer; certain politically sensitive, even dangerous subjects called for ellipsis and discretion, or were better not painted at all. Decisive, however, was the need to produce the series and to have our meetings in limited real time. Tshibumba was working against a deadline (our departure in December 1974) and had to time his production such that the result was a "complete" History of Zaire—balanced among the periods covered and leading up to the present. As it turned out, we eventually had time to add an epilogue of visions of the future, but the point is made: Not only in some specific respects (performances as sources of inspiration, connections between different expressions of popular culture), not only in its parts (composing individual paintings, arranging sequences within the series), but as a whole, as a matter of timed delivery, Tshibumba's History was an accomplished performance.

AN EPILOGUE ABOUT TREES AND THE FOREST

I wanted to show how certain aspects of the making of Tshibumba's History can be understood if they are approached as performative in the more technical and epistemological sense of the term. As a result—without making this a conscious decision—I hardly addressed at all the ways in which the artist constructed his History as the enactment of a

31. Thus our thoughts on framing pictures lead us back to the notion of framing as it is applied, following above all G. Bateson, in studies of communicative performances (see Bauman et al. 1977, 11–13; and Wilden 1972, index, *s.v.* "frame" and "framing").

plot. It is easy to overlook the forest when one looks at trees. The larger picture, the outlines of the overall message of Tshibumba's work, will be discussed in the next chapter. Nevertheless, I would briefly like to show, in this chapter on performance, how Tshibumba stages one episode, the story of the fall of Patrice Lumumba, through one of his more obvious emplotments.

The national hero appears in two sequences of paintings in the series. Lumumba is first depicted ten times as one actor among others in the story of independence: As the director of a brewery (Painting 36), he symbolizes the rising elite from which came the leaders of movements, later political parties, that forced the Belgians to abandon their colony. He is the first leader to seek international contacts (Painting 37, "Lumumba Meets Kwame Nkrumah"); he is among the Congolese politicians who met at the Brussels World's Fair for the first time (Painting 39); he is the soul of the Léopoldville uprising in 1959 (Painting 40). Imprisoned by the colonial authorities (Painting 44), he is freed under pressure (Painting 45) and participates in the Brussels Round Table that prepared formal independence (Painting 46). He presides as the first prime minister of the Congo over the ceremonial conferral of independence (Painting 47), inscribes independence in the "Golden Book" (Painting 48), and delivers his famous harangue of the former masters (Painting 49).

There is one picture (Painting 44) in this first sequence that announces — iconically — the second one. In it Lumumba appears for the first time in a role that Tshibumba will have him play in the second sequence, which could be titled "The Passion of Patrice Lumumba." Although a crown of thorns is lacking, the savior of the nation, dressed only in trousers and an undershirt and covered with the bloody traces of beatings he received, faces the viewer much like Christ in an *ecce homo* picture, a genre of Christian high art as well as popular devotional iconography. I don't think it is unduly stretching iconic similarities to see in Painting 64 ("The Kasavubu-Lumumba Conflict"), the first picture of the second Lumumba series, a reenactment of Jesus being presented to the people by Pontius Pilate. That scene is followed by a picture of Lumumba's arrest (Painting 65), another station on his "way of the cross," and by his being shown once again to the masses assembled in a stadium (Painting 66). When Lumumba is being led from the airplane on arrival in Lubumbashi while his enemies look on (Painting 67), the larger plot is inscribed in the title "African Calvary." The sequence culminates in the painting that shows the death of Lumumba and his two companions, with three crosses looming in the background (Painting 68).

Of course, one could now wonder just how creative Tshibumba was as the author and, as painter and narrator, as the performer of such a plot. Or, put differently, was what we described as a drama with a plot not just an allegory, a figure of speech, rather than a script for performance? Lumumba, we are told in the comments on this painting, was "like the Lord Jesus," and that would fit an allegorical interpretation. A similar expression in the narrative also has the cautious "like" (*sawa*), but there the statement takes on

a different character. Although the passage was presented in Part I, it deserves another look, in a more literal version. Tshibumba had just reported one of the theories explaining how Lumumba's body disappeared, when he stepped outside the story, as it were (a transition marked by a switch to second and first person singular):

> You see that I made three crosses back there. [About] the meaning of this picture, I am saying that Lumumba d[ied; *he interrupts himself and makes a new start*] I, in my opinion, I, the artist Tshibumba, I see that Lumumba was like the Lord Jesus of Zaire.

There is no attempt here to escape into allegory. Speaking in the first person, and actually giving his name and profession, he asserts his authorship of the story and assumes responsibility for its emplotment.[32]

32. That Lumumba was a "martyr for independence" is repeated in Painting 87, which Tshibumba, in another supremely timed move, places much later, among pictures illustrating Mobutu's exploits.

What Happened:
Historiology and the Meaning of History

HISTORIOLOGY: FROM STORY TO HISTORY

We have shown, in much detail, how Tshibumba realized his project, how he painted, told, and, indeed, performed his History of Zaire. We should now take him up on his claim that he is not only a painter and storyteller but also a historian. We should question pictures and recorded texts about the ways he conceptualized and expressed what happened in a given event and in the entire series of events, which, after all, he presented as a series because he felt that the events were part of one and the same story.

Producing a history requires, apart from knowledge, certain knowledge-interests that may include, but must go beyond, those that make a performer of oral tradition verbalize the contents of shared memory or a chronicler of events write down places, persons, and dates. When events are related by and to an unquestioned, hence diffuse, "we," stories can be told endlessly through the night, every night. A history is a work that must somehow be complete in itself. Not only must it have a beginning and an end, it needs something like a vanishing point in drawing, a perspective revealing a subject on whom what happens in events can be predicated, who makes events happen, or to whom events happen.

Who or what is the subject of Tshibumba's History of Zaire? To answer that question, even in general terms, is much more difficult than it may at first appear. It is decidedly not just a matter of collating subjects and predicates and then deciding on whom or what Tshibumba laid the burden of history all or most of the time. Nor can we get rid of the problem by declaring it a simple question of choices of representation. Like other historians, Tshibumba claims to represent what really happened. This intent brings up truth (an issue that will be addressed in Chapter 5); more immediately, it concerns reality, socially shared reality or praxis, of which narrating, in pictures and stories, is a part (and this is critical for our purposes). What delimits, shapes, and structures such a praxis? In Chapter 1 we argued that a shared, bounded system of *ukumbusho*, or remembering, was articulated by Shaba genre painting, which provided the ground on which Tshibumba stood and from which he took off when he embarked on his History. What

was it that enabled him to take off, not just incidentally (something that he and other genre painters seem to have done now and then) but consistently?

Tshibumba was able to fuse his own knowledge and recollections with the shared memory of his contemporaries because he found, or imagined, a subject for his History. Before considering evidence of this claim, we must emphasize that like almost every aspect of his work, imagining a subject was a process rather than a single act. Thus, while it is possible to discern the direction of Tshibumba's thought, we may expect variation, inconsistencies, perhaps contradictions — in short, evidence of a process not concluded.[1]

Here is how Tshibumba goes about defining the subject of his History in the first paragraph of his narrative. The relevant terms are in boldface:

> **T:** The **black man** [*mutu mweusi*, lit. "black human being"] existed since Adam and Eve.
>
> **F:** Mm-hmm.
>
> **T:** Thus, without following the teaching [*adisi*, lit. "story, history"] of religion, such as the Catholic, Protestant, or Kimbanguist [denominations], **our Zaire** existed, it existed from the days of old. And [there were] **our ancestors,** they were as you can see them there, those [were] our ancestors. And they knew how to dress; they had raffia clothes, as you see here in the picture. They knew how to work. They were the ones who worked on the water, fishing, and, in **Katanga,** they began to make copper ingots at that time. . . . They knew how to govern themselves [*kujigouverner*].
>
> **F:** Mm-hmm.
>
> **T:** That is to say, they had **government** [*gouvernement*], for example Banza Kongo, right?
>
> **F:** Mm-hmm.
>
> **T:** They had a complete government.
>
> **F:** Mm-hmm.
>
> **T:** Yes, such as the people of Ngongo Lutete, all of them had governments. But they had not yet gotten themselves together to create **unity** [*unité*]. They made a **federation** [*fédération*], right?

Although Tshibumba starts out with a racial self-identification, he immediately takes a monogenist position (which he later defends against a racist interpretation of the biblical story of Noah and his sons) and thereby locates African history in universal history. In deference to Mobutist terminology, he names the country with which he identifies "our Zaire," because it was the place of "our ancestors."[2] Then he specifies a region, the one in which he lives, as Katanga, this time ignoring political correctness by not calling

1. I would like to refer to H. White's (1980) extension of a Hegelian thesis (that there is no history, properly speaking, until the modern state constitutes itself as its subject) to narration and narrativity (there may be chronicling, but historical narration presupposes the state as moral subject). The problem popular historiography has with being coherent and systematic may reflect practical, and realistic, problems with acknowledging the state as a reality (see also Fabian 1990a, 190–91).

2. Before this, in a sort of preface to the narrative (presented here as the Prelude), he had stated that he would tell "the story [*adisi*] of the whole country [*inchi*]. Every country has its story."

it Shaba. While this general presentation may sound rather vague, he quickly brings it into focus with two statements, one positive, the other negative. He insists that "from the days of old" the people whose history he is about to relate were constituted politically, they had government. What they had not yet realized was unity. Significantly, he names Banza Kongo, a ruler with whom he had neither regional nor ethnic ties, as the foremost example of a government, mentioning others only summarily, except for Ngongo Lutete, a symbol of identification for people of his own ancestry.

When Tshibumba moves from prehistory to history, he starts with Banza Kongo as the embodiment of African civilization,[3] as the one who first encountered the colonizers and eventually gave his name to the country that was to be called Congo. Tshibumba's tracing national unity to the pre–nineteenth-century colonial past was a remarkable act of construction and required, as we have seen in another context, a chronological tour-de-force. Leopold II is depicted not so much as the founder of a colony whose borders were later to contain "our Zaire" but as the one who took away sovereignty from existing governments and called this "independence." Leopold simply took over from the Portuguese (notice that Tshibumba presents Diogo Cão and the Belgian military explorers as contemporaries; Stanley himself he says was Portuguese, and his expeditions were staffed by Portuguese). Leopold's work is completed when he takes, first, Banza Kongo's name to confer on his colony, and then his life, both after making sure that the murder of the African ruler would vacate a center of power to be occupied by the Belgian king's governors. What Tshibumba has distilled here from a history of several centuries is the essence of strategies deployed to legitimize colonial rule. He shows that colonial government was parasitical on African government and that a process toward Congolese unity was under way long before the country emerged as one when it became independent.[4]

Fashioning his History as that of a unified country put Tshibumba before difficult choices. Most remarkable is the resolve with which he refused to write his account from an ethnic perspective. When we look backward from a present marked by regional strife and "ethnic cleansing" and remember that Tshibumba had seen similar outrages when he was an adolescent in the early sixties, it is difficult to imagine how he could have developed and maintained such a position. Without getting into a discussion of just how old, authentic, and real ethnic categories, imposed or chosen, have been in Zaire,[5] we can point to existential and political reasons that made his stance possible. Remember that Tshibumba, though he was born in Katanga/Shaba, counted as a Kasaian, because his father had immigrated from that region. In one of his most moving recollections,

3. Remember also that Banza Kongo was construed by Tshibumba, or his sources, as a quintessential ruler at the time of first contact. The name was that of a place, not of the person Diogo Cão actually negotiated with (see the note to Painting 5 in Part I).

4. On the early political history of state formation and supraregional integration in the savanna regions of Zaire, see Vansina 1966.

5. That discussion, with a focus on the ethnic background that was also Tshibumba's, is critically analyzed by T. Turner in an article on ethnogenesis in Zaire (1993a).

straining to remember chronological detail and naming names, he tells of interethnic, neighborly friendship among adolescents during the troubles of the Katanga secession:

т: [At that time] we were beginning to go out [*kutembea*, lit. "to take walks"].

ғ: Mm-hmm.

т: Together with our peers. We did not recognize [ethnic divisions] — say, those are Katangese, they are locals — we were just friends, young children. We just went out, but actually we were already people [who could reason; the original expresses this simply as *bantu*], we were already in the fifth grade.

ғ: Mm-hmm.

т: Yes, fifth grade [*hesitates and then lowers his voice, talking to himself*]. No, that's not right. Yes it is. Well, I think it was already in fourth grade.

ғ: Fourth grade.

т: Yes, fourth grade in elementary school.

ғ: And you went, at the time, you went out with — who was it again?

т: I went out with — we were just friends . . .

ғ: Mm-hmm.

т: With my best friend who then disappeared. He died, let's say. Yes, Jean Yav [a Lunda name]. We began going out, taking walks there [in Likasi].

ғ: Mm-hmm.

т: And then we would go home; our lots were nearby [i.e., they were neighbors].

National unity is also stressed in indirect ways; for instance, in the emplotment of the pictorial series and the narrative covering the beginning of the Katanga secession. Instead of depicting Tshombe's becoming the head of Katanga, Tshibumba recalls the heroic fight of the Force Publique (that is, of army units loyal to the central government) against the Belgian paratroopers (Painting 51). He maintains this counterperspective throughout the section on the secession, especially in his interpretation of the United Nations refugee camp as a refuge or place of detention for people who were for national unity: "Among those people who fled [to the camp], there were many who loved unity [*unité*]. They loved the unity [now giving the Swahili term *umoja*] of the Congo" (Painting 59). Remember also what was said in Chapter 2 about the symbolic role Tshibumba assigned to the Congolese flag in various scenes depicting the troubles of secession and his laconic response when I asked for the ethnic identity of Kamakanda (Painting 29): "He was a Congolese." One of the strongest statements of his political commitment to unity is made in Painting 84, inscribed "The rebellion in the Congo" but dominated by Lumumba's monument in Stanleyville/Kisangani. Again, the one-plus-six–star flag symbolizes unity (stated explicitly) — as does of course Lumumba's monument (on which he is called a national hero!). From his comments it is clear that Tshibumba sides with Lumumba and the people who die for unity. In sum, I am fairly certain that Tshibumba would have agreed had I proposed to him that the subject of his History was *le peuple*

congolais, a phrase that we both would have associated with Lumumba more than with anyone else.[6]

Tshibumba knew, of course, that political unity was a contested political program, not a fact. His faith in one Congolese nation did not lead him to deny ethnic diversity. There is one episode that can be read as an expression of ethnic pride. He almost waxes lyrical over the extraordinary achievement that was the building of Mbuji-Mayi from nothing, in the middle of the bush (Painting 76). This was an enterprise that started with Luba refugees from ethnic conflicts in Luluabourg/Kananga, Shaba, Kisangani, Bukavu, Mbandaka, and Kinshasa — that is, from practically all the regions of the country. The very enumeration of places conjures up an image of unification, and Tshibumba emphasizes at the beginning of this passage that Europeans were not involved at all in the building of this new city. But what of the fact that Kalonji's V-flag dominates the scene and that the same picture was used earlier (as Painting 54) to represent Kalonji's Luba empire? Does this mean that Tshibumba wanted to celebrate Luba imperialism? Not at all, because after showing Kalonji as emperor (Painting 77) the sequence quickly turns to resistance against him (Painting 78) and ends with Tshinyama's coup d'état (Painting 79), a victory for unity symbolized by the six-plus-one–star flag that dominates the picture.

In Tshibumba's mind there is tension between national unity and identity, and this, rather than the question of the state as subject and agent of history (to be discussed below), is the perspective from which we can address a troublesome problem. Among the arbitrary impositions of colonial power, none is thought to have had more long-lasting and invidious effect than the drawing of colonial borders around territories that later became independent states. It may appear as if Tshibumba simply accepted the colonial "Congo" as reality and then projected it onto a precolonial past. As far as I can see, political borders are evoked or represented on only three occasions: when the Ethiopian campaign is said to have responded to imminent invasions (Painting 29); when the whites of Katanga flee across the border to Zambia (Painting 50); and when the mercenaries under Schramme retreat to Rwanda, causing the rupture of diplomatic relations with that country (Painting 89). Of these few instances, only the first can be construed as concern with territory and borders. On balance, this indicates that Tshibumba shared the acceptance of the colony as a reality in popular consciousness. But it also indicates that, contrary to its conception in colonial and imperialist discourse,[7] its reality was not primarily experienced in spatial or territorial terms.

Because his History is event-centered, places, rather than space, serve to localize memory. In the narrative and in some of the pictures he speaks of regions (such as [North] Katanga or the Kasai), but in about two thirds of the paintings a specific town or village, or a specific place within a town, is either announced (through inscriptions) or identi-

6. As I was writing this, Reinhild König, a student of mine, reported that a commemoration in Brussels of the thirty-third anniversary of Lumumba's assassination included an exhibition of Tshibumba's paintings of the passion of Patrice Lumumba.

7. See on this the extraordinary study by J. Noyes (1992).

fiable (through landmarks). The importance, rather than neglect, of places occasionally makes Tshibumba deviate from academic historiography and commit "errors" that are analogous to deviations from established chronology. When he locates Livingstone's death in Mulungwishi, a village near the center of the Methodist missions in Katanga, rather than at Tshitambo on Lake Bangweulu (see the note to Painting 10), he is appropriating the Protestant explorer and missionary for the History of Zaire. Placing Lumumba's arrest in Lodja (rather than Lodi; see note to Painting 65) adds to the significance of the event, because Lodja is the center of the Tetela, Lumumba's ethnic group. Yet it could not be said that Tshibumba constructs his historiography primarily as topography, something that is a prominent trait of the *Vocabulary of the Town of Elisabethville*, where historical narration tends to consist of entries in a glossary of place-names.[8]

Another issue that a discussion of Tshibumba's historiology must address is agency: Who acts in this history of Zaire? Response to lectures and occasional published statements on what was previously known about him suggests that Tshibumba painted a history of men, and of big men, at that. I think that such an evaluation, or rather dismissal, fails to do justice to this extraordinary historian. To be sure, he conceived his work as a thoroughly political history. Inevitably, this led him to concentrate on wielders of power — kings, warlords, prelates, and politicians — and their agents, among whom there were no women. But women are far from absent. They may not appear often, but when they do they play important roles. In earliest times they are equal partners (Painting 2, "Ancestral Couple"), housewives and mothers (Paintings 3, "Traditional Chief"; and 4, "The Three Magi"). As mourners they bear the brunt of bereavement (Paintings 10, "Livingstone's Death"; and 14, "The Poisoned Banza Kongo"). They suffer the indignities and cruelties of colonization (Paintings 25, "Simon Kimbangu in Court"; 28, "Victims of the Miners' Strike"; and above all 34, *Colonie Belge*"); they are among the victims of postcolonial strife (Paintings 57, "Fighting at a Railway Overpass"; 59, "The Refugee Camp"; 60, "The Secession in North Katanga"; 61, "Fighters Strafing a Village"; and, most dramatically, 69, "The Deaths of the Innocent Children"). Women also have a part in overcoming colonization (Painting 54/76, "The Building of the Town of Mbuji-Mayi"), and they appear as members of a politician's entourage (Painting 77, "Kalonji, Emperor of South Kasai"). In one episode during the Katanga secession women stage a violent revolt (Painting 63). Finally, in Tshibumba's visions of the future, women are the cheerleaders (*animatrices*) of Mobutu's party, itself elevated to a religion (Painting 99). All these examples are taken from the pictorial record only; many more could be added from Tshibumba's narrative and comments.

European men appear, as might be expected, in about two thirds of the first thirty-five pictures, then five times in the sequence that covers the end of colonial rule, after which

8. See Fabian 1990a, 171–72. This document is, apart from Tshibumba's work, one of the few truly popular histories from Shaba told (and written) by the colonized for the colonized. We will return to it several times later on in this chapter.

they disappear from the scene except toward the very end (Paintings 91, "Pope Paul VI Approves Mobutu's Policies"; and 94, "Zairianization"). Incidentally, white women, depicted as ladies wearing long dresses, show up three times, all of them occasions that mark the end of colonial rule (Paintings 39, "Kasavubu and Lumumba Meet at the Brussels World's Fair"; 41, "Troops Intervene in Léopoldville"; and 50, "Whites Fleeing the Congo").

An impression one easily gets when quickly reviewing the series — of big men dominating most pictures and of ordinary people filling in the background — needs qualification. The Africans depicted are recognizable as warriors, peasants and urbanites, fishermen, hunters, housewives, porters, metalworkers, soldiers, railway men, miners, and businessmen. More important, Tshibumba took care to represent his awareness of history being conditioned by the environment, by institutions and classes, by means of transport and communication, by a world market, and so forth. He has a clear concept of the role that mineral wealth played in making his country a target of colonization (although agriculture, including the forced cultivation of cash crops that was part of the colonial experience of many Congolese, is hardly mentioned in this series); he also knows of the power of the mining company and its subsidiaries. Cars, trains, and airplanes carry protagonists through many scenes;[9] business establishments, including a bank and a bookshop, evoke the circulation of goods, money, and knowledge. Telephones, transistor radios, and television sets spread fame and information globally (literally so in Painting 93, as the backdrop to Mobutu's speech to the United Nations Assembly).

After a period of laying the blame on, hence attributing agency to, multinationals aided by foreign governments, scholarly discussion of the history of Zaire, led by political scientists, has turned its attention to the Zairian state and the regime that has been in power for thirty years now.[10] Many statements by Tshibumba, both pictorial and verbal, would seem to support this emphasis on institutions as agents of history. C. Young concludes his essay on the history of Zaire as seen by Tshibumba: "What, then, is history thus narrated? It is a construction of the public realm, of the points of juncture between state and society. The state is an alien other, as it has been since Leopold II created its present form. . . . Tragedy originates outside, in the state domain, and not in society itself" (1992, 135).[11] After having seen how Tshibumba construes the subject of history, I have reservations. In Tshibumba's account, there was more to the history of colonization than alien domination and local submission, and there is more to postcolonial history than survival under oppression. On the whole, Tshibumba does not reify the

9. Airplanes — military, civilian, or both — are visible in nineteen pictures!

10. See Callaghy 1984, Young and Turner 1985, and two collections of critical essays, Jewsiewicki 1984b and Nzongola-Ntalaja 1986.

11. C. Young's thoughtful essay is based on his collection of Tshibumba's historical paintings (assembled at about the same time as the series discussed here, but not as extensive). Several years earlier, this leading scholar of Zairian politics paid homage to Tshibumba when he took two of his paintings ("*Colonie Belge*," cf. Painting 34; and another version of "The Beginning of Belgian Colonization," cf. Painting 19) as the point of departure in introducing a study on the rise and decline of the Zairian state (Young and Turner 1985, 3–7).

state as an alien other. Measuring it against the ideal of unity that was never attained, he shows it as a process of struggle engaging, ultimately, the people, his own people.[12]

Agency brings up the question of cause and causation. Tshibumba reasons in terms of natural causes and effects (remember, in a rainy country one is likely to see rainbows). He has no grand scheme of causation, be it divine providence, the laws of evolution, or the mechanisms of class struggle. But does he not take that "ultimate recourse of someone who is desperate"; does his painting, "taken as an act of the production of popular knowledge, belong to [a] universe of magico-religious acts and bear the traces of such expressions?" (Biaya 1988, 95, 96). What Biaya puts as a question is actually his thesis in a sweeping interpretation, full of valuable insights,[13] of popular painting in Zaire, including the decade in which Tshibumba produced his work. About despair more will be said toward the end of this chapter. As regards recourse to the "magico-religious," there are moments in Tshibumba's History that perhaps exemplify what Biaya has in mind. His founding myth, the story of the Magi (Painting 4), suggests itself, as do Msiri's lethal head (Painting 18), the cannibalistic Simba Bulaya (Painting 22), and Kimbangu's miracles (Painting 25). He recounts that Leopold's monument (Painting 27) was declared to have replaced traditional symbols of power, the kinds of objects often called fetishes. Occasionally, one may detect intimations and allusions in his comments suggesting that the powerful of the country guard secrets that include magic means of aggression and protection. But where is the evidence that Tshibumba would systematically construct his History as a play of magic forces? Magic and magical practices were facts of life in the world in which he lived. He would not have been the "thinker" of history that he was had he simply ignored them.

Of course, Biaya could be right about popular painting and collective memory, in which case, to maintain our interpretation, we would have to conclude that, at least as the author of this History of Zaire, Tshibumba was not a popular painter articulating collective memory. In view of our discussion of genre painting in Chapter 1, this clearly is not an acceptable solution. I suspect, without being able to examine such a difficult issue in any detail here, that confusion arises from a failure to distinguish collective memory, a notion Biaya adopted and developed from Jewsiewicki's work and qualifies as an ideology,[14] from what I have called historiology. The system of *ukumbusho* that was postulated as the substrate of Shaba genre painting, and similar formations that I assume are

12. I would argue that Tshibumba's perspective on the state was closer to that of J.-F. Bayart, whose study led him to conclude that "the State in Africa rests upon autochthonous foundations and a process of reappropriation of institutions of colonial origin which give it its own historicity; it can no longer be taken as a purely exogenous structure" (1993, 260).

13. A notable example is the well-argued thesis that, in popular painting, collective memory contradicts and contests ethnicity, "a practice manipulated by dominant and dominated classes in their political, social, and economic relations" (1988, 110).

14. Biaya refers to Jewsiewicki 1984a and 1986b. The concept of collective memory, following a revival of M. Halbwachs's theory of the social construction of the past, enjoys growing popularity in numerous disciplines. A collection of essays from anthropology and history was published by Bourguet, Valensi, and Wachtel (1988);

found elsewhere in Zaire, may be ideological. Such systems always have that potential, because as discourses they require a certain degree of closure. But Tshibumba had to overcome the constraints of that system, among them material and economic constraints, before he could realize his historical project. We know that he was not the only one to try. That he succeeded with the help of the academe, represented by the ethnographer, put him in the company of Zairian intellectuals who have had the privilege of academic training that was denied to him. It is thus all the more saddening when Biaya, in a rather offhand and somehow defensive response to interpretations of Tshibumba's work, dismisses him as clumsy and passé and, with only the slightest hesitation, puts him into a class of lumpen-intellectuals, because he was said to have been an *instituteur*, an elementary-school teacher with minimal education (Biaya 1992). I have no idea where this biographical information comes from. It certainly is not borne out by the texts published in this study.

A final issue that must be addressed in these observations on historiology is periodization, presumed to be central to the writing of history. A glance at the table of contents, where I have supplied subject headings that summarize the presentation of the paintings in Part I, shows that Tshibumba divides his History in a fairly conventional manner into periods and episodes. The result resembles what one finds in most histories of Zaire. But to leave it at that would miss a crucial difference. His is not a written history; it was painted and performed. His narrative bears traces of a literary approach in the occasional remark such as, "All right, now to another chapter [*kipande*],"[15] or, at the conclusion of the first session, "All right, this is the end of the first chapter." Once he introduces a new episode by stating explicitly: "Suivant l'histoire: sawa tunakatulula kwa kipande: nazania kipande ingine . . . ," or "following history, since we arrange [it] in chapters, I think another chapter [starts]. . . ." "We arrange" is my tentative translation of *tunakatulula*, derived from *katu(l)a*, "to polish, brighten, clean by rubbing," according to the Oxford *Standard Swahili Dictionary*. If I am correct, then it would mean that Tshibumba employed *kipande* not primarily to designate periods or episodes as (classificatory) "cuts" but as an aesthetic device of presentation. But then one would have to add another twist of meaning, because the ending *u(l)a* "conveys the opposite meaning to that expressed in the root" (Ashton 1947, 238)—"messing up" history by cutting it into chapters?

Be that as it may, periodization as such never became a topic in our conversations, and the narrative, although structured in sequences and episodes, is not divided into labeled periods. One of the temporal indications Tshibumba uses most frequently is *ile*

see also Rappaport 1990. I have already cited Küchler and Melion 1991 for art history; see Lipsitz 1990 and Rowe and Schelling 1991 for popular-culture studies. Some of the most encompassing theorizing on "cultural memory" I have seen comes from work on the ancient Near East and Europe by J. Assmann (1992).

15. Literally "a piece," *kipande* can also mean a stretch of time or a piece of territory. But it is safe to assume that Tshibumba here uses the designation of chapters as *bipande* that is common in Shaba Swahili (*sura* would be the term in East Coast Swahili). "Another chapter," *kipande ingine*, occurs three times in the third session.

wakati or *wakati ile*, "at that time, in those days," but also simply "then." Only a few times is *ile wakati* specified by a date. Expressions such as *wakati ya Bwana Yezu*, "at the time of Lord Jesus," or *wakati ya Congo*, "at the time of the Congo [i.e., during colonial times]," could be read as designating periods but hardly amount to a scheme. These expressions are above all narrative markers, and almost as frequently as he places an event "at that time," Tshibumba is likely to introduce it with *ile siku*, "on that day"; *siku moja*, "one day"; or *siku ingine*, "another day," as one might expect given the event-centered conception of history we have posited in his work. Examining occurrences of *siku* made me attentive to another interesting phrase, *siku kidogo*, "a few days [later]." It occurs most often in the first part of the narrative — as if Tshibumba felt pressed to speed up a story covering long spans of time. *Siku kidogo* is, with one exception that confirms this suspicion, absent from commentary texts.[16] This last observation brings us back to Tshibumba's thought: Since, as we argued in Chapter 3, it is essential to understand his History as performance, it comes as no surprise that his foremost concern would be with timing — having events happen, having them dance to a narrative rhythm of times or days — rather than with devising an order of times as a grid to be filled by stories.[17]

MEANING: COLONIZATION AS LOSS AND DECEPTION

Having given much attention and space to the making of Tshibumba's History, we should now be prepared to discuss its message or meaning. "Meaning" means different things to different students of culture. Some propose to reconstruct, in fact reproduce, an author's intentions through the hermeneutic labors of interpretation. Others opt for a more formal, systematic reading that reveals rather than reproduces meaning. We have practiced some of the former when we probed fragments of text, and we touched on the latter when we considered the significance of semiotics for our study. It is also possible to decode messages that are constituted by relations among the parts that make up a product of popular culture. For instance, it can be shown that the author (or authors) of the *Vocabulary of the Town of Elisabethville* constructed this account according to a schema of alternating events of European onslaught and African resistance (see Fabian 1990a, 208–11). Tshibumba shared such a perspective to some extent, but in this History of Zaire he came up with a more complex emplotment. His is not just a story of action and reaction, and certainly not one of European initiative and African response. Unlike the *Vocabulary*, which was written only a few years after independence, Tshibumba's series covers both colonial times and the history of a new state; almost half of his account addresses the period between 1960 and his present, 1974.

16. *Siku kidogo* occurs eight times in the first session, once in the second, and twice in the third. Its sole use in a commentary occurs during the telling of an anecdote.

17. See also related reflections in "Placing and Timing: Logic vs. Performance," Fabian 1990a, 201–4.

Still, for better or worse (for worse, mostly), the history of Zaire has been a history of colonization and its aftermath. It was only to be expected that Tshibumba, searching for a key to that history, would concentrate on finding it in the nature of colonization. The heading of this section anticipates what he found. But what exactly does the "as" imply when I suggest that he conceived colonization as loss and deception? Do I want to discuss evidence that colonization was experienced by Tshibumba as loss and deception? Yes, but his individual experiences alone would not carry much weight in an inquiry that is directed at a better understanding of the history of colonization — which is one of my aims and certainly was Tshibumba's. Or will I be arguing that, no matter how he experienced colonization, Tshibumba chose to express it in statements and images as loss and deception? That, too, might be interesting, but it is of limited significance. Nor is the "as" I have in mind the one we find in sociological studies that propose to approach, say, religious movements "as" social change, or the making of pictures on canvas "as" a case of "cultural diffusion," or the telling of stories that accompanied this particular series of paintings "as" oral tradition. By sociological standards, the work and talk of one artist could hardly be considered representative of his society or even of the forms of expression he chose.

In the perspective from which I propose it here, the "as" takes on a rhetorical, contestatory edge. It announces an argument. For some time, self-fulfilling imperial visions of colonization have been countered with histories of resistance. Now the latter have become the object of critique: Resistance, even if demonstrably successful, shares with domination a common plot of action and reaction. Popular historiology confronts academic colonial history with alternative visions and competing explanations. Of course, recalling colonization as loss and deception neither logically nor historically contradicts a view of colonization as imperialist oppression. Imperialism can, and did, include deceit, and oppression invariably resulted in loss. Within such a general scheme of things,[18] the kind of knowledge popular historiology produces is easily placed on some lower level in a taxonomy of historical knowledge. But when Tshibumba and his fellow popular historians create their visions, keeping to those lower stations that are usually assigned to nonacademic knowledge is not on their minds. They resist the authority of written and printed histories of their country and they contest official colonial history, in detail as well as in its overall conception.

Zairian popular painting, much like Zairian theater and music, certainly belongs to the "arts of [not 'as'] resistance" — the "weapons of the weak" (Scott 1985). That painters, actors, and musicians create representations of domination and resistance in objects, speech, movement, and sound is obvious; that their work is praxis, that it is, to use rhetorical terms, metonymic rather than metaphorical, needs arguing, given the prevalence of

18. A scheme that is explored, for instance, in E. Said's *Culture and Imperialism* (1994), which contains informative discussions of many participants in recent debates about the nature of colonialism.

symbolic and semiotic conceptions of culture in anthropology and in other fields, including history. Even the little we know of popular historiology in Shaba—little compared to what must exist in the "archives" of the people—tells us that endeavors to contest authorized visions, although part of a collective effort, did not create conformity. To be sure, Tshibumba's work is related to these projects, but that does not mean he simply painted and talked according to a widely shared scenario. He struggled with meaning and labored to make sense, and that struggle, not an "ideology," is what makes him representative of popular culture and its producers.

Colonization and Loss

If our interpretation is correct, it should not take more than a viewing of the pictures and a reading of the texts exhibited in Part I to reveal loss as a central theme. Presently we will point to paintings and text fragments in which this theme is most conspicuous. But first we should adopt the philological strategy of the *lectio difficilior*, the more difficult reading, which in our case would be instances where Tshibumba does seem to echo the more familiar story of colonization as submission.

In his narrative and in our conversations Tshibumba repeatedly speaks of the state of being colonized as *butumwa*, slavery. What happened with the arrival of the Europeans is concisely phrased in a comment made on Painting 26, which shows two leaders of religious resistance, Simon Kimbangu and John Panda, in prison. Again, here is a more literal rendition of the passage whose searching, hesitant, and yet powerful message makes it as important as it is difficult. The fragment is brief enough to be quoted first in the original transcript, as an example of the problems of translation:

> John Mpanda par exemple: alikuya ni bwana moya: na are: alikuwa mu Kinshasa mule/ mais alifia nayee: kama: alifia ku: kujua pourquoi tuko: mu butumwa? mais: apashwe shee bote mais tu: tukuwe égal/ c'est-à-dire mu butumwa...?...déranger: tuko batumwa puisque balitukutanisha/

> Take John Panda. He was a man from Kinshasa and he died together [with Kimbangu]. Was it that he died because he wanted to know why we live in slavery? Whereas we should all be equal? Slavery means [a short passage is incomprehensible] that things are out of order. We are slaves because they [the Europeans] made us meet one another.

The key phrase is the last one: "tuko batumwa puisque balitukutanisha." Swahili morphology makes it possible to load a single verb form with heavy significance: *balitukutanisha* combines the subject prefix "they" with the tense marker (past), the object infix "us," the verbal stem "meet," the reciprocal derivation "each other," and the causative derivation "made us." At first glance, both the term *batumwa* and this particular phrase seem to fit exactly the discourse of domination and submission, which have been key figures of speech in celebratory as well as critical accounts of colonization. But two con-

siderations put us on the track of Tshibumba's own, alternative, conceptualization of the initial "impact."

The first emerges when we search his History for the specific meaning he gives to *butumwa*, slavery. From its first occurrence in the narrative, it is clear that it signifies neither an abstract state (lack of freedom) nor a specific social institution, although precolonial forms of slavery as well as colonial forced labor and cultivation certainly were among the memories Tshibumba shared with his people. *Butumwa* is presented as a political fact. In the narrative that goes with Painting 20, "The Congo Free State," Tshibumba says,

> In July 1885 the [treaty giving to Leopold's possessions the status of] independent state was signed. People were at the bottom of *butumwa* under the whites. The whites were very, very few, and yet they imposed their rule [*busultani*].

That colonization is a matter of power politics — not only among colonizing powers but between the colonizers and the colonized — is something Tshibumba claims for the whole of its history. How else could a handful of whites keep the people of a country in "slavery"? He has no use for ideological obfuscations, such as the famous *oeuvre civilisatrice*; colonization was *butumwa*. In fact, if one were to establish a list of "absences" from Tshibumba's history, the foremost carrier of the *oeuvre civilisatrice* — institutionalized religion — would occupy a place close to the top. We never talked much about religion (and that may be significant in itself), even though Tshibumba had a Christian upbringing, probably went to mission schools, once sang in a church choir in Likasi, and was, as a literate person, generally familiar with the role the missions had played in the colonization of his country. Yet his references to them are limited to a few positive remarks on Livingstone's missionary work; a few negative remarks on the role of Monseigneur de Hemptinne, vicar apostolic and later archbishop of Elisabethville/Lubumbashi (whom he depicts as both a reincarnation of Leopold II and an incarnation of oppressive colonialism); a painting that shows the pope deciding in favor of Mobutu in his conflict with Cardinal Malula; and his prophecy of the "end of religion" brought about by the elevation of party rituals to a kind of cult, presumably taking over functions organized religion had had during colonial times.

To appreciate the full meaning of the term *butumwa* we also need to consider *busultani*, literally "chiefship, rulership," and the place this concept occupies in the narrative. It is invoked in connection with Banza Kongo, whom, although he was a regional ruler at the time, Tshibumba depicts as the embodiment of Congolese sovereignty before the arrival of the whites. As we saw in the text quoted near the beginning of this chapter, even before Tshibumba gets to Banza Kongo's story, he first mentions him when he asserts, using the French term *gouvernement* for emphasis and clarity, that Africans had

political institutions long before the whites came. He reverts from *gouvernement* to *busultani* when he later tells the story of Banza Kongo. The one who first received the whites led by Diogo Cão, Banza Kongo was also the one whom the whites had to remove as an obstacle to their rule. Conflating and inverting "objective" chronology, the narrative that goes with Painting 14, on the death of Banza Kongo, takes us to the heart of Tshibumba's vision of colonization. Let us take a closer look at the text:

> **T**: After they had killed the Arabs—[let us now] take Banza Kongo. He liked everyone, white or black. He liked the whites; he liked the black man. Above all, he was a person who liked being chief [*alipenda busultani yake*], and he made much progress. There was, as I told you, civilization among the black people of Kongo. All right, [Banza Kongo] was friends with Leopold II.
>
> **F**: Mm-hmm.

Tshibumba goes on to tell how Leopold decided, "for political reasons we don't know," to honor his friend by adopting his name—Congo—for the entire country.

> **T**: He called it "Congo," and the name "Zaire" died at that time.[19]
>
> **F**: Mm-hmm.
>
> **T**: When the name Zaire had died . . . , the whites told Banza Kongo: "We want to organize a feast . . . during which you will be installed as ruler of the entire country of the Congo."
>
> **F**: Mm-hmm.
>
> **T**: Truly, he was pleased to accept, and there was joy, great and sincere. And then, in the midst of this joy, they gave Banza Kongo some poison. They poisoned him and he died. With the death of Banza Kongo, I believe, the people lost [*balipoteza*] all their possession and all their knowledge. It was as I explained to you and as I wrote on the painting.

Tshibumba then reads a quotation from Mobutu's speech and concludes:

> That was the time when the black man lost [*alipoteza*] everything, and from then on he lived in slavery [*utumwa*].[20] Then they took a white person, a Portuguese,[21] who replaced Banza Kongo. Once they had replaced Banza Kongo there was no way out; we lived in slavery [*utumwa*]. Our sovereignty [*usultani*] died right there.

19. For "died," the original has *ilikufa*, linking this gesture of honoring Banza Kongo to his death by poison. The verb *-pote(z)a*, lit. "to lose," is frequently used as a synonym or euphemism for dying (comparable to English "passing away"). Furthermore, *-poteza* can be a phonological variant of the causative form *-potesha*, "to cause to lose," but also "to destroy, to kill." At one point Tshibumba states, "[The whites] came to set up [their] government and . . . they destroyed [*kupoteza*] the people" (Painting 13).

20. Like many speakers of Shaba Swahili, Tshibumba here employs the alternate form, *u-*, of the *bu-* noun-class prefix. He does the same for *(b)usultani*, below.

21. That "Portuguese" is Stanley, as is clear from the larger context. As Banza Kongo embodied original Congolese civilization, Stanley was the embodiment of the original colonizer.

Twice in the quoted passages the effect of colonization—an enterprise marked by killing and dying—is described as loss. Loss, moreover, is not limited to a forfeit of sovereignty; it is not just a political prerogative that perishes, but "everything" is lost, including "all possessions and knowledge." This last phrase could be understood as either an extension or a specification. I believe that the latter was what Tshibumba intended. He had a thoroughly historical and political concept of culture.

That loss (rather than the abstract concept of domination and submission) is Tshibumba's key to colonial history is confirmed on several other occasions in his narrative as well as his comments. It is in fact traced back to mythical origins and first encounters in a summary of the story that goes with "The Three Magi" (Painting 4). The scriptures tell us that one of the three was a black man from Africa, Tshibumba says, and that proves that "the black man, too, had his origin in the days of old." He then goes on to reject as a lie the racist interpretation of the story of Noah and his sons. The black man's predicament did not come from Noah's curse. It goes back to the fate of the African among the Three Magi. He came with the other two to visit the infant Christ. But:

> He did not return [*hakurudiaka*]. They killed him [*balimuuaka*] and he perished [*alipoteaka*]. To this day he cannot [*hakuwezaka*] come back. I believe this is the story [*adisi*] of the black man right there; it was lost [*ilipotea*].

This is a remarkable statement in several respects. Does Tshibumba accept one of the most pervasive assumptions of colonization, namely that Europeans encountered people "without history"? Perhaps, but to him, being without history is not a "natural" fact; it was caused by a perfidious act, or rather repeated acts, as he seems to argue when he uses four verb forms with the suffix *-ka*, which marks an action as iterative or habitual.

Loss is lamented also at the end of the story that goes with "Ancestral Couple" (Painting 2): "The thing is, we don't know the ancestors anymore; we have lost that knowledge." That it is important for Tshibumba to emphasize intellectual loss can be inferred from his employing several terms, each having somewhat different connotations: *akili*, "intelligence"; *mawazo*, "thoughts" (the content of *akili*); *maidées*, here referring to specific "notions," or cultural inventions. Incidentally, the result of losing *akili* is not stupidity but forgetfulness. At one point, when Tshibumba had trouble remembering certain historical details, he stated, "I used to know all those stories, but I forgot [*nilipoteza akili*, 'I lost intelligence'] as I grew up" (Painting 13).

He also deplores the loss of traditional languages (Painting 3) and traditional *dawa* (medicines, charms; Painting 27), but the loss of political sovereignty is clearly foremost on his mind, and he returns to this topos in several striking pictures and statements. Such repetition is itself a statement: colonial domination was not a single impact or event; it had to be asserted again and again. Thus the removal of Msiri, the crucial event

in the conquest of Katanga, was not complete until the chief was beheaded and his head carried all over the country (Painting 18), until finally it was lost (probably to some museum in Europe, Tshibumba speculates): "I think that was when the sovereignty of the black people was definitely lost. No one was left; they had eliminated all [the African rulers]" (Painting 18). Still, Belgian rule was not really consolidated until much later. It was symbolically asserted when Léopoldville was incorporated as a city (in 1941) and, to celebrate the event, a monument for Leopold II was erected (Painting 27): "And they said they were going to put up [his monument] because he was the king of the Congo. On the other hand Banza Kongo's [memory] was completely lost; there was no monument, no nothing."

Being a key to past history, it is not surprising that loss also becomes a central theme in Tshibumba's visions of the future: People are simply going to "lose [their] way" (Painting 98), and this "will come from God" (Painting 99). There will be loss of churches, indeed, of religion, as party ideology takes their place. Churches become party temples and people pray to Mobutu (Painting 100). Incidentally, -poteza came up one last time, when we said goodbye to each other. Tshibumba regretted the loss of a "very important client." Little did I know then that we were to lose him so soon.

What is the significance of our earlier observations on "absences" from Tshibumba's account in the light of this notion of loss? Increased attention to memory as remembering inevitably leads one to think about the significance of forgetting in constructions of history. Theoretically—ever since Nietzsche—it is clear that "history" needs forgetting as well as remembering. Forgetting is, as it were, the way historical memory works. In fact, the concept of genre, as it has been used in this study, could be said to capture a process of communal forgetting that results in a canon of *ukumbusho*. However, to document this philosophical insight ethnographically is another problem altogether. Tshibumba himself was aware of it. At one point he stated that there was no continuity between what he had learned about history at school, or through reading when he was young, and what he now put into his paintings. Much of what he once knew he had forgotten, he said, but it could be recuperated through "search" (Painting 13). Occasionally he identified his forgetting of facts: for instance, when he told me that he forgot the name of one of the three magi (Painting 4) or that he did not remember the day or the year of the hanging of Lumpungu (Painting 21). Once, when he tried to put an exact date on the arrival of the railroad at Sakania (Painting 23), he regretted that he had forgotten "the piece of paper" on which he had noted "those dates."[22]

How might one presume to pronounce on what Tshibumba's History forgot? To actually establish a list of omissions of, say, major events or sequences of events would make sense only if there were an objective external standard of completeness, which, by defini-

22. Apart from these examples there are more than ten places where he states, often apologetically, that he has forgotten personal and place names. As far as I can see, he never admits to having forgotten an event.

tion, cannot exist. Historical knowledge is always subjectively mediated. Of the omissions he made, not because he forgot but because he could not do everything (omissions are concomitants of perspective; perspective implies partiality), we know some specifically, and others he discussed in general terms when he talked about the need to take short-cuts (Chapter 3) or to cover with silence certain "affairs of the big shots" (Chapter 5).

Betrayal and Deception

Having established the salience of loss in Tshibumba's History,[23] we can now ask further questions. Loss can describe a state which, while not totally devoid of content, may be almost as abstract as the conceptualizations we set out to overcome: submission, reaction, or even resistance. Tshibumba, we maintained, takes a different view of colonization. By that we meant not simply that he works with alternative abstractions or generalizations but that he chooses concepts and figures of speech that enable him to give a different content, or meaning, to colonization.[24] His representations of colonialism in the Congo are never abstract or purely ideological. Nor does he anywhere entertain the idea that Belgian colonization should be taken literally as European agricultural settlement. Although it is a fact that, compared to British colonies to the south and east, planters and breeders played a minor role in Belgian colonization, particularly in Katanga/Shaba, their almost total absence from Tshibumba's History is as remarkable as that of the missions.

In his search for meaning, Tshibumba introduces terms like "friendship" and "betrayal," which express emotions and moral values, but it would be wrong to conclude that he has a sentimental view of colonial relations. The colony he depicts maintains an army and builds railways and factories, and when its meaning is summarized emblematically it becomes *"Colonie Belge,"* an oppressive, punitive scene set in a prison yard (Painting 34). The colony asserted its presence physically; memories of bodily suffering or fear link historiography and (auto)biography. This is what happens in the seemingly abstruse story Tshibumba tells with Painting 31, which shows Prince Charles's visit to the Congo in 1947. The text is extraordinarily difficult to translate; many parentheses, doubtful pronominal references, shifting scenes, and multiple starts and repairs testify to Tshibumba's unease with this episode, which he undoubtedly took from popular lore. Here is its gist: Two orders are issued on the occasion of the royal visit in 1947, expressing with unrivaled succinctness two essential features of colonialism: exploitation and imposition. African men must have their hair cut off so that it can be collected and used to stuff the

23. It should be noted that the texts selected for comment above (and their corresponding pictures) are only those in which loss was verbalized by -*potea* and its derivatives. Tshibumba had, of course, other means to express loss, and he used them as well.

24. Tshibumba employs French loanwords to refer to colonization (he has no Swahili gloss for them in his repertoire). But, apart from the noun *colonie,* he uses only the verb, the past participle, and occasionally the adjective (*coloniser, colonisé, colonial*). Nouns such as *colonisation* or *colonialisme* do not occur in the recorded texts.

mattress on which Prince Charles is going to sleep; and, evoking the biblical topos of the Innocent Children, all male children born during the year of Charles's visit must have one of their eyes gouged, to match the visitor's own deformity (in fact he had a paralyzed eyelid). For Tshibumba this story has autobiographical meaning; born in 1947, he belonged to the cohort of children that was threatened. The story dramatizes mimesis and embodiment in colonization:[25] the deformity of the European is to be inflicted on Africans as if to stamp them with a seal of his likeness. In the end, we are told, the crazy orders were rescinded by the Belgian parliament. If this is to show reason in colonization, it does so only by first conjuring up fantastic images denouncing the madness of the enterprise.

Tshibumba's search for the meaning of colonial history takes him back to origins that become the point of departure for his conceptualizations. That point is imagined neither as a quasimechanical impact or clash, nor as an unpredictable or unexplained happening. There are passages commenting on Stanley's mission that sum up Leopold's motives as a desire "to know" (whether Africans are really people and what their country looks like). Others imply that early travelers, for instance Livingstone, were prospecting for mineral resources. But these motives are secondary in beginnings that are defined as encounters, that is, as entering mutual relations on an equal footing. Initial equality is ingeniously visualized in the painting that shows the first historical encounter,[26] between Banza Kongo and Diogo Cão (Painting 5): Standing with their backs to the viewer, they both contemplate the river Zaire. Foreshadowing what was to come, the inscription on this painting and Tshibumba's narrative make it clear that the encounter, equal though it may have been, was marred from the beginning by misunderstanding (*habakusikilizane*, they did not understand each other). In this passage (see Part I), the painter comes up with what I call a vignette, a tightly packed insight into the nature of historical events,[27] in this case on the role of writing during early contact. Diogo Cão is shown a river and asks its name. For all conquerors, toponymy has been the first gesture of taking possession. The name he hears he writes down: discovery is not complete without inscription in a book (see such a gesture depicted in the following painting, "Livingstone in Katanga"). Knowing a name, or pronouncing a name, is not enough; it must

25. These concepts are usually employed when speaking about the colonized (see Kramer 1993). But they may also inform our understanding of colonization from the other direction, a theme imaginatively explored by M. Taussig, most recently in his book on mimesis and alterity (1993). Representations of the colonized have become the object of study as anthropologists begin to turn their attention to colonialism's culture; see Dirks 1992, and especially Thomas 1994.

26. Remember that there was also a prehistorical, mythical encounter, namely when a black man was one of the three magi, an equal among equals.

27. One can find these vignettes—minimal statements or observations with maximal significance—throughout the texts. To point out just one example: Msiri's head (Painting 18) and its lethal progress through the colony before it disappears "in Europe, in some museum or in the house of Leopold II." The head as trophy, power that kills, transfer of power as transport, power stored and exhibited—each of these themes and images could occasion reflections, completed with ethnographic documentation and comparison, that would fill many pages.

be written down. But in this case writing does not so much record knowledge as it eternalizes initial misunderstanding (mishearing). As has frequently happened in the history of discovery and exploration, a descriptive term ("river") is promoted to a proper name. And then the misunderstood term is written down in a wrong transcription (*Zaire* instead of *nzadi*). Much went wrong here, and as Africans were to find out, their visitors soon vaunted their power by imposing misunderstood names on the land of their hosts.

All in all, making friendship the starting point of colonial history (something that may express collective memory of countless pacts of friendship and blood-brotherhood in the early phases of European penetration) sets the terms for conceptualizing the causes and effects of loss experienced by the colonized. They can be summarized as betrayal and deception. How Banza Kongo was set up by his "friends" was described in one of the passages we quoted earlier. Another conspicuous example of a breach, if not of friendship then of trust, is the famous massacre among striking mine workers in Elisabethville (Painting 28). In an attempt to draw the leaders and active supporters of the walkout into the open, the entire population of the workers' settlement was summoned to a soccer stadium (some said under the pretext that a movie was going to be shown). A confrontation with the Katanga governor Maron, the camp manager, and other officials who had come with a military escort went wrong. When a certain Mpoyi, who acted as spokesman for the workers, tried to talk to Governor Maron, the latter "pulled a gun . . . and shot Mr. Mpoyi. Mpoyi died right there." The order to shoot into the crowd was all the more horrible because it had been decided beforehand and had the blessings of the church:

> There had been an understanding between the bosses of the mining company and the religious leaders, you understand? The go-ahead for all this was given by Monseigneur de Hemptinne, Jean de Hemptinne.

In this instance, Tshibumba reports a firmly and generally held conviction: The employers, instead of protecting their workers, first tricked them into assembling in the soccer field and then delivered them to the colonial regime and its military. Even more insidious was the prelate who betrayed his fellow Christians among the mine workers.

This episode is an example of how Tshibumba often draws on widely shared lore. In the account of this massacre that appears in the *Vocabulary of the Town of Elisabethville*, the betrayal theme is invoked even more explicitly:

> There was a male nurse at the UMHK who had a good understanding with Bwana Maron Alphonse. He was a Kabinda. He had an understanding with Bwana Maron, and his name, too, was Alphonse. Then Maron got angry and shot him with a pistol. He died on the spot. That is when the soldiers began to fire [their] guns. It was a year during the war of 1940 to 1945. Many, many people died. They died for higher monthly wages. That day there was much mourning among the people of E/ville because of this Bwana Governor, Bwana Alphonse Maron. And fate caught up with him in a French city which is where he arrived

on November 11 in the year 1947. This is the story of the massacre of the people of UMHK. (Fabian 1990a, 109)

Notice that this version makes the workers' spokesman and the governor *majina*, namesakes, a relation that belongs to the category of friendship (as distinguished from, say, kinship). *Majina* relations, which entail mutual aid and other obligations, are highly valued in an urban context, where people, especially wage earners such as mine workers, either live without kinsfolk or must support too many of them. In the case of Mpoyi and Maron, the name relationship was clearly constructed as an emplotment of history. Maron's first name was actually not Alphonse but Amour (and that, perhaps, adds yet another twist to the story).[28]

A story of betrayal is also told with the painting that follows that of the miners' strike. Tshibumba tells of Kamakanda, a Congolese war hero during the Abyssinian campaign. While his white officers were resting, he took command of a posse of Congolese soldiers and defeated the Italians. After his return from the war he was told to get some rest and recuperate. And then "they gave Kamakanda an injection and Kamakanda died. They just killed him with an injection" (Painting 29). As part of Tshibumba's plot, this act of betrayal does not figure as an exceptional, if deplorable, incident. It was the straw that broke the camel's back, and reaction to it eventually grew into a full-blown revolt (Painting 30).

As I am stringing these examples together,[29] I realize that they may leave an impression I do not want to create. Stories of betrayal and deception are not just sad and wistful, but rather disconnected, reflections. They are a pervasive theme, and they serve to emplot not only the period of direct colonization but also Tshibumba's entire History, including its pre- and postcolonial periods. Take, for instance, the story of friendship and betrayal that is told as a sort of preface to the Belgian occupation of Katanga. Two chiefs, Katanga, who gave his name to the region, and Msiri, himself an invader and usurper of Nyamwezi origin, we are told, were united in friendship. When Katanga, the leader of a few other chiefs who were holding out against Belgian rule, was near death, he called in Msiri and asked him to be the warden of his infant son and the trustee of his office and possessions (Painting 15). Msiri accepted, but once he had tasted the "sweetness" of power, he grabbed Katanga's possessions and killed his son (Painting 16). Just before he told this, Tshibumba had made a remark on Painting 15 that amounts to a "flashforward" to postcolonial times and adds further significance to the betrayal theme:

28. That betrayal is also the key to colonial history in the *Vocabulary* is asserted repeatedly, most dramatically in the fable "The White Man and His Lady Dog" (Fabian 1990a, 115–19).

29. Others are dispersed throughout the account and range from offhand remarks (such as when we are told that the whites stole from Chief Katanga the art of metalworking, implying that they abused his hospitality; see the comment to Painting 15) to haunting, gruesome tales of white cannibalism (to be discussed in Chapter 5).

T: This is what I am telling you and what it says on the picture [*reads in French from painting*]: "Grand Chief Katanga takes his leave of Msiri, the criminal." [*Continues in French:*] At any rate, take good note, Msiri is the great-grandfather of Munongo, formerly Godefroid,[30] who used to be minister of the interior of the former Katanga, right?

F: Mm-hmm.

T: So, here we are. [*Goes back to Swahili:*] He [Msiri] was a forefather of Munongo, right? That is the story.

This exchange was one of the rare moments when Tshibumba, conscious of the political delicacy of his remark, switched to French, perhaps because he had just read from an inscription on the painting in French, but maybe also in order to signal his stepping outside the narrative. He repeated his remark in Swahili before he resumed the story of Chief Katanga. The sentence that concludes this fragment is ambiguous. It could also be translated as "this is a story," in which case it would be a political hedge. Still, as a partisan of a unified country as envisaged by Lumumba, Tshibumba points to the criminal ancestry of treacherous Katanga politicians such as Godefroid Munongo (not to be confused with Antoine Munongo, the Yeke paramount chief), who was nicknamed *kifagio*, the broom, and had the reputation of being as ruthless as his ancestor.

In pointing out the connection between Msiri and Munongo, Tshibumba extends the betrayal theme from colonial into postcolonial times, where it comes up again and again: On the eve of independence, Colonel Kokolo, who took the side of the people in the Léopoldville uprising, is killed in his own house (Painting 42); Lumumba, betrayed by Kasavubu, is removed from power and killed (Paintings 64–68); Dag Hammarskjöld dies under mysterious circumstances suggesting foul play (Painting 73), as does Jason Sendwe (Painting 74); Kalonji is deposed in a coup d'état by one of his generals (Painting 79); the anti-Mobutu rebel Mulele gets caught and disappears when, as everybody knows, he returned from exile by invitation of Mobutu (Painting 83); Tshombe also is lured back from exile and said to have been poisoned (Painting 90). Perfidious acts (more so than brutal but guileless violence, greed, hunger for power, and so forth) are, as it were, the vertebrae which make up the spine that supports Tshibumba's History of Zaire.

Deception, Disappointment, and Rage

The effect of deception has been *déception* — disappointment. A mood of regret, of expectations not met, and of future doom pervades Tshibumba's History. It is impossible to discern a change of mood as the account passes the turning point of 1960, when independence was granted. Not until the very end of the series as it was planned originally (in two or three of the last five paintings) do we get a message that sounds more upbeat

30. The original has *ex-Godefroid*, a kind of hypercorrection in that Tshibumba projects the Mobutist edict ordering that Christian first names be abandoned onto a period before it was applied.

(see Painting 95, which suggests an apotheosis of Mobutu)—only to have it taken back immediately when Tshibumba reminds us of the price that is paid for this "happiness, tranquillity, joy of living in peace" by "the martyrs of the economy" (Painting 96), after which he embarks on his gloomy visions of the future.

At this point, we should bear in mind that Tshibumba addressed his account to an expatriate researcher. No matter how much rapport, mutual respect, and deep sympathy we developed in the course of our meetings, it was easier for Tshibumba to confront me with past events of colonization than to share present memories of what it had meant to be colonized. Colonization was past, but its wounds had not healed. Not that mere politeness—a virtue which ethnographers have learned to dread in their "informants"—ever dulled his critical intent (more about this in Chapter 5). Still, in view of the objective relations that history had established between us, much of what he told me had to "go without saying."

What Tshibumba did tell me about the effects of, or response to, colonization is all the more illuminating in comparison with what I found in the *Vocabulary of the Town of Elisabethville* (Fabian 1990a). There is striking convergence between the two accounts as well as important differences, both summarized schematically in Table 4.1. The differences as regards authors, sponsors, addressees, and compilation dates (ca. 1965 and 1974, respectively) are obvious. However, the author (or authors) of the *Vocabulary* and Tshibumba share views on the nature of historiology and the effects of colonization. For both of them, history involves remembering (*kukumbuka*). Both insist that memory is an intellectual *activity* and express this semantically by a preponderance of terms that signify not so much recollecting (that is, retrieving memories from a store) as thinking (*kuwaza, mawazo*). The latter is especially important in Tshibumba's case, because *kuwaza*, to think, is what historiology and artistic creation have in common.[31]

While both documents make betrayal and deception a key to colonial history, a remarkable difference appears when it comes to describing the effects of colonization. In the *Vocabulary*, suffering (*mateso*) is clearly foregrounded and provides this account with a focus that is lacking in Tshibumba's. Conspicuously absent from his History are also the many expressions of pride we find in the *Vocabulary*: pride in the contributions domestic servants (and other Congolese workers) made to the organization of modern urban life and to the development of the colony. Although the *Vocabulary*'s story ends with disappointment and somewhat petulant political complaints, these remain limited to the interests of the sponsors and do not compare to the pervasive mood of disappointment and pessimism we find in Tshibumba's History.

Of course, Tshibumba also mentions suffering, but not nearly as frequently as the *Vocabulary*. On a few occasions he qualifies people's reactions to colonial oppression and postcolonial atrocities as *kusikitika* (to grieve, to regret; Paintings 31, 34). Only in one of

31. See the section "On Being a Historian Who Paints," in the Prelude.

Table 4.1 *Responses to Colonization in the* Vocabulary of the Town of Elisabethville *and in Tshibumba's History of Zaire*

	VOCABULARY	TSHIBUMBA
Author	"Scribe" and compiler	Artist and "historian"
Sponsor	Association of former domestic servants	Ethnographer
Addressee	Same as above: the colonized of Elisabethville	Sponsor representing the world at large
Nature of historiology	Memory (*kukumbuka*); thought (*kuwaza, mawazo*)	Same as *Vocabulary*
Key to colonial history	Betrayal/deception	Same as *Vocabulary*
Effect of colonization	Suffering (*mateso*)	Disappointment, rage, silence

his pictures — *"Colonie Belge"* (Painting 34) — is grief represented as more than a re-sponse to specific situations.[32] In all his versions of this most popular genre painting he shows two women sitting and waiting to deliver the food and drink they brought for their imprisoned relatives (as was customary in colonial times). In his comments on the paint-ing, Tshibumba translates this part of the scene into a story:

> They encountered the husband [of one of them] who was being beaten. [*Addressing the ethnographer:*] Here you see the man's own wife; she holds her hand to her cheek, she grieves [*anasikitika*]. This [woman, sitting next to her] also grieves. We don't know which of the men is her husband. She, too, grieves.

Inasmuch as *"Colonie Belge"* encapsulates oppression, all the major figures (the colonial officer, the prison guards, the prisoner who is being punished, and the visiting women) take on the status of symbols summarizing predicaments and experiences. Through the image of the visiting prisoners' wives, grief is presented as a collective response, without being the only, or even the dominant, message conveyed by this painting. As one of the names for this genre indicates, *fimbo,* the cane or whip, is perceived to be the most significant reminder of the oppressiveness of colonial rule (see Dembour 1992). Humili-ation is encoded in the prisoner's prostrate position and the baring of his buttocks. The indignities of colonization are a theme that Tshibumba, and Shaba genre painting in

32. In a few other cases grief is the response to a specific event: see Paintings 10 and 14, where the deaths of Livingstone and of Banza Kongo are mourned, and possibly Paintings 60 and 61, where women respond with gestures of grief or distress to the atrocities they witness.

general, shares with the *Vocabulary*. Finally, *"Colonie Belge"* denotes colonial oppression, but it almost certainly connotes the present oppressive regime.[33]

Suffering, grief, and humiliation signify moods, emotions, and experiences that are essentially passive. "Passion" certainly is one way in which Tshibumba conceived what happened to the victims of betrayal and deception, most dramatically in his emplotment of the story of Patrice Lumumba as the suffering of Christ. But it is another meaning of "passion" — "strong emotion, outburst of anger," according to my *Pocket Oxford Dictionary* — that brings us onto the track of another theme that pervades Tshibumba's narrative and comments. Lexically, it is signaled by the verb *kutomboka*, literally "to burst" (as in blowing a tire) or "to explode." Having learned Shaba Swahili directly from its speakers, I heard, whenever Tshibumba used *kutomboka*, its general connotations: rage, outburst of anger and frustration. Only now, after checking my dictionaries, do I realize that the word had long ago acquired a more specific political meaning.[34] Going back to the recorded narrative and conversations, I find that Tshibumba himself employed the term in this sense when he told stories that went with pictures of mutinies, revolts, and rebellions. Only three such events, or series of events, are placed in the colonial period. The first recalls the killing of a member of a Belgian expedition to Katanga, Bodson, by Chief Msiri, whose actions are interpreted by his people as *kutomboka*, exploding (Painting 17). The term returns in narrative and comment on "The Tetela Revolt," referring to widespread rebellion in the early to mid forties. The popular, mainly rural uprising was triggered by a mutiny of the military, which Tshibumba linked to the death of Kamakanda (Paintings 29 and 30). That story is alluded to once more, significantly when Tshibumba tells of Lumumba's ascent as the future leader of the revolution (see his comments on Painting 36). People are said to have "exploded" during the Léopoldville riots on the eve of independence (Paintings 40 and — in a portion of the narrative that does not appear in Part I — 42). Almost all the other examples regard "postcolonial" ethnic and political uprisings and conflicts: ethnic riots followed by a massacre of Kasaians at Kipushi mine (Painting 72); the Kanioka revolt against Kalonji's empire (Painting 78); and the Mulelist rebellion in Kwilu (Painting 83) and the rebellion led by Nguebe and Soumialot in the Northeast (Painting 84), both directed against the central government.

33. We arrived at this conclusion by way of a somewhat technical semiotic argument in Szombati-Fabian and Fabian 1976, 15.

34. The Oxford *Standard Swahili Dictionary* has no entry for *-tomboka*. Sacleux identifies it as "Kingwana" (i.e., Congo Swahili) and translates it as "se révolter." He also has a noun or participle, *mutomboki*, "révolté." Lenselaer likewise points to the term's Congo origin (is this a lexical trace of a political history of rebellion?) and somewhat widens its meaning: "se révolter, jaillir hors de, se fâcher, etc." (to rebel, to burst out from, to get angry), adding an example, *Watu wanatomboka kule*, "les gens se révoltent là-bas, manifestent" (people are rebelling over there, they are protesting). In Tshibumba's narrative and comments, *kutomboka* occurs in fourteen passages of varying length and importance. Once or twice he provides the French synonym in the same phrase. For instance, "na walitombokaka/ balifanya révolte/ la révolte Batetela": and they exploded, they made a revolt, the revolt of the Tetela (Painting 30). In the *Vocabulary*, the term is found only once, and then only to describe rage felt by whites during the troubles of independence (Fabian 1990a, 124, 125).

In these examples *kutomboka* seems to have the specific meaning of African collective resistance, spontaneous or organized. However, we also find occurrences of the term that do not fit that pattern. When Tshibumba comments on Painting 50, which shows Europeans fleeing the country (on orders of expulsion issued by Lumumba, then prime minister), he recalls his own memories of the panic and confusion among the African population. The soldiers of the former colonial army were running away from their barracks:

> "What's going on?" [people asked]. The word was out: "The whites are exploding [*banatomboka*]." "They're exploding, where are they exploding?" "They are just exploding [*banatomboka tu*]," it was said. "You've never seen anything like it."

Although neither the painting nor the commentary suggests the organized action we have seen this concept entail, this explosion of the whites could be paraphrased in political terms as "staging a counterrevolution." This interpretation would certainly have been given officially when Cardinal Malula "exploded" in response to what he understood to be Mobutu's proclamation of *retour à l'authenticité* — or return, rather than recourse, to authenticity — symbolized by various measures, among them a prohibition of Christian first names. But this incident is presented by Tshibumba as a conflict between two persons (eventually decided when the pope takes Mobutu's side; Painting 91).

Finally, search for occurrences of *kutomboka* led me to an extraordinary episode, an extreme case of rage in response to loss — loss of meaning, of direction, and in fact, of mind. When we were looking at the picture of an air raid on the Lubumbashi smelter during the Katanga secession (Painting 75), Tshibumba remembered a story (not depicted in the painting) that, I believe, gives a new dimension to the meaning of *kutomboka* — and thereby to his views on the effects of colonization. Here is a more literal version of the text presented in Part I:

> **T:** The smokestack of [the Lubumbashi smelter of] Gécamines . . . is the one place where there was fighting throughout the entire Katanga war. [What I can tell you about it] would be a long story, [but let me give you just this one incident:] There, way up [on the smokestack], was a man who had been exploding [*alitombokaka*].[35] He had joined the Katanga army.
>
> **F:** Mm-hmm.
>
> **T:** [Even though] he was a Kabinda.
>
> **F:** Was he?
>
> **T:** When he got to [a state of] exploding, he climbed [*alipandaka*] to the top of the smokestack here and began to fire his Katanga mortar — in every direction, right into the communities of Kenia and Katuba [Lubumbashi townships]. He was killing [people]. Finally, he was killed, too.

35. Again the verb is marked by the *-ka* suffix, marking iterative or habitual action. So we could translate: "He was exploding."

F: Was he crazy?

T: He was just — I don't know, was it rancor or what?

F: Ah.

T: And then he [*rummages through the paintings*] . . .

F: Yes?

T: Then he d[ied]. Eventually they killed him, but not right away. They caught him.

F: Mm-hmm.

T: They tied his hands together and then [*claps his hands*] dragged him away behind a jeep.

F: Mm-hmm.

T: They went really fast, and as he was on the ground, he was getting torn up; his flesh was torn to pieces and he died.

F: Who did this?

T: The Katangese. He was a Katangese,[36] he had joined the Katanga army.

F: I see.

T: In the end he just exploded [*alitomboka*].

Tshibumba stages the incident and anecdote in one of the most popular genre pictures of Shaba painting, a veritable topos in the local "arts of memory." That alone assigns to *kutomboka* an important place in his History. The story's protagonist is identified as a Kabinda, that is, a person who would fall under the broad ethnic category of Kasaians, many of whom opposed the Katanga secession. "Kabinda," also the name of a region, is used as a synonym for "Songye," a tribal designation (and, incidentally, the group to which Tshibumba himself belonged, his parents having come to Katanga from Kabinda). The incongruence of a Kasaian joining the Katanga army (while most Kasaians had either fled Katanga or were in refugee camps) is topped by that of a soldier aiming his mortar not at the United Nations planes attacking the smelter but at the population of Elisabethville he was supposed to defend — or was he? Does his crazy, homicidal act not also symbolize what the quintessential colonizer of Katanga — the all-powerful mining company (then still called Union Minière du Haut Katanga) — had done to the people when it employed doubtful methods of labor recruitment, encouraged ethnic divisions, most of which were colonial inventions, and then played on ethnic distinctions and tensions in its "labor policy"?

The final sentence of the text takes on a momentous significance. In retrospect, it sums up a history of rage turning against the enraged; prophetically it anticipates — during the "golden years" of Mobutu's regime, when few would have entertained such

36. This does not contradict his earlier identification as a Kabinda, as Tshibumba clarifies in the next phrase.

thoughts — the self-destruction of the so-called Zairian Revolution, which ends, if not with the death, then with the coma of a nation, to use a term that has much currency in Zaire these days.

THE MORAL OF THE STORY

Stories (*adisi*) often have a moral; does history? Tshibumba was steeped in oral lore when he conceived his pictorial series and pronounced his verbal narrative. He often stated what a depicted or narrated event meant (or what it "truly" meant). Nowhere did he attempt to spell out or summarize a moral of his History. When he addressed questions of meaning, it was because he was aware that "what really happened" was a matter of interpretation, hence of differences in interpretation. He was not a cool hermeneut who calmly distilled meaning from texts. As "a historian and therefore (*c'est-à-dire*) an artist" (which was his way of putting it, in our conversation of December 12, 1973), he "thought," and he never left any doubt that thinking was acting.

In trying to show in this chapter that he formulated an alternative to the domination and submission accounts of colonial history, I have concentrated on what I call his "keys to history," key notions such as sovereignty and slavery, friendship and betrayal, and the term "explosion." That is not to argue that his historiography is construed around a few images and metaphors. As we have seen, Tshibumba thinks, and thinking, for him, is creative, productive work. He works the figures of speech and the metaphors; metaphors don't work him. He constructs, and we can detect his construction, hence structure, in single paintings as well as in the series and his narrative. Perhaps other structures may be found that operated by the force of an unconscious logic — the classical structuralist assumption — but our search has been above all for the content of Tshibumba's vision of history. As we saw in Chapter 2, Tshibumba makes and uses symbols in profusion, because he wants to (and must) condense statements and representations. But he does not get carried away with his skills; he never loses touch with the reality he set out to represent. For him, history, although represented, remains present: it intrigues, exhilarates, hurts, depresses. Cognitively, he struggles for comprehension by fashioning (or adopting) concepts — such as loss, betrayal, deception, disappointment, and rage — that are comprehensive. However, he does not merely classify events according to a scheme or theory. His paintings are thoughts (*mawazo*) that constitute his History, not illustrations of a preexisting text.

In the light of these considerations and qualifications, we can now address the question of Tshibumba's overall intent, by which I mean the posture he assumes as a historian. Should concepts like friendship, which he posited as a point of departure for colonization, and characterizations such as betrayal, disappointment, and his general pessimism be taken as a moralization of what was actually a matter of military force, eco-

nomic exploitation, and bureaucratic control? Should one conclude, for instance, that Tshibumba accepted and internalized one of the most insidious inventions of Belgian colonial rule, its "platonic paternalism," to use an insightful phrase coined long ago by T. Hodgkin (1956)? Not for a moment. The institutions that embodied this ideology more than others—the missions—are conspicuously absent from this History, except when they act politically, in collusion with the colonial regime. Throughout, Tshibumba's vision is critical and political rather than moral. The challenge he poses to established historiography goes much further than that of critical academics who expose the wrong We did to Them. He undercuts any complacency we may find in revisionist historiography—necessary and laudable though this effort may be—and urges us to ponder universal loss, the damage that colonization as betrayal and deception did to the very ideals of rational understanding and critical emancipation that may guide our efforts to understand and explain "what really happened."

Images, Words, and Realities:
From Interpretation to Confrontation

Until recently, cultural anthropology shared with other sciences the idea that scientific knowledge aims to explain or interpret reality, or realities, as evidenced by behavior or action and mediated by signs or symbols — in short, by representations.[1] It was the investigator's task, we thought, to determine what counted as representations and to define the terms that constituted such representations as systems, that is, as entities with external boundaries and internal structures. Culture was the highest abstraction we came up with; language was one of culture's metaphors. In ethnographic practice, the task was to collect data that represented realities whose significance (indeed, whose reality) was determined by the agendas of our discipline. The little word "as," I argued in the preceding chapter, was a constant marker of such an epistemological position: Movements, for instance, were studied as social change; ritual as drama; religion (but also ideology, art, and what have you) as a system of symbols; terminologies as dictionaries, and those in turn as cognitive maps; change as acculturation or modernization; and so forth.

Such was the intellectual climate in which I proposed a research project to study labor and language among Swahili-speaking workers in Shaba. Between 1972 and 1974, through field research in a factory and two workshops, I gathered a great amount of information on the semantics and sociolinguistics of work. At the same time, popular culture as expressed in painting, theater, music, and other manifestations that I never had the time to pursue more thoroughly (such as clothing, everyday objects, urban living space, sports) began to interest me more than the project that had been funded. As I see it now, two things happened simultaneously: I began to experience all these *representations* of reality as *realities*. I began to think of them as practices, and I realized that these practices and my own ethnographic practice (of representing realities) were confronting each other *on the same level*. It became impossible to maintain the position that the

1. The difference between explanation and interpretation, significant though it may be in other arguments, can be neglected for the purpose of this one. The view of signs and symbols as mediators succeeded or coexisted with that of other key concepts such as traits, patterns, and values.

production of knowledge starts on "our side," with problems (theory) that are tested on realities (data) on "their side." Modern anthropology, that is, the work of anthropology carried out under the conditions of our time, does not search for truth and reality *behind* cultural representations. The aim now is not to cut through surface manifestations in search of a deeper, perhaps unconscious, reality but to confront other searches for truth and reality and to negotiate knowledge through critical reasoning.[2]

As I understand it, the idea that ethnographic knowledge is produced through confrontation rests on a dialectical conception of knowledge whereby understanding progresses through breaks and discontinuities — in fact, through contradictions. It follows that an ethnography of Tshibumba's History of Zaire of the sort I have in mind cannot do away with breaks and contradictions by letting them stand as described or explaining them on a level of discourse purportedly higher than that in which they occur. Readers familiar with recent debates in anthropology may find these remarks on confrontation and contradictions a strange way to invoke postmodern concerns with deconstruction, dialogue, and multivocality. I share these concerns, but working with Tshibumba, twenty years ago and now, never let me settle into the complacency that self-professed postmodernists seem prone to, one that, after all, is not unlike the peace of mind we once thought was guaranteed by following the prescriptions of scientific method. In this concluding chapter I hope to show why matters must remain unsettled.

CONFRONTATION I: CHIEF LUMPUNGU AND THE LIONS FROM EUROPE

The version of Tshibumba's History of Zaire that is being considered in this study exists in three kinds of records (not counting ethnographic notes): a series of paintings, a narrative, and conversations between the painter and the ethnographer. The confrontations — deliberate breaks in a sequence, challenges regarding interpretations — that are to be documented now occurred in all three.

The first example announced itself by a break in a sequence of pictures. Having depicted precolonial life, discovery, exploration, and the beginnings of occupation, Tshibumba continued the pictorial series with a sequence that might be titled "crushing resistance to the establishment of the colony." It begins with the defeat of the Swahili in the so-called anti-Arab campaign of the early 1890s (Painting 12). The execution of their leaders (Painting 13) is followed by the killings or executions of African rulers: Banza Kongo of the lower Congo is poisoned (Painting 14), Msiri of Katanga beheaded (Painting 18), and Lumpungu of the Basongye hanged (Painting 21). Then Tshibumba recalled the definitive establishment of the colony, starting with paintings of the arrival of the railroad in Katanga (Painting 23) and the foundation of the Union Minière du Haut Katanga (Painting 24). However, before he got to that, he inserted one of his most pow-

2. An argument for ethnography as confrontation is formulated in Fabian 1991b, ch. 10, esp. 196–200.

erful paintings: "Simba Bulaya, Lions from Europe" (Painting 22). Within the two ad-joining series (that is, Paintings 12, 13, 14, 18, and 21 and Paintings 23 and 24), pictures fol-low one another in roughly chronological sequence.[3] Simba Bulaya appears as a break in the flow of historical events; it has a pivotal function in relation to the episodes around it. It also led ethnographer and artist to confront each other more directly and openly than on other occasions. Tshibumba's narrative (see Paintings 21 and 22) reveals the logic and intent that made him insert this picture at that particular point. Here is the passage that puts up the challenge:

> All right, they hanged Lumpungu, and we admitted the fact that Lumpungu had destroyed a human being. But at that time, at the very same time that Lumpungu committed this crime, the whites themselves were busy colonizing us; they took people too, and many more than [he did].

Then he describes how the Simba Bulaya operate and concludes with a meta-remark:

> I think I got to this story [adisi] here [i.e., at this juncture in my History] because I wanted to show that even right now they may be waiting for this person, and when he gets close they grab him, and what they do to him is take his clothes and tie him up with a rope. Then they carry him away to this place we do not know. Those people — they are not just figures in a tale [adisi] or in some kind of report [abari] — that's how they are, up to this very day. We don't know whether they ate them, or how they disposed of them. All right. All right, I think that's that.

Several ready interpretations could be given for Simba Bulaya as an interruption of the narrative sequence. On one level, it grants "time out" from the historical account, an artful device to keep and increase attention; on another, it represents a generic break from history to what an outsider must take for legend or fantasy. Interestingly, the break is accomplished by a picture that may have to be counted as a genre painting. Although I cannot recall having seen a version by another genre painter, Tshibumba had been painting and selling Simba Bulaya before he embarked on his History. At any rate, the topic certainly was part of popular memory; most people in Shaba (and elsewhere in Zaire) have heard stories about it.[4] A more sanguine analyst may even suggest that the switch here is one from history to myth, from a superficial account to a deep explanation

3. Chronology, however, is not the only organizing principle. Especially in the sequence following "Simba Bulaya," we find a pattern that was also characteristic of the narrative of colonization in the *Vocabulary of the Town of Elisabethville*. Every account of colonial onslaught is countered by one of African resistance (see Fabian 1990a, 207–8): The creation of the Union Minière is followed by the story of Simon Kimbangu; the erection in Léopoldville of a monument to Leopold II by the miner's strike in Elisabethville; the exploits of the colonial army in the Abyssinian campaign by the Tetela revolt.

4. See also the comments on this painting by B. Jewsiewicki (1986a). He proposes that Tshibumba merged two motifs, that of the "White eaters of Blacks" and of "White men who take Black souls . . . to Europe (*Bulaya*)" (368). He dates the respective stories to the twenties and thirties and cites Ceyssens 1975 and MacGaffey 1972.

of colonial relations. Perhaps Tshibumba sensed my incredulity and imagined the explanations I might come up with. That is why he made sure I understood what he wanted to accomplish with this painting: to create a kind of presence — "even right now they may be waiting" — that would keep me (or us) from getting comfortable with tales of the past. After I had acknowledged, with the usual "mm-hmm," his statement in the last line of the fragment quoted above, he kept insisting:

> T: Do you understand the story [*adisi*]?[5] Do you?
>
> F: Yes, yes.
>
> T: Do you really understand? Do you?

He started to describe the uniform and equipment of the Simba Bulaya as they appear in the painting, but then he broke off, rapidly recounting what had happened to his own father before we moved on to resume the historical narrative.

CONFRONTATION II: HISTORY VS. ETHNOGRAPHY

When Tshibumba had finished the portion of his narrative that went with the first installment of the series, we looked again at each painting and talked about them. The following exchange, this time unedited in order to preserve the flavor of our conversation, took place when we got to Simba Bulaya:

> F: Fine, now to Simba Bulaya, [this is] something amazing.
>
> T: So you are amazed, eh? You never heard about it?
>
> F: No. Never. I have heard about the Simba [lions]. [*Pondering the term:*] Simba, Simba . . .
>
> T: Lions in the bush?
>
> F: . . . in the old times. No, not lions in the bush.
>
> T: Hmm.
>
> F: Simba, a group, it was like a society of sorcerers.[6] In some regions they were called Simba, in others they were the leopard people.
>
> T: All right, as for that . . .
>
> F: Ah [now I remember], it was the Anyoto . . .
>
> T: Fine, I'd like to explain what you are talking about.
>
> F: . . . in the North.
>
> T: Is that what you are talking about?

5. In view of his earlier denial that this "was not just an *adisi*," the question may be confusing. The meaning of the term in Shaba Swahili can oscillate between "just a story" and "a true story," depending on the context.

6. Most people probably associate "Simba" with the rebellious APLN (Armée Populaire de la Libération Nationale), who operated in the Northeast and eventually terrorized Europeans and Africans alike. Tshibumba knew immediately that this was not the meaning I was looking for. Notice how, in an unusual display of impatience, he interrupts me twice while I search my memory following this statement. It is as if he knew that I would come up with a tiresome argument.

F: Mm-hmm.

T: It's like this. Because among us, you see, this is how it used to be in the old days. People, a living person . . .

F: Mm-hmm.

T: . . . was able to enter a house just like that — as I am now with you, right? The person would enter the house and do his charms, magic things.

F: [*Impatient*] Yes, yes, we see that.

T: All right then. When he worked his charms, you see, he was able to change. He would become a wild animal, [for instance] a lion.

F: Mm-hmm.

T: Or an elephant. If he hated a certain person, he would just go [*claps his hands*], take up [his charms] so as to change. But perhaps you understood this idea you are talking about [to mean] that a person would dress up [as an animal]. No [that's not it]. That I saw in the book *Tintin au Congo.*

F: Mm-hmm.

T: *Tintin au Congo* [*chuckles*]. That's what it says, right? About the time when this missionary met Tintin and about this missionary hating Tintin.

F: Mm-hmm.

T: And then they dressed up a man in a leopard skin, right?

F: Mm-hmm.

T: Together with a stick they had fashioned into a leopard's paw.

F: Mm-hmm.

T: He beats the ground [with it], right?

F: Mm-hmm.

T: He beats the ground. And then they tell him he should grab Tintin. Instead, a snake grabs him [the leopard man]. [But] no, that's not it.

F: Mm-hmm.

T: Those are notions that were brought [here], notions,[7] let's say, that were held at the time when the whites were destroying our charms and other things. But [*putting emphasis in his voice*] it really was the person who worked the charms and came out as a leopard. Because, in my very own village, there used to be a certain man. He was going to — he was old . . .

F: Mm-hmm.

T: . . . he was going to marry a girl, right? One whose breasts were small.

F: Mm-hmm.

T: That's how it is in our country, right? This is how many marriages are arranged.

F: Mm-hmm.

T: If you have money you can marry a small child, even though you are old and your hair is white. All right, so this girl did not like that husband of hers. She would arrive [at his place] and return to her [parents'] home, every time. The husband would go after her to bring her

7. What I translate as "notions" is *maidées*, from the French loanword *idées*, which in this context has a restrictive, perhaps negative connotation: "just some ideas."

back, and she went home the same day. But one day the husband got angry. He changed into a lion.

F: Mm-hmm.

T: When that girl went outside he grabbed her [*claps his hands*] and killed her. He devoured her, and [only] the bones were left.

F: Is that true?

T: As regards Simba Bulaya, it was a system the whites had.[8] All right, what were they up to? At night they would dress up, [as] I explained to you on another occasion and told you that my father had met them.

F: Yes, yes.

T: And [now] I repeat: [it also happened to] me personally. This is not a lie; what I am explaining to you is true. [It happened] in the place where my mother had given birth to me, in the KDL railway workers' compound — BCK, it used to be called.

F: Mm-hmm.

T: In Likasi.

F: Mm-hmm.

T: There had been a wake at my [her] aunt's. Mother left with me. I was still light-skinned, a toddler.

F: Mm-hmm.

T: And she carried me on her belly. She told me about this just recently; if we go to Likasi she will tell you about it.

F: Mm-hmm.

T: So we left and went outside. When we were outside, Mother put me down to let me relieve myself, you understand? All right. That was when the Batumbula came.

F: Who? People?

T: Those Batumbula.

F: Tumbula?

T: Batumbula.[9]

Tshibumba then went on to explain the name and to tell a fascinating story of white cannibalism: The Batumbula, or Simba Bulaya (who employed African helpers), would take

8. It was important to Tshibumba to point out that Simba Bulaya was a "system," not an incidental occurrence. He had used the term already in his narrative (in a passage not reproduced in Part I) where he quoted Mobutu speaking of *systèmes sporadiques* that the whites employed in colonizing the country (Painting 22).

9. Perusal of my favorite Luba dictionary revealed that the story had been part of common lore by the early fifties, at the latest: "-*tumbula*: tuer des bêtes [to kill animals] . . . ; *mu-tumbula*: boucher; on applique aussi le nom aux Blancs qu'on accuse parfois de tuer des enfants [butcher; the name is also applied to whites who are sometimes accused of killing children]" (Van Avermaet and Mbuya 1954, 751). Whites make another appearance in this entry: "*tumbila*: . . . être cause de mort [to be the cause of death]; *mulopwe wantumbila*: le chef est la cause de ma mort (dira p. ex. un homme dont le fils est envoyé par le chef au loin comme travailleur dans une entreprise d'Européen) [the chief is the cause of my death, said, e.g., by a person whose son is sent far away by the chief to be a worker in a European-owned enterprise]" (750). Swahili dictionaries (Sacleux, Johnson, Lenselaer) have the verb -*tumbua*, disembowel, but do not list a noun. Therefore, *batumbula* must have come to Shaba Swahili through Luba.

their victims to the Biano grasslands and the Kundelungu mountains (close to Likasi, Tshibumba's hometown). There, not far from the railroad, they had put up a building, called the Hôtel des Biano, where their victims would be fattened and eventually eaten. This was an actual hotel that was in business during the fifties until independence came.[10] Now it is in ruins. We then tried to match this information, without much success, with some memories I had of a big farm owned by Tshombe that I had seen in ruins.

Tshibumba returned to his comments on the painting, and the clash of "meanings" came to a climax:

T: That is the meaning of this painting. I imagine you now understand its meaning for the first time?

F: No, because we have known for a long time about the lion or leopard societies . . .

T: [interrupts] Not lions . . .

F: . . . and also the snake people.

T: [exasperated] Ah, yes, it is true that there were people who operated in the dark.

F: Such as in some places here in the Congo, the leopard people were just sorcerers.

T: Fine.

F: They were groups of sorcerers. They may actually [have] changed; others just dressed up.

T: Mm-hmm.

F: Furthermore, they had claws.

T: Fine.

F: Leopard claws, but those claws were made from iron.

T: There you are, that's what I told you [it says] in the story of Tintin.

F: We have seen them. I saw the claws with my own eyes in . . .

T: Really?

F: Yes.

T: You don't say.

F: They took the claws, which were like a curved knife.

T: I see. Mm-hmm, all right, and then he would strike and kill a person.

F: [illustrating the gesture] This is how they would do it. But it was a knife.

T: It was a knife.

F: But if you saw the wound you would say . . .

T: [impatient] Fine, that's true.

F: . . . it was a leopard.

T: If you put it that way I have to agree, don't I?

10. An official guide from the early fifties mentions the location as part of a touristic route from Elisabeth-ville to Kamina: "After Kansenia, set against the Biano mountain range, near the railroad is *Biano* station, elevation 1,600 m, African seat of the Compagnie des Grands Elevages Congolais (Grelco), founded in 1930. . . . Biano is also at the heart of a country retreat and has a good and comfortable hotel, *Hôtel des Biano*" (Office du Tourisme 1951, 406, with an illustration showing the pavilions of the Hôtel des Biano).

F: Well, yes.

T: That way . . .

F: [*interrupts*] I saw this, I . . .

T: [*interrupts*] You saw this, eh? Fine. Where did this man get [the metal claws] from? He just roamed the villages and the bush there.

F: Mm-hmm.

T: There was no knowledge of how to do this thing, to fashion it so that it fit an arm.

F: Ah.

T: So where did he get it from?

F: Hmm, yes.

T: [*chuckles*] That is to say, it was true, they had many kinds of magic. The fact is, a person changed into a wild animal.

F: Mm-hmm.

T: And he grabbed his fellowman.

F: Ah, mm-hmm.

When reality is contested, historical truth will not be attained by matching account and reality. Which and whose reality? Once the ethnographer has ceased to think that being in touch with reality and truth is guaranteed by following the rules of scientific investigation,[11] the outcome of contests and confrontations such as the one we just documented cannot be a victory (be it explanatory or interpretive) of one position, or of one kind of knowledge, over the other. Subsuming the contesting account as "data" creates a spurious understanding, because it aims for knowledge whose production devours what it knows. Such epistemic cannibalism cannot be all we have to deal with Tshibumba's story of colonial cannibalism.[12]

An approach that contrasts with this classical stance is often characterized as one based on "negotiating" meanings, interpretations, and hence accounts. Our conversation could be given this rather charitable reading, but then we would have to note that negotiations were broken off before they could be concluded in some sort of agreement. Tshibumba stuck to his "werewolf" theory, politely acknowledging that there may have been secret societies operating in the dark. I did not abandon the received ethnographic (i.e., sociological) interpretation that was backed up by "hard evidence," such as items of material culture I had seen in museums, although I, too, conceded that changing into wild animals may be a feat accomplished by magic. Notice that the two polite concessions were

11. This is not to imply that one has given up the search for reality and truth. Having lost faith in a scientific objectivity *ex opere operato*, we are free to construct a critical notion of objectivity (see Fabian 1991c).

12. A comparable view, though stated with a historian's circumspection, also informs L. White's recent article (1993) on the related theme of colonial vampirism and its context (similar to that of Simba Bulaya) in "African debates about labor and religion."

similar in that both were little more than verbal strategies serving to keep the conversation going. But they were dissimilar in that Tshibumba dismissed my interpretation as irrelevant (without having to take a stand on the existence of lion societies), whereas I simply didn't believe that "were-lions" existed. My problem was to keep "negotiating" with someone who did.

Our confrontation looks much like a standard situation in anthropological studies of religion or of other "belief systems." But religion is not the issue here; history is. Furthermore, there is not only a discrepancy of views but a conflict. Tshibumba actively contests the ethnographic solution I propose. In so many words, he accuses me of having fallen for a tale of leopard people that he knows from his reading of *Tintin au Congo*, one of the most popular and most notoriously colonialist comic strips. All of a sudden, I find my realistic interpretation transposed to the realm of imagination. Tshibumba has the printed source to prove it.[13]

The relevant passage occurs in one of the frames that is completely filled with text and is obviously intended to be educational, imparting "ethnographic" knowledge.[14] The reader is informed of an anti-white secret organization, called Aniota, whose members stalk their victims in leopard gear. In the original edition the text, printed in capital letters, is in plain French. In the color edition the content is somewhat modified, and the text is rendered in *petit nègre*, undoubtedly to make it more authentic — so much for eliminating racism from this later edition. Still, what Hergé tells us could have come straight from a textbook;[15] it is more "accurate" than the recollections I came up with in our conversation (see the detail of the staff in this passage, also mentioned by Tshibumba). I take this to be yet another reason to qualify the painter's response to my ethno-

13. It is hard to resist getting sidetracked by this episode in *Tintin au Congo*. The strip is by Hergé, probably the most popular Belgian author in this genre (whose works have been translated into forty languages, including Bengali, Basque, Gaelic, and Serbo-Croatian, but also Esperanto and regional languages such as Bernese Swiss, Galician, and Occitan). *Les aventures de Tintin au Congo* was first published in black and white in 1931, then reprinted in 1937. The first color edition appeared in 1946. Then the strip seems to have run into increasing criticism for its racist images and statements. This led to a revised version in 1970 (on this, as well as other representations of the colony in Belgian comic strips, see Herman [1985]; also an essay, with references to interpretations of *Tintin au Congo*, by M.-R. Maurin Abomo [1993]).

Tshibumba was an avid reader of Hergé's comics. He cited him verbally at least one more time, when he explained to me the insignia of a traditional chief as being a scepter "like in [Hergé's] *Le sceptre d'Ottokar.*" I suspect that iconic citations are even more numerous, but that, as well as the general question of to what extent Tshibumba's (and other genre painters') conception of a painted series was influenced by comic strips, needs to be looked into more thoroughly (see also the section "Inscriptions: Painting and Writing," in Chapter 2).

14. Several faxes and telephone calls to Moulinsart S.A. in Brussels, holders of the copyright for *Tintin* comics, failed to get permission to reproduce the relevant images and passages from *Tintin au Congo*. Moulinsart, I was told over the phone, wants to restrict utilization of *Tintin* as part of its marketing strategy after taking over the rights from the original publisher. But history cannot be restricted; the interested reader should have little trouble finding a copy of the strip.

15. It is more likely, however, that Hergé got the "authentic" detail for his *Tintin au Congo* from illustrated colonial magazines or an exhibition at the Musée royal de l'Afrique centrale in Tervuren (see Halen and Riesz 1993, 178). A much-cited work on leopard people appeared later (Joset 1955, with illustrations of leopard paraphernalia from the museum in Tervuren).

graphic diversion as a serious contestation of knowledge. That he aligns me with *Tintin* is not just a gentle jibe, a roundabout way of telling me that I should not believe in popular fantasy. It is a challenge to ethnography as it appears in *Tintin*, one of the sources that were available to Tshibumba.

The option to file this episode away as an ethnographic curiosity is not one I am prepared to take. On the other hand, deciding "what really happened" would ultimately involve ontological decisions that cannot be the subject of this project of interpretation. The realities contested here are not ultimate ones, but those constituted by different ways of producing historical knowledge. It would seem that progress in what I called negotiating could be made by looking more closely at the ways in which the painter himself invokes truth and reality in the course of producing his History of Zaire. As I reflect on the occasions when this happened — other than the somewhat extraordinary incident we just discussed — I find that truth and reality became problems to be confronted in two different contexts, with contrary results. The first regards the question of whether truth could be told. It came in the form of repeated confrontations with political danger, yielding not negotiated solutions but a kind of negotiated silence. The second consists of numerous reflections in our conversation in which we directly addressed issues such as truth, fiction, and history.

CONFRONTATION III: VOCIFEROUS SILENCE

By now it should be clear that I am interested in exploring confrontation as an epistemological concept. As a social praxis and process, knowing necessarily has its agonistic, conflictual aspects. Producing knowledge is always also a matter of overcoming obstacles, shining light onto darkness, penetrating secrets. Therefore, the one who knows may be threatening; he certainly is threatened in situations such as Tshibumba's, where an autocratic regime needed to control representations and formulations of historical knowledge. "Remembering" and "thinking" the History of Zaire (as he would describe his work) was never just a matter of collecting what was known; it made him confront again and again what he perceived as demands of historical truth and accuracy that he felt compelled to acknowledge without being able to meet them.

In trying to characterize Tshibumba's strategies of confronting dangerous truths I came up with the seemingly contradictory phrase "vociferous silence." Before I go on to show what I mean (by commenting on examples from the recorded narrative and our conversations), let us recall that this History is painted as well as told. Tshibumba's ways with depicting dangerous truths and secrets are many. Here is just one example: Without having to say a word, he may reveal Mobutu's hypocrisy in making Lumumba, whom he had helped to bring down, if not to kill, the national hero of his regime. When he gets to this event in his account of the rise of Mobutu (Paintings 85, 86), he simply confronts in-

scribed praise for the party with Lumumba at the scene of his death (Painting 87). In a case like this, one picture is indeed worth a thousand words, not because of what it represents but because of what it is meaningfully silent about.

Matters are different when it comes to telling history and talking about it. To speak of something without saying anything—at least nothing that can get you into trouble with the authorities—is an art which Tshibumba, like other creators of popular culture, had to master. Many examples of veiled metaphors, allusions, and ironies could be identified in our texts. Ethnographically more interesting than these separate instances is a process that I find documented in our exchanges. Tshibumba may have sensed that the outsider to whom he told his story needed to be guided through narrative and conversation to a point where danger could at least be signaled. Throughout his account, but increasingly so as it gets closer to the narrator's present, there are intimations of *mambo*, affairs, from which "we"—that is, the people Tshibumba identifies with—are excluded. He makes a first remark to that effect when he reports that Lumumba probably sealed his fate when he insulted King Baudouin during the celebrations of independence (Painting 49). "There were many *mambo* about his death that we don't know, however." Seen in a wider context, this apparently offhand statement appears as an attempt to fashion a signal we could exchange whenever the representation of an event got us onto politically dangerous ground. We needed something that could be said so that nothing more had to be said.

During the third session, which covered the most sensitive periods of recent history (Lumumba's death, secessions and rebellions, Mobutu's rise to power), Tshibumba began to employ a stereotypical phrase (undoubtedly adopted from common speech). It was first intimated in the following remark, made when we got to Painting 64, "The Kasavubu-Lumumba Conflict": "There was conflict among the *bakubwa* [leaders, bosses, big shots]." [16] Being what they are, big shots "have their secrets that we cannot know." That this only looks to be a factual statement becomes clear when we get to Painting 66, "Lumumba Is Brought before the People," where the remark is repeated—with a twist:

> The *mambo* that happened there, that concerns only the *bakubwa*. As I explained to you. [Nevertheless] if it is history, I am going to pursue [these matters] for history's sake.

Tshibumba confronts the challenge: He signals danger but insists on his responsibility as a historian. From then on he can be certain that we understand each other, and he just repeats the formula, for instance, when he talks of the place where Lumumba was taken

16. As it is used by Tshibumba, *bakubwa* has two different, albeit related, meanings. It can refer to "the old ones"—that is, the elders or ancestors who are cited as authorities—or to persons who currently hold power.

before he was killed: "The things [*mambo*] that happened there, let's say, they are mat-
ters that concern the big shots [*mambo ya bakubwa*]" (Painting 68).[17] Now the dodge is
obvious — no longer a reference to any political body or type of knowledge, simply a sig-
nal that he cannot talk. The formula, also with "let us say [*tuseme*]" added, is repeated
when we get to the death of Hammarskjöld (Painting 73). It is followed by a laconic re-
mark: "We know history." The formula next occurs when Tshibumba reports on Tshombe
negotiating with the Belgian government (Painting 81). The matter itself (debts, com-
pensation) was unclear to most politicians. As to the story that was told of Tshombe's suc-
cess: "Whether it was true or whether it was a lie, that is something that concerns the big
shots." Finally — that is, for the last time in the narrative portion — *mambo ya bakubwa*
is invoked when we get to Tshombe's arrest in Algiers (Painting 90).

As might be expected, the signal we had agreed on was again exchanged during the
comments on these pictures. Regarding Lumumba's arrest in "Lodja" and his transfer to
Kinshasa, Tshibumba reminds me: "As I told you, what happened there is *mambo ya
bakubwa*, right?" (Painting 66). A little later in the same passage, he first repeats this as-
sertion in almost the same words, then adds an interesting qualification:

> As I told you, the things that happened were *mambo ya bakubwa*. And some of us know how
> [it was]. But I already told you, hmm? It was *mambo ya bakubwa*. Many things [*mambo*]
> happened there, because many big shots [*bakubwa*] were there.

We exchanged the formula two more times, once when we talked about the fate of Mulele
(a rebel leader who opposed Mobutu's regime, Painting 83) and then again when we got
to Tshombe's death (Painting 90). In both cases, our exchange became almost a sort of
friendly banter:

> ᴛ: And Mulele, instead of fleeing to some other place in Africa or to Europe, I don't know
> the story [*sais pas histoire*], he was arrested in Brazza[ville], it is *mambo ya bakubwa*.
>
> ꜰ: Mm-hmm. *Mambo ya bakubwa?*
>
> ᴛ: *Ya bakubwa* [*chuckles*].
>
> ꜰ: *Mambo ya bakubwa.*
>
> ᴛ: That's it, so we got to another place [where] we say *mambo ya bakubwa*.
>
> ꜰ: [*incomprehensible, overlapping with T.*]
>
> ᴛ: Ah [*now giving a sort of translation, using French lexemes*], the affairs of the authorities
> [*maaffaires ya baautorités*], they don't concern us.

17. Incidentally, T. K. Biaya offered the following association in a recent personal communication. He re-
members a Kabasele song of ca. 1967: "Maloba ya Mobutu, maloba ya mokolo" (the affairs of Mobutu, the af-
fairs of the big ones).

Undoubtedly, one function of *mambo ya bakubwa* is to direct attention to certain events. All large-scale politics is *mambo ya bakubwa*, but the formula takes a specific meaning when it highlights dangerous boundaries of knowledge. When public events are declared *mambo ya bakubwa*, the formula clearly does not signal secret knowledge. Tshibumba makes me understand that in these cases, and in others that were less notorious, people know what happened, but one does not tell. In other words, when knowledge is given form in accounts such as his narrative and comments, the censoring of the verbal telling is foregrounded by the formula. Given such tacit (or muted) general knowledge, a painting becomes all the more powerful as a reminder. *Ukumbusho* not only refers to remembering past events (or the knowledge thereof), it also asks to remember present knowledge of a kind that cannot be spelled out verbally.

TRUTH AND LIES: SOME OBSERVATIONS ON TSHIBUMBA'S METAHISTORY

Kulitoka hadisi: kulitoka bongo. *There is no story that is not also a lie.*[18]

In this study we have been exploring an approach that takes ethnography to be something other, and more, than subsumption of data under theoretical schemes. But confrontation, as we called the project, would stop short of our aims if it were to exclude the meta-level of communicating and formulating knowledge. H. White's *Metahistory* (1973) has had a great influence on anthropology as well as on history. The book has been variously read as deconstructionist, even nihilist, or as reducing historiography to poetics or tropology. It gave the coup de grâce, if such was needed, to any lingering idea of historiography as describing "what really happened." I recall my reading it as an exploration of "what historians really do." The "meta" in its title may imply a purely theoretical study; to me, however, it is a critical investigation of practice, something that ethnography aspires to also.[19] Tshibumba made meta-statements about the nature of history and historiography, about truth and reality, and about fact and fiction that deserve serious consideration.

In the first of our recording sessions we exchanged thoughts about history before the actual narrative started. The following version of the relevant passage in the Prelude follows the original even more closely, highlighting Swahili and French terms:

> **F:** Yes, [we can do] as you like. We can begin with the story [*arisi*], or let's just start with a little conversation about how you got the idea [*mawazo*] to make this history [*histoire*]. Um,

18. Lit. "Where the story came forth, there appeared a lie," an adage about storytelling from Shaba, reported in a dissertation-in-progress by Marjolein Gijsels, Department of Anthropology, University of Amsterdam.

19. To point out this common intent should have been my response years ago to H. White when he remarked, after reading earlier attempts to interpret Shaba popular painting (probably Fabian and Szombati-Fabian 1980), that this work amounted to aiming [theoretical] cannons at [empirical? aesthetic?] mice, or something to that effect.

how you first thought of it. This idea to do a series [*série*], right? A sequence [*msululu*] like the one you've done now.

T: Yes.

F: [A series] of stories [*adisi*]. Was this [a thought] you've had for a long time?

T: I have had this idea [*mawazo*] long ago.

F: I see.

T: But I had no one come to me and ask me to work, the way you have asked me now.

F: I see.

T: Yes. When you asked me, I got the strength to tell myself: I should work [to show] how things used to be [*sawa vile mambo ilikuyaka*].[20] It is the story [*adisi*] of the whole country. Every country has [*inakalaka na*, lit. "stays, exists, lives with"] its story [*adisi*].

F: Its story [*adisi*].

T: Yes.

F: I see. So — but you needed to teach yourself, didn't you? You needed to teach yourself the story [*adisi*] of the country. Like long ago, in the time of the ancestors — they had their stories [*maadisi*], hmm? And each ancestor would tell his story to his successor.[21]

T: To his successor, yes.

F: ...?...

T: He who had a successor would impart to him his story.

F: Right.

T: Take us, we had our father. He explained what happened to him. For instance: "That was the year I had an accident."

F: Mm-hmm.

T: It had stayed in his head. So we would sit by the fire in the evening with our parents [and he would say], "You see, in the old days [*zamani*], this is how this country used to be [*inchi hii ilikuyaka hivi*]." And then we entered school, and school also taught us how it used to be in the past [*zamani*], [our] ancestors, we had the Arabs, and how they treated us. And some told lies and others spoke the truth.

F: Mm-hmm.

T: Then I followed the books, and some spoke the truth and so we followed that story [*adisi*; could also be plural: "those stories"].

F: Mm-hmm.

T: We grew up that way and now saw these things [*mambo*] with our own eyes [and that they were] true. We began to work with them and we made progress.

F: So — how shall I say — the way you see the story [*adisi*] now, it differs from the way [things] used to be seen long ago, or does it not?

20. In Tshibumba's Swahili the verb *-kuwa*, "to be," is often realized as *-kuya*, making it a homonym of *-kuya*, "to come." Here, then, the phrase "sawa vile mambo ilikuyaka" could also be translated as "how things came about." The suffix *-ka* marks repetitive, durative, or habitual action, a stylistic trait of *adisi*, in the sense of tales and fables.

21. What I translate here as "ancestor" and "successor" is covered in Swahili by the single term *nkambo*, "grandparent, ancestor." The salient semantic feature is reciprocity, but that does not mean that succession is excluded as part of the relation.

т: That's right. Formerly we followed what was said among the elders.

ғ: Mm-hmm.

т: Among the ancestors.

ғ: And today?

т: Whereas today we will work out in our own minds [*akili*] how it used to be [*sawa vile ilikuya*].

This text illustrates, first of all, that we were groping for a Swahili term corresponding to *histoire* (story, history, and historiography/historiology). At stake here was not just settling on a linguistically correct label; we were trying to get a grasp of, demarcate, a domain of knowledge. Remember that this passage was the beginning of our first session, a reflexive preface to the narrative. The terminological problem was to some extent of my own making. As I recall, although I used *histoire* in the same sentence, I wanted to stick to a Swahili word: *arisi/adisi/hadisi*, the Shaba variants of East Coast *hadithi*. Its dominant meaning is a story, rather than history, and certainly not historiography.[22] Tshibumba played along until, like other speakers of Shaba Swahili to whom linguistic purity is of little concern, he turned to French *histoire*. Soon after the passage quoted, *histoire* came to replace *arisi* when we talked about history; *arisi* remained as the designation of a specific story or tale.

Problems of terminology did not, however, prevent Tshibumba from formulating in this brief passage two ideas that I take to be meta-statements about his conception of history: First, history as he wanted to do it was something that "we will work out in our own minds." In the quoted fragment, but also elsewhere throughout the recordings, copious semantic evidence supports this approach. Again and again, the activity of selecting events, of arranging their sequence, and of representing them in paintings was described as *kuwaza*, "to think, to conceive ideas." Accordingly, the products of that activity may be called *mawazo*. History as thought is a purposeful intellectual activity, not a handing-down of something that had been passively received; Tshibumba kept his distance from the authority of both traditional elders and colonial schoolbooks.[23] Second, although the very ending of the fragment ("how it used to be") may suggest otherwise, Tshibumba

22. The Oxford *Standard Swahili Dictionary* does list "history" as one of the meanings of *hadithi*, but it glosses "history" (presumably also in the sense of historiography) with a European loanword, *historia*.

23. Earlier I had encountered the fundamental significance of thought and thinking (*kuwaza, mawazo*) in popular religion (in the teaching of the Jamaa movement; see Fabian 1969) and in the *Vocabulary*, a written history of the town of Elisabethville (discussed in Chapter 4; see also Fabian 1990a, 182–84). V. Y. Mudimbe, accepting a translation of these terms as "gnosis," thinks that this concept best expresses the nature of "African thought" as distinct from both academic and traditional "African philosophy"(1988, ix). Incidentally, Mudimbe — and this is perhaps not just a *fait divers* — is Tshibumba's age-mate, shares his "ethnic" background, and grew up in the same region. He was the dean of humanities at the University of Zaire in Lubumbashi at the time when the History was assembled and recorded, and he helped to make my stay in Lubumbashi possible and enjoyable. J. Vansina's recent observation (1994, 219) that the two of us together with B. Jewsiewicki then formed a trio that was to bring postmodernism to African Studies is somehow flattering but historically doubtful.

held anything but a naive view of historical truth and reality. On several occasions, for instance, he insisted on showing and telling what truly happened (as opposed to what is said to have happened), or how what truly happened must be interpreted truthfully. In other words, to him the search for truth was often a matter of contesting other claims.

Outside the episode discussed above, Tshibumba made one of his strongest statements when he qualified the biblical story of Noah's curse afflicting the offspring of his son Cham as simply a lie (*ni bongo*; see the commentary to Painting 4). When he dismissed this racist myth and when he later invoked *Tintin* in our ethnographic confrontation, he resisted and rejected "truths" imposed by colonial discourse. In both cases (and on many other occasions throughout the series) such resistance was expressed not so much incidentally as systematically.[24] Awareness of injustice, the will to contest and challenge received versions, a partisan perspective on events after independence, consciousness of present dangers—all these were elements of Tshibumba's metahistory. All of these reasonings, motives, and attitudes became topical on occasion and were expressed in images and speech and, more important, served to inform (give shape to) and emplot this History of Zaire in a manner that was political to the core. Poetic tropes, a visual style, and oral genres undoubtedly were among Tshibumba's "means of production," and as we saw in Chapter 4, it is possible to discern certain dominant themes in the overall message that he wanted to convey. However, we would still be far from doing justice to Tshibumba's artistic and intellectual accomplishments if we were to stop here and declare his History a chef d'oeuvre of critical, political resistance.

Tshibumba was a thinker, a theorist who formulated thoughts that address issues wider than the concerns of a popular historian of colonization and of postcolonial strife and oppression. To make that point, I shall concentrate, in conclusion, on just one type of evidence for what I take to be his dialectical approach to historical truth. On several occasions (one of them documented in the excerpt on page 21) Tshibumba explicitly speaks of truth and falsehood. He may oppose one to the other—"this is not a lie; it's the truth"—but the more intriguing instances are those where, in an almost formulaic manner, truth (*kweli*) and lie (*bongo*) are distinguished without being opposed to each other. How are we to interpret this? The saying that was quoted as an epigraph to this section gives us a clue: Tshibumba conceived his work against a cultural foil that locates the message of *adisi*, stories between truth and lie.

In the following excerpt, both opposition and juxtaposition are documented. When, at the end of our third session, I suggested that he conclude his History with some paintings of the future, Tshibumba accepted the task but not without first raising the question of truth. I had asked for a sort of "logical" extension of his narrative from the past and present into the future. Tshibumba understood this as an invitation to a different kind of discourse, prophecy:

24. Yet its expression is sometimes skillfully understated: the painting that goes with the rejection of the Noah story is a deceptively naive genre picture of the adoration of the newborn Christ by the three magi.

т: Fine. But [there is a point to be made first]. What you say regards the truth [*unasema mambo ya kweli*]. What I have been telling you so far is not a lie [*si bongo*]. Nor did I say what I said in order to make some money.

ғ: Mm-hmm.

т: No, these are true things [*mambo ya kweli*] that I myself have seen. As to the future, I have thought about the future even before you told me [to think about it].

Then he recalls an example. In 1959 — when he was twelve years old — he started a diary in which he would write down daily events. This he continued until he left Kamina, that is, when he was already working as a painter. (The "book," as he called it, was left behind with his younger brother, who took it along when he moved to Kananga.) One day he made an entry about "the affairs of the country." He foresaw that Jason Sendwe might die "within a week," and then it happened.[25] What he accomplished then — "and I am not saying that I am a prophet" — he could do again:

т: As regards the future of the country, I can think [it, about it]. I will say things that are true or that are a lie [*mambo ya kweli ou bien ya bongo*]. But if I am lucky, you will see, and you are going to say ...?... [*his voice trails off*]. I'll just try. That's what I think.

ғ: Yes.

Of the statements I should now like to quote, the first would seem to be dictated by political considerations; the second, however, is in my view of an epistemological (and aesthetic) nature. Commenting on one of his apparently most laudatory pro-regime paintings, "Mobutu's Speech before the United Nations Assembly" (Painting 93), Tshibumba made this intriguing remark:

It is true, it was on October 4 [1973], if I am not mistaken, that he traveled to the UN. When he arrived there he made a speech, and that speech remains [*with emphasis*] truly historic [*historique*]. Even I, when I thought about it, [told myself], "It is true [*c'est vrai*]." So the things Mobutu began to think — he began to think [things] that were true — or else [they were] a lie [*ya kweli ou bien bongo*]. But that's something I keep to myself [*inabakia mu roho yangu*, lit. "it remains in my soul"].

In its very ambiguity, this is a crucial statement of Tshibumba's position regarding the Mobutu regime. The last remark is certainly not just a *reservatio mentalis*, a political hedge. Ambiguity is not merely implied; it is stated. Immediately following the passage just quoted, Tshibumba said: "It is true that he started out thinking things that were true." What looks like undecided sliding from truth to lie to truth is characteristic of Tshibumba's dialectical ways with truth.

25. Sendwe died in June 1964 (see the note to Painting 74 in Part I).

Consider the following juxtaposition of truth and lie that was occasioned by a seem-ingly irrelevant detail. It came up in the course of Tshibumba's comments on Paint-ing 45, depicting Lumumba's travel from prison to the Brussels Round Table preceding independence. Here Tshibumba addressed his remarks directly to an artistic problem: How to depict the prosaic event of air travel, a fact, in an expressive picture, a fiction? (Again, in order to make the point, the translation follows the original more closely than in the passage given in Part I.)

> T: It is true [*ni kweli*], that day he boarded [a plane] and left Lubumbashi.
>
> F: Mm-hmm.
>
> T: Yes, he left Lubumbashi. [*Pointing to the picture*] This, I think, is something you know: When you walk that road there is a bridge.[26]
>
> F: Mm-hmm.
>
> T: That is where the Lubumbashi River flows.
>
> F: Mm-hmm.
>
> T: Right. So now [Lumumba's plane] takes to the air and goes away. They are thoughts I had [*njo mawazo niliwaza*]. That is the kind of thought you had in mind when you talked about thoughts.[27]
>
> F: Mm-hmm.
>
> T: As far as I am concerned, [*with a chuckle*] they are my thoughts that I work out [lit. "make"]. Lies and truth [*bongo na kweli*] I put in it, so as to compose [the painting].

When we looked at the painting, Tshibumba must have sensed my being intrigued by his choice of this particular scenery. His response testified to his artistic awareness; with-out inventing and composing he would not be a painter. But how else is one to interpret his remark about *bongo na kweli* if not as evidence for a dialectical conception of truth? It is possible to translate the phrase as "fiction and truth," and that would take the sting out of the contradiction. Mixing fact and fiction is, after all, a common enough device. When Tshibumba resorts to the juxtaposition of truth and lie, he does not abandon truth claims for his History, including claims that may contradict those of academic historiog-raphy. More than once, Tshibumba concluded the narration of an event that he per-ceived as running against common opinion, politically accepted opinion, or as we shall see presently, the ethnographer's opinion with a statement such as *ni histoire*, "it's his-tory." Truth comes to itself, to use a Hegelian figure, not in single facts and events but in history. Let me illustrate this with one last confrontation between the two of us.

26. Tshibumba ties the image of the bridge to my factual knowledge of the place but also presumes that I somehow know of its place in the imagination and memories of the people. The same bridge over which Lu-mumba flies on his mission for freedom and independence was the scene of the deaths of the innocent chil-dren during the secession of Katanga (Painting 69).

27. This is a free translation of a difficult, elliptic sentence: "ii ni mawazo sawa ulisema: mu mawazo yako." The reference is to our earlier discussion about History being worked out in "thoughts."

We were looking at details in two pictures that relate the story of Simon Kimbangu's trial and imprisonment in what was then Elisabethville (Paintings 25 and 26). Eventually, the discussion got around to the exact location of the prison where he was kept for more than thirty years. Tshibumba said it was at Kasapa, where at the time of our conversation the university campus, a military camp, and a prison (all going back to colonial times) were located at a safe distance from the city of Lubumbashi. I knew that placing Kimbangu at Kasapa was an anachronism; certainly for most of the period of his imprisonment the government jail was in town. Tshibumba insisted on his version. When I came up with more detailed information ("the prison used to be near the pharmaceutical warehouse"), he responded (switching, perhaps significantly, to French) with a half-hearted "Is that so?" (*c'est vrai?*). Then we continued:

F: Yes, [I cannot pinpoint the place] but that is where the prison used to be in the old days.

T: Maybe that's the case. But in following, as it were, history [*kufwata sawa histoire*], that [i.e., what I told you about Kasapa] is what we say.

F: [*conceding*] But it is true, yes, later they built [a prison] there in Kasapa.

T: [*noncommittal*] Mm-hmm.

F: And also, he died at Kasapa.

T: [*echoing*] He died at Kasapa.

F: We know the grave.

T: Mm-hmm.

F: We know the place.

T: Really, eh?

F: Mm-hmm.

Then we moved on to the next painting. The episode involved, somewhat like our discussion of leopard people, a confrontation of knowledge.[28] What I remembered of the history of Kimbangu made me contradict a statement of Tshibumba's and then go overboard when, in a move that was really falsely conciliatory, I said that the prophet died at Kasapa, although I only knew that his grave had been located there before his body was transferred to lower Zaire (I remembered reading that he died in a hospital, but I needed to check my academic sources on this). Notice what happened in this exchange: I stated a historical fact. He contradicted it categorically. When I went on to elaborate on my version, he invoked "history" against my historical fact. Switching to the first person plural — "that is what *we* say" — he opposed another body of knowledge, not just his private opinion, to my version of history.

28. Incidentally, this confrontation was prepared by an earlier exchange we had when we talked about Livingstone's death (Painting 10) and the location of his grave. The village, Tshibumba said, was long abandoned and the place overgrown and forgotten, as in the case of Kimbangu's grave. I countered with a remark to the effect that "some people know the place . . . ; it is at Kasapa," to which he responded with a laconic "ah."

When "historical facts" and "history as told" contradict each other, the easy solution is to relativize the contradiction as a coexistence of different discourses. The question of truth is then bracketed, although the one who does the bracketing keeps his certainties up his sleeve. Tshibumba, being aware of contesting discourses, made it clear from the very beginning that his ambition was to paint and tell history, *tout court.* I have tried to develop the argument that a relativist escape is not necessary when we grant to Tshibumba's History the same status we must grant to academic historiography: that of a dialectical process, itself historical and hence contingent.[29] Such a process necessarily (with epistemological necessity) runs into pièces de résistance, islands of untransformed material. Truth is a matter of emancipation from imposed ideology, unreflected opinion, and seductive images, not just the result of matching facts with transhistorical standards of verification.

29. Though we differ somewhat in our conclusions — what I have called confrontation takes us a step beyond seeking a common ground for vernacular and academic historiology in "sociological models" — W. MacGaffey's lucid and informative essay "African History, Anthropology, and the Rationality of Natives" (1978) comes closer than anything else I have read to the position I have taken in this chapter.

PAINTINGS BY TSHIBUMBA

The lists contain paintings by Tshibumba in the collection of J. Fabian. Entries give the following information:

Number in the historical series, if applicable
Registration number, preceded by T[shibumba]
 or G[enre]
Title or inscription, as spelled on the painting
Description
Genre, if applicable
Date of acquisition
Dimensions

The History of Zaire

1
T10
Untitled
People crossing a river near village
Paysage
December 9, 1973
42 × 71 cm

2
T15
Untitled
Warrior and woman in traditional attire
Village
December 21, 1973
55 × 40 cm

3
T14
Untitled
Chief in traditional attire
Village
December 21, 1973
52 × 39 cm

4
T63
Untitled
Nativity scene with three magi
Biblical scenes
October 16, 1974
40 × 54 cm

5
T31
"Diego-Cao et le roi du Congo"
Banza Kongo and Diogo Cão looking out on the
 river Zaire
September 9, 1974
62 × 35 cm

6
T46
"Déjà au XVIème siècle Livingstone avait rencontré
 une caravane qui provenait du Village – Katanga"
Livingstone with a notebook meeting Africans
 transporting copper *croisettes*
October 6, 1974
35 × 62 cm

7
T30
"Stanley 1ᵉʳ explorateur – arrive au Congo"
Stanley walking ahead of his porters toward a
 village
September 9, 1974
62 × 36 cm

8
T29
"Stanley fait ses raports (situation en Afrique centr.)
 en Belgique chez Roi Léopold II"
Stanley reporting to Leopold II
September 9, 1974
35 × 62 cm

9
T27
"Rencontre Stanley – Livingstone à Mulunguishi"
Stanley and Livingstone meeting
September 9, 1974
34 × 63 cm

10
T47
"La mort de Livingstone"
Livingstone on his deathbed, Africans praying
October 6, 1974
39 × 55 cm

11
T28
"Ngongo Lutete mangeur d'hommes et le
 commissionnaire arabe"
Chief Ngongo Lutete and an Arab trader, in the
 chief's enclosure
Oppressors
September 9, 1974
34 × 63 cm

12
T25
"La fin des Arabes"
War scene from the anti-Arab campaign
September 9, 1974
35 × 63

13
T48
"Les chefs arabisé sont tuer / Rumaliza – Tipo Tipo
 – Munimutara"
Three Arab leaders facing Force Publique firing
 squad, with a white officer commanding
October 6, 1974
36 × 62 cm

14
T33
"Le roi Banza Congo mort empoisoner"
Banza Kongo on his deathbed
September 15, 1974
34 × 63 cm

15
T34
"Grand chef Katanga fait ses adieux à Msiri le
 criminel"
Chief Katanga and Msiri drinking maize beer
September 15, 1974
35 × 62 cm

16
T35
"Le fils du chef Katanga executer par Msiri l'ami
 de son père"
Msiri beheading the son of Chief Katanga
September 15, 1974
35 × 63 cm

17
T32
"Bodson fût tuer par Msiri"
Msiri killing Bodson
September 15, 1974
62 × 35 cm

18
T42
"Msiri fût couper la tête"
White officer leading porters carrying Msiri's head
September 29, 1974
40 × 68 cm

19
T26
"Début de la – Colonie Belge"
Yard of station, with white officers and Africans
 saluting the Belgian flag
September 9, 1974
34 × 62 cm

20
T36
"Juillet 1885 / Etat indépendant du Congo"
Left side: portrait of Leopold II; right side: yard of
 station, with white officers, native soldiers, and
 Africans saluting flags of Belgium and Congo
 Free State
September 15, 1974
35 × 63 cm

21
T37
"Grand chef Lumpungu pendu à Kabinda"
Hanging of chief Lumpungu; yard of station, with
 white officers, native soldiers, and Africans
 saluting
September 15, 1974
35 × 62 cm

22
T49
"Les Simba – Bulaya / (Lion – d'Europe)"
Two whites in miners' hats, dark glasses, and black
 coats in a village, with African victims
October 6, 1974
40 × 68 cm

23
T50
"Le chemin de fer fût instaler à Sakania en 1905"
Arrival of the first train at Sakania
October 6, 1974
39 × 55 cm

24
T51
"En 1906 UMHK fut créée"
Copper smelter under construction
October 6, 1974
50 × 41 cm

25
T43
"'Simon' Kimbangu"
Simon Kimbangu in court
September 29, 1974
43 × 59 cm

26
T45
"Kimbangu et Jhon Panda"
Left side: Kimbangu and Panda in prison cell;
 right side: yard of Kasapa prison
September 29, 1974
36 × 62 cm

27
T52
"Monument Roi Léopold II / Léopoldville fure. . . .
 instaurée le 21-juin-1941"
Equestrian monument of Leopold II at
 Léopoldville
October 6, 1974
41 × 53 cm

28
T40
"Les martyrs de l'U.M.H.K"
The victims of the miners' strike
September 24, 1974
40 × 55 cm

29
T44
"La victoire du Force-Publique contre les Italiens"
Force Publique soldiers attacking Italians
September 24, 1974
40 × 68 cm

30
T41
"La révolte batetela"
The Force Publique fighting Tetela warriors
September 24, 1974
35 × 62 cm

31
T53
"Prince Charles visite le Congo-Belge en 1947"
Prince Charles and entourage at Léopoldville
 airport
October 6, 1974
40 × 68 cm

32
T54
"Sa Majesté le roi Baudouin Ier visite le Congo-
 Belge en 1955"
King Baudouin and entourage reviewing troops at
 the airport
October 6, 1974
43 × 59 cm

33
T55
"'Mangez buvez et danser ensemble avec lesnoirs
 du Congo'" (Baudouin)
King Baudouin giving a speech
October 6, 1974
55 × 39 cm

34
T5
"1885–1959/Colonie-Belge"
Prison yard; prisoner being flogged by guard, with
 white officer watching
Belgian colony
November 21, 1974
39 × 51 cm

35
T62
"Mr Pétillon à la résidence du 1ᵉʳ bourgemestre de
 la ville de Jadotville en 1957"
Pétillon giving a speech, being heckled by white
 population of Jadotville
October 16, 1974
48 × 50 cm

36
T58
"Lumumba directeur de brasserie de Stanleyville"
Lumumba, as the director of a brewery, at his desk
October 16, 1974
39 × 55 cm

37
T61
"Lumumba et Kwamé-Kruma en 1957 / à la
 Conférance panafricain à Ghana"
Lumumba and Nkrumah meeting at airport in
 Ghana
October 16, 1974
49 × 41 cm

38
T56
"En 1958 Kasa-Vubu devient bourgemestre de la
 Commune de Kintambo"
Kasavubu giving speech
October 16, 1974
51 × 44 cm

39
T59
"A l'Exposition de Belgique 1ᵉʳ rencontre
 Lumumba Kasa-Vubu en 1958"
Lumumba and Kasavubu meet at an art exhibition
October 16, 1974
50 × 38 cm

40
T18
"Discours du 4 janvier 1959 / les martyrs de
 l'indépendance"
Left side: portrait of Lumumba; right side:
 Lumumba leading the people breaking the
 chains of colonial rule
January 18, 1974
41 × 69 cm

41
T57
"4 janvier 1959 à Léopoldville et l'intervention de
 l'ONU (Ghana)"
UN soldiers facing rioting population in
 Léopoldville
October 16, 1974
40 × 54 cm

42
T60
"Le 4 janvier 1959 Colonel-Kokolo fût tué chez-lui"
Colonel Kokolo's body watched by four Ghanaian
 UN officers
October 16, 1974
39 × 52 cm

43
T70
"Kasa-Vubu devant le tribunal"
Kasavubu facing a colonial court
October 25, 1974
40 × 54 cm

44
T78
"A Buluo avant de s'envoler pour la table-ronde de
 Belgique"
Lumumba at Buluo prison
October 25, 1974
54 × 43 cm

45
T67
"Après sa libération de Buluo Lumumba s'envole
 vers la table ronde"
Sabena plane flying over copper smelter in
 Lubumbashi
October 25, 1974
41 × 50 cm

46
T76
"La table ronde de Bruxelle de 1960"
Congolese leaders at the Brussels Round Table
October 25, 1974
51 × 44 cm

47
T72
"o heure proclamation de l'indépence le
 30-juin-1960"
Scene of independence ceremony
October 25, 1974
38 × 51 cm

48
T2
"Vive le 30. juin Zaïre indépendant"
Lumumba and King Baudouin; Lumumba signing
 book
November ?, 1973
37 × 69 cm

49
T3
"Vive le 30. juin Zaïre indépend"
Lumumba and King Baudouin; Lumumba giving
 speech
November ?, 1973
44 × 69 cm

50
T68
"Tous les Belges doivent quitter le Congo dans 24h
 (Lumumba)"
Whites fleeing in their cars
October 25, 1974
39 × 51 cm

51
T66
"La Force-Publique – contre les para belge"
Force Publique soldiers fighting Belgian
 paratroopers
October 25, 1974
49 × 41 cm

52
T69
"Les soldats de la F.P. embarquer dans les wagons"
Soldiers of the Force Publique being loaded onto a
 train at Jadotville
October 25, 1974
40 × 50 cm

53
T64
"Les Baluba contre les Lulua"
Scene of ethnic warfare
October 25, 1974
47 × 50 cm

54
T80
"Le Royaume baluba, la construiction de
 Mbuji-Mayi"
Bush with elephant, urban construction site
November 6, 1974
39 × 55 cm

55
T75
"Attaque des Balubakas – contre l'ANC"
War scene in a village
October 25, 1974
41 × 54 cm

56
T65
"Le 11 juillet 61 Katanga devient indé"
Katanga flags flying over a building at
 Elisabethville
October 25, 1974
40 × 50 cm

57
G30 (by Kabuika; unsigned)
Untitled
Katangese soldiers shooting at refugees at
 Lubumbashi railway underpass
War
October 26, 1974
34 × 47 cm

58
T71
"Apelle à l'ONU"
UN troops getting off a plane
October 25, 1974
35 × 47 cm

59
T73
"A Lubumbashi – de 1961–1963 / camp des réfugiés
 / groupe (Baluba – Tshokwe – Kasaï etc etc)"
Refugee camp guarded by UN soldiers
October 25, 1974
48 × 52 cm

60
T74
"Nord-Katanga dans la césession"
Attack on train at Kamina
Train
October 25, 1974
37 × 51 cm

61
T77
"Fougan-Magister ravage le Nord-Kat"
Jet fighters strafing a village
October 25, 1974
51 × 40 cm

62
T12
Untitled
Troops arrive by train at Luena station
December 16, 1973
42 × 69 cm

63
T24
"Manifestation des femmes katangaises"
Women demonstrating against UN soldiers
September 3, 1974
35 × 62 cm

64a
T38
"Conflît Kasa-Vubu – Lumumba"
Lumumba and Kasavubu at a stadium
September 22, 1974
35 × 62 cm

64b
T22
"Le conflît Kasa-Vubu – Lumumba"
Black-and-white version of 64a
March ?, 1974
44 × 61 cm

65
T11
"Arrestation à Lodja"
Lumumba being arrested
December 16, 1973
42 × 69 cm

66
T88
"Lumumba devant le peuple au stade ex Baudouin
 Iᵉʳ à Léopoldville"
Lumbumba, bound, between two military guards
 in a stadium
November 12, 1974
44 × 52 cm

67a
T4
"Calvaire d'Afrique"
Lumumba as prisoner at Elisabethville airport
November 21, 1974
44 × 69 cm

67b
T23
"Calvaire d'Afrique"
Black-and-white version of 67a
September 3, 1974
35 × 63 cm

68
T89
"Le 17 janv 1961 / Bob Denard a tué Lumumba –
 Mpolo – Okito"
Lumumba and two companions dead
November 12, 1974
40 × 50 cm

69
T87
"La céssession katangaise / La mort des inoncents"
Jet fighters flying over refugees near copper smelter
November 6, 1974
54 × 42 cm

70
T85
"A Jadotville les Balubakat contre les Kat"
Katangese soldiers shooting at people in Jadotville
November 6, 1974
51 × 38 cm

71
T82
"Le monstre de la céssession katangaise"
A homemade armored vehicle fighting UN troops
 at Elisabethville airport
November 6, 1974
39 × 51 cm

72
T84
"Les Baluba dans le massacre historique de
 Kipushi"
Soldiers shooting Luba-Kasai miners at Kipushi
November 6, 1974
51 × 38 cm

73
T81
"La mort tragique de Mᵣ Dag-Hammarskjold"
A crashed airplane hosed by firefighters
November 6, 1974
39 × 53 cm

74

T90

"Président des Balubakat assassiné en 1964, par des rebelles"

Jason Sendwe's tomb

November 12, 1974

52 × 40 cm

75

T7

Untitled

Planes attacking copper smelter

Smokestack and slag heap; war

December 9, 1973

37 × 61 cm

76 (documented as 54 above)

77

T86

"Kalonji (Albert) / empereur du Sud-Kasaï / Etat autonome / 1er royaume Luba du XX S"

Kalonji and a military escort being cheered by the population

November 6, 1974

50 × 41 cm

78

T83

"Au Sud Kasaï les Kanyoka se révoltent"

Soldiers shooting at village rebels

November 6, 1974

40 × 50 cm

79

T79

"Coup d'Etat / La fin du royaume Luba / Le Général Tshinyama"

General Tshinyama addressing soldiers

November 6, 1974

52 × 44 cm

80

T91

"Après la démission de Mrs Ileo et Adoula / Tshombe devient 1er congolais et le drapeau change"

Congolese flags flying over parliament at Léopoldville

November 12, 1974

41 × 50 cm

81

T92

"Donnez-moi 3 mois et je vous donnerai un nouveau Congo"

Tshombe coming off the airplane from Belgium

November 12, 1974

51 × 38 cm

82

T93

"Election présidentielle 1964"

Airplane dropping campaign flyers in front of Elisabethville railway station

November 12, 1974

51 × 39 cm

83

T94

"Au Kwilu les muleliste contre l'ANC"

Congolese army fighting village rebels

November 12, 1974

44 × 38 cm

84

T95

"La rebellion au Congo"

Slain people around Lumumba monument at Kisangani-Boyoma

November 12, 1974

53 × 41 cm

85

T1

"24 novembre et bonne année 1974"

Mobutu and party symbols

November ?, 1973

40 × 69 cm

86

T19

"Salongo Alinga Mosali"

Mobutu rolling up his sleeves

January 12, 1974

41 × 68 cm

87

T20

"Grâce à MPR / Lumumba héros national"

Lumumba in front of the house where he was murdered

January 12, 1974

40 × 69 cm

88
T96
"Les mercenaires de Bukavu"
Parachutists killing people at Bukavu
November 12, 1974
53 × 41 cm

89
T97
"Jean et ses amis s'enfuient vers le Rwanda"
Jean Schramme looking out from tank turret
November 12, 1974
51 × 44 cm

90
T98
"L'arrestation d'Alger (Tshombe et sa fin)"
Spanish airplane at Algiers airport, soldiers
November 12, 1974
49 × 40 cm

91
T99
"Pape Paul VI est daccord avec Mobutu"
Pope Paul VI at his desk
November 12, 1974
51 × 38 cm

92
T100
"Vive *le* 20 mai naissance du M.P.R. la grande
 famille — zaïroise avec le P^dt fondateur
 Mobutu S. S"
Party monument at Kipushi
November 12, 1974
50 × 39 cm

93
T21
"Le discours le plus applaudi de l'ONU"
Mobutu addressing the United Nations
January 12, 1974
40 × 67 cm

94
T101
"Mesure du 30 nov 1973"
Zairianization: white businessman departing,
 African businessman in the doorway of his shop
November 12, 1974
44 × 52 cm

95
T102
"Bonheur — tranquillité — joie de vivre en paix"
Mobutu standing in a limousine, with the party
 emblem as the sun
November 12, 1974
50 × 41 cm

96
T108
"20 juin martyrs de l'économie national"
Mining accident at Kipushi
November 21, 1974
53 × 41 cm

97
T103
"Clé de l'avenir / Rêve mystérieux de l'artiste
 Tshibumba-Kanda-Matulu"
Party flags flying over domed building, skeletons
November 21, 1974
35 × 47 cm

98
T104
"Le monde de demain sera peupler"
A crowd of people between high-rise buildings
November 21, 1974
51 × 44 cm

99
T105
"Dans l'avenir il n'y aura pas des relligions"
Party *animatrices* dancing in front of a church that
 has been converted to a temple of the party
November 21, 1974
40 × 50 cm

100
T106
"'Je crois en mobutu le père tout puissant'"
Old man, under Party emblem, kneeling in prayer
November 21, 1974
51 × 38 cm

101
T107
"Dans l'avenir les 4 position"
Uniformed members of the national army,
 gendarmerie, and brigades, with the people in
 the background and the party monument in
 the center
November 21, 1974
50 × 40 cm

Other Paintings Acquired before December 1974

T8
Untitled
Arab slave traders
Arab slave traders
December 9, 1973
40 × 68 cm

T9
Untitled
Fishermen in dugout canoe
Paysage
December 9, 1973
48 × 54 cm

T13
Untitled
Lion and lioness
Powerful animals
December 21, 1973
43 × 57 cm

T117
"20-juin-1971 martyrs de l'économie national"
Mining accident at Kipushi: ambulance, men
 running, women mourning
November 21, 1974
38 × 61 cm

T120
"La rebellion Kisangani Ville martyrs du Congo"
Bodies of slain people on Kisangani street
November 21, 1974
39 × 53 cm

T121
"(La rebellion) la mort des plusieurs Congolais se
 faisait à de km de Kisangani"
Two kneeling men in business suits being executed
 by warriors in tribal dress; white soldiers
 watching in background
November 21, 1974
34 × 49 cm

T122
"De la rive droite àla rive gauche de Kisangani"
People fleeing across a bridge over the Congo River
November 21, 1974
44 × 37 cm

T123
"La rebellion les survivants de Kisangani arrivent à
 Léopoldville"
Refugees from Kisangani arriving at Kinshasa
 airport
November 21, 1974
54 × 40 cm

T124
"(La rebellion) un soldat de l'ANC garde les corps
 de quelques personallité de Kisangani"
Soldier kneeling and praying, bodies covered by
 blankets
November 21, 1974
34 × 47 cm

Paintings Acquired in Spring 1976
(transmitted by B. Jewsiewicki)

T109
"A Mbuji May la chasse aux trafiquants du
 diamant"
Soldiers and helicopter chasing diamond diggers
38 × 60 cm

T110
Untitled
Good businessman and bad businessman
Crédit est mort
38 × 60 cm

T111
"La politique économique U.M.H.K. debuit
 1906 — Gecamines en 1966"
Copper smelter
Smokestack and slag heap
38 × 60 cm

T112
"La culture africaine dans l'animation à chaque
 arrivé et départ"
Mobutu greeted by party *animatrices* in front of
 building at Lubumbashi
38 × 60 cm

T113
"Le pays a connu un grève général en 1976 (la crise
 mondial)"
Train stopping at Lukuni station; strikers
38 × 60 cm

T114
"Manifestation des étudiant à Kin."
Commandos shooting at demonstrating students in
 Kinshasa
39 × 61 cm

T115
"Manifestation des étudiants à Lubumbashi"
Commandos chasing demonstrating students in
 front of university administration building at
 Lubumbashi
38 × 61 cm

T116
"Le samedi a était consacré au travail collectif
 (le "salongo") au village comme en ville"
Collective cleaning up in village
39 × 60 cm

GENRE PAINTINGS

The following genre paintings in the collection of
J. Fabian are reproduced in Chapter 1. Descriptions
appear in the captions that accompany each figure;
genres are listed in Table 1.1. The entries below give
the following information:

Figure number
Artist's name
Date of acquisition
Place of acquisition
Dimensions

Figure 1.1
B. Ilunga [Ilunga Beya]
December 30, 1973
Lubumbashi
39 × 46 cm

Figure 1.2
Ndaie Tb.
January 2, 1974
Lubumbashi
30 × 35 cm

Figure 1.3
L. Kalema [Louis Kalema]
June 7, 1974
Lubumbashi
57 × 66 cm

Figure 1.4
Kabuika
October 25, 1974
Lubumbashi
35 × 47 cm

Figure 1.5
K. M. Kamba
December 26, 1973
Kolwezi
59 × 43 cm

Figure 1.6
Y. Ngoie
November ?, 1973
Kolwezi
49 × 69 cm

Figure 1.7
L. Kalema
July 3, 1973
Lubumbashi
44 × 54 cm

Figure 1.8
Matchika
March 9, 1974
Kolwezi
39 × 71 cm

Figure 1.9
C. Mutombo [Mutombo Nsenji]
February 10, 1974
Lubumbashi
38 × 68 cm

Figure 1.10
Kapenda
December 1, 1973
Lubumbashi-Katuba
43 × 60 cm

Figure 1.11
B. Ilunga
December 9, 1973
Lubumbashi
41 × 48 cm

Figure 1.12
Matchika
March 9, 1974
Kolwezi
71 × 42 cm

Figure 1.13
Makabu Mbuta
? 1974
Lubumbashi
59 × 39 cm

Figure 1.14
Y. Ngoie
November ?, 1973
Kolwezi
49 × 69 cm

Figure 1.15
Ndaie Tb.
September 26, 1974
Lubumbashi
45 × 70 cm

Figure 1.16
Luaba Tshimanga
January 2, 1974
Lubumbashi
38 × 52 cm

Figure 1.17
L. Kalema
? [1973/74]
Lubumbashi
58 × 75 cm

Figure 1.18
Ndaie Tb.
April 17, 1974
Lubumbashi
48 × 64 cm

Figure 1.19
Kabuika
October 16, 1974
Lubumbashi
44 × 60 cm

Figure 1.20
L. Kalema
June 17, 1974
Lubumbashi
51 × 72 cm

REFERENCES

Adorno, Rolena. 1986. *Guaman Poma: Writing and Resistance in Colonial Peru*. Austin: University of Texas Press.

Alpers, Svetlana. 1983. *The Art of Describing: Dutch Art in the Seventeenth Century*. Chicago: University of Chicago Press.

Andersson, Efraim. 1958. *Messianic Popular Movements in the Lower Congo*. Uppsala: Almquist and Wiksell.

Asch, Susan. 1983. *L'église du prophète Kimbangu: de ses origines à son rôle actuel au Zaïre*. Paris: Karthala.

Ashton, E. O. 1947. *Swahili Grammar*. 2d ed. London: Longmans.

Assmann, Jan. 1992. *Das kulturelle Gedächtnis: Schrift, Erinnerung und politische Identität in frühen Hochkulturen*. Munich: C. H. Beck.

Bal, Mieke. 1991. *Reading "Rembrandt": Beyond the Word-Image Opposition*. Cambridge: Cambridge University Press.

Barber, Karin. 1987. Popular Arts in Africa. *African Studies Review* 30 (3):1–78, 105–11.

Bauman, Richard. 1986. *Story, Performance, and Event: Contextual Studies of Oral Narration*. Cambridge: Cambridge University Press.

Bauman, Richard, et al. 1977. *Verbal Art as Performance*. 2d ed. Prospect Heights, Ill.: Waveland Press.

Bayart, Jean-François. 1993. *The State in Africa: The Politics of the Belly*. London: Longman.

Bemba, Sylvain. 1984. *Cinquante ans de musique du Congo-Zaïre*. Paris: Présence africaine.

Bender, Wolfgang. 1991. *Sweet Mother: Modern African Music*. Chicago: University of Chicago Press.

Benveniste, Emile. 1971. *Problems in General Linguistics*. Translated by Mary Elizabeth Meek. Coral Gables: University of Miami Press.

Biaya, T. K. 1988. L'impasse de la crise zaïroise dans la peinture populaire urbaine, 1970–1985. *Canadian Journal of African Studies* 22:95–120.

———. 1992. Et si la perspective de Tshibumba était courbe? In Jewsiewicki 1992, 155–64.

Bilsen, A. A. J. van. 1962. *L'indépendance du Congo*. Brussels: Casterman.

Blankert, Albert. 1987. What is Dutch Seventeenth-Century Genre Painting? A Definition and Its Limitations. In *Holländische Genremalerei im 17. Jahrhundert: Symposium Berlin 1984*, ed. Henning Bock and Thomas W. Gaethgens, 9–32. Berlin: Gebr. Mann.

Bontinck, François, with K. Jansen, ed. and trans. 1974. *L'autobiographie de Hamed ben Mohammed el-Murjebi Tippo Tip (ca. 1840–1905)*. Brussels: Académie royale des sciences d'outre-mer.

Bourguet, M.-N., L. Valensi, and N. Wachtel. 1988. *Towards a History of Memory*. London: Harwood.

Brassine, Jacques, and Jean Kestergat. 1991. *Qui a tué Patrice Lumumba?* Paris: Duculot.

Brett, Guy. 1986. *Through Our Own Eyes: Popular Art and Modern History*. London: GMP Publishers; Philadelphia: New Society Publishers.

Callaghy, Thomas M. 1984. *The State-Society Struggle: Zaire in Comparative Perspective*. New York: Columbia University Press.

Le camp des Baluba: Une initiative de l'O.N.U.–O.N.U.-ville. Rapport secret. [1962?]. Brussels: Charles Dessart.

Centre de recherches et d'information socio-politiques. 1964. *Travaux africains, dossier documentaire: Les partis politiques congolais–1964.* [Compiled by J.-C. Willame]. Brussels: CRISP.

Ceyssens, R. 1975. Mutumbula, mythe de l'opprimé. *Cultures et développement* 7:483–550.

Chomé, Jules. 1959. *La passion de Simon Kimbangu, 1921–1951.* Paris: Présence africaine.

Clifford, James, and George E. Marcus, eds. 1986. *Writing Culture: The Poetics and Politics of Ethnography.* Berkeley: University of California Press.

Comaroff, John, and Jean Comaroff. 1992. *Ethnography and the Historical Imagination.* Boulder, Col.: Westview Press.

Coote, Jeremy, and Anthony Shelton, eds. 1992. *Anthropology, Art, and Aesthetics.* Oxford: Clarendon Press.

Cornet, Joseph-Aurélien, et al. 1989. *Soixante ans de peinture au Zaïre.* Brussels: n.p.

Cornevin, Robert. 1963. *Histoire du Congo (Léopoldville).* Paris: Berger-Levrault.

———. 1989. *Histoire du Zaïre.* 4th ed. Brussels: Hayez.

Delière, Line [Jacqueline de Middeleer]. 1973. *Katanga rouge.* Brussels: [author].

Delvaux, Henri. 1950. *L'occupation du Katanga, 1891–1900: Notes et souvenirs du seul survivant.* Elisabethville: Essor du Congo.

Dembour, M. B. 1992. Whipping as a Symbol of Belgian Colonialism. *Canadian Journal of African Studies* 26:205–25.

Dening, Greg. 1993. The Theatricality of History Making and the Paradoxes of Acting. *Cultural Anthropology* 8:73–95.

Deward, Georges. 1962. *Histoire du Congo: Evolution du pays et de ses habitants.* Liège: H. Dessain.

Dirks, Nicholas B., ed. 1992. *Colonialism and Culture.* Ann Arbor: University of Michigan Press.

Drewal, Henry John. 1988. Performing the Other: Mami Wata Worship in West Africa. *Drama Review* 32, no. 2 (summer): 160–85.

Dumont, Georges-H. 1961. *La table ronde belgo-congolaise (janvier–février 1960).* Paris: Editions universitaires.

Dupré, Georges. 1992. La signification de la perspective dans sept tableaux de Tshibumba Kanda-Matulu. In Jewsiewicki 1992, 139–53.

Eco, Umberto. 1976. *A Theory of Semiotics.* Bloomington: Indiana University Press.

Elisabethville. 1961. *Elisabethville, 1911–1961.* Brussels: L. Cuypers.

Emerson, Barbara. 1979. *Leopold II of the Belgians: King of Colonialism.* London: Weidenfeld and Nicolson.

Ewens, Graeme. 1991. *Africa O-Ye! A Celebration of African Music.* Enfield, Middlesex: Guinness Publishing.

———. 1994. *Congo Colossus: The Life and Legacy of Franco & OK Jazz.* Northwalsham, Norfolk: Buku Press.

Fabian, Johannes. 1969. An African Gnosis: For a Reconsideration of an Authoritative Definition. *History of Religions* 9:42–58.

———. 1974. Genres in an Emerging Tradition: An Anthropological Approach to Religious Communication. In *Changing Perspectives in the Scientific Study of Religion*, ed. Allan W. Eister, 249–72. New York: Wiley.

———. 1978. Popular Culture in Africa: Findings and Conjectures. *Africa* 48:315–34.

———. 1983. *Time and the Other: How Anthropology Makes Its Object.* New York: Columbia University Press.

———. 1990a. *History from Below: The "Vocabulary of Elisabethville" by André Yav.* Amsterdam: John Benjamins.

———. 1990b. *Power and Performance: Ethnographic Explorations through Proverbial Wisdom and Theater in Shaba, Zaire*. Madison: University of Wisconsin Press.

———. 1991a. *Language and Colonial Power: The Appropriation of Swahili in the Former Belgian Congo, 1880–1938*. Cambridge: Cambridge University Press, 1986. Reprint, Berkeley: University of California Press.

———. 1991b. *Time and the Work of Anthropology: Critical Essays, 1971–1991*. Philadelphia: Harwood Academic Publishers.

———. 1991c. Ethnographic Objectivity Revisited: From Rigor to Vigor. *Annals of Scholarship* 8: 381–408.

———. 1993. Keep Listening: Ethnography and Reading. In *The Ethnography of Reading*, ed. Jonathan Boyarin, 80–97. Berkeley: University of California Press.

Fabian, Johannes, and Ilona Szombati-Fabian. 1980. Folk Art from an Anthropological Perspective. In *Perspectives on American Folk Art*, ed. Ian M. G. Quimby and Scott T. Swank, 247–92. New York: W. W. Norton.

Fetter, Bruce. 1976. *The Creation of Elisabethville, 1910–1940*. Stanford: Hoover Institution Press.

Finnegan, Ruth. 1992. *Oral Traditions and the Verbal Arts*. London: Routledge.

Forty-six Angry Men: The Forty-six Civilian Doctors of Elisabethville Denounce U.N.O. Violations in Katanga. [1962?]. N.p.

Friedländer, Max J. 1963. *Landscape, Portrait, Still-Life: Their Origin and Development*. New York: Schocken.

Geerts, Walter. 1970. *Binza 10. De eerste tien onafhangelijkheidsjaren van de Democratische Republiek Kongo*. Ghent: E. Story-Scientia.

Geertz, Clifford. 1988. *Works and Lives: The Anthropologist as Author*. Stanford: Stanford University Press.

Gérard-Libois, Jules. 1966. *Katanga Secession*. Madison: University of Wisconsin Press.

Graburn, Nelson H. H., ed. 1976. *Ethnic and Tourist Arts: Cultural Expressions from the Fourth World*. Berkeley: University of California Press.

Halen, Pierre, and János Riesz, eds. 1993. *Images de l'Afrique*. Brussels: Textyles-Editions.

Harding, Frances. 1990. Performance and Political Action: The Use of Dramatisation in the Formulation of Tiv Ethnic and National Consciousness. In *Self-Assertion and Brokerage: Early Cultural Nationalism in West Africa*, ed. P. F. de Moraes Farias and Karin Barber, 172–95. Birmingham: Centre of West African Studies.

Heinz, G., and H. Donnay. 1969. *Lumumba: The Last Fifty Days*. Translated from the French by Jane Clark Seitz. New York: Grove Press.

Hergé. [1974?]. *Tintin au Congo*. Tournai: Casterman.

———. 1982. *Les aventures de Tintin au Congo*. Brussels: Editions du Vingtième Siècle, 1931. Facsimile reprint, Tournai: Casterman.

Herman, Paul. [1985]. Bande dessinée et Congo: De la passion au flirt discret. In *Zaïre 1885–1985: Cent ans de regards belges*. Brussels: Coopération par l'Education et la Culture/ASBL.

Higginson, John. 1989. *A Working Class in the Making: Belgian Colonial Labor Policy, Private Enterprise, and the African Mineworker, 1907–1951*. Madison: University of Wisconsin Press.

Hinde, Sidney Langford. 1897. *The Fall of the Congo Arabs*. London: Methuen.

Hodgkin, Thomas. 1956. *Nationalism in Colonial Africa*. London: Muller.

Hymes, Dell. 1974. *Foundations in Sociolinguistics: An Ethnographic Approach*. Philadelphia: University of Pennsylvania Press.

Institut royal colonial belge. 1948. *Biographie coloniale belge*. Vol. 1. Brussels: Librairie Falk/van Campenhout.

Janssens, E. (General). 1979. *Histoire de la Force Publique*. Brussels: Ghesquiere and Partners.

Jewsiewicki, Bogumil. 1984a. Les pratiques et l'idéologie de l'ethnicité au Zaïre: quelques réflexions historiques. In Jewsiewicki 1984b, 103–6.

———. 1986a. Collective Memory and Its Images: Popular Urban Painting in Zaire—A Source of "Present Past." *History and Anthropology* 2:365–72.

————. 1986b. Collective Memory and the Stakes of Power: A Reading of Popular Zairian Historical Discourses. *History in Africa* 13:195–223.

————. 1987. La mort de Bwana François à Elisabethville: La mémoire, l'imaginaire et la connaissance du passé. *Annales Aequatoria* 8:405–13.

————. 1988. Mémoire collective et passé présent dans les discours historiques populaires zaïrois. In *Dialoguer avec le léopard?* ed. B. Jewsiewicki and H. Moniot, 218–68. Quebec: Safi; Paris: L'Harmattan.

————. 1991a. Painting in Zaire: From the Invention of the West to Representation of Social Self. In Vogel and Ebong 1991, 130–51.

————. 1991b. Peintres des cases, imagiers et savants populaires du Congo, 1900–1960. *Cahiers d'études africaines* 31:307–26.

Jewsiewicki, Bogumil, ed. 1984b. *Etat indépendant du Congo, Congo belge, République démocratique du Congo, République du Zaïre.* Ste-Foy, Quebec: Safi.

————. 1992. *Art pictural zaïrois.* Sillery, Quebec: Editions du Septentrion.

Jewsiewicki, Bogumil, and David Newbury, eds. 1986. *African Historiographies: What History for Which Africa?* Beverly Hills: Sage.

Johns, Elizabeth. 1991. *American Genre Painting.* New Haven: Yale University Press.

Joset, P. E. 1955. *Les sociétés secrètes des hommes-léopards en Afrique noire.* Paris: Payot.

Jules-Rosette, Bennetta. 1984. *The Messages of Tourist Art: An African Semiotic System in Comparative Perspective.* New York: Plenum.

————. 1988/89. Expression in Aesthetics, in Science and Art: Ethnography as Discursive Sabotage. *American Journal of Semiotics* 6:37–55.

————. 1990. Simulations of Postmodernity: Images of Technology in African Tourist and Popular Art. *Society for Visual Anthropology Review* 6, no. 1 (spring): 29–37.

————. 1992. What Is "Popular"? The Relationship between Zairian Popular and Tourist Paintings. In Jewsiewicki 1992, 41–62.

Kalonji Ditunga, Albert. 1964. *Ma lutte, au Kasai, pour la Vérité au service de la Justice.* Barcelona: CAGSA.

Kanza, Thomas. 1972. *Conflict in the Congo: The Rise and Fall of Lumumba.* Middlesex: Penguin Books.

Katanga, Government of. N.d. *Livre blanc du gouvernement katangais sur les activités des hors-la-loi dans certains territoires Baluba. White Book of the Katanga Government about the Outlaw Activities in Some Baluba Areas.* Elisabethville: Katanga Government.

————. N.d. *Livre blanc du gouvernement katangais sur les événements de septembre et décembre 1961. White Paper on the Events of September and December 1961.* N.p.

Katzenellenbogen, S. E. 1973. *Railways and the Copper Mines of Katanga.* Oxford: Clarendon Press.

Kestergat, Jean. 1986. *Du Congo de Lumumba au Zaïre de Mobutu.* Brussels: Paul Legrain.

Kramer, Fritz. 1993. *The Red Fez: Art and Spirit Possession in Africa.* London: Verso.

Küchler, Susanne, and Walter Melion, eds. 1991. *Images of Memory: On Remembering and Representation.* Washington, D.C.: Smithsonian Institution Press.

Langdon, Helen. 1979. *Everyday-Life Painting.* New York: Mayflower Books.

Lenselaer, Alphonse. 1983. *Dictionnaire swahili-français.* Paris: Karthala.

Lipsitz, George. 1990. *Time Passages: Collective Memory and American Popular Culture.* Minneapolis: University of Minnesota Press.

Lohaka-Omana. 1974. Ngongo Leteta. *Likundoli* 2:53–62.

Mabika Kalanda. 1959. *Baluba et Lulua: Une ethnie à la recherche d'un nouvel équilibre.* Brussels: Remarques congolaises.

Mabi Mulumba and Mutamba Makombo. 1986. *Cadres et dirigeants au Zaïre: Qui sont-ils? Dictionnaire biographique.* Kinshasa: Centre de recherches pédagogiques.

MacGaffey, Wyatt. 1972. The West in Congolese Experience. In *Africa and the West: Intellectual Responses to European Culture*, ed. P. Curtin, 49–74. Madison: University of Wisconsin Press.

———. 1978. African History, Anthropology, and the Rationality of Natives. *History in Africa* 5:101–20.

Mandjumba Mwanyimi-Mbomba. 1989. *Chronologie générale de l'histoire du Zaïre (des origines à 1988).* 2d ed. Kinshasa: Centre de recherches pédagogiques.

Manya K'Omalowete a Djongo. 1985. *Patrice Lumumba, le Sankuru et l'Afrique: essai.* Lutry, Switzerland: Editions Jean-Marie Bouchain.

Martin, Marie-Louise. 1975. *Kimbangu: An African Prophet and His Church.* Oxford: Basil Blackwell.

Maurin Abomo, Marie-Rose. 1993. *Tintin au Congo ou la négrerie en clichés.* In Halen and Riesz 1993, 151–62.

M'Bokolo Elikia. 1976. *Msiri: Bâtisseur de l'ancien royaume du Katanga (Shaba).* Paris: ABC.

Mendiaux, Edouard. 1961. *Histoire du Congo des origines à Stanley.* Brussels: Charles Dessart.

Mitchell, W. J. Thomas. 1986. *Iconology: Image, Text, Ideology.* Chicago: University of Chicago Press.

———, ed. 1994. *Landscape and Power.* Chicago: University of Chicago Press.

Mobutu Sese Seko Kuku Ngbendu wa za Banga. 1975. *Discours, allocutions et messages.* 2 vols. Paris: Editions J.A.

Mudimbe, V. Y. 1988. *The Invention of Africa. Gnosis, Philosophy, and the Order of Knowledge.* Bloomington: Indiana University Press.

Munongo, Antoine Mwenda. N.d. *Pages d'histoire Yeke.* Elisabethville: Imbelco.

Musée royal de l'Afrique centrale. 1992. *La naissance de la peinture contemporaine en Afrique centrale, 1930–1970.* Annales: Sciences historiques, no. 16. Tervuren, Belgium: Musée royal de l'Afrique centrale.

Neumann, Klaus. 1992. A Postcolonial Writing of Aboriginal History. *Meanjin* 51:277–98.

Ngandu Nkashama, Pius. 1990. *Eglises nouvelles et mouvements religieux: L'exemple zaïrois.* Paris: L'Harmattan.

Noyes, John K. 1992. *Colonial Space: Spatiality in the Discourse of German South West Africa, 1884–1915.* Philadelphia: Harwood Academic Publishers.

Nzongola-Ntalaja, ed. 1986. *The Crisis in Zaire: Myths and Realities.* Trenton, N.J.: Africa World Press.

Office du Tourisme du Congo Belge et du Ruanda-Urundi. 1951. *Guide du voyageur au Congo Belge et au Ruanda-Urundi.* 2d ed. Brussels: Office du Tourisme du Congo Belge et du Ruanda-Urundi.

Okpewho, Isidor. 1992. *African Oral Literature: Backgrounds, Character, and Continuity.* Bloomington: Indiana University Press.

Perrings, Charles. 1979. *Black Mineworkers in Central Africa.* London: Heinemann.

Pétillon, L. A. M. [1955]. *Speech by the Governor General M. L. Pétillon [sic].* N.p.: Belgian Congo, Government Council.

———. 1967. *Témoignage et réflexions.* Brussels: Renaissance du livre.

———. 1985. *Récit: Congo, 1929–58.* Brussels: Renaissance du livre.

Preston Blier, Suzanne. 1988/89. Art Systems and Semiotics: The Question of Art, Craft, and Colonial Taxonomies in Africa. *American Journal of Semiotics* 6:7–18.

Puren, Jerry. 1986. *Mercenary Commander.* Ed. Brian Pottinger. Alberton, RSA: Galago.

Pwono, Damien M. 1992. Institutionalization of African Popular Music in Zaire. Ph.D. diss., University of Pittsburgh.

Rappaport, Joanne. 1990. *The Politics of Memory: Native Historical Interpretation in the Colombian Andes.* New York: Cambridge University Press.

Reed, David. 1965. *111 Days in Stanleyville.* New York: Harper and Row.

Reefe, Thomas Q. 1981. *The Rainbow and the Kings: A History of the Luba Empire to 1891.* Berkeley: University of California Press.

Rösiö, Bengt. 1993. The Ndola Crash and the Death of Dag Hammarskjöld. *Journal of Modern African Studies* 31:661–71.

Rowe, William, and Vivian Schelling. 1991. *Memory and Modernity: Popular Culture in Latin America.* New York: Verso.

Sacleux, Charles. 1939. *Dictionnaire swahili-français.* Paris: Institut d'Ethnologie.

Said, Edward W. 1994. *Culture and Imperialism.* New York: Vintage Books.

Salmons, Jill. 1977. Mammy Wata. *African Arts* 10:8–15, 87–88.

Schechner, Richard. 1988. *Performance Theory.* Rev. ed. London: Routledge.

Scott, James C. 1985. *Weapons of the Weak: Everyday Forms of Peasant Resistance.* New Haven: Yale University Press.

Stengers, Jean. 1989. *Congo, mythes et réalités: Cent ans d'histoire.* Paris: Duculot.

Ströter-Bender, Jutta. 1991. *Zeitgenössische Kunst der "Dritten Welt."* Cologne: DuMont.

Studstill, John D. 1984. *Les desseins d'arc-en-ciel: Epopée et pensée chez les Luba du Zaïre.* Paris: Centre national de la recherche scientifique.

Svenbro, Jesper. 1987. The "Voice" of Letters in Ancient Greece: On Silent Reading and the Representation of Speech. *Culture and History* 2:31–47.

———. 1988. *Phrasikleia: Anthropologie de la lecture en grèce ancienne.* Paris: La Découverte.

Szombati-Fabian, Ilona, and Johannes Fabian. 1976. Art, History and Society: Popular Painting in Shaba, Zaire. *Studies in the Anthropology of Visual Communication* 3:1–21.

Talon, Vicente. 1976. *Diario de la guerra del Congo.* Madrid: Sedmay Ediciones.

Tan Siew Soo. 1989. *The Malayan Special Force in the Heart of Africa.* Petaling Jaya: Pelanduk Publications.

Taussig, Michael. 1993. *Mimesis and Alterity: A Particular History of the Senses.* London: Routledge.

Thomas, Nicholas. 1994. *Colonialism's Culture: Anthropology, Travel and Government.* London: Polity Press.

Tonkin, Elizabeth. 1992. *Narrating Our Pasts: The Social Construction of Oral History.* Cambridge: Cambridge University Press.

Tshimanga wa Tshibangu. [1976]. *Histoire du Zaïre.* Kinshasa: Editions du Ceruki.

Turner, Thomas Edwin. 1973. A Century of Political Conflict in Sankuru (Congo-Zaire). Ph.D. diss., University of Wisconsin, Madison.

———. 1993a. "Batetela," "Baluba," "Basonge": Ethnogenesis in Zaire. *Cahiers d'études africaines* 33:587–612.

———. 1993b. Patrice Lumumba. Review article. *African Studies* 52 (1): 101–11.

Turner, Victor. 1986. *The Anthropology of Performance.* New York: *Performing Arts Journal* Publications.

Union Minière du Haut Katanga. 1956. *Union Minière du Haut Katanga, 1906–1956.* Brussels: L. Cuypers.

Ustorf, Werner. 1975. *Afrikanische Initiative: Das aktive Leiden des Propheten Simon Kimbangu.* Studies in the Intercultural History of Christianity, 5. Frankfurt: Peter Lang; Bern: Herbert Lang.

Van Avermaet, E., and B. Mbuya. 1954. *Dictionnaire kiluba-français.* Tervuren, Belgium: Musée royal du Congo belge.

Vanderlinden, J. [1980]. La seconde république (1965–1980). In *Du Congo au Zaïre, 1960–1980: Essai de bilan,* ed. J. Vanderlinden, 139–75. Brussels: Centre de recherches et d'information socio-politiques.

Vanderstraeten, L. F. 1985. *De la Force publique à l'ANC: Histoire d'une mutinerie, juillet 1960.* Brussels: Duculot.

Van Lierde, Jean, ed. 1963. *La pensée politique de Patrice Lumumba.* Paris: Présence africaine.

Vansina, Jan. 1966. *Kingdoms of the Savanna: A History of Central African States until European Occupation.* Madison: University of Wisconsin Press.

———. 1985. *Oral Tradition as History.* Madison: University of Wisconsin Press.

———. 1986. Afterthoughts on the Historiography of Oral Tradition. In Jewsiewicki and Newbury 1986, 105–10.

———. 1994. *Living with Africa*. Madison: University of Wisconsin Press.

Vellut, Jean-Luc. 1974. *Guide de l'étudiant en histoire du Zaïre*. Kinshasa-Lubumbashi: Editions du Mont Noir.

———. 1990. La peinture du Congo-Zaïre et la recherche de l'Afrique innocente. *Bulletin de l'Académie royale des sciences d'outre-mer* 36 (4): 633–59.

———. 1992. Une exécution publique à Elisabethville (20 septembre 1922): Notes sur la pratique de la peine capitale dans l'histoire coloniale du Congo. In Jewsiewicki 1992, 171–222.

Verbeken, Auguste. 1956. *Msiri, roi du Garenganze: L'homme rouge du Katanga*. Brussels: L. Cuypers.

Vincke, Edouard. 1992. Un outil ethnographique: La peinture populaire contemporaine au Zaïre. In Jewsiewicki 1992, 223–41.

Vogel, Susan, and Ima Ebong, eds. 1991. *Africa Explores: Twentieth-Century African Art*. New York: Center for African Art.

Wærn, Jonas. 1980. *Katanga: Svensk FN-trupp i Kongo, 1961–1962*. Stockholm: Atlantis.

Washburn, Gordon Bailey. [1954]. *Pictures of Everyday Life: Genre Painting in Europe, 1500–1900*. Exhibition catalogue, October–December 1954. Pittsburgh: Department of Fine Arts, Carnegie Institute.

Weinrich, Harald. 1973. *Le temps*. Paris: Seuil.

Wendl, Tobias. 1991. *Mami Wata, oder ein Kult zwischen den Kulturen*. Münster: Lit.

White, Hayden. 1973. *Metahistory: The Historical Imagination in Nineteenth-Century Europe*. Baltimore: Johns Hopkins University Press.

———. 1980. The Value of Narrativity in the Representation of Reality. *Critical Inquiry* 7:5–27.

White, Luise. 1993. Vampire Priests of Central Africa: African Debates about Labor and Religion in Colonial Northern Zambia. *Comparative Studies in Society and History* 35:746–72.

Wilden, Anthony. 1972. *System and Structure: Essays in Communication and Exchange*. London: Tavistock.

Willame, Jean-Claude. 1990. *Patrice Lumumba: La crise congolaise revisitée*. Paris: Karthala.

Yates, Frances A. 1966. *The Art of Memory*. Chicago: University of Chicago Press.

Yoder, John C. 1992. *The Kanyok of Zaire: An Institutional and Ideological History to 1895*. Cambridge: Cambridge University Press.

Young, Crawford. 1965. *Politics in the Congo: Decolonization and Independence*. Princeton: Princeton University Press.

———. 1992. Painting the Burden of the Past: History as Tragedy. In Jewsiewicki 1992, 117–38.

Young, Crawford, and Thomas Turner. 1985. *The Rise and Decline of the Zairian State*. Madison: University of Wisconsin Press.

GENERAL INDEX

Page numbers for all names, places, and subjects mentioned in Tshibumba's History of Zaire (Part I) are italicized. Tshibumba's use of specific terms has been retained; for example, his references to present-day Kinshasa will be found under both Léopoldville and Kinshasa, as indicated by the cross-references.

Abako (Alliance des Bakongo), *73n, 75n, 78n, 80n, 82n, 84, 86n, 88, 113–14*, 149
Abyssinian campaign, *62n*
Academy of Fine Arts: at Elisabethville, *210*; at Kinshasa, 11
Accra, *73n*
Adorno, Rolena, 219n
Adoula, Cyril, *123, 145–46, 148n, 154n*
Africa and Africans, *20, 24, 26, 27, 31, 45, 71*, 119, *152, 154, 157, 170, 173*; conceptions of dreaming, 258–59; general evocations of, 208, 233, 243; popular culture in, 247n; the state in, 275n, 276n; urban, 194, 197, 233, 247
Albert I, *59, 64*
Albertville, *133–34. See also* Kalemie
Algeria and Algerians, *164–65*
Algiers, *164–65*
Allegory, 266–67
Alpers, Svetlana, 214n, 239n
Amato Frères (business firm), *50*
America and Americans, *32, 82n, 107, 131, 162–63, 170–71*
Anachronism, 216–17, 233n, 260, 315. *See also* Chronology
ANC (Congolese National Army), *97n, 103–4, 109n, 111n, 115, 122, 134n, 151–52, 156n, 162–63*
Ancestral memories, *197, 198, 208*
Ancestral stories, 12
Andersson, Efraim, 55n
Angola, *25–26, 120n, 163n*

Anthropology: of art, 189; cultural, 297; of religion, 305
Anti-Arab campaign, *23n, 33n*
Arabs (*waarabu*), *23, 32–33, 34, 35, 170, 197, 202, 210, 215, 216*
Art: African, 188, 189; and aesthetics, 189; anthropology of, 189; and critique, 10–11; and history, 189; naive, 242, 244; and performance, 249; and thought, 10; tourist, 211; traditional, 244n; and work, 7
Art history, 188n, 194n
Artists, associations of, 8–9
Asch, Susan, 55n
Ashton, E. O., 277
Asia, *71, 170–71*
Assmann, Jan, 277n
ATCAR (Association des Tshokwe du Congo, de l'Angola et de la Rhodésie), *113–14*
Auburtin, Jean, 87n
Authenticity, return to, 293

Bakwanga, *102, 104n, 137. See also* Mbuji-Mayi
Bal, Mieke, 190n, 220n
Balubakat, *125–26, 130n, 133*
Banana, *45n, 118n*
Bangala region, 157
Bangweulu, Lake, *30n*
Banza Kongo (king), *17, 22–23*, 189n, 263, 271n, 281–82, 283, 286
Barber, Karin, 247n
Bateson, Gregory, 251n, 265n
Batumbula. *See* Simba Bulaya ("Lions from Europe")
Baudouin, King, *57, 65n, 66, 67, 70–71, 73n, 89, 91, 92–93*
Bauman, Richard, 249n, 265n
Bayart, Jean-François, 276n

BCK railway company, 52n
Bela, 210
Belgian colony (*Colonie Belge*; genre), 197, 203, 209, 273, 275, 285, 291–92
Belgium and Belgians, 25–26, 27, 41, 45, 46, 60, 61–62, 64–65, 66, 67, 68–69, 72, 73n, 76, 77, 81–82, 87, 94, 96–97, 99, 105n, 120n, 121–22, 126, 147–48, 161, 162–63; exploration and colonization by, 263, 271, 285, 295
Belgrade, 154n
Bemba, Sylvain, 256n
Bender, Wolfgang, 256n
Benveniste, Emile, 223n
Berlin Conference, 45n
Biaya, T. K., 188n, 198n, 242n, 276–77, 308
Bilsen, A. A. J. van, 84n
Blacks, 17, 20–21, 22–23, 31, 32, 34, 36, 43, 49–50, 53, 55, 59, 64, 67, 71, 72, 74, 76, 77–78, 79, 81, 85, 170, 172. *See also* Africa and Africans; America and Americans
Blankert, Albert, 194n
Boboso, Louis, 116n
Bodson, Omer P. G. J., 22–23, 41–42
Body art, 246
Bol, Victor, 220
Boma, 45
Bontinck, François, 33n
Bourguet, M.-N., 276n
Boyoma township, 153
Brassine, Jacques, 73n
Brazilians, 171
Brazzaville, 152. *See also* Congo-Brazzaville
Brett, Guy, 188n
Brussels, 28n, 57, 73n, 77, 87, 88, 147, 165n
Buisseret, Auguste, 73n
Bukavu, 5, 138, 160–61, 163n, 164
Bulambemba, 117–18, 119
Buluo, 85–86, 87
Bunkeya, 13, 41

Cairo, 152n
Callaghy, Thomas M., 167n, 181n, 275n
Cannibalism: epistemic, 304; white (*see* Simba Bulaya ["Lions from Europe"])
Cão, Diogo, 22–23, 189n, 263, 271n, 282, 286
Cartel (Cartel du Katanga), 114n
Catholic religion, 17, 27–28, 78n, 182
Ceyssens, R., 299n
CFK railway company, 51–52
Charles, Prince, 64–65
Chenge, B., 210
China and Chinese, 151–52, 157, 171
Chomé, Jules, 55n

Chronology: "objective," 262, 282; in popular history, 263; and sequence, 262, 299; telescoping of, 263, 271, 282; and timing vs. dating, 263
Churchill, Winston, 231
Classification: of colors, 243; and genre, 193–94; folk, 196; vs. production, 195
Clément, Pierre, 73n
Clifford, James, 187n
Coca-Cola, 140, 231n
Code. *See* Pictorial language, Tshibumba's
Cofoka/Cofoza construction company, 4
Colonial schools of painting, 195, 209n, 210–11, 214n, 221
Colonie Belge. See Belgian colony
Colonization: as betrayal of friendship, 285–89; chronology of, 263; as deception, 279, 285–89; as domination and submission, 280–83; embodiment of, 285–86; as exploitation and imposition, 285; as loss, 279, 280–85; and mimesis, 286; and misunderstanding, 286–87; reaction and resistance to, 278–79, 289–95, 299n (*see also* Reactions to colonization); and religion, 281, 287, 296; and slavery, 280; and sovereignty, 281–82, 284; and suffering, 290–91; as a system, 302
Color: vs. black and white, 264; choice of, 242–43; cultural classification of, 243; as object of pleasure, 212
Columbus, Christopher, 148n
Comaroff, John and Jean, 187n
Comekat factory, 127
Comic strips, 236, 312. *See also Tintin*
Comité Spécial du Katanga, 52n
Communication: and confrontation, 221; and noise, 251; nonverbal, 223; and sharing of time, 251
Conaco, 88, 149–50
Conakat (Confédération des associations tribales du Katanga), 130n
Conakry, 177n
Confrontation: and communication, 221; and epistemology, 306; between popular and academic historiology, 279, 314–15; between popular culture and ethnography, 297–309
Congo, 22–23, 25, 27, 36, 45n, 46, 47, 51, 57–58, 61–62, 64–65, 66, 76, 79, 85, 88, 89–90, 91, 103, 107, 108, 123, 141, 144, 145, 147–48, 153, 156n, 163, 175. *See also* Congo Free State; Democratic Republic of the Congo; Unity, Congolese/Zairian; Zaire
Congo-Brazzaville, 161. *See also* Brazzaville
Congo Free State, 23n, 33n, 46, 60, 224–25, 230, 262
Congolese people, 35, 62, 67, 78, 80. *See also* Zairian people
Congo River, 36, 45n. *See also* Zaire River

Gérard-Libois, Jules, 97n
Ghana, 74, 81, 107
Gijsels, Marjolein, 256n
Gizenga, Antoine, 88, 114n, 134n, 152n, 154n
Graburn, Nelson, 211n
Greeks (merchants), 140, 172
Guaman Poma, 219n
Guinea, 75, 177n

Halbwachs, Maurice, 276n
Halen, Pierre, 305n
Hammarskjöld, Dag, 107n, 131–32, 289, 308
Harding, Frances, 249n, 262n
Heinz, G., 116n, 120n, 122n, 159n
Hemptinne, Jean de, 27–28, 55, 57, 60, 261, 281, 287
Hergé, 305
Herman, Paul, 305n
Higginson, John, 60n
Hinde, Sidney Langford, 33n
Historiography: academic, 217, 247, 274, 314, 316;
 African, 190; *Annales* school of, 249n; colonial,
 219n, 262; and knowledge interests, 269; and
 poetics, 309; popular, 253; revisionist, 296;
 theatricality of, 249n, 261, 262n; and topography,
 274; and writing, 236, 277
Historiology, 248n, 249, 269–77, 290. *See also*
 History
History: and agency, 274–75; and causation, 276;
 country/state, as subject of, 11, 270–71, 273,
 275–76; and ethnic identity, 211, 271–73, 292,
 294; and forgetting, 284; and genre painting, 9,
 13–14, 211–17, 236; and magic, 276, 304; meaning
 of, 278–80; and metahistory, 309; and myth,
 299; vs. oral tradition, 248; and periodization,
 277–78; philosophical, 249n; and prophecy, 256,
 312, 313; secrets of (*see* Secrets); and stories, 12;
 the subject of, 269–73; Swahili terms for, 311;
 and truth, 13, 269, 306
History of Zaire (Tshibumba's): Africans as agents
 of, 275; and the Bible, 229, 255; emplotment of,
 265–66, 272, 278, 288, 292, 312; Europeans as
 agents of, 274–75, 293; French scenario for,
 188–89; and genre painting, 193, 211–17, 236,
 270; as history of colonization, 217; iconographic
 sources of, 231n, 236, 258, 260, 266; men as
 agents of, 274; moral of, 295–96; narrative vs.
 comment, 223–27, 257, 278; omissions, 284–85;
 origin, x, 11; periodization in, 277–78; and
 popular memory, 210, 258, 261, 299; production
 of, 220–27, 269; recording of, 221–27; shortcuts
 in, 265; subject of, 269; traditional and literary
 sources of, 12, 217, 236, 258; as tragedy, 262n;
 women as agents of, 274; and writing (*see*
 Inscriptions)

Hodgkin, T., 296
Hymes, Dell, 221n

Ilebo, 5, 51
Ileo, Joseph, 73n, 93n, 107n, 123, 145, 154n
Ilunga, B., 9–10, 199, 204, 245n
Images, and storytelling, 219–20, 226, 227–35, 248
Independence, Congolese, 209, 289
India and Indians, 128
Inscriptions: artist's signature, 237–38; as speech,
 240; caption, 238; comment, 238; date, 238;
 epigraphic character of, 239–40; on objects
 depicted, 238–39; of places, 273–74; quotations,
 238; semantic function of, 239; table of, 237–39;
 title, 238
International African Association, 23n
Intersubjectivity, 251
Italy and Italians, 61–62, 154n

Jacquemin, J.-P., 220n
Jadotville, 66, 70, 95n, 96, 99n, 125. *See also* Likasi
Jamaa (religious movement): genre in, 194–95;
 thought in, 311n
Janssens, E., 28n, 62n, 63n
Japanese, 151, 171
Jesus, 20–21, 122
Jewsiewicki, Bogumil, xiv, 188–89n, 195n, 220n,
 248n, 275n, 276, 299n, 311n
Johns, Elizabeth, 194n
Joset, P. E., 305n
Jules-Rosette, Bennetta, 188n, 211n, 227n

Kabasele, 308n
Kabinda, 47, 103, 135, 141, 294
Kabinda (painter), 221
Kabongo, 110
Kabongo (chief), 133–34
Kabuika, 7, 106, 200, 208, 215, 222
Kagame, Alexis, 42
Kakanda, 68
Kalamba Mwanankole (chief), 101
Kalamu township, 75n, 80n
Kalema, L., 198, 200, 202, 207
Kalemie, 5, 133. *See also* Albertville
Kalima, 73n
Kalonji, Albert, 86, 88, 100, 102n, 103–4, 138,
 139–40, 141–42, 143–44, 149, 231, 289
Kalumba, Gabriel, 10
Kamakanda, 61–62, 63, 72, 212, 288, 292
Kamba, K. M., 201
Kambove, 4, 69n, 121, 134
Kamina, 5, 9, 95n, 96, 109, 161, 167, 313
Kamitatu, Cléophas, 114n, 116n, 150n
Kananga, 5, 100–101, 137. *See also* Luluabourg

Luena, 111
Lulua, 100–101, 137
Luluabourg, 63n, 83n, 100–101, 137, 146n, 150n, 235.
 See also Kananga
Lumenga Neso, 217n
Lumpungu (chief), 47–48, 299
Lumumba, Patrice, 9, 72–73, 74–75, 77–78,
 79–80, 85–86, 87, 88, 89–90, 91, 92–93, 94,
 100, 102–3, 110, 113–14, 115–16, 117–18, 119–20,
 121–22, 123–24, 125, 130n, 148, 152n, 153–54, 156n,
 158–59, 179, 190n, 215, 216, 258–59, 266–67,
 272–73, 289, 292, 306–7
Lunda, 189n
Luputa, 104, 141–42

Mabika Kalanda, 101n
MacGaffey, Wyatt, 263n, 299n, 316n
Madrid, 145–46
Makabu Mbuta, 205
Malemba Nkulu, 110
Malula, Cardinal, 166–67, 281, 293
Mandjumba Mwanyimi-Mbomba, xiii
Maniema region, 34, 163n
Manya K'Omalowete, 73n
Marcus, George E., 187n
Maron, Amour, 59n, 287–88
Martin, Marie-Louise, 55n
Matadi, 68
Matchika, 202, 204
Materiality, 251–52
Maurin Abomo, M.-R., 305n
Mayombe region, 23n
Mbandaka, 138. *See also* Coquilhatville
Mbanza Kongo, 23n
Mbanza Ngungu. *See* Thysville
M'Bokolo Elikia, xiii, 39n
Mbuji-Mayi, 102, 103, 104, 137, 140, 144, 231, 264, 273
Mbuya, B., 229n, 302n
Melion, Walter, 188n, 277n
Memory: art of, 198, 294; collective, 276; and forget-
 ting, 284; levels of, 196–98; and performance,
 247; personal, 209; and place, 273–74; and
 popular music, 259; and popular painting, 188n,
 195–96; subversive potential of, 214. See also
 Ukumbusho (memory)
Mermaid genre. *See* Genres, of Shaba popular
 painting: mermaid
Metaphor vs. metonym, 230, 247, 279
Mexico and Mexicans, 170–71
Miketo, Pierre, 125
Missions. *See* Colonization: and religion
Mitchell, W. J. T., 209n, 220n
MNC (Mouvement National Congolais), 73n, 75n,

80n, 113; MNC-Kalonji, 86n, 88, 101n, 114n, 130n,
 149; MNC-Lumumba, 86n, 88, 101n, 114n
Mobutu Sese Seko Nkuku Ngwendu wa Zabanga,
 xiii, 21, 25, 37, 45, 59, 80n, 116n, 133, 139–40,
 148, 152n, 155–56, 157, 158–59, 160, 162, 165n,
 166–67, 168–69, 170–71, 172–73, 175n, 176–77,
 178, 181, 182, 183, 196, 238, 258, 259, 267n, 281–82,
 283, 302n, 306–8, 313
Mode Muntu, 210
Monument: history as, 14, 234; a painting as,
 239–40; as symbol, 234
Morocco, 152n
Mpolo, Maurice, 120n, 121–22
Mpoyi, 59, 287–88
MPR (Mouvement Populaire de la Révolution),
 158, 168–69, 181
Msiri, 23, 38–39, 40, 41–42, 43, 288–89, 292
Mudimbe, V. Y., 311n
Mukanda Bantu, 39n
Mulele, Pierre, 114n, 116n, 151–52, 154, 289, 308
Mulungwishi, 24, 27, 29–30
Mungul Diaka, Bernardin, 116n, 165n
Munie Muhara, 23. *See also* Mwinimutara
Munongo, Antoine Mwenda, 39n
Munongo, Godefroid, 38, 105, 119–20, 122, 130n, 289
Music, popular, 8, 257–59, 279
Mutaka wa Dilomba, 105
Muteb, Kabash, 211, 244
Mutombo, C., 203, 211, 244
Mutonkole, Noël, 76
Mwana Shaba (company newspaper), 54–55, 169n,
 175n, 177n, 260
Mwanga (newspaper), 14
Mweka, 116
Mwene Ditu, 141–42
Mwenze Kibwanga, 9, 210, 212–13, 214n, 244
Mweru, Lake, 24
Mwinimutara, 35. *See also* Munie Muhara

National Society of Zairian Historians, 217
Ndaie, Emmanuel. *See* Kasongo Nyembo (chief)
Ndaie, Tb., 199, 206, 207
Ndjili airport, 65, 80n, 107
Ndola, 131–32
Ndzilo, 99n
Nendaka, Victor, 115, 120n, 150n, 165
Neumann, Klaus, 247
Newbury, David, 248n
Ngalula, Joseph, 73n, 75n, 143–44
Ngandajika, 102n, 104, 141–42
Ngandu Nkashama, xiii, 102n
Ngiri-Ngiri township, 75n
Ngoie, Y., 201, 205

Said, Edward, 279n
Sakania, *51, 68, 69n*
Salmons, Jill, 198n
Samalenge, Lucas, *120n*
Sankuru, *73n, 116n*
São Salvador, *23n*
Sapwe, Pius, *120n*
Schechner, Richard, 249n
Schelling, Vivian, 277n
Schramme, Jean, *122n, 161n, 162–63*
Scott, James C., 279
Secrets: magico-religious, 276; of the powerful, 307–9
Semiotics: and culture, 219–20, 227n, 230; and history, 278; and interpretation of pictures, 229–30; and language, 227; and politics, 214
Sendwe, Jason, *133–34, 234, 313*
Shaba, *30n, 47, 52, 66, 87, 92, 106, 119, 131, 133, 135, 137, 142, 188, 196, 263n, 271*; Swahili (*see* Swahili: of Shaba). *See also* Katanga
Shelton, Anthony, 189
Signature. *See* Inscriptions
Silence: negotiated, 306; and truth, 306
Simba Bulaya ("Lions from Europe"), 49–50, 298–306
Simba rebels, 300n
Songye people, *33n, 48n, 294*
Soumialot, Gaston, 153–54, 292
South Africa, 51–52
Spaak, Paul-Henri, *148n*
Spain and Spanish, *144n, 145, 160*
Speech community, 223
Speech events: components of, 221; and ethnography, 221–27; and genre, 194–95
Springer, John M., *30n*
Stairs, W., *23n, 39n*
Stanley, Henry Morton, 22, 25–26, 27–28, 29–30, 31, 34, 38, 282n, 286
Stanleyville, *31, 72–73, 86n, 134n, 140n, 153–54*. *See also* Kisangani
Stengers, Jean, *45n*
Story (*adisi, arisi*), 256, 295, 299, 300n, 309, 311, 312
Storytelling, 222, 225, 254–55; pictorial, 219–20, 226, 227–35, 248
Ströter-Bender, Jutta, 211n
Studstill, John D., 229n
Style: decorative, 244; distinctive, 8, 242; figurative, 195, 244; of representation, 233; Tshibumba's, 244–45; in Tshibumba's aesthetic vocabulary, 245
Sudan, *23n*
Svenbro, Jesper, 239n
Swahili, *40, 50, 89, 179*; East Coast Standard, 198, 222; people (*see* Arabs [*waarabu*]); of Shaba, 196,

222, 240, 243, 256, 280, 282n, 292, 302n, 311
Sweden and Swedish, *82n, 132n*
Swissair, 75
Symbols: African, 197, 228; cultural vs. transcultural, 228–30; and icons, 232; of oppression, 291–92; and representation, 295; and signs, 219, 227–35; totalizing, 197
Szombati, Ilona, xiv, 188n, 193, 196–97, 211n, 214n, 220n, 222, 230n, 242n, 309n

Tabu Ley. *See* Rochereau, Tabu Ley
Taifa (newspaper), 14
Talon, Vicente, *154n*
Tanganyika, Lake, *30n*
Tan Siew Soo, *58n*
Taussig, Michael, 286n
Tetela, *33n, 63, 72–73, 103, 292, 299n*
Tetela kingdom, 22
Texts: as documents, 251; and genre, 194–95; oral, 253; presentation of, 3; and speech events, 195; and transcripts, 223
Theater, popular, 279
Thinking: *kuwaza*, 217, 257, 290, 306, 311; and remembering (*kukumbuka*), 217, 290, 306
Thiriar, James, *28n*
Thomas, Nicholas, 286n
Thought (*mawazo*), 212, 260, 283, 295, 311, 314n
Three Magi, 20–21
Thysville, *54, 116n, 120n, 122n*
Time: irruption of, 250–51; real vs. story time, 251; sharing of, 251
Timing: and dating, 263; and framing, 264; and performance, 251, 255, 263, 278; and photography, 264; and "time out," 251, 299
Tintin, 132, 301, 305–6
Tipo Tip, *33n, 35*
Tolenga, François, *73n*
Tonkin, Elizabeth, 248n
Tradition, oral, 248
Tragedy: Aristotelian conception of, 249n; Tsibumba's History as, 262n, 275
Transcripts, Swahili, 189–90
Truth: and contestation, 312, 316; and danger, 306–9; dialectical conception of, 312–14; and fiction, 314; and history, 13, 269, 306; and lies, 308, 312–14; and reality, 306, 312
Tshatshi, Colonel, 115
Tshibangu Tshisuku, Monseigneur, 167
Tshibumba Kanda Matulu, *77–78, 83, 122, 178*; aesthetic vocabulary of, 244–46; as artist, 190, 295; as educator, 217; and genre painting, 190, 193; as historian and painter, 11–15, 189, 217, 295,

307; life and work of, ix, 3–15, 281; metahistory of, 309–16; as reader, 12, 217, 236, 265; style of, 244–45; technique of, 242, 244; as writer, 188–89, 262n, 313

Tshiluba language, *40, 101n, 112*

Tshimanga wa Tshibangu, xiii, *39n*

Tshinyama, General, *143–44*

Tshitambo, *30n*

Tshokwe, *106, 108, 113–14, 130n*

Tshombe, Moïse, 88, 96, 103, 105, 110, 119, 122, 134, *136n, 144n, 145–46, 147–48, 149–50, 151, 154n,* 160, *164–65,* 166, 289, 303, 308

Turner, Thomas E., *63n, 73n, 101n, 171n, 173n, 181n,* 220n, *271n, 275n*

Turner, Victor, 249n

Ujiji, *30n*

Ukumbusho (memory), 195–96, 198, 210, 212, 213, 254, 276, 284, 309. *See also* Genres, of Shaba popular painting

Union Minière du Haut Katanga, *52n,* 53, *59–60, 136n, 149,* 294, *299n*

United Nations, 21, *37n, 45n,* 81–82, 83, *106n,* 107, 108, 112, 123–24, 127–28, 131–32, 136, 170–71, 215, 231, 256, 272. *See also* Gécamines mining company

United States. *See* America and Americans

Unity, Congolese/Zairian, 212, 230, 231, 270–73, 276. *See also* Ethnicity

Ustorf, Werner, *55n*

Valensi, L., *276n*

Van Avermaet, E., *229n, 302n*

Vanderlinden, J., *156n*

Vanderstraeten, L. F., *80n, 83n, 84n, 93n, 95n, 97n, 99n, 107n, 116n, 118n, 120n*

Van Gogh, Vincent, *77–78*

Van Lierde, Jean, *80n*

Vansina, Jan, 248n, 271n, 311n

Vatican, *167n*

Vellut, Jean-Luc, xiii, *48n, 195n,* 220n

Verbeken, Auguste, *39n*

Vignettes, 286

Vincke, Edouard, xiv

Visual pleasure, 212–13

Vivi, *45, 46*

Vocabulary of the Town of Elisabethville, 261n, 274,

278, 287–88, 290–91, 292n, 299n, 311n

La Voix du Congolais (newspaper), *73n*

Wachtel, N., 276n

Walu Engundu, 257n

Washburn, Gordon Bailey, 194n

Weinrich, Harald, 223n

Wendl, Tobias, 198n

White, Hayden, 270n, 309

White, Louise, 304n

Whites, 32, 35, 36, 39, 42, 44, 45, 46, 47, 49–50, 51, 53, 54–55, 56, 57, 59, 61–62, 66, 67, 69, 70, 79, 81, 84, 94–95, 97, 121, 137–38, 144, 154, 173. *See also* Europe and Europeans

Wilden, Anthony, 251n, 265n

Willame, Jean-Claude, *73n, 82n, 86n, 87n, 90n, 93n, 95n, 104n, 105n, 107n, 109n, 111n, 118n, 130n, 140n, 156n, 159n*

Writing: anthropological, 187–88; and historiography, 236, 277; and painting, 219 (*see also* Inscriptions)

Yamaina Mandala, 217n

Yangambi, *73n*

Yates, Frances, 198

Yav, André, 261n

Yeke, 289

Yoder, John C., *142n*

Young, Crawford, *48n, 65n, 109n, 171n, 173n, 181n,* 220n, 275n

Zaire, 22, 25, 29, 33, 51, 88, 91, *101n,* 122, 123, 145, 147, 153, 155–56, 161, 164, 172, 174–75, *177n,* 181, 188, 256n. *See also* Congo; Congo Free State; Democratic Republic of the Congo; Unity, Congolese/Zairian

Zaire (currency), 156, *157n,* 161

Zaïre Afrique (newspaper), *181n*

Zaire River, 22–23, 117–18, 156, 167. *See also* Congo River

Zairian people, 35, 167, *177n. See also* Congolese people

Zambia, *94–95,* 131–32

Zanzibar, 32, 33

INDEX OF PAINTINGS

Johannes Fabian, painted by Ndaie Tb. in Lubumbashi, 1974.

Johannes Fabian is Professor and Chair of Cultural
Anthropology and Non-Western Sociology, University
of Amsterdam, and author of *Time and the Other: How
Anthropology Makes Its Object* (1983), *Language and
Colonial Power: The Appropriation of Swahili in the Former
Belgian Congo* (California, 1991), and many other works.

Tshibumba Kanda Matulu worked as an artist in the mining
towns of southeastern Zaire. He thought of himself as a
historian and educator of his people; his History of Zaire was
intended to help them overcome the trauma of colonization.
Many of his paintings have been exhibited in Europe and
the United States.

DESIGNER
Nola Burger

COMPOSITOR
G & S Typesetters, Inc.

CARTOGRAPHER
Bill Nelson

TEXT
Electra

DISPLAY
Gill Sans, Electra

PRINTER/BINDER
Data Reproductions Corp.